ONTOHACKERS PART III

Before you start to read this book, take this moment to think about making a donation to punctum books, an independent non-profit press,

@ https://punctumbooks.com/support/

If you're reading the e-book, you can click on the image below to go directly to our donations site. Any amount, no matter the size, is appreciated and will help us to keep our ship of fools afloat. Contributions from dedicated readers will also help us to keep our commons open and to cultivate new work that can't find a welcoming port elsewhere. Our adventure is not possible without your support.

Vive la Open Access.

Fig. 1. Detail from Hieronymus Bosch, *Ship of Fools* (1490–1500)

ONTOHACKERS: RADICAL MOVEMENT PHILOSOPHY IN THE AGE OF EXTINCTIONS AND ALGORITHMS, PART III: METAHISTORIES OF MOVEMENT: PHILOSOPHIES IN BECOMING. Copyright © 2025 by Jaime del Val. This work carries a Creative Commons BY-NC-SA 4.0 International license, which means that you are free to copy and redistribute the material in any medium or format, and you may also remix, transform, and build upon the material, as long as you clearly attribute the work to the authors (but not in a way that suggests the authors or punctum books endorses you and your work), you do not use this work for commercial gain in any form whatsoever, and that for any remixing and transformation, you distribute your rebuild under the same license. http://creativecommons.org/licenses/by-nc-sa/4.0/

First published in 2025 by punctum books, Earth, Milky Way.
https://punctumbooks.com

ISBN-13: 978-1-68571-282-2 (print)
ISBN-13: 978-1-68571-283-9 (ePDF)

DOI: 10.53288/0545.1.00

LCCN: 2025942125
Library of Congress Cataloging Data is available from the Library of Congress

Book design: Vincent W.J. van Gerven Oei
Cover image: Jaime del Val
All images in the volume are by the author unless otherwise stated.

As this is a book in progress, updates, extensions, and errata will be made available on www.ontohackers.com.

p. punctumbooks
spontaneous acts of scholarly combustion

HIC SVNT MONSTRA

ONTOHACKERS
Radical Movement Philosophy
in the Age of Extinctions and Algorithms

Part III:
Metahistories of Movement: Philosophies
in Becoming

Jaym*/Jaime del Val

*Metahumanist Philosophy, Aesthetics, and Politics for an
Earth Liberation and Regeneration:
Undoing Human Supremacism and Its Planetary Holocaust.
(Theory-Pragmatics of Metaformativity or Enferance/Enphereia)*

An Impossible Book for a Metahuman Reader

p.

Contents

PART III
Metahistories of Movement: Philosophies in Becoming ... 13

BOOK 7.
How Movement Has Been Thought: Metaphilosophical Histories, or the Rise and Fall of Human Supremacist Thinking ... 15
 7.1 Warning to the Reader ... 15
 7.2 Rethinking Movement (and Mobilizing Thinking): Metaphilosophy and the Wars of Movement and Form ... 16
 7.2.1 Indian Movement Philosophy ... 20
 7.2.2 Chinese Movement Philosophy ... 21
 7.2.3 Aztec Movement Philosophy ... 24
 7.2.4 African and Aboriginal Movement Philosophies ... 24
 7.2.5 Excursus 1: Dual Thinking: How Did the Dominant Anomaly Emerge? ... 26
 7.2.6 Excursus 2: High Treason: From *Philokinesia* to *Philosophia* and Back ... 26
 7.3 Pre-Socratic Thinking of Movement and the Invention of Fixity ... 27
 7.4.1 Circular and Vortical Movements ... 29
 7.4.2 Kinezoism, Hydrontology, Gignestology, Indeterminism ... 29
 7.3.3 Field Dynamics of Opposites, Likes, and Unlikes ... 32
 7.3.4 Indeterminate Origin and the Movement of Separation or Fight and Tension of Opposites ... 34
 7.3.5 Atomism as Early Physics of Transformation ... 35
 7.3.5.1 Rhythm, Contact, Orientation ... 36
 7.3.5.2 The Superiority of "Eternal" Circular Motion ... 39
 7.3.6 The Invention of Space (as Limit) ... 40
 7.4 Parmenides, Plato, and Aristotle: The Triple Turn toward Form ... 41
 7.4.1 Parmenides' Radical Turn to Absolute Immobility ... 41
 7.4.2 Plato's Cosmology ... 42

7.4.2.1 An Etymological Incursion	45
7.4.2.2 *Khōra*	46
7.4.3 Aristotle's *Kinēsis* as Both Potential and Actual	47
7.4.3.1 Animal Locomotion	51
7.4.4 Epicurus and Lucretius, Post-Aristotelian Precursors of RMP: Everything Swerves and Spreads Indeterminately	53
7.5 Mechanism: The Dominant Anomaly	56
7.5.1 Spinoza and Leibniz: Precursors of RMP	58
7.5.2 The Materialist–Dialectical Turn	60
7.6 Undoing the Mechanistic Inflexion	62
7.6.1 Nietzsche's Absolute Becoming	65
7.6.2 Bergson: Precursor of RMP	69
7.6.3 Excursus on Chance and Necessity as Wrong Dichotomy, from Democritus to Monod	73
7.6.4 Rethinking Experience: Proprioception, and Rhythm	74
7.6.4.1 James's Pure Experience	74
7.6.4.2 Sherrington's (Unnoticed) Revolution: The Proprioceptive Field	77
7.6.4.3 Boccioni's Pure Plastic Rhythm	78
7.6.4.4 Dalcroze's Rhythmic Field of Proprioceptions	79
7.6.5 Rethinking Experience (2): Phenomenology, Merleau-Ponty, Ontokinetics, and Interweavings Beyond Lines	80
7.6.5.1 Note on Phenomenology (from Husserl to Sheets-Johnstone)	80
7.6.5.2 Merleau-Ponty's Intentional Arc	81
7.6.5.3 Ontokinetics in Heidegger: The Existential Movements of Experience	83
7.6.5.4 Almost Moving Beyond Lines	84
7.6.6 The (Arche-)Somatic R/Evolution: Thomas Hanna and Somatics Practitioners	86
7.6.7 Process and Transduction	89
7.6.7.1 Whitehead's Nexus	89
7.6.7.2 Simondon's Transduction	91
7.6.8 Further Takes on Rhythm: Foucault, Lefebvre, and Beyond	93
7.6.9 The Return of the Fluids	95
7.6.9.1 Irigaray's Fluid Mechanics of Desire	95
7.6.9.2 Serres and the Return of Fluid Mechanics	97
7.6.10 *Différance* Diffracting	99
7.6.10.1 Derrida's *Différance*	99
7.6.10.2 Performativity	100
7.6.10.3 Diffraction	102
7.6.10.4 Anzaldúa's Mestiza and Sandy Stone's Near Legibility	104
7.6.10.5 Stiegler's Neganthropy	105
7.6.11 Deleuze and Guattari's Absolute Movement	109

 7.6.11.1 Absolute Movement as Field 111
 7.6.11.2 Rhythm, *Clinamen*, and Rhizomes 114
 7.6.11.3 Curves and Folds: From Leibniz to Cybernetics and Beyond 116
 7.6.11.4 Topological Digression with Parisi 119
 7.6.12 Beyond Chaos and Order: Undo the Priest's Promise of a Sweet Death! 121
 7.6.13 Massumi's Charge of Indeterminacy 123
 7.6.14 Manning's Relational Incipience 126
 7.6.14.1 Incipience and Acceleration 127
 7.6.14.2 Relationality 128
 7.6.14.3 Technoecologies of Bodying 130
 7.6.14.4 Micromovements and Virtual Movements: Dancing with Gil's Total Movement 131
 7.6.14.5 Opening Chiasms with Merleau-Ponty 134
 7.6.14.6 Fielding Forth 135
 7.6.14.7 Minor Gestures 136
 7.6.15 Nail's Kinetic Ontology 138
 7.6.15.1 Geokinetics 142
7.7 Rhizomatic Genealogies: For a Regenerative Field Thinking in Motion 143
 7.7.1 *Philokinesia*: Undoing Supremacist Philosophy — Toward a Radical Field Theory 145

EPILOGUE 1.
Supremacist Philosophy and False Transvaluation: Or Thus Speak I, Zarathustra, Today 147
 The Metahuman Mutation 152

EPILOGUE 2.
2100: Metahuman World — The Last Narrative. A Realistic Science-Fiction Story 155
 Introduction 155
 1. The Collapse 156
 2. Transitions 160
 3. Metahumans 162

EPILOGUE 3.
Enphereia 165

Glossary 167

References 181

PART III

Metahistories of Movement: Philosophies in Becoming

BOOK 7

How Movement Has Been Thought: Metaphilosophical Histories, or the Rise and Fall of Human Supremacist Thinking

> *Nothing is one and invariable, and you could not rightly ascribe any quality whatsoever to anything, [...] since nothing whatever is one, either a particular thing or of a particular quality; but it is out of movement and motion and mixture with one another that all those things become which we wrongly say "are" — wrongly, because nothing ever is, but all things are becoming* [γίγνεται]. *And on this subject all the philosophers, except Pamenides, will agree — Protagoras and Heraclitus and Empedocles — and the chief poets in the two kinds of poetry, Epicharmus, in comedy, and in tragedy, Homer, who, in the line "Oceanus the origin of the gods, and Tethys their mother" has said that all things are the offspring of flow and motion.*
> — Plato, *Theaetetus*[1]

7.1 Warning to the Reader

The following should be taken as a draft or sketch for a book rather than a fully developed one and as a large appendix or extension to the previous two volumes, reviewing the history of philosophy from a Radical Movement Philosophy perspective, highlighting a number of issues from an unusual perspective and correcting what I see as some fundamental errors or oblivions, not only in the original theories but also in the reading of ancient philosophy, due to a pervasively problematic (mis-)understanding of movement among most philosophers. The chosen chronological approach is just one among the possible ones, within which, however, I highlight certain rhizomatic genealogies. When movement definitions are missing, or in complement to these, indexes for it are to be found in definitions of perception, the body, experience, space, or time amongst others, and in the related cultural practices, including kinship, technics, or work. So these issues will appear as occasional threads of our genealogies. This book brings together my research into movement philosophies, which has been growing in parallel to the development of my own theories. It does not expose my starting point but a number of discontinuous and tangential references (some more than others) that I have encountered along the way. It opens up a broad landscape, where some aspects are more fully elaborated, while others are only drafted, and I may or may not elaborate them more fully in

1 Plato (1921, 43). Translation modified.

the future. I think it is worth sharing this material as it is. Perhaps others can take on the work of completing these sketches into fuller and more accurate histories of philosophies of movement and as movement.

This long final part can be seen as a third layer that deepens the field presented in the first two parts. The first one presented and unfolded the core philosophy, whereas the second expanded it in a number of fields (cosmology and evolution, critique of technocultures, aesthetics, and politics). This third layer situates my proposal in a larger, historical field.

7.2 Rethinking Movement (and Mobilizing Thinking): Metaphilosophy and the Wars of Movement and Form

I propose that movement is the fundamental question of philosophy and of life, even when it is apparently missing. One can, in fact, measure the level of antivitalism of philosophies by the degree to which movement is missing or assumed through questionable and given conceptions. Pre-Socratic philosophy (except in Parmenides) was altogether a question of understanding Nature (all that is) as movement–change and processes of becoming (emergence, transformation, and propagation–dissipation). But Aristotle laid the foundations for a wrong understanding of movement that has never been completely questioned in its foundations: a *determination* of movement that is both expression of and foundational to an epochal tendency to domination-as-reduction, unleashing an extinction cycle. Underlying most, if not all philosophies, sciences, technologies, arts, politics, and common sense there are mostly unquestioned assumptions about what movement is.

However, before, around, and after this dominant narrative other modes of moving–thinking and of thinking movement have proliferated. This is the central thesis of this book: that the predominant history of philosophy linked to metaphysics and ontology is an anomaly that became dominant, emerging from among myriads of other modes of thiking–moving. And growing together with Human Supremacism, it has hence contributed to the current mass extinction process, has little future, and needs to be urgently overcome.

This book proposes a reverse history of philosophy through the lens of this mostly neglected term: *movement*, diagnosing philosophies through it and looking for hints of more promising terms. I introduce a new vision of the history of philosophy as inflection or anomaly where deterministic modes of thought, linked to ontology and metaphysics, have emerged as epochal and disastrous inflection within a much broader and older field of pluralistic and nondeterministic proposals.

What I propose is a metaontological journey into ways of thinking about movement different from the ones prevailing today. I demand from my fellow travelers some predisposition toward ontological plasticity along the way, as we traverse wormholes to parallel universes that may challenge basic assumptions about the world.

For this I will focus at first on a crucial epoch: pre-Socratic philosophy, the period when philosophy itself started around the question of movement, with a plurality of nascent and inventive ways of thinking it, a certain innocence which was completely erased after Aristotle. This book is an attempt to recover that innocence in thinking movement and take it further. Pre-socratic philosophy was already a radical movement philosophy! It was plural set of only-movement doctrines. which were thinking nature (*physis*) as becoming (*gignesthai*) and movement–change (*kinēsis*), before

the triple tragic turn to fixity, being, and form came in via Parmenides, Plato, and Aristotle.

Movement has a history, many histories. It actually creates histories but not only that. It creates fields whose histories are nonlinear. In what different ways has movement been thought? Which of these have been erased or underdeveloped due to the predominance of others, biasing thinking ever after?

My claim is that these biases are not only theoretical but also perceptual, and thus come from movement itself. My theory is kinetic all the way through in accounting for how reductive philosophies of movement came about with reductive motions and perceptions emerging in increasingly geometric environments.

The following section isn't just a history of movement philosophies, it's also about a metaphilosophical[2] problem related to the perceptual bias of philosophy and its relation to movement. Metaphilosophy (in my own account, resonant with but different from Lefebvre's) studies the movement underlying philosophy as well as the implicit philosophies in movement itself, through the lens of metaformativity and Radical Movement Philosophy, implying a superseding of philosophy itself toward a *philokinesia*, a transformative thinking in/as motion. Increasingly reductive movements fostered increasingly reductive thoughts, spiraling with each other into a concentric vortex. It is time to infuse some centrifugal force into the field, undoing this epochal vortex.

The Aristotelian definition of movement as displacement has never been fully questioned yet, and this I set out to do. I also propose that movement was the core problem of philosophy from the beginning and that setting limits to movement has been its major drive, so what I offer is also reverse history of philosophy, revealing the underlying motif of movement. Causality and dualism, as we will see, are fully grounded in limiting movement, but the first philosophers (like many recent ones) did not attempt to do this. Thinking movement and the world's dynamism had perhaps a different *ethos* as a means for better and *more plastic movement with the world*. The problem was always ethico-political.

I propose an "ontological journey" to different epochs and modes of thinking, epochs that share assumptions different from the predominant thinking of our own era.[3] This is the ontohistory of a transvaluation toward the denial of movement's openness or indeterminacy. This transvaluation occurred by formulating an opposi-

2 Lefebvre's *Metaphilosophy* (2000) from 1964, proposes, building mainly upon Marx and secondarily upon Nietzsche and Heidegger, the study of philosophy's relation to the world and its transformative potential, where metaphilosophy, as superseding of philosophy, is identified with *poiēsis* as transformative creativity or creation. Metaphilosophy is unclassifiable in the given systems, as it doesn't systematize, but transforms: it mobilizes speech against discourse, it arises from uncertainty and ambiguity and from everyday life, its *poiēsis*, being poetry and truth, no longer has anything to do with the systematizing one of philosophy, moving in between fragmentary knowledges addressing partial problems, it refuses to define being, and it restores desire, where poietic power is the "inexhaustible presence of the infinite at the heart of the finite" (293), and where "the project of a radical transformation of everydayness cannot be distinguished from the superseding of philosophy" (115).
3 For instance, the idea of repetition couldn't be thinkable in Greece as we think it today in a culture of seamless reproduction (of music, images, gestures, perceptual ratios). Just try to think of how cosmic cycles (as cyclic times of eternal recurrence) were perceived in their irreducible difference of the days and the years, before geometrically repeatable abstractions of identical repetition appeared and dominated thinking, becoming the reference, orienting perception so that the cycle is considered identical in its quantitative timeline and its geometric (astronomic) trajectory in spite of its irreducible differences in other regards.

tion to movement, fixity, which became thinkable as the result of increasingly fixed perceptions in geometrical environments. Fixity gave way to form, form to actuality and causality, in the triple turn effected by Parmenides, Plato, and Aristotle, which culminated the denial of indeterminacy by associating it to lack, in an almost complete reversal from the first philosophical conceptions of the Milesians Thales, Anaximander, and Anaximenes, and the Ionian Heraclitus. This turn expressed a consolidation of increasingly abstract power relations in mature slave societies (Thomson 1954).

The history of philosophy could thus be characterized as *the wars of movement and form*. In the three hundred years between Thales and Aristotle we may see a tension or ongoing war, often within a same philosopher, between philosophies of movement and philosophies of fixity and form whereby the latter triumphed.

This relates to movement and its *undefined nature*, its indeterminacy as the unrecognized core philosophical problem driving ontology from the beginning. Why was it such a crucial problem? Perhaps because domination is all about reducing movement's indeterminacy, *putting limits to movement*. So ultimately the war was between two tendencies: modes of thought that are reductive and tending to domination, and modes of thought that are less reductive and less dominant, that dance with chaos, that take on the movement of evolution as variation. Reductive or reactive vs. creative or active. Ancient thought can be seen as the history of an incipient and growing fight and oscillation between active and reactive forces, where the latter took over as empires imposed themselves. Ever since, philosophy as movement has been a struggle between domination and freedom.

The philosophical turns in thinking movement are indissociable from science. Overall, there are three main inflections: Greece (along the emergence of geometry); Mechanism (ensuing from perspectival vision); and in the past 100 years or so (along the scientific revolutions of relativity, quantum mechanics, field theories, biology, and numerous other fields). I warn that the trip has no pretension to present an encyclopedic, all-encompassing view. The trip is already biased by my attempt to look for hints of a radical movement and field philosophy.

I will focus here on the Eurocentric tradition of the *logos*. But as Brice Parain (1971, 2) points out, there are various kinds of reasoning (mathematical, poetic, historical, musical) and different ways of communicating it. It's possible that language can only talk to the body through movements of the body and that we need to introduce bodily practices in our philosophical teachings and thereby other modes of reasoning. *Logos* was indeed a word with extremely broad connotations for ancient Greeks. Egyptian and Greek philosophies are embodied in their dances. Christianity evolved into an unmoving dogma without dance. *Rationalism is the aligned dance of technics.* According to Neher (1971, 53), the pluralism intrinsic to polytheism pointed to an indeterminism which was contested in antiquity by Hebrew monotheism, in a logic derived from the singular God. Maybe the degree of self-reflection of a culture on its movements and on life is itself a sign of nihilism or decadence? This is the paradox of reflexivity and civilization: we reflect on movement the more we have lost movement! Can then philosophy, he asks, survive metaphysics? With a new physics, I argue!

...

The metaformative metaphilosophical approach looks at the unacknowledged perceptual–kinetic conditions underlying philosophies. Furthermore it looks at implicit

Fig. 1. Diagram of the anomaly and unfolding of supremacist philosophies

movement philosophies in understanding the tendencies in societies or cultures to sustained openness or closure, to variation or homogenization, to relationality or separation, to flow or stasis, in dealing with movement in thought and life, and examines the entanglement or separation of thought and life, of thought and/as motion.

Thereby the link between movement's reduction to being, and supremacist dominion systems will be crucially revealed, whereby the philosophical age of being/ *ontos* and metaphysics is denounced as supremacist philosophy underlying and cementing human supremacism and with it the current mass- and self-extinction process. This happened through the creation, in thought itself, of the very splits and alignments on which this supremacism has been grounded, starting with the split between thought and movement, which emerged with sensorimotor alignments that preceded philosophy in hundreds if not thousands of years.

The history of philosophy is that of a great reductive inflection (fig. 1) that now needs to be completely overcome, ontohacked, and where metaphysics and being/ *ontos* or form have emerged as means to determine movement. As I expose in Books 5 and 6, aligned movements emerged in the Neolithic and with them, gradually, aligned modes of thought tending to increasing splits, creating the split between thought and movement/world in the process.

First grand static ideal forms emerged (the Greek inflection), then mathematical forms–trajectories consolidated (the mechanistic inflection) allowing a second global homogenization of movements in the biosphere, and lastly dynamic topolo-

gies and patterns (the cybernetic and postcybernetic inflection) are the most recent expression of that process as it heads exponentially to an extinction singularity or black hole. Before and all along other modes of thinking–moving have existed that now need to return more than ever, with new force, overcoming all aporias and errors of the age of Extinctions and Algorithms.

It will be subject for other potential books to study the plethora of other implicit or explicit ways of thinking movement in India (Zimmer 1965; Daniélou 1987), China (Cheng 2002; Wilhelm 1977; Laozi 1983), in the Aztec cosmology of ancient Mexico (Maffie 2014; Séjourné 1964), or in other imperial and non-imperial cultures, Indigenous, and Aboriginal cultures. I will, however, make here some brief references to diverse non-Western movement philosophies as matter for deeper future study.

7.2.1 Indian Movement Philosophy

In ancient Indian philosophy, there is a radical affirmation of the never-ending transmutations (*kāya*) of cosmic energy (*śakti*), as expressed by Śiva, the cosmic dancer, Indian predecessor of Dionysus, as affirmative and expansive principle of unfolding. In the "Creation Hymn" an originary vibration within an indeterminate formless principle is the world's origin, desire sprouting as movement of vibration. Some Indian cosmologies present the world as rhythmic and vibratory process emerging from an indeterminate substrate. This vibration unfolds into a nondualist rhythmic process of diversification and into complex micro–macrocosmic correspondences and transmutations of elements.

Śivaist cosmology speaks of cosmic cycles in which a primordial spacing creates vibrations, the energy creates rhythms, and the rhythms create matter, which is a vision astonishingly close to contemporary cosmology (Daniélou 2006). Śiva creates the world through rhythm. In its recurrent, often ithyphallic figurations, Śivaist movement philosophy is expressed in the cosmological icons of Śiva Naṭarāja, whose multiple nondual torsions rhythmically create, preserve, and destroy worlds: a fivefold movement. As Naṭarāja, the cosmic dancer of creation and destruction, Śiva's many arms represent the multiple dance of creation (drum), destruction (fire), protection, grounding (or embodiment), and release. Śiva's dance of cosmic creation implies a centrifugal force and *principle of expansion*, in which energy creates rhythms whose *perceptions* create space, time, and matter (Daniélou 2012, 27). Space has dimensions only in relation to particular vibrations and their lengths (Daniélou 2006, 147).

Śiva's dances acquire numerous expressions in temple sculptures, for instance in the 108 *karanas* (key dance transitions), in the sixty-four *kalās* (arts) to be learned, but also in the erotic, tantric sculptures of the Khajuraho temples, where ecstatic, orgiastic dances may have been danced in dedication to Śiva.[4]

4 For an extended account of Indian philosophies and their exuberant and affirmative expressions of an indeterminate and dynamic principle, see Zimmer (1965, 268–81). See Woodroffe (1974, 68) on vibrational movement as the nature of matter in ancient Indian philosophies of *tantra* and *śakti*. See Daniélou (1987) on Śivaism, Indian cosmogonies, and Tantrism and its relation to Dionysian cults.

7.2.2 Chinese Movement Philosophy

In Chinese philosophy, *qi* is the "vital force." *Qi* is in flux between its indeterminate principle and the infinite plurality of its transitory manifestations, the primordial being dynamism itself (Cheng 2002, 36). The *yin–yang* principle is a ternary movement focusing on a dynamic middle, which acquires further consistency through the cycles of mutations of the five elements, which are not substances but processes following a cyclic movement. This complex set of dual, ternary, and cyclic motions seems core to the Chinese model (Vandier-Nicolas 1971).

The Chinese *Book of Changes* or *Mutations*, *I Ching* or *Yijing*, one of the oldest known books, is a naturalist pragmatics for interpreting the cosmos as made of incipient, barely perceptible processes of change, transformation, mutation, or becoming.

Chinese Daoist movement philosophy is condensed in the diagram which hosts the *yin–yang* symbol at the center surrounded by combinations of the *Yijing's* sixty-four hexagrams, which express the multiplicity of processes of mutation of the world's unfolding. The diagram is used as part of the *fengshui* compass, as a geomancy technique that seeks to identify the energies of places as possible sites for buildings or activities, or for "correcting" bad energies of some places. The *yin–yang* symbol itself seems to echo in the spiraling movements of some ancient Chinese longsleeve dances. Chinese calligraphy and painting embody this sense of being in the world as moving with it. It is in how one moves that one gets the key to harmonious living. But, as in Greece, the Confucian, anthropocentric account took over, imposing the more immobile accounts of family kinship and state.

The hexagrams of the *Yijing* were arguably derived from much older ways of interpreting movements in nature existing in almost every ancient culture, taking on a more abstract symbolism. The sixty-four hexagrams afford a multiplicity of signs for interpreting any mutation in the cosmos. In this ancient Chinese mode of thought situations are always of transition or mutation, and they are approached in their incipience. Core to this thought is the sensibility toward germs, imperceptible or barely perceptible stirrings, the approaching of life and the cosmos both as ongoing transformation and in the nascent process of neverending changes. The combinatory of the movements exposes the process of differentiation where the multiplicity of the universe comes about, but always in relation to the latent potential from which it continually stems.

The hexagrams include a continuous line that signals an undifferentiated unity (*yang*), and a discontinuous line that signals the opening to difference (*yin*). The sixty-four hexagrams expose all the possible combinations of these two principles grouped in sets of three and six. What they expose is modes of alternation between the *dao* (undifferentiated latency) that seems to resemble the *apeiron*, and the principle of action (*yi*), a minimal action that perhaps resonates with the *clinamen* or with the ancient etymology of chaos. The cosmic principle is the oscillation between the imperceptible, formless, latent, undifferentiated unity and the changing and transitory manifestations emerging from it and returning to it. This oscillation is between latency and the movement of action, between an unfolding of *yang* (difference) and a return to latency and *yin* (stillness). *Qi* is the cosmic dynamism that underlies both the condensing into transitory forms and their overcoming (a sort of will to power of variation as it is in my proposed principle of fluctuation). All things are transitory condensations in different modes and degrees. Condensing is being born, dissolving back into the indeterminate potentiality is to die. *Dao* is both the field of potential-

Fig. 2. Cosmic movement diagrams, mandalas, and cosmic representations. A cosmic representation from Tibet with dance at its center (upper left), a statue of Śiva Naṭarāja from India (lower left), a *yin–yang* symbol surrounded by hexagrams from China (lower right), the Ptolemaic–Aristotelian division of the spheres from Greece (upper right), the representation of Aztec cosmology with *ollin* at its center (opposite page, lower left), and a modern logarithmic representation of the observable universe by Pablo Carlos Budassi (opposite page, upper left). Some of them host at their core a dual tension movement principle balanced by a law of the middle (*yin–yang* and Aztec). On the opposite page, upper right my "cosmic mandala" summarizes some aspects of this book's cosmology: the outer limits are our observable universe as part of a larger universe from whose limits in time-space (big-bang) a double unfolding happens, entangled from all directions. The middle circle of spirals signals matter flows and the age of stars, and the inner circle the subatomic vibrations of matter. These two are also entangled in their in between planetary level where new complexity appears. The V inflection on top is the current age of conflict and extinctions that paralyses flows and evolution. The two inner circles expose the multiple entangled and woven movements of becoming: oscillations, spirals and weaving, like in Aztec philosophy, appear as expression of a more fundamental fluctuation that spaces in the same movement of internally diversifying.

ity that affords the mutations, and the moving, advancing, which is in turn both the walking and the way (a field conception).

The hexagrams thus express the movements of the world. Their associated ethos assigns a negative sense to all that stiffens and blocks the mutations, the energy transformations. It's thus about interpreting the emergent movements of the world before they become formed, for moving with them, avoiding their congealment into stiff forms, keeping the movement of differentiation going in its continued relation to the indeterminate source. The hexagrams are thus a system of interpretation of the cosmos as made of incipient movements of transformation, and whose aim is to better move with these, in the oscillation between differentiation and indifferentiation. Hexagrams are metabodies in so far as they expose the emergent movements composing a situation, as both movements and modes of interpretation and relation, as diagrams.

Arguably it was only later that these became settled into a system of opposites in Daoism that is almost identical to the Pythagorean system (Guthrie 1962), already in a mature epoch of imperial China, whereas the *Yijing* could be the nonbinary heritage of pre-imperial searches for understanding the movement of the world: not to dominate but to better move with its mutations. Thomson (1975, 189) proposes that the abstraction of the *yin–yang* dual principle was related to despotic monarchies in China. Here one can trace a crucial bifurcation. Where *dao* as a sort of void is the indeterminate field of potentiality, in Pythagoreanism and later atomism the void

seems to lose part of its dynamism while still being the condition for movement, an active principle. Fluctuations in quantum field theory bring back the idea that the field of potential is itself the dynamic matrix, they are both *dao* and *qi*.

7.2.3 Aztec Movement Philosophy

James Maffie (2014) has provided a deep interpretation of Aztec thought where *teotle* is becoming and movement–change (thus resembling both Greek concepts of *gignesthai* and *kinēsis*), both material and immaterial, third element, process, power, energy in motion, self-unfolding, self-arranging, self-becoming, and self-presenting. Time–place is how *teotle* moves, unfolding its rhythms, fielding. *Teotle* has three main movements: (1) *ollin*: bouncing, oscillating, pulsating, centering, curving, rounding, undulating, the cycles of the cosmos; (2) *mallinali*: spiraling, spinning, twisting, gyrating, revolving, whirling, sweeping, and cleaning for refeeding (as in sacrifice or hair brushing); (3) *nepantle*: weaving, intersecting, joining, juxtaposing, superimposing, middling, balancing, destruction–creation, neither–nor, ambiguity, entanglement of opposites in fight (war and sex are examples). *Nepantle* is the most fundamental working of the cosmos, the law of the center, based on an *inamic agonistic unity* of fight of opposites, cyclical, in endless coordinated microprocesses; it is both a metaphysics and an ethics.

Aztec movement philosophy is condensed in its cosmic calendar, the stone of the sun, at whose core is *ollin*, the movement hieroglyph, and the five ages of the sun, the four opposites that weave in a middle, surrounded by the actual calendar cycle, and enclosed by two serpents. The imperial dances of the Aztecs expressed this cosmic dimension (see Book 6).

The symbol for movement, *ollin*, is an interlacing of two lines and is ubiquitous and of primary importance in Aztec culture. The four ends connecting in the center are said to mean the union of contraries in tension, four interlaced opposites and four directions, both orderly and chaotic, and four principles: generation, congregation, displacement, and integration, interlaced in the center, which is the present era of the sun, the four ends being also the four previous cosmic eras: "Ollin has been described as being composed of four (Nahui) concepts, *Tloke* ('what is near') or the principle of generation, *Nahuake* ('what is closed') or the principle of congregation, *Mitl* ('arrow' or 'direction') or the principle of displacement, and *Omeyotl* ('dual essence') or the principle of integration."[5] Though also based on pairs of opposites in conflict that seem to partly resemble a Heraclitan worldview, Aztec metaphysics prioritized motion over substance.

The three Aztec ways of understanding movement as *oscillating*, *spiralling*, and *interweaving* seem to be very interestingly exposing field conceptions, similar to the ones I propose in this book.

7.2.4 African and Aboriginal Movement Philosophies

Jahnheinz Jahn (1994) proposes four main concepts shared across numerous African cultures as a possible spine of an "African philosophy":

5 See *Wikipedia*, s.v., "Nahui Ollin," https://en.wikipedia.org/wiki/Nahui_Ollin. See also Séjourné (1964).

1. *Muntu*: intelligent force–movement (human or divine), of which Ntu is the cosmic force–matter–movement (these terms are not separated: everything moves);
2. *Kintu*: force that is moved (animals, plants, things);
3. *Hantu*: spacetime force: space and time are often thought interchangeably as situations for events. The time can be a place, like when saying "at the boat," and the place can be named as a time;
4. *Kunto*: modal forces: laughing, life activities — made of two aspects determination (word) and rhythm. The latter is crucial and defines every aspect of life, hence the relevance of the dances and their masks.

The split between human and nonhuman in *muntu* and *kintu* expose an anthropocentric bias in African philosophy as well, although in other respects such as the relevance of nonmetric rhythm as modal force, of nonseparation between force and matter, of spacetime being interchangeable forces, it presents a very promising movement-field approach. African movement philosophy has perhaps its best expression in the actual dances that permeate life.

Australian aboriginal movement philosophy also acquires expression in the totemic dances, especially in the intricate and complex Corroboree and in art. Erin Manning (2009, 155) exposes contemporary aboriginal painting as proprioceptive field diagram recomposing experience, seeing in motion, inviting to move, as polyrhythmic quality and velocity in which life is woven as dreaming, in a spacetime where experience and the land are coemerging, where the land is them, the body, and its dance. Marcus Barber describes the relationships between people, water, and places in the everyday life of the Yolngu people of Yilpara in northeast Arnhem Land as follows:

> In the Yolngu world, a sophisticated understanding of the fluid and dynamic relationships between fresh and saltwater is given a greater priority than the division of the coast into land and sea. These waters are continually moving and mixing, both underground and on the surface, across an area that stretches from several kilometres inland to the deep sea, and they combine with clouds, rain, tides, and seasonal patterns in a coastal water cycle. Yolngu people use their understanding of water flows as one basis for generating systems of coastal ownership, whilst water also provides a source of rich and complex metaphors in wider social life. (Barber 2005, xi)

Similarly, Inuit movement philosophy is, or was till recently, implicit in their sensorimotor capacities to orient themselves on the ice, moving with the flows (till this capacity was largely erased by the use of GPS), in their playful activity in work, or in their modes of kinship, alien to the modesty and privacy taboos of European colonial sexual morality.

...

And so forth. A metaphilosophical research into movement practices and conceptions of any people past and present may shed light onto how far the degree of self-reflexivity is linked to an impoverishment of movement itself. But can't one create modes of thinking movement that are nonreductive? Were there or still are there such modes already?

7.2.5 Excursus 1: Dual Thinking: How Did the Dominant Anomaly Emerge?

How did the tendency to dualist, polar, binary reduction appear? How did the reductive and neurotypical anomaly of thinking in terms of opposites emerge?

Most (but not all) cosmogonies show this dual bias: dual pairs emerging from an indeterminate source or directly from a dual principle as in Heraclitean, Daoist, or Aztec philosophies. Claude Lévi-Strauss proposes in *The Savage Mind* (1966, 75) that a previous impoverishment of empirical experience has allowed the conception of opposing terms as if they were different, ensuing in a logic of opposition. "Savage thought," whether ancient, tribal, in modern arts, or in common sense is described by Lévi-Strauss as the tendency to distinguish and create systems of oppositions, a reductive thinking in different modes and stages.

But maybe there have been other modes of thought in motion, in the dancing bodies and their disaligned expressions. I propose that there was a gradual transition from a sense of symbiotic variation to the emergence of a sense of difference between a self and an "other" or a world, and between life and death, with roots in bipedalism, its step-based walking on two legs, its operation with *two* hands and eyes, and the gradual tendency to geometric alignment and reduction of movements, perceptions, and relations, from vortical into circular, linear, and pyramidal networks. The fundamental dualisms could be self–other and life–death as evolutions from a prehuman sense of symbiosis and variation:

— symbiosis → self–other → subject–object, active–passive, cause–effect, dominator–dominated, master–slave, human–nonhuman, man–woman, culture–nature, mind–body, etc.
— variation → life–death → being–nonbeing, order–chaos, limited–unlimited, affirmation–negation, good–evil, right–wrong, love–hate, full–empty, light–darkness, etc.

Another evolutionary factor underlying dualist tendencies is possibly in the increasing articulation of *biparental* sex and kinship. But biparental sex is just one mode amongst many:

— all sex → biparental → semialigned (animals and tribal) → aligned (sex in kingdoms, empires, states) → superaligned (Christian–puritan–Victorian, Islamic, monotheistic, and algorithmic).

Dualities are a strange neurotypical bias, a collective fiction that has colonized the world, the effect of an "altered perception" of bipeds in geometric environments that reduce indeterminacy, the effect of the determination or alignment of movement that arises with linearity, causality, and teleology. Causal linearity also invented accidents and errors, which do not exist *per se* if movement fluctuates indeterminately as in the wandering of free animals.

7.2.6 Excursus 2: High Treason: From *Philokinesia* to *Philosophia* and Back

In Book 6 I propose a choral and kinetic theory of the origins of philosophy and an altered perception hypothesis: Greek philosophy emerged from a variety of ecstatic practices in mystery religions, some linked to Apollo and immobility-induced trance,

others to Dionysus and ecstatic dances, as well as from mimesis, drawing on the two primordial kinds of dances in antiquity, ecstatic and mimetic as the two primordial, archaic, embodied, and kinesthetic forms of knowledge. Both converged into logical reasoning, in a complex synthesis effected by Plato and culminated by Aristotle.

This transition was the symptom of a culture that was becoming increasingly governed by geometric reductions of movement and perception, where bodies were increasingly oriented by external geometric cues, with a growing sense of individuality, which, along with the preoccupation with death and the soul, led to the concept of immobile eternal being.

Philosophy emerged from states of altered perception, and reason evolved as the mode of thinking of a generalized altered perception of aligned bodies. Immobile trance techniques leading to a neglect of movement and the senses and a foregrounding of self-referential logical chains of language (Parmenides); the emergence of dialog out of Dionysian religious cults and from cults of the dead leading to dialectics (Socrates); and mimetic knowledges leading to geometry and laws of movement in early pre-Socratic accounts of *physis*, all of these expressed tendencies to reduction of movement that became synthesized by Plato and culminated in Aristotelian causality and logic.

Philosophy was the result of a reduction where bodies stopped sensing their movement and learning how best to move *with* the world, and became trapped in a self-reflexive reason that assumed an immobile position, fictionally external to the world, never reflecting upon the world but developing and expressing an internal structure and a self-referential movement, externalizing it, imposing it onto the world, unfolding up to today's nightmare of all-encompassing algorithmic world reduction.

Philosophy betrayed itself soon after it started, in changing its subject from nature as movement–change and becoming, to being and fixity; from rhythm, orientation, and contact to form, order, and position. It is time to recover the ancient spirit of philosophy and its positive concern with movement.

Philokinesia, not *philosophia!* The mistake was to start talking about movement and "thinking about it," but from an increasingly immobile body, to later go on to deny and ignore movement. This is the deep sense in which Alfred North Whitehead's comment that Western philosophy can be seen as a series of footnotes to Plato must be read: footnotes to human supremacism and its immobile bodies. My proposal is metaphilosophical (or perhaps counter- or antiphilosophical), since it opposes and looks beyond a static "love of wisdom" and proposes the urgency of mobilizing thought-knowledge in motion. There is only love of movement: *philokinesia*.

7.3 Pre-Socratic Thinking of Movement and the Invention of Fixity

Following Plato's statement in the *Theaetetus* (1921, 43) that all thinkers before him (except Parmenides) considered that *nothing is* but *everything is only in becoming* (*gignesthai*), one could say that *all philosophy was a movement philosophy*, and the radical anomaly that came up with Parmenides was the very idea of categorical fixity. The "only motion" doctrine was not Heraclitus's privilege, rather it was a universal assumption of ancient thought.

I want to suggest that at the origins of philosophy one can see different conceptions of movement which gradually intermingle in complex ways, culminating in Plato and Aristotle, from which at least three stand out more clearly, and a particu-

Circular motion

Vortical motion

leading to displacement

differential field conception

Fig. 3. Circular and vortical motion, the two main conceptions of movement in early Greek thought, the first one as reductionism and abstraction of the motion of heavenly bodies leading to the notion of displacement, the second instead implying a differential field conception and observable in water flows.

lar hybrid of two of them ends up dominating: *flow and the vortex* is the first, *circular motion* is the second, and *rectilinear motion in infinite space* is the third.

I will distinguish three main genealogies, one linked to flow, water, and the elements outlining a first potential physics of transformation and of movement as field that eventually got lost until recently; the other to astronomy and the resulting geometric sphere and the universally high esteem for the continuous circular movement of the planets in ancient Greece; the third one relates to the emergence of the concept of space, leading to Aristotle's definition of movement universally conceived as divisible displacement. They are often intertwined in complex manners. *Vortexes*, *spheres*, and *grids* are the three major tropes unfolding with these three genealogies.

The generalized conception of all first philosophers (except Parmenides) and in ancient cultures in general was of movement as continuous, movement equating all forms of change, and movement as all that there is, equated also with intelligence, reason, soul, and life. The more continuous movements were the ones most embodying intelligence (*nous* in Anaxagoras), reason (*logos* in Heraclitus), soul (*psychē* in the Pythagoreans), and the *hylozoist* material moving principle (*archē* in the Milesians). The *archē* was not a cause for movement, nor was reason, soul, or principle. They *were* movement, or movement was them; they were the animating force of life. The true identification at the time was not of matter and life (*hylozoism*) but of movement and life, that is, *kinezoism*.

Kinēsis meant every kind of change, including growth and alteration of quality. *Kinēsis* as both movement and change and becoming (*gignesthai*) as process of generation were the preoccupations of early philosophy, accounting for *physis* or nature as all that there is, including its expressions in language, thought, perception, knowledge, ethics, and politics. They were all an issue of movement. It is difficult for us post-Aristotelians, Euclideans, and Cartesians to understand these early conceptions, closer perhaps to modern physics, as they rely upon a different intuition and common sense that changed forever with Aristotle. Plato was still in between, still

inheriting the older traditions for thinking movement, and his cosmology cannot be properly understood without these prior traditions.

7.4.1 Circular and Vortical Movements

I propose that there were at first two major conceptions of movement in early ancient Greek philosophy and culture: *circular* and *vortical* (fig. 3). Only later a more linear or gridded conception would appear. Circular movement came from the study of the stars and planets and gave rise to the first concept of displacement, while vortical motion came from the study of water and flows, being closer to a field conception.

The vortex was a source of ubiquitous interest of ancient cultures in the movement of the world, resulting in ubiquitous spiral designs (particularly in Minoan and Cycladic cultures, and inherited by Mycenaean culture), along which a concern for circular movement. Circular dances arose through the study of the motion of stars and planets (and in the coming together of macro- and microcosmic). Circular motion was of crucial importance in ancient Greek thought, linked to the study of the heavens (implying the rational soul of the world in Plato), a movement which we now know is part of the larger vortexes of star systems and galaxies.

Phora, displacement, seems to stem from the motions of planets as the primordial trope for linear motion evolving into the notion of circular motion and into the abstract geometric sphere. But *phora* meant also to carry, as in *amphora*, or transfer as in *metapherein*, which not by chance is linked to the new tendencies of Neolithic societies to accumulate, store, and carry around. Linear motion is thus an abstraction of the motion of heavenly bodies. So is circular and spherical motion.

The spiral instead was linked to the "disorderly" motion of the flows (the irrational soul of the world in Plato), perhaps also to some bodily motions which were animal in quality, as the ecstatic, vortical dances of the maenads. The body itself can also be seen as a multiple vortex where every joint can act as inflection node, though it can be trained to perform circular–linear movements.

We will start by examining the vortical approach more closely, which perhaps stemmed from ancient sympathetic magic and tendencies to mimesis in animism and early naturalistic religions, as attempts to read the movements of the world and learn from them, so as to move with them, amongst which the movement of water was primordial as the movement of life itself.

> *The ancient peoples confounded movement with life absolutely. The movements of water in particular were manifestations of the universe as a great animated being [...]. Water, that was the abode of all science, was also the educator of the artistic sensibility of the Greeks.*
> — Luis Siret (1996, 248, 263)

7.4.2 Kinezoism, Hydrontology, Gignestology, Indeterminism

In *The Birth of Physics*, Michel Serres (2000) claims a revival of Lucretius's account of Epicurean atomism, which together with Archimedes's mathematics would have outlined a consistent early physics based on the hydraulic model of turbulence and flow where the *clinamen* is the differential deviation in the movement of atoms that brings in novelty and freedom in the world. I want to broaden this hydraulic model to a wider set of attempts to think movement in the first philosophers, but also

Fig. 4. Frying pans of Cycladic cultures, ~2500 BCE, Archeological Museum in Athens. They include the ubiquitous spiral designs stemming from the study of water's movement. Photos by the author.

Fig. 5. Golden octopus decorations. Mycenae, ~1600 BCE, Archaeological Museum in Athens. They express the ubiquitous spiral designs stemming from the study of water's movement. Photo by the author.

before them and in non-Western traditions, related to the movement of water, the elements, and natural phenomena, including the body. The fluid model is its most developed or outstanding outcome, but there is more in what I regard as an emergent field-thinking of movement. For the Greeks, movement and change were one and the same thing, so that alteration of quality, growth, and displacement (primarily of the heavenly bodies) were the primordial types of movement.

Movement, we will see, was not yet distinct from matter (a later Aristotelian abstraction). It was the animating self-moving motor of the world. The demand for a cause of movement had not yet appeared. This identification of movement and life or kinezoism, was also a hydrozoism, where the movement of water best embodies this identification.

Since being (*ontos*) and ontology had also not yet fully emerged, at stake was understanding becoming (*gignesthai*), a gignestology as theory of becoming which, rather than pointing to a unified thinking or monism, eventually points to an *indeterminism* implicit in thinking movement as only principle.

The first genealogy I propose thinks movement through water and the moving elements. Thales inaugurates the philosophical tradition by considering a moving principle that accounts both for the origin and the continuous transformation, but also the *cohesion* and *consistency* of everything. Thales took water, or water's movement and change, its powers of generation, nutrition, cohesion, and mutability as principle of all becoming. I identify this with what archeologist Luis Siret considers to be a generalized tendency in many ancient cultures, notably the Cycladic one, of a fascination with water and the study of its movements (figs. 4–5), whence the ubiquitous spiral designs (Siret 1996, 247–63) present also in the many ancient cosmologies or mythologies that place the ocean as origin.

Condensation as a visible process in the interactions of water, fire, and air (steam, fog, cloud, ice, but also in the tissues of living organisms as warm and moist, in the warm and humid earth, in air humidity and the action of breathing, in digestion processes with its acids, in the viscosity of sex and the warm humidity of seeds) have most likely inspired the naturalistic understanding of the movements of becoming in ancient cultures.

…

Movements of the elements or of the living body become source for larger descriptions of principles: breathing in and out, condensation and dissipation, spirals and flows, and transmutations of state. Spirals or vortexes, as perhaps the most visible recurrent motion in water, were subject of study in many ancient cultures, associated to life, a sort of intelligence of life whose secrets the hydromancer (such as the Babylonian *bāru*) had to read, interpret, and reveal, a sort of writing of life. Spirals and its related waves include diffractive movements of different kinds. One could thus say that these cultures, rather than representational, were diffractive cultures which produced a diffractive knowledge, long before the arrival of specular–optical modes of representation, movement, and thought. At stake was learning to move like water, disclosing the secrets of the universe through it, as its moving intelligence.

Siret speaks of spirals as an *archē*-writing to decipher life and act upon it. The animals moving like water, the snake, the cat, or the octopus, were sacred sources of knowledge for the same reason, long before the arrival of anthropomorphic deities. As we gradually aligned in geometric environments, developing atrophy, we started venerating movement. Spirals and whirlwinds evolved into all sorts of abstractions,

including the swastika, whose origin Siret attributes to the study of water, which could explain the simultaneous appearance of the design in different parts of the world and its relation to other similar signs (thus proposing a contrasting theory to other prevailing ones related to basketry or astronomy). He also explains how the triangle appeared in spiral designs as the abstraction of the space in-between vortexes or spirals.

Siret's theory is important, for it points to a widespread knowledge, a kind of science–philosophy, partly also a religion–magic, around water's movements, also related to art, decoration, and writing. I suggest that sympathetic magic–religion had perhaps more to do with taking on a movement or propagating it diffractively than with representing or mimicking.

Thales's choice of water as principle may have several genealogies, in resonance with Egyptian and Babylonian cosmogonies, river cultures where life is associated to the action of water both in terms of the fertility of the earth after the floods and of the humid heat in our bodies. The water in us that needs to be continually renewed by drinking. Another empirical source is that water is the substance whose transformation into solid or gas can be more easily seen directly.

Water was equated to intelligence because thought was not split from sensation and motion. As William Guthrie (1965) points out, *noein* was at first an action of seeing, of knowing through perception. The first separation came perhaps in identifying within movement a living force (the soul, *psychē*, as well as the deities as forces of the world, manifestations of movement, thus a world immanently full with deity, as is Spinoza's *natura naturans*).

7.3.3 Field Dynamics of Opposites, Likes, and Unlikes

The first Greek philosophers defined movements not as trajectories of things in a space but as all that there is, therefore as fields defined by an internal dynamics. The world, nature, *physis*, is this field made of diverse movement dynamics. Or rather: every type of movement is a *kosmos*. Some attempts to define these dynamics were bound to sets of opposites, likes, and unlikes.

Following Francis Cornford in *The Laws of Motion in Ancient Thought* (1931), in the pre-Socratics the laws governing movement were unquestioned assumptions taken from common sense expressed in universal principles such as "like moves toward like," the attraction of opposites, or the repulsion–collision of the unlike. Thales and Anaximenes considered movements of condensation and rarefaction, Anaximander considered the movement of separation of opposites from the boundless principle, while Empedocles and Anaxagoras would speak of movements of mixture or combination and separation, the former following a double principle of attraction of likes but also of unlikes (with desire as cause of movement).

Heraclitus did away with the indeterminate principle and introduced the notion of ongoing tension or fight of opposites as only moving principle or *logos* of becoming, while Leucippus and Democritus considered the vortex as field motion in which collisions or repulsions happen between the unlike, while atoms that are alike will get together and become interlaced or entangled, an economy of movement without laws where things "find their place."

This idea of things "going to their natural places" which one finds later also in Aristotle, presents an economy of motion very resonant with Daoism and Relativity. It is movement as coming first, as moving along its most economical paths, that

defines the laws of the universe and not the reverse. In atomism we find possibly the most mature expression of this tradition in which the atom is defined in terms of rhythm, orientation, and contact outlining a swarming ontology of movement, where necessity is also chance and thus not determination.

In Anaximenes, we find the first more systematic attempt to consider that all qualitative changes come from quantitative changes, inaugurating scientific thought. Degrees of condensation of air, which was at the same time a substance and a moving principle, would account for the plurality of bodies and variations. In this idea of density as only principle, he was advancing the notion of gravity as economy of fluctuating movement. As in Thales, the genealogy of Anaximenes's principle, air, also implies a principle of eternal motion, which could be related to prephilosophical assumptions as much as to logical reasoning. The link between breathing and life was ancient (also to be found in Indian philosophies), and fog as indeterminate origin appears in diverse cosmogonies. Degrees of condensation create the qualitative diversity of all that is: fog, clouds, the air we breathe, or the substance of the stars, or water, ice, and earth. Its resonance in contemporary accounts of continuum mechanics is striking.

Later, atomism adds the variation of the composition, orientations, contacts, and rhythms between the atoms as a more complex way of understanding variation, once the idea of imperceptibly small entities composing the substances that we see emerges. But until the arrival of atomism there is no discrete material substance, and even then, it isn't a separate from an attribute: matter and substrate are indeed Aristotle's later abstractions.

The idea of an indeterminate origin from which movements of separation into pairs of opposites create the world is common to many cosmologies. Anaximander gave it philosophical ground by dispensing with the gods and putting in their place a boundless principle from which primary opposites separate, forming the overall dynamics of the generation of everything, including animal life, as emerging from hot–cold, humid–dry pairs. As I mentioned in Books 4 and 5, the pairs of opposites defining common sense and early philosophy are themselves offspring of increasingly aligned movement relations in large-scale social organization, arguably emerging since the agricultural revolution. New kinds of thinking or observation are entangled with inheritances from common sense and myth, like science today still is.

Anaximander's unbounded principle resonates in contemporary cosmology and in vacuum fluctuations as primordial state of the universe. Contraries define a fundamental force-field like electromagnetism, whereas the other fundamental fields have no such pairs of opposites: gravity lies in the mentioned economy of movement where concentration of mass creates spacetime curvatures; the strong and weak nuclear forces expose more complicated, non-dual interactions.

The most radical expression of this tradition is in Heraclitus, who dispenses with any indeterminate origin and places all becoming, transformation, and, importantly, *cohesion*, in the tension and fight between opposites. It is the vibrating tension of the lyre's string that exposes the *logos* of becoming, not the two opposing forces that provide its tension. Heraclitus displays a world conceived as pure play of differentials yet still grounded in tensions and fight between opposing forces.

But for Heraclitus there is also an identification between movement and what Aristotle calls material substrate. The moving principle is fire, following the association of life and heat. But he also introduces the idea that the underlying principle is

not directly visible, and that we should not be deceived by the senses. This takes a much more problematic turn with Parmenides.

After Parmenides' denial of the sensible and motion, and his demand for a cause of motion that we will examine later, Anaxagoras takes on Heraclitus's *logos* conceived as *nous*, intellect, itself a mobile cause of movement, within a spherical plenum where *nous* enacts the endless combinations of the imperishable seeds. Empedocles will propose a *double cause* (love and hate, attraction and repulsion) as cause for the movements and compositions of his imperishable four bodies or elements, again in a spherical plenum. Plato will take many elements from Empedocles for his cosmology.

7.3.4 Indeterminate Origin and the Movement of Separation or Fight and Tension of Opposites

In its ancient etymology, as in Hesiod's *Theogony*, *khaos* is a yawning cave or abyss: an opening (Jaeger 1947; Thomson 1975, 175). Chaos, as originary opening, interval, yawning cave, gape, or abyss is also part of this genealogy of indeterminate principles, and only became conceptualized as disorder much later. I persistently claim this old etymology against what I call the "entropic fear" of disorderly chaos. Discussion on its etymology include the Greek verb "to yawn," *khaskhō*.[6] Other etymologies trace it back to Egyptian gods Huh and Hautet, the formless and infinite, from Egyptian cosmogony, which traces the origin of the world to a watery chaos. So, we have three connotations that possibly evolved over time, long before it became associated to disorder: chaos as gap or abyss (separation), as yawning cave (movement of opening, stretching, interval, or spacing), and as formless indeterminate principle: interval of separation,[7] an opening, a spacing within movement, *différance*.

The Babylonian cosmogony not only places water as origin, but an indeterminate mix of three types of water: sea, sweet, and gaseous. This undetermined mix or indeterminate principle that one also finds in Daoism and Indian cosmogonies, focuses on the idea of the formless, while Plato's *khōra* (space as formless receptacle of becoming) takes on the triple meaning of *khaos* as formless principle, movement of differentiation, and spacing, where eternal forms make their imperfect appearances.

The meaning of *apeiron* in Anaximander has been extensively problematized, as it could imply something nonsensuous underlying the visible manifestations of the elements, or it could be itself an unformed substance in which contraries manifest through separation and to which they return.[8] It could be a single or a mixed sub-

6 See Derrida (1995) and Beekes (2010). Note that yawning is a very proprioceptive sense of spacing, linked to stretching and waking up.
7 The idea of a movement of separation from a primordial indeterminacy is present in numerous ancient traditions, as expressed in the *Enuma Elish* and Hesiod's *Theogony*, where separations from the initial chaos engender the gods and the world, expressing the very movement of separation of incipient algorithmic ecologies. In *The Savage Mind* Lévi-Strauss also identifies the emergence of separations in early societies as constituting a grid-like logic of the social (1964, 75). George Thomson (1954), in turn, associates this process to the establishment of an "other" in primitive societies and later to the emergence and consolidation of slave societies reaching maturity in Greece. Jean Gebser's (1985) analysis of unperspectival cultures based on polarities, and later perspectival cultures based on dualities would be another possible take on this subject.
8 The fragment of Anaximander quoted by Simplicius reads: "Whence things have their origin, thence also their destruction happens, according to necessity; for *they give justice and reparation to*

stance, or it could be movement itself. It could be a quantitatively infinite or qualitatively indefinite reservoir or potential (close to *dao* in Daoism).

Cornford (1976) associates *apeiron* to the ring, circle, or sphere, and it may anyway have a circular sense in the becoming and perishing, the injustice and retribution of contraries separating themselves from the principle and returning to it. Guthrie (1962) stresses that the most likely meaning relates to the notion of *peirata*, limits or bounds, of internal limits: something boundless or indeterminate within itself from which contraries emerge in a movement of separation. This image of internal indeterminacy relates nevertheless to the boundlessness of the circle, ring, or sphere, resonating with the Greek's universal conception of the universe as spherical, and of the circular movements of the heavens as the most perfect, continuous, eternal, and *intelligent*.

Guthrie correctly points out that *apeiron* cannot imply an infinite extensive space, as this idea had not yet emerged. According to Hermias, the principle in Anaximander is in fact eternal movement (Eggers Lan and Juliá 1978, 102). Even Plato's *khōra*, is still bound up with movement and is also space. *Khōra* is an evolution of Anaximander's *apeiron* and is the forerunner of Aristotle's *hylē* (matter).

In Anaxagoras *nous* is eternal movement yet distinct from the seeds and compounds it animates, in an increasing movement of separation gradually outlining a nonsensuous intellect, the first trace of which we find perhaps in Heraclitus's *logos*. A distrust in the senses where *logos*, though immanent to the moving principle of fire, is also a rational principle, which must be prehended in order to understand the world, negating the validity of pure sensory experience.

7.3.5 Atomism as Early Physics of Transformation

In approaching ancient atomism, I will now take a contrasting view to existing accounts, which in my view have simply accepted Aristotle's misreading and have missed its dynamic relational vision.[9] Arguably the description of the atom by Leucippus and Democritus is the most complex and mature expression of this genealogy of movements of flow, water, elements, or natural phenomena, as it unfolds in three terms: *rhythm*, *contact*, and *orientation*, accounting for how everything comes about from the swarming movement of atoms, as pure mechanics of transformation without law or recourse to any transcendent *nous*, *logos*, or form, the only cause of motion being the void allowing atoms to move and collide forming compounds. They also incorporate the vortex as a movement where combinations and separations happen, not between opposites but between endlessly varied rhythms (as dynamic forms) of the atoms in mutual contact and changes of orientation. The void as principle of motion is strikingly close to current physics where fluctuations are present in the void, and vortexes "naturally appear" due to momentum in flow: from galaxies to star systems or atmospheric phenomena.

one another for their injustice in accordance with the arrangement of time" (Barnes 1987, 75). In italics the presumed only original quote from Anaximander.
9 Karen Barad, for instance, takes this view by associating the idea of a discrete entity suspended in the void, ignoring the dynamic relationality that defines it. Barad even associates the origins of representationalism to this idea of atoms in the void, as bringing in the notion of appearance (Barad 2007, 48). But we have seen how this was in the works in all pre-Socratic philosophy: the identification of principles that were not visible to the eye.

Aristotle translated the dynamic and relational account of Leucippus and Democritus into a far more static ontology by saying (in *Metaphysics* I, 4, 985b) that rhythm (*rhythmos*), contact (*diathigē*), and orientation (*tropē*), mean form or figure (*skhēma*), order (*taxis*), and position (*thesis*), in what I regard as one of the most tragic and most ignored misreadings in the history of philosophy. Aristotle's immense authority aborted a promising relational vision, putting in its place his own formal and causal ontology.

Now, atoms do count as eternal entities, and the void accounts for their motion. This has a double origin: on the one hand it was a reply to Parmenides' imperative of being as eternal and for demanding a cause of motion, on the other they elaborated upon the Pythagorean account of void and numbers-points as the primordial constitutive of reality that we will examine in a coming section on space. But they also hacked these ideas, while inventing the most visionary concept in ancient physics, the atom, and defining it by far not as inert discrete entity. Rhythm, contact, and orientation are its only characteristics, as dynamic relational entity always forming compounds of swarming entities, composing and decomposing.

7.3.5.1 Rhythm, Contact, Orientation

Although there is no consensus on the etymology, *rhythmos* may derive from *rhein*, "to flow," perhaps meaning the constant or sustained flow of a water current, or the regular movements of waves. Following Maria Isabel Santa Cruz de Prunes and Néstor Luis Cordero (Eggers Lan et al. 1980, 197–99), other etymologies point out that its root is *eru-* or *ru-*, "to hold, maintain, or sustain," which is only in opposition to the former if one eliminates the flowing nature, but not in terms of the sustained aspect of the flow. Flow is a regular movement and yet with fluctuations. As proportion or measure it accounts for a dynamic capacity for relation constituting a local movement. It may also relate to a tempo or speed in this relation. Jaeger points out that the rhythm is what imposes limits to the movement. For Plato — whose definition has prevailed — it is the *order and measure in movement*, and for Aristotle it is pattern or model of recurrence that in rhetoric expresses a *proportion* or *measure*. Its etymological field appears to bounce between flowing and holding together (openness and consistency). In Democritus it is also a relational term, as it is what allowed similar atoms to hook onto each other forming compounds (Rojas Osorio 2001, 162).

Linguist Émile Benveniste, while acknowledging the etymological connection with *rhein*, denies that *rhythmos* could mean "regular movement of waves," or even "rhythm." He affirms that Aristotle's interpretation of the word as "form" or "figure" was correct and gives a number of other examples from Democritus himself, as well as other authors. But he also points out an important difference between *rhythmos* and other words being used for "form," which point to the reason why Democritus used it, and which relates to the etymology derived from *rhein*. Whereas *skhēma* or *eidos* might imply fixed forms, *rhythmos* points to a dynamic form:

> The form in the instant that it is assumed by what is moving, mobile, and fluid [...] improvised, momentarily, changeable [...] meaning literally "the particular manner of flowing" [...] describing disposition or configurations without fixity [...] arising from an arrangement that is always subject to change. The choice of a derivative from *rhein* for explaining this specific modality of the form of things is characteristic of the philosophy which inspired it; it is a representation of the universe in which the particular configurations of moving are defined as "fluc-

tuations." There is a deep connection between the proper meaning of the term *rhythmos* and the doctrine of which it discloses one of its most original notions. (Benveniste 1971, 285–87).

In this light Aristotle's equation of the word with *skhēma*, which is a more fixed account of form, seems very inappropriate. Benveniste then goes on to discuss Plato's influential definition of *rhythmos* as *order in movement*, part of *choral art*, as defined in the *Laws* (Plato 1926, Book II, 653). He expands on the dynamic sense that the word already had in Democritus as mobile forms acquired by the body, rather than fixed forms or figures, though acquiring now the sense of order, besides that of proportion or disposition, and of numerically regulated measures, from which also the currently predominant concept of rhythm is derived. Thus, both Plato and Aristotle have important roles in subjugating the fluctuating connotations of the term *rhythmos* to an orderly, formalist, and numeric ontology.

Michel Serres, in turn, questions Benveniste and claims back the supposed original etymology of *rhein*, "to flow," by associating it precisely to the study of vortexes, as *rhythmic fluctuations* in flow (2000, 154). In any case, the term *rhythmos* points to a surprising dynamism that is lost in the transposition of Aristotle to the notion of figure (*skhēma*, whose etymology relates it to "holding" or "sustaining").

Diathigē, mutual contact, is a neologism of Democritus and Leucippus that presents the atom only as related to other atoms, again reinforcing a dynamic relational ontology. It is a moment in a movement, a reciprocal and dynamic contact that does not mean fusion but maximum proximity (Eggers Lan et al. 1980, 199), an ongoing touching without ceasing the movement that makes the compounds of atoms something essentially dynamic, in striking resonance with contemporary physics. Again, this is lost in the Aristotelian definition of order that points to a more static vision.

Lastly, *tropē* means "turn" as well as "change" (as in entropy meaning "change within"), but is also translated as "orientation" and "direction." It "is property of the atom only as it forms part of a compound," and the atom is therefore only thinkable as part of compounds. It implies almost the notion of affordance in perception: atoms sense each other as they change orientation while hooking or moving together. *Tropē* "indicates that an atom, in itself immutable, turns continually toward other atoms, is oriented toward others" (Eggers Lan et al., 1980, 199). That orientation is dynamically changing, and with it the direction. Again, Aristotle transposes the dynamic and relational atomistic proposal to a static framework with the notion of position.

Atoms in Democritus and Leucippus have neither size (there is controversy about this, and size appears in some texts) nor weight. In Democritus we have a dynamic relational ontology with no underlying formal entities. For Democritus and Leucippus everything is explained by the interrelation of atoms: from the formation of the universe (one amongst infinite universes in the infinite void) and the planetary bodies, which emerge from the occasional swirling motions of vortexes (very precise in terms of current cosmology) to elements and bodies of all sorts, but also accounting for perceptions and extending into thought and ethics.

Vortexes emerge occasionally by chance, which is also necessity, an indetermination of causes in necessity. There are no primary elements as such but everything we see is made of the infinitely varied kinds of atoms and relations, whereby the similar ones connect to one another. Fire is said to have a rounder *rhythmos*, like the soul, which thus interpenetrates everything, being not categorically different from other

types. Soul and intellect are thus implicit in the atoms and their movements and so is sensation, which happens through the alterations in the composites, anticipating what I will call *archē*-proprioception.

Within the agitations and collisions eventually circular motions and vortex aggregations occur as well as composites, following the fundamental law, not of attraction, but quite simply of interconnection of similar atoms when they collide. There is no mysterious external force of attraction. This comes later with Anaxagoras and Empedocles because they refuted the void, thus something had to account for movement in a plenum that would otherwise be static. This discussion has taken on an interesting turn in contemporary cosmology where the vacuum is considered to exist, but is never absolute, as there are inevitable vacuum fluctuations, akin to Epicurus's *clinamen* as inevitable, minimal variation.

The void resonates with Anaximander's *apeiron* and prefigures Plato's *khōra* in that it is the very cause of movement, the very possibility for the endless compositions and changes, and in that it exists while not existing, a neither–nor ambivalence. Meanwhile, atoms have no qualities, are undefined and infinite, and in eternal movement. Aggregation and separation (due to *rhythmos*) accounts for coming to be and passing away while alterations rely on contact and orientation.

Since some atoms, like fire or soul, are described as round and atoms are generally also referred to as *eidos*, a kind of visual form, it is quite possible that there was a certain notion of form or structure (Aristotle's *skhēma*) emerging, and yet within a dynamic process of relation and forming of composites. This tension exposes what I refer to as the wars of movement and form. The relational view of Democritus foreshadows the notion of field, and movement doesn't imply trajectories but relations composing bodies.

Modern science introduces many new levels of indeterminacy in the atom. Its indeterminate wave–particle nature, its uncertain spacetime momentum, its inseparability from the field it expresses and its virtual particles, which are excitations of the field, down to subatomic fluctuations of Quantum Field Theory or to string vibrations in String Theory. And yet, ever since Parmenides, science continues in a quest for symmetries and laws, for something unchanging. For this reason, Serres argues, atomism has been neglected, though its premises have been accepted (even by Plato) by imposing laws on them.

What does it mean that in atomism chance and necessity were together or even the same thing, in a universe without law or causality? Atoms were not subject to a law like in Newtonian mechanism. They collided and formed compounds or flows, by chance, but this chance was also necessity. Necessity is in the local movement in the void, the impenetrability and thus the collision, but chance is in how they collide and get entangled, how they meet and compose the world. This seems to imply neither a determinism nor a pure randomness. Determinism was perhaps only fully thinkable when mechanism defined universal laws of order and with it an opposing idea of disorder. At a time when the bipolarity of order and disorderly chaos was not yet established, perhaps necessity was neither deterministic nor indeterministic, and chance was not randomness, perhaps it was openness. Democritus was a defender of democracy, so it seems unlikely that his physics, which was also the ground for ethics, social organization, perception, emotion, or psyche, would be deterministic. The ethos for reaching a good life is perhaps in learning to move with the world and letting novelty and freedom come up in the process, it is never passive adaptation. It is close to Daoist nonaction and can take very dynamic turns.

Can one see emergent accounts of proprioception in the description of physiology, movement, and sensation, for instance as atoms spread their motion in the body, moving it, or in the sense of weight and effort? We need to carefully rediscover all the fragments of the pre-Socratics and see what the critics have omitted due to the bias of the five senses and mechanical movement.

7.3.5.2 The Superiority of "Eternal" Circular Motion

Another crucial genealogy of movement philosophies comes from astronomy, from the study of the movement of stars and planets, a continuous movement that resulted in the geometric sphere. The sphere became a crucial pivotal point, a source of fascination to philosophers, boundless and finite, rotating without displacing, subject to very different and contradictory abstractions, linked to eternal motion and its associated intelligence or soul, and therefore as moving principle, and as spherical shape and orderly movement of the cosmos.

It was an assumption of Greek common sense that the universe was spherical, not a sphere hanging in an infinite space, but a finite spherical space of circular motions bounding the universe. As I mention in Book 5, the study of the heavenly motions was a general concern of all ancient cultures, constituting a very different movement, seemingly more permanent, and cyclic, from that of the elements and flows, leading to multiple kinds of circular observatories and forms. The sphere was a more complex abstraction resulting from these studies.

Circular motion as the most continuous, perfect, and eternal was identified with intelligence, a tradition that culminates in Plato's *Timaeus*. It is the intelligent circular motion of the heavens that influences the disorderly motion of the four bodies or elements down to our thought (therefore the circular form of the head) and to the circular group dance of the chorus as fundamental means of education in Plato's ideal city in the *Laws*.

It must be noted that the only account of displacement, *phora*, that one finds in Plato is actually in relation to circular motion, resonating with relativity where the apparent curvilinear orbit is actually a linear movement in a curved space. *Phora* thus stems from planetary motion as the primordial trope for linear motion, evolving into the notion of circles and into the abstract geometric sphere. But *phora* meant also to carry, as in *amphora*, or transfer as in *metapherein*, which not by chance is linked to the new tendencies of Neolithic societies to accumulate, store, and carry around.

The other type of circular motion features also prominently in the first genealogy we exposed. The vortex is crucially linked to cosmogony and the origins of life, its cycles and living forces. In Plato's cosmology, the vortex is the effect of the circular motion of the heavenly bodies influencing the disorderly shakings of the four elements. Current astronomy shows that circular movements of planets are instead part of larger vortical movements of star systems and galaxies within even larger amorphous fluctuations of density distributions (galaxy filaments).

So, circular motion was the pivotal movement that on the one hand counted as intelligent, eternal motion, the prototypical continuous displacement that ends up dominating, but can also take on the differential form of vortexes in fluid models.

Through Pythagoras and Plato, it became the ideal of orderly, mathematical proportions in movement, related to music intervals and rhythm. A whole cosmology of universal laws and order was grounded on circular motion, and thus an ethics, education, and politics, down to our thoughts and choral dances.

7.3.6 The Invention of Space (as Limit)

The third genealogy is not at first about movement, but about the emergence of space, as well as points, and the idea of limit, and will lead to *displacement in a space* as overarching trope for movement.

In all the previous accounts of movement it is important to remember that they were not happening in an abstract space, as the concept of space had not been fully defined. Space or place was more of a practical reference to where bodies find themselves. The place for my body can be my chair and for the chair the room and for the room the house, and so on. This paradox of place having a place, having a place, to infinity, was attacked by Zeno in one of his paradoxes, thus denying space. Perhaps place was only a practical and relative term signaling the relative immobility of something: the place, context, or situation where I am or in relation to which I move now.

This third genealogy deals with how space as distinct and fixed entity (and the distinctness of entities *in* space) emerged, derived from the Pythagorean void (as that which lies between the numbers) along the emergence of Euclidean geometry and gridded cities, culminating in Aristotle's definition of *topos* and in Euclidean space.

The units of number in Pythagoras are an important inflection in the emergence of the idea of discreteness of entities and points. They are the limit (Guthrie 1962), but perhaps also related to discrete segmented movements: manual movements of counting. The space in between numbers, still considered as physical entities, appears then as something necessary for movement, plurality, and relation.

The distinctness of numbers was combined with the idea of the void as space in between numbers. Pythagoreans describe a changing world that arises from an originary unity: from the one (the limit) comes the two (the unlimited) and from it numbers, from numbers points, from points lines, from lines planes, from planes three-dimensional geometric bodies that are the source of the elements composing sensible bodies. This is what Plato calls the movement of becoming, which resonates in current physics, chemistry, and molecular biology, when simple one- or two-dimensional molecules start forming more complex three-dimensional compounds (proteins and growth) from simpler ones (flows of non-organic matter). The numbers one and two relate to a whole series of fundamental opposites: limited–unlimited, man–woman, active–passive, and so forth. The Chinese *yin–yang* principle and its pairs of opposites has an astonishing similarity with Pythagoreanism in all these regards, appearing almost simultaneously.

Parmenides reacted against this idea of a plural world emerging from a unity, denying the void. His reaction was perhaps initially aimed at Heraclitus, but also the Pythagorean school. Holding onto being as unity and trusting only logic, he denied movement and plurality (Guthrie 1965).

In turn, Zeno, according to some scholars (like Tannery and Cornford, see Guthrie 1965, 84) was not a mere epigone of Parmenides seeking to affirm his denial of movement, but an original thinker who was exposing the paradoxes of other systems and exercising logic as a sort of gymnastics. His attack was perhaps on Pythagorean cosmology as consisting of discontinuous numbers–points that were confused with sensible bodies, which he considered as an absurd conception.

Zeno's paradoxes expose more of a war between the limited and the unlimited rather than a logic of movement understood through divisible time and space. And yet they seem to have played a crucial role in Aristotle's final systematization of

space and displacement, triggering his idea that movement is divisible, indeed infinitely divisible, by distinguishing potential from actual infinities.

Aristotle's concept of space as immobile limit and of movement as divisible displacement, marks the ontological shift from pre-Socratic thought to our own, defining the still prevailing ontology. Aristotle's concept is nevertheless still far from mechanism's view of absolutely divisible movement and space. He still follows the Greek tradition of thinking movement as all forms of change, and form as the intelligibility governing change in thought and logic, rather than a purely mathematical form.

Modern science, however, is pointing back to conceptions of movement and space that recover some of the pre-Aristotelian ways of thinking in exceeding both displacement and space as given. As Cornford states, "the Euclidean era thus presents itself as a period of aberration, in which common sense was reluctantly lured away from the position that it has now, with no less reluctance, to regain" (1976, 15).

7.4 Parmenides, Plato, and Aristotle: The Triple Turn toward Form

7.4.1 Parmenides' Radical Turn to Absolute Immobility

Parmenides enacted what I see as the most radical and tragic turn ever to have happened in philosophy or cultures at large: the turn from "only movement" to "only fixity," introducing the major shift that has conditioned and founded Western metaphysics of being.

Parmenides builds upon the distrust of the senses that Heraclitus had already introduced by defining a *logos* of becoming as underlying an invisible logic while reacting against his radical doctrine of pure flow and tension of opposites, turning it upside down by considering all sensation an illusion under which immobility is the only source of true knowledge. Parmenides reacted against the idea of a plural world in never-ending flow or of plurality emerging from a unity, and denied the Pythagorean void as source for plurality, holding instead onto the idea of unchanging substrates that one finds in Pythagorean numbers. Holding onto being as unity and trusting only logic, he denied movement and plurality.

Parmenides' affirmation of fixity resulted from what could be the first radical logical chain in thought, where language affirms its own implacable logical movement against all evidence of the senses. In the famous passage of *The Way of Truth*, he starts by affirming that *being can only fully be* (Cornford 1939, 30). This is the starting point for his logical chain. Since being can only fully be it cannot not-be nor become, it must therefore either fully exist or not exist at all. From what wasn't it cannot come to be, nor can it engender something else. It is thus ungenerated and imperishable, unchanging, and incorruptible, fully realized and complete. It is now, eternal (timeless), all in one and continuous, indivisible, a single homogeneous plenum without beginning or end, bound to the chains of necessity firmly in its position, imperceptible but thinkable, absolutely immobile, its outer limit like the mass of a sphere, a homogeneous and equidistant spherical plenum. Thus, a linguistic logical chain imposes itself, perhaps for the first time, implacably, upon any evidence of the senses.[10]

10 No less than three words affirm the idea of immobility (*akinēton*) in Parmenides' book. I thank Anna Markopoulou for the following clarifications, from our email exchanges: "Three Greek words mean

Parmenides takes on the general Greek conception of the spherical universe but turns the prevailing notions of eternal movement into complete immobility. With Parmenides the sphere serves the unprecedented purpose of *denying* movement. Parmenides' sphere is fixed and eliminates movement and time in the logical chain of affirmation of being. It seems that the paradoxes of the sphere as a figure that can move, rotating on itself without gliding or displacing (moving while being immovable), that is both finite and boundless, may have played a crucial role in this radical turn.

But I want to suggest that another important cue leading to the affirmation of fixity is to be found in the ecstatic practices in which Parmenides presumably took part, stemming from Scythian or Siberian shamanism (Guthrie 1969, 2). These were practices of sensory deprivation and immobility, so-called incubation, related to the cult of Apollo in which an altered state of consciousness associated to truth was achieved through complete immobility of bodies lying for several days in subterranean rooms (Kingsley 1999, 102–4, 112).

Parmenides denied movement (and time as change) in an astonishing radical turn whose foundations are perhaps not only at the onset of abstract logical chains of language, abstract geometric forms like the sphere (intelligible more than perceptible), and shamanistic practices of immobility, but also in the bodily and kinetic organizations of his time that were orienting perception to increasingly fixed and abstract affordances, geometric environments, architectures, objects of trading, numbers, and money.

Parmenides doesn't confront the corporeal (*somatikon*) and incorporeal (*asomaton*), because this Platonic distinction didn't yet exist (Guthrie 1969, 25), but rather the perceptible (*aisthēton*) and intelligible (*noēton*). His plenum was thus corporeal and immanent, but only intelligible, not perceptible.

Parmenides' conception led to the demand for a cause of movement, which one finds in Empedocles, Anaxagoras, and later Plato and Aristotle, in a process of increasing separation of terms: the cause from the substrate, the sensible and the insensible, and so forth. *Thought itself was enacting the movement of dualist separations that it was describing*, and of which Aristotle is the most accomplished evolution.

Parmenides' immobile and eternal being as only truth is perhaps the major source of Plato's theory of forms, while it is significant that Plato elaborated movement with as much rigor as forms, and the sphere in his cosmology is again bound to eternal motion and the moving principle. In another astonishing turn, Plato acknowledges movement but relegates it to a secondary category foregrounding a world of eternal forms, creating thus in fact a triple (not dual) reality: forms, becoming, and the mediating term, *khōra* or the formless receptacle.

7.4.2 Plato's Cosmology

Plato's theories of motion have received relatively little attention, and yet, following J.B. Skemp's detailed study on *The Theories of Motion in Plato's Later Dialogues* (1942), the dynamic nature and richness of his vision of the world of becoming, and the consistency with which it is elaborated in his later dialogues, particularly the *Timaeus*,

akinēton in Parmenides' context: ἀκίνητον, οὐλομελές, and ἀτρεμὲς. (1) ἀκίνητον (*akinēton*) because it has no movement in it; (2) οὐλομελές (*oulomeles*) it's a full member entity and, thus, it cannot be divided (since division is a kind of *kinēsis*); and (3) ἀτρεμὲς (*atremes*) since it does not flow in any direction.

is striking. His position is important and unique in our narrative as he synthesizes all previous philosophies of motion in an ontology that still belongs to a mode of thinking movement that is difficult for us to think, as it was Aristotle who crafted the great division. Plato was on the one hand paving the way for Aristotle, laying the foundations for the metaphysical and dualist tradition, yet his theories of motion are rich and dynamic and cannot be understood without attention to earlier philosophies of movement. He exposes a sort of crucial overlap between ontologies, which is also where his own inconsistencies emerge in trying to offer a bridge (through *khōra*) between eternal forms and the world of the senses, with an inevitable middle term. Movement is the unsolved key question in mediating between the forms and the world of becoming. Aristotle's work can indeed be seen as an attempt to overcome Plato's inconsistencies in this regard.

Plato's cosmology offers a synthesis of the Eleatics and the Milesians, where necessity is related to the agitations and shakings (*seismos*) of the four elements, whereas mind or *nous* is linked to the orderly circular motions (*kyklophoria*) of the heavens that contain all other movements within the cosmic sphere. Plato thus largely acknowledges the Heraclitean and Milesian account of movements of interfusions of the four elements as correct with regard to the "how" but adds onto them the "why," the cause, which is double: necessity and intelligence, each of which relates to a different soul of the world, as *mobile motor* (Skemp 1942, 75). These causes are of primary importance, above the distinction of the three types of primordial substances: being (the forms), becoming (the world of the senses), and *khōra* (space and formless receptacle, where imperfect copies of the forms appear, conforming the world of becoming).

Plato elegantly brings together elements from almost every previous philosopher into a strikingly dynamic cosmology: from Pythagorean cosmology (numbers as ultimate entities and a geometric base for elemental bodies, though denying the void, and the principles of opposites); from Alcmeon (circular movement linked to thought); from Anaximander's *apeiron* (*khōra* as formless receptacle and the boundless spherical motion of the heavens as principle); from Empedocles (the four bodies or elements, the dynamic spherical plenum as space of the cosmos, and the double cause of motion); and perhaps from Anaxagoras (*nous* as one of the two causes of motion); from atomism (in necessity and irrational motion being another principle of movement, in the interfusions of elemental bodies and irrational shakings of the receptacle, in the movements of combination and separation, and the vortex); from Anaximenes (in the movement of condensation and rarefaction, as coming together and dispersing, assimilation and dissimilation); and perhaps even Heraclitus (in fire being the primary most simple and lightest triangular element and in the ongoing tension between rational and irrational motions underlying eternal flow).

Plato's space is neither a void nor an abstract extension. His movement and space theories remain in the pre-Aristotelian realm where space has not been separated from matter, bodies, and movement. Space (*khōra*) is both where the different kinds of movement "somehow" happen, as described in the *Laws*, and is also the formless receptacle of becoming described in the *Timaeus*. The fundamental types of movement as described in the *Laws* include the planetary motions, so that one type of space is the spherical space of the universe and its circular rational motion. The other types of movement may be more related to the irrational motions of necessity or their combinations with rational motion composing all bodies and their alterations

or growth. The formless receptacle of becoming, which is also space, *khōra*, is more like a spacing where forms make their appearances *through movement*.

Skemp (1942) analyzes the importance of Ionian elements in Plato's philosophy as something not of secondary but primary importance. It seems significant that Plato treated *kinēsis* with as much consistency as forms. So, at the core of Platonism (and of Western philosophy) we have the often ignored problem of movement and of the relation between eternal forms and their appearances constituting the sensible world of becoming. I argue that these appearances happen *through different kinds of movement*.

Trying to understand how Plato thought motion means delving into pre-Aristotelian reason, thinking, and common sense that is quite alien to most Western people nowadays. Indeed, I think that many great commentators of Plato, including creative critics like Derrida, have missed the crucial problem of movement in his philosophy and in the larger philosophical landscape before and after him, as exposing other ways of thinking, neither mythological nor logical.

Plato's four bodies or elements incorporate aspects from both Empedocles and the Pythagoreans in that they have a geometric base made of triangles that can compose with one another when meeting (following the principle of like toward like) but also disaggregate when colliding, eventually recomposing into another element. The triangular base of the Platonic solids (which include a fifth element for the heavens) proposes a geometric dynamics for the interfusion, transformation, and composition of the bodies which echo in far more static way the *rhythmos* of the atoms in Democritus.

Underlying the primordial formation of these triangular "molecules" — not so distant from the hexagonal images of molecules in contemporary chemistry — Plato exposes one of his ten fundamental types of motion, rather difficult to think, derived from the Pythagoreans, and which he calls coming to be or becoming,[11] which I see as a sort of primordial becoming or *archē-genesis*, a kind of spacing or unfolding of the world, the process in which visible bodies come to be from triangular elements, the triangle comes to be from a plane, the plane from a line, the line from a point, the point from a number, which is the limit upon the unlimited, as described above in relation to Pythagoreans from whom this doctrine stems.

There are two ways for this to happen, the Pythagorean way is in points connecting and forming first lines, then a triangular plane, and lastly a triangular pyramid. This seems to be the scheme taken on by Plato for the triangular composition of the four elements. But there is also the fluxion theory, by which a line forms a point, which unfolds in square and the square into a cube (Guthrie 1962, 260–64).

This primordial becoming or *archē-genesis* is one of the ten fundamental types of motion (Plato 1926, Book X, 893b). The ten kinds described are: (1) circular motion around a fixed center; (2) locomotion (gliding or rolling); (3) combination; (4) separation; (5) increase (growth); (6) decrease; (7) becoming; (8) perishing; (9) other-affecting motion (or secondary causation); and (10) self-and-other affecting motion (or primary causation).

Alteration of quality (which was generally considered by the Greeks as a type of movement–change, a major type of *kinēsis*, together with growth, coming to be, and

11 Though also using the term *genesis*, Plato refers to this as *gignetai* "comes into being," the verb form whose infinitive is *gignesthai*, "to become" which is the closest in ancient Greek for "becoming" as process, or "process of becoming" as noun, as opposed to the unchanging nature of *einai* "to be."

displacement) seems related to the aggregations and disaggregations of the four elements composing visible bodies. These imply a complex movement, related to cosmogony in the *Timaeus*, since at the origin of the world the elements get separated in regions due to the shakings of the formless receptacle of becoming (*hypodokhē*), also called space (*khōra*), which acts like a sieve. Then the geometric interactions between the bodies following necessity (almost resonant with Democritus) mix the elements into new compounds as well as dissolve and recompose them.

But it is striking that gliding and rolling (of the heavenly bodies) is the only mention in *Laws* of a kind of displacement (*phora*) as fundamental type of motion. This motion is of particular importance, because it is the orderly motion that influences the disorderly motion of necessity, from the heavens down to Earth, including our thoughts and bodies. Our circular head — this Plato takes form Alcmeon the Pythagorean, who was the first in locating thought or intelligence in the head — is circular precisely because thought acquires the circular motion of the heavens.

It is significant that displacement (*phora*) doesn't feature in other ways, as the general type of movement, strange to us Newtonians for whom displacement is the overarching trope for thinking movement in our daily situations and for describing the movement of bodies. Also, there is yet no theory of locomotion in Plato, and it seems that the idea of our local movements didn't feature as fundamental trope of displacement, perhaps due to the fact that there was yet no abstract conception of space. Movement was an issue of becoming, emergence, and relations rather than happening in a container.

7.4.2.1 An Etymological Incursion

Aristotle recognized Plato as as the first one attempting, while not fully accomplishing, a systematization of the thinking of space that Aristotle himself would complete. But did he? Both the words *topos* and *khōra* were used in ancient Greek to define space or place. *Khōra* was linked in particular to the space outside the political territory of the *polis*. Some interpretations have divided the terms by stating that *topos* is linked to a practical notion of place and *khōra* to an abstract notion of space (Abdelwahab 2018). This distinction is not entirely consistent, as we will see, as Aristotle's account of place is strikingly abstract and immobile, while Plato's *khōra* is alive, bound to movement.

The etymology of *khōra* includes *khaos* as gap, wide space, opening, yawning cave, or abyss. The link is also conceptual, as chaos is linked to *apeiron* and void as indeterminate principles. But the etymological field is far more interesting and open. One crucial aspect which I propose is in the potential link to *khoros*, which is not only group dance, but also the place of the group dance. This binds *khōra* to movement more profoundly: it is an open space, but also relates to a chorus, a spacing of bodies dancing. *Khoreia* is more generally dance (hence choreography) as the becoming rhythmic order of movement–space, as the becoming enclosure of chaos, but also as the Dionysian reabsorption into the *apeiron*, the formless.

Chaos already has this undecidable nature as both opening and separation, interval, and yawning. *Khōris* instead means separate, in another place. *Khōra* is thus open space, as undefined principle, but also a site for separation and determination. Another evolution in this undecidable oscillation of the term is in the *agora*,[12] as

12 From *ageirō* (to gather) from Indo-European *$*h_ger$-, linked to the Latin *forum*, from *$*d^worom$ (enclosure) < *$*d^wer$- (door), again undecidable between gathering, open space, opening, and enclosure. See

both gathering, public square, and market or exchange place inside the *polis*, whereas *khōra* was mostly the territory outside of it.

The notion of opening or spacing or open space, linked to the Indo-European etymology of *$*gʰeh_2$-* (to be gaping, wide open, yawning) relates thus to the apparently opposed root *$*gʰer$-* (to enclose or grasp). *Khaskhō* is yawning, *khortos* is enclosure or garden, *kheras* is window.

The connection of *khōra*, defined by Plato also as mother and nurse, with the matrix or womb is to be taken seriously in that, on the one hand, *khorion* is an ancient name for the membrane surrounding the foetus, and on the other, more fundamentally, the conception of female reproductive organs as brute matter, inferior to the form-giving semen of the male was later affirmed by Aristotle, while other Greek and Roman theorists like Hippocrates and Galen stress the resemblance and complementarity of sexual organs.[13]

Plato also makes yet another etymological leap in the *Laws* (Plato 1926, Book II, 654), by associating the chorus to *khara*, joy.

7.4.2.2 Khōra

In Plato, the world of becoming is made of mere qualifications of the substrate (through movement), thus a first crucial but still unclear distinction between substrate and attribute is made. Forms appear and change in their endless manifestations, as *qualifications* of the formless receptacle–space (*hypodokhē*) which is also space (*khōra*) as pure appearance.

Following Derrida (1995), but also Irigaray (1985a), *khōra* implies an excess, an irreducible principle that on the one hand is the very condition of possibility of certain orders and of the forms as guiding principles taking imperfect and varying expression in the sensible world, while on the other being an irreducible otherness that accounts also for multiplicity and becoming, and for the irrational motions of necessity (which seem to imply chance as well).

Derrida (1995, 91–126) describes *khōra* as double (metalogic) oscillation between neither and both, a category beyond all binary logic, not even another, as always invested and occupied political space of the *polis* at war, yet independent and not retaining any mark. As space of inscription it is anachronistic and beyond origin in how it exceeds and precedes inscription; an abyss, chiasm, or chaos inside the encyclopaedic *logos* of the *Timaeus*, having its own *physis* and *dynamis* which do not *exist* but *insist*, a shaking sieve that selects, situating woman–mother–nurse outside of binary logic in associating it with the nameless and formless, and analogous to Socrates in the dialogue as the receiver–listener of all, as one who disidentifies both with those who have a place and the errant ones (Sophists), thus related to *genos* (race) as spacing without origin, whose receptivity is partly welcoming and gathering. It is place itself but also half place, indeterminate, an *errant cause linked to necessity*, which accounts for its hybrid reason.

Khōra has also been subject of intense feminist debate as to whether it represents the exclusion of woman (who appears as another qualification of *khōra*) from metaphysics, from being and from the domain of the speakable or thinkable, as receptacle for the self-replication of man-as-form, or whether this opens up the possibility to claim a political agency which is not about becoming speakable, becoming form, but

Beekes (2010).
13 *Kēr* (heart) and *khordē* as both string and intestine further expand the tissue resonances of *khōra*.

about questioning form as reductive principle. Is there an agency proper to *khōra* itself?

Judith Butler's reading of Irigaray's reading of Plato's *khōra* in the *Timaeus* defines the foundations of Western metaphysics as phallocentric fantasy of autogenesis, where woman or mother is associated to the formless receptacle (*hypodokhē*) that cannot participate in the forms but only be their formless substrate of inscription, equivalent to Aristotle's matter (Butler 1993, 40). However, both Butler and Irigaray seem to resonate with Derrida in assigning to this irreducibility of *khōra* a generative power that exceeds the forms, perhaps as very condition for politics, as a *constitutive outside* that continually resists, exceeds, and mobilizes the boundaries of the speakable, of forms, of discourse. And yet it seems that this outside is only invested with political force in its dialogue with the inside of discourse, being, and the *logos*, only in relation to the ontological territory whose boundaries it opens up: by shifting the boundary.

I want to suggest that while it is clear that Plato's cosmology is phallogocentric, *khōra* is not reducible to a term of prohibition and negation (of the category woman to become speakable). It derives, rather, from pre-Platonic conceptions of movement which are more clearly expressed in the various accounts of movement in Plato's cosmology and in the *Laws*. I think one needs to take this into account in order to resituate Plato's cosmology within a prior tradition that exposed traits of other ways of thinking, and also in order to allow a more vigorous reappropriation of *khōra* that is not always necessarily bound to the formative inside that Plato's metaphysics arguably created. *We need to read Plato through his predecessors, not through Aristotle, if we are to look beyond.*

Situating oneself fully in *khōra* — the plane of immanence — in the consistency of the formless, could be a radical way of claiming what Luciana Parisi (2004) calls a microfemininity (expanding on Deleuze's and Guattari's becoming-woman) that resonates partly with Irigaray's program, a femininity in excess of phallogocentric forms. A becoming not bound to the oppositions of discourse. Thinking *khōra* through movement rather than matter brings in a new turn also for feminist and other minority politics.

But there is a more important, ambivalent, and forgotten term: *movement*, wherein a force of becoming is manifested that was prior to the forms and can live without the forms. Movement as the radically elusive but radically real and consistent term is the promising site for a complete rethinking of philosophy and language beyond the ontological tradition since words and concepts are also movements.

7.4.3 Aristotle's *Kinēsis* as Both Potential and Actual

Aristotle tries to solve Plato's inconsistencies in bridging between the world of eternal forms and the world of becoming. While in Plato the world of becoming has its immanent mobile causes of motion and the world of forms is a separate *genos* or type of reality, Aristotle places form as the immobile mover, the transcendent but immanent *telos* driving movement from within as law of causality. For this a number of steps is necessary, including the overall definition of movement as displacement and the definition of space as immobile limit. He thus achieves what Bergson (1944, 359) describes as the ancient subjection of movement to immobile forms as privileged moments in movement.

Aristotle takes a decisive step toward our modern common sense by separating space completely from movement. And yet Aristotle's concept of space is neither an abstract infinite extension nor is there an infinite void. He holds on to the previous and still prevailing conception of a spherical plenum where things follow their natural movements to their places. Aristotle as systematizer operates a splitting: space from movement, movement from matter, matter from bodies, substance from attribute. He embodies better than anyone at the time the movement of increasing separation of the world as happening through splits in thought itself.

In Plato, space (*khōra*) is not fully distinguishable from movement; substance and attribute have not yet been fully split. Aristotle splits Plato's *khōra* into numerous categories: place (*topos*), movement (*kinēsis*), potentiality (*dynamis*), actuality (*energeia*), and matter (*hylē*). Matter as fully inert and abstract substance is perhaps the most direct and problematic derivative of Plato's *khōra*, along with space as equally inert immobile limit, whereas movement and potentiality (which of course existed by themselves as important concepts for Plato) take on the indefinite and the dynamic aspect of *khōra*, but as negativity and incompleteness, a lack of form.

For Aristotle, place is the first immobile limit of what contains a body, "the limit of the containing body, in contact with the contained and movable body" (Aristotle 1961, 212a6, translation modified). This container and limit is immobile with regard to the mobile body it contains. Place is neither recipient nor matter nor form, it is not the concrete body, object, or land hosting another body. It seems that this conception of space as immobile limit is strangely abstract and inert and crucially linked to his notions of continuity, discontinuity, and divisibility in movement and to his account of displacement as overarching trope for all kinds of movement, including growth and alteration of quality.

Divisibility in Aristotle is not so much a question of absolute measurement, as it is linked to the problem of continuity and rest in motion. Aristotle still elaborated the ancient idea of continuous movement as the superior kind of movement, which in Plato features as rotation and gliding of heavenly bodies, as the only fundamental type of displacement (*phora*). Instead, for movements of alteration and growth, composition, and collision, he sees moments of rest and contraries at play.

In his *Physics*, Aristotle differentiates three types of movement: local movement/locomotion/displacement/change of place, alteration of quantity (augmentation or diminution, sometimes understandable as or including growth), and alteration of quality (Atistotle 1961, 225b5). Displacement is transversal to the other modes and is considered primordial since it is the only one that can be continuous and is not limited by contraries, and because in every movement of alteration and growth there are local displacements of elements aggregating or changing composition in the play of contraries (hot and cold, humid and dry, and so forth). The inherited paradigm of contraries as a fundamental law of motion is linked crucially to the *moments of rest* appearing in alteration and growth, but not to the continuous displacement of heavenly bodies, the superior kind of motion.

Aristotle posits displacement as origin for combination or separation, leading to condensation or rarefaction, leading to affections and alterations, leading to augmentation and diminution. Linear are also the movements of orbits, though he places the planets and stars in a sphere and puts them in a separate element or body with eternal circular motion, the most perfect kind, the model.

The formalization of displacement as overarching trope for movement, once movement has been split from space, allows the establishment of causality as the

universal law of motion by which movement (including alteration of quality and growth) is always a displacement, a logical trajectory tending to a form. Along this affirmation of the primordial character of displacement, Aristotle affirmed the divisibility of movement, thus taking aspects from Zeno while refuting the paradoxes and the denial of movement.

Movement as described by Aristotle is in a way difficult to grasp. Movement is not the passage from potential to actual, which is a medieval scholastic idea (Pardo 2011, 35). Movement "is held to be something indefinite," "it cannot be classified in absolute terms as being only potentiality or only actuality" (Aristotle 1961, 201b25, translation modified). Instead it is the *actuality of potential*: the being at work of potentiality, in its incompleteness. Movement is always potential, undefined, difficult to think. He correctly stresses this fundamental problem of the undefined nature of movement, which I consider the core problem of philosophy. Neither actual nor potential, and both. Doesn't this recall Plato's definition of *khōra* as middle term, as neither–nor and both, as double metalogic oscillation?

Movement is actual in its potentiality, is at work or persisting in its incompleteness, without ever finding completion, movement remains always potential while being in-act. As the *actuality of potential*, it is the irreducible term of becoming and change in nature. "Movement is the actuality of potentality of a thing as considered not in itself but as movable. [...] "Movement is the actuality of potential as potential" (Aristotle 1961, 201b5). Later again: "movement is the *incomplete actuality of the movable*" (257b, translation modified).

This indefinition or indeterminacy, as incompleteness, is a lack of form. Form is nature, or nature is the movement toward form. Change in nature happens through movement as the incompleteness in relation to form (193b10). A negativity bound to form, rather than a surplus opening up form. More than a generative power it seems to be a lack and a way of explaining the "problem" of change. Aristotle thus effects a complete transvaluation of indeterminacy, which in the boundless principle of earlier philosophers was a generative power and an ongoing substrate to which things return, into a negativity or lack.

Bergson correctly identifies this negativity when he refers to the ancient mode of reducing movement in relation to eternal forms: "As the stable forms have been obtained by extracting from change everything that is definite, there is nothing left to characterise the instability on which the forms are laid, but a negative attribute, which must be indetermination itself" (1944, 354). Eternal forms, as "snapshots taken by the mind of the continuity of becoming" (349), are a way of capturing all kinds of change and becoming in a *telos* that has been extracted from movement itself, not in terms of space but of poses, ideas, origins, and finalities.

Unlike Plato, who synthesizes diverse movement theories of his predecessors into a rich spectrum where causes of motion were themselves movable (eternal forms constituting a separate reality), Aristotle instead unifies movement under the trope of displacement (*phora*) while multiplying the distinctions between substrates and attributes that were inexistent in earlier thought.

Form as pure thought can only be immobile because movement implies change and incompleteness. Absolute actuality, as related to form and thought, is a transcendent and immobile God. Every changing expression of nature is an always incomplete tendency to form. Displacement and causality are their universal expression and law. Form is thus at the source, at the end (as *telos*), and all along (as law of causality) that which orients movement, its universal, metaphysical affordance. Plato's

forms become the immobile mover, through causality as formal principle of movement.

Energeia, from *ergon*, "work," could be translated as "is-at-workness" (Sachs 2005), the being in-act of a process. Aristotle differentiates *energeia* as an activity or process that is complete throughout, from *kinēsis* (movement–change) as the activity which is incomplete and persists in its incompleteness. The former is associated for instance to thought and seeing. So Aristotle performs a separation of movement from activity, actualization, the in-act, the is-at-workness of *energeia*. It is significant that *energeia* and *entelecheia* (another stricter term for the actual) were neologisms of Aristotle, whereas *dynamis* (potential) was a common word in Greek, which signals Aristotelian thinking of the actual as the novelty, that resignifies potentiality in return.

Why should this be distinct from movement? Movement accounts for the incomplete side of all activities, the potentiality at work in all processes, and thus has the ambiguous nature of being the actuality of potentiality itself. But since actuality and form are linked to thought as immobile, while all things partake of thought and form in *different degrees*, then movement, *energeia* and *entelecheia* speak of these *different degrees* and modes of participation of nature-as-change in form and thought.

Whereas in Plato *kinēsis* and thought seem to be identified in modes and degrees, it is in Aristotle that they fully separate, precisely through elaborating forms-in-process as actualizations governing movement. In Aristotle the activity of thought and reason is not *kinēsis* but *energeia*. Seeing and thinking, as examples of *energeia*, are considered to be complete throughout in their at-workness, while building or walking are movements because they are incomplete or imperfect throughout. This example from the *Metaphysics* (Aristotle 2002, 173), seems to present an alliance of vision and thought as strangely exempt of movement, extraordinarily advancing the turn to rationalized vision of Renaissance perspective arriving nearly 1,700 years later.

Entelecheia is a more complex neologism of Aristotle that can be described as persisting-in-completeness, persisting-to-be-complete, effort-of-continuing-to-be-full-grown, or being-at-work-staying-the-same (Sachs 2005), which implies that every apparently complete activity or entity is always in process.[14] For Aristotle, pure actuality is to be found only in the immobile mover, God, who is transcendent. All things besides God are either movements or actualities in process, never fully complete, or whose completeness is itself a process, a persisting.

The immobile mover appears for various reasons, given that causality and movable things always have a mover, this cannot go to infinity, he claims (again in reply to Zeno). At the same time, an eternal motion as the one of the heavens, the superior one, must also have an eternal mover, which must then be immobile. Aristotle builds the schema of there being always an immobile part in relation to a mobile into physiology and animal locomotion through his vision of the joint, which he strikingly considers as always having an immobile side. He considers absurd the idea that everything that moves must also be movable, a striking belief considering that in all previous philosophies immobility was absent; there was no cause and everything

14 According to Sachs (1995, 245), "Aristotle invents the word by combining *entelēs* (ἐντελής, "complete, full-grown") with *echein* (*hexis*, to be a certain way by the continuing effort of holding on in that condition), while at the same time punning on *endelecheia* (ἐνδελέχεια, "persistence") by inserting "telos" (τέλος, "completion"). This is a three-ring circus of a word, at the heart of everything in Aristotle's thinking, including the definition of motion."

moving would move other things, so that in Plato's and other philosophers' causes were movable themselves. Maybe what he does is precisely to do away with this generalized idea, and, taking the need for a cause to the limit, he arrives at the extraordinary conclusion of putting the fully realized account of Parmenides' being and Plato's forms, as the origin and *telos* of all motion, but itself immobile. Since Plato conceived of moving motors, while placing the forms in a separate realm, it seems that his immobile mover tries to solve Plato's inconsistencies. But does it really?

Energeia and *entelecheia* converge, since "the end and completion of any genuine being is its being-at-work" (Sachs 2002, li). *Entelecheia* implies that every thing's "thingness" is a kind of being-at-work, or, in other words, a specific way of being in motion (everything being in motion, besides God). All things that exist besides God are beings-at-work, and all of them have a mode of persisting, of being-at-work in a particular way that is their proper and "complete" way. "Just as *energeia* extends to *entelecheia* because it is the activity which makes a thing what it is, *entelecheia* extends to *energeia* because it is the end or perfection which has being only in, through, and during activity" (Sachs 2005).

As happened in Plato's *khōra*, Aristotle acknowledges that there is something beyond the particular intelligible completeness (form) of an activity, something neither actual nor potential and yet both, which is an essential aspect of nature as change. It is indeed the very core, the true subject of *physis* as change. It is the undefined term underlying actualization, and yet this undefined term is described as negativity or incompleteness, an incomplete but irreducible reality that is always moving toward a form. Like *khōra*, it enacts all forms without ever keeping any, always retaining its necessary ontological indefinition and incompleteness.

The inconsistency in Aristotle is thus in assigning a negative value to the core aspect of nature, subduing it to form, similarly to how Plato defines *khōra* in obscure negative terms, as if it were an issue of negative theology. Aristotle is displacing but not solving the problem posited by *khōra*. Movement keeps the dynamic aspect of *khōra*, and yet by subsuming it to a law of causality he seems to eliminate openness, chance, emergence, and novelty.

Form as actuality is logically prior to potentiality, therefore the need for an ultimate immobile mover which is pure form, immobile, pure intellect. God, while transcendent and disengaged, instils through its very existence the universal tendency to form, so that every being is defined by a continual movement toward a form that constitutes its essence. Aristotle's immobile and transcendent God contrasts with Plato's more immanent demiurge as mobile mover.

The debates on the transcendent or immanent God will of course be crucial during the Middle Ages and will feature again in mechanism. So, theology is crucially linked to the question of movement and its universal motor, which Aristotle placed in a transcendent immobility.

7.4.3.1 Animal Locomotion

Where Aristotle develops more original and visionary theories of movement is regarding the locomotion of animals, which focuses entirely on the complex field of the body itself, and not on displacements of bodies in a space, thus pointing to a proprioceptive, swarming, and field theory of motion. This aspect has been seemingly ignored by many readings of his theories of locomotion.

In *De Motu Animalium* (1978) he exposes individual body parts as independent, having their own movement and influencing one another, and places external body

extensions in continuity with them, with no categorical difference, in a striking resonance with posthumanist discourses on prosthetic bodies (the cane of the blind as example, as in Merleau-Ponty). He speaks of feedback relations between affections that prepare motion and are in turn prepared by imagination and sense perception, where feelings heat or cool parts of the body, memory doing the same by way of likeness and anticipation. Bodies are fashioned with flexible or elastic tissues so that these reciprocal affections can happen, changing from more solid to more liquid and vice versa. Limbs can move independently so that the middle section, which is their origin, can effectively become more than one (as limbs move independently), and this middle section transmits affections between parts.

Aristotle distinguishes between two kinds of irrational motions: *Involuntary movement* of the heart and penis, which move when something appears but are also like independent living entities with generative force (intelligence, which he links to the heart, and semen or vital moisture); and *nonvoluntary movement*, including sleeping, walking, and breathing. He speaks of the way in which small nonvoluntary motions somewhere may unleash alterations of motion in larger parts, and of the varying degrees of irrational motion in relation to the same thoughts, which relates to the varying reciprocal influence of passive and active affections and matter within the body.[15]

He also speaks of motion itself establishing its intrinsic order rather than being subject to an external order. Thus he approaches in many ways how I theorize a swarming proprioception. Yet what could be a very promising field theory of movement and the body is subjected by himself, within the same treatise, to a teleological and hierarchical theory of the unmoving principle (represented by joints) and of the center of desire for the goal, which is the limit, thus structuring natural motion itself "like a city well governed by laws" (Aristotle 1978, 52). Laws become an inherent property of nature itself through his causal understanding of motion. The origin is in the middle, where desire is, in the heart "or some other part" where *pneuma* (soul and breathing) also is. Parts can influence each other reciprocally but by going through the origin.

It seems that the more visionary aspects of Aristotle's conceptions have passed unnoticed through the ages. He displays a surprising conception of the moving body as made of independent parts that affect one another sometimes via minimal movements, with no distinction between external and organic limbs, but traceable to a hierarchy in an origin, desire, which, however, is also affected by movement and transmits movement to other parts, and where imagination and memory play a role in recognizing or distinguishing. Desire is the direct source that sets affections in motion, that in turn move the body starting from small alterations in body parts, which is reminiscent of the idea featured in Lucretius involving the *clinamen* as that which accounts for freedom, thus bringing in a radical reversal of teleology.

Both imagination and sensory perception seem to relate to memory and likeness in defining the role of desire. The sequence appears to be the following: Thought or senses → *phantasia* or memory → desire → affections that prepare organic parts → motion. There seem to be multiple noncentralized processes going in the body, from irrational motions to active and passive matter unleashing changes and independent

[15] "As for the fact that, as a result of the same thoughts there is sometimes an irrational movement in the parts, sometimes not, the reason for this is that sometimes the passive matter is present in the right quantity and quality, and sometimes not." (Aristotle 1978, 54).

body parts that move. Yet Aristotle nevertheless imposes a teleological causal logic of intentionality and desire, where there are always unmoving parts and a center of desire. He seems to be struggling with himself in continually counterposing a radically decentralized and a centralizing conception.

In linking memory or imagination to perception or thought as that which prepares desires, which in turn unleash affections that in turn prepare the body, Aristotle advances much of contemporary thought on retentions and protentions, or rather sets their ground within a causal, teleological scenario that has ruled supreme ever since, placing the desiring subject (or animal) in the center. Yet his thought on irrational motions, independent body parts, unevenness of passive and active matter reciprocally influencing one another, where tiny modifications may unleash great effects somewhere else, and in the relations of thought, memory, and imagination to motion, clearly advances other more visionary ideas that apparently have not fully been developed afterward.

In a way, my theory could be said to elaborate upon the abovementioned aspects of Aristotle's theory, removing from them the hierarchical and teleological aspect: bodily parts, including technical prostheses connect to one another in decentralized ways, have a life of their own, affect one another creating memories and open-ended expectations, capacities to act in more ways as a distributed swarm of interactions, the unevenness of matter reciprocally affecting and being affected in a swarming in between beyond passive and active, a swarm of joints with no immobile parts.

Proprioception undoes Aristotle's teleological conception completely in that everything is always moving, fluctuating in many directions or no directions at the same time, without goal, in many tensional zones, like Heraclitus's lyre but with many shifting and interlaced strings, not in a tension of opposites fighting, but of multiplicities dancing. And desire, always multiple, is in the vectors emerging from the swarm and across swarms.

7.4.4 Epicurus and Lucretius, Post-Aristotelian Precursors of RMP: Everything Swerves and Spreads Indeterminately

Epicurus, and later Lucretius, brought a revival of atomism and of some Pre-socratic doctrines in a post-Aristotelian world. I have discussed Lucretius's *clinamen* in Book 3 and we have seen some of the relations and differences between Epicurean and Democritean atomism. In his three books on Lucretius, Thomas Nail (2018a; 2020a; 2022) claims that the *clinamen* concept is originally Lucretius's and may not have been there in Epicurus's philosophy. It is a concept that exceeds atomism, whereby Lucretius carefully avoids the term atom. The principles, bodies, or seeds are those that swerve. Nail claims more generally the actuality of Lucretius's proposal, that matter just swerves indeterminately, in face of current quantum physics and cosmology, including the most radical current speculations about the multiverse. Nail thus emphasizes the crucial importance of this concept that could be one of the most important, perhaps even *the* most important concept of all philosophy. This is of course including all its ethico-political implications for rethinking not just matter flows, organic life, or the body, but relations, sociality, or freedom as well as sensation, affect, or thought. The *clinamen* is an *intrinsically queer concept* where creative Nature *varies by principle* and *continually deviates from any previous form.*

Nail explores both the ontology, ethics, and history of movement in Lucretius, building upon the previous work of Serres and Deleuze. Nail claims that "no one

before Lucretius had ever given such a direct and clear ontological primacy to motion over space and time. He is therefore the prince of motion" (2018b, 56). Nail claims the underestimated force of Lucretius's text as core to a *kinetic revolution* that is only just starting, following the ancient vortical revolution and the modern atomic revolution.

Some of these claims may be slightly exaggerated, while in other respects the presence of some ideas in pre-Aristotelian philosophy is perhaps not fully considered; for instance, in terms of the multiverse, it is not so much an issue of Lucretius prefiguring current ideas of a multiverse. Instead, the interesting similarity one can see is in the type of speculative intuition. Because space is infinite and matter flows everywhere, composing bodies, there have to be endless other worlds, just like current cosmologists consider that given the primacy of fluctuation in the hazardous tuning of this universe there have to be other universes that are differently tuned. These other worlds are not in the visible stars for Lucretius, as these heavenly fires are supposed to be just slightly smaller or larger than one sees, so it is a real and visionary speculation. But the idea of multiple worlds was certainly not original of Lucretius, it was almost ubiquitous in ancient cultures.

From the different multiverse theories that are currently existing, the one that comes closer to Lucretius is the one of infinite Hubble volumes, which are caused by the same Big Bang but are causally disconnected, and which, due to fluctuations, may even have different laws, understood as provisional organizations of movement, not as *a priori* universal static laws. Such laws are also absent both in Democritean and Lucretian physics.

But the claim for multiple worlds was ubiquitous in ancient thought. This is why it is important to outline a genealogy of the anomaly of Aristotelian thinking of motion, as I propose here. His earlier precursors in atomism also need to be reread, undoing the Aristotelian misreading, as I propose in Book 3 and in the previous passages here where I explain how Democritean physics was relational, dynamic, self-organizing, and free from Aristotelian ideas of trajectories (displacement), or of static form. The *clinamen* comes in a post-Aristotelian world, assuming trajectories, displacement, the falling movement, and form but trying to open them up.

Both Democritean and Lucretian physics are visionary in considering that atoms *always* move, even in the combinations that create most solid materials, where the movements are, however, more intricately interlaced (just like in current physics everything is in motion inside the atomic nucleus), an idea that pervades most of ancient physics, also in the Heraclitean view: there is no stillness anywhere.

In his comment on sensation as an interweaving, mutual, and reciprocal process Nail (2020a, 171) omits, as have done all others before him, mention to proprioception or kinesthesia, which is the new paradigm I propose for understanding perception as always only an issue of entangled mutually affecting fields. Lucretius was perhaps indeed visionary, and so was Democritus, in advancing some of these ideas, but this has been ignored due to completely erroneous definitions of perception that still prevail in most if not all philosophical imaginaries.

A truly visionary aspect of the *clinamen* in this regard — which has perhaps not been fully appreciated — is revealed when Lucretius states that, even in our movement, there is a freedom that lies deeper than the freedom of rational choice: the deviations brought in by the *clinamen* itself, which prevent reason's choices from being enclosed in their own internal necessity! This appears in *De Rerum Natura*, Book 2, verse 292, precisely in the section where the *clinamen*, as movement of devia-

tion of the "principles" is described as happening in indeterminate space and time, and as source for all creativity in nature. This resonates with my proposal of the proprioceptive swarm.
...

Nail highlights Lucretius's crucial denunciation of the fear of death, its relation to a fear of movement–change and of the sensible world of matter and bodies (Nail 2020a, 44). Yes! But in my view the excessive self-awareness of certain humans (if not of *sapiens* at large) and their fear of death, their will to self-preservation and stasis, their sense of lack, unhappiness and dissatisfaction, their increasingly abstract ways of thinking and search for disembodiment, their somatophobia, kinetophobia, and sensophobia, all of these are not cause, but effect, symptom, and part of a generalized impoverishment of movement, the senses, and experience coming up in agricultural societies, and growing ever since. We may be reaching now the most critical point of the planetary disruption that this anomaly has created, or perhaps not yet.

Nail claims that for Lucretius "ethics is the study of moving well. The desire for immobility is therefore antithetical to ethical practice and is the source of the hatred of death, matter, mobility, and the body" (65). Nail claims the importance of not falling back onto a vitalist ethics that ends up reproducing the mistake that "in order to preserve the lives of some, others are systematically dominated, destroyed, colonized, enslaved, and their land and wealth accumulated by those wanting to live longer, more, or better. The quest for life is identical with the production and management of regimes of death" (112). Therefore, an ethics of movement implies an ethics of death as much as of life. Here it seems to me that Lucretius's affirmation of free death is a precursor for the Nietzschean tragic Dionysian worldview.

Nail unfolds a Lucretian kinetic ethics in three parts: pedetic, entropic, and collective. A first ethics of motion implies not wanting to stop and control *pedesis*. *Pedesis* is a concept from physics designating the indeterminately varying trajectories of particles in gas or liquid known as Brownian motion and is proposed by Nail as central to his approach to indeterminacy, which, by implying relationality, is not equating randomness. In this it comes closest to my definition of movement as indeterminate fluctuating fields in variation. *Pedesis* is still burdened by the idea of trajectory, as it seems to stem from definitions of Brownian motion, the "random" trajectories of particles, but Nail strives to stretch the concept when claiming that even though motions seem to follow one another (an idea I explicitly challenge and which is linked to trajectories) because they are relational as well as indeterminate, thus not constrained by the relation, then this indeterminacy exceeds randomness and points to a different account of openness (124).

A second ethics implies the entropic circulation of desire as superabundance rather than lack, a joyful circulation linked to specific relational practices like weaving or dancing. Here Nail appeals to crucial terms of my proposal such as the *khoros* as both dance and space, and *khōra* as indeterminate, emergent space. Kinetic ethics is emergent and cannot congeal in a defined set of values and rules. Nail also stresses Lucretius's denunciation of property as prefiguring current discourses of commons that need to be reviewed under the light of movement. "Property, for Lucretius, is an attempt to stop the constant flow of matter" (121).

A third kinetic ethics stresses the relational, collective aspect of *pedesis* that implies the emergent quality of ethics itself, a radical claim for a *kinetic anarchism*

that considers pregiven sets of rules unethical by principle, as well as, of course, any will to dominate, accumulate, and escape death.

Nail claims a kinetic Lucretius that exceeds vitalist visions of the past, where movement is as much about life as about death and denounces the way vitalism can end up committing the same error of self-preservation, domination, and death-denial that Lucretius denounces. I would add that movement is about variation, therefore the importance of death!

In any case, the visionary proposals by Lucretius on cosmology, evolution, and natural selection, or psychology, as well as on perception, the emergence of language, the moving body, ethics, freedom, social organization, anarchism, and atheism, are of paramount importance, and Nail's contribution to their recovery is deep and very necessary.

7.5 Mechanism: The Dominant Anomaly

Aristotle laid the foundations for all further reduction of movement by defining space as fixed and separate and movement as divisible and bound to form and causality. During the Middle Ages, Aristotle's immobile God and his logical system continued to rule, through scholastic philosophy, over movement's causality and teleology (now as teleology toward God himself, who however can never be reached). Along the way modifications appear, as in considering movement the transition from potentiality to actuality (Pardo 2011, 36), which misses some of the more complex and dynamic aspects in Aristotle, for whom the actual is always in process while movement is also actual. Movement is a mere accident of substance (even if some like Duns Scotus take accidents very seriously). These changes foreshadow the emergence of mechanism.

In the Renaissance, the rediscovery of Greek maps and grids and the subsequent invention of linear perspective in the context of the Florentine bourgeoisie afforded for the first time a fully calculable and homogeneous perception of the world and defined an external observer through the fixed point of vision. This is the foundational turning point underlying colonialism, anatomy, and all the modern sciences leading to mechanism, Cartesianism, and later industrial and disciplinary societies.

If Aristotle was biased by grid perception, Galileo in 1604, Descartes in 1636, and Newton in 1686, fully biased by perspective, consolidated and gave mature ontological and physical elaboration to mechanistic accounts of movement. Through Copernicus's and Galileo's physics, which contradicted some of Aristotle's theories, the circular motions of astronomy continued to provide an important foundation to the reformulation of Aristotelian physics into mechanism. Aristotle had considered rest as primordial, but Galileo conducted famous measurements which led to Newton's negation of absolute rest, as well as absolute position and absolute space, since these were observer-dependent. Unlike Aristotle, Newton believed in absolute time as independent from space, perhaps due to the proliferation of mechanical clocks as time panopticons, and in the possibility for unambiguous measurements of movement.[16]

16 Previously Spanish physicists Domingo de Soto and Juan de Celaya already elaborated, in 1517 and 1545 respectively, the grounds for Newtonian laws of motion in their works on Aristotle's *Physics*. Soto was the first in establishing the law of constant acceleration in a falling body.

The formulation of universal mechanism and Newton's three laws of motion, where movement is an external accident of pre-existing bodies caused by forces, leaves aside Aristotelian form as teleological process of becoming and considers a world of fully actual entities performing an equally actual and measurable movement. The subsequent proliferation of mechanism's worldview had the effect of disseminating mechanical choreographies and perceptions across the entire social field, especially since the onset of industrial society as based on mechanical apparatuses.

Universal mechanism emphasized the mathematical divisibility of any movement at any moment, thus placing time at the same level of space, indeed time as reversible. This absolute time was different from ancient accounts of time. In Aristotle, time is given by movement, implying that it is not prior to it: it is a particular type of movement that produces a particular time measurement if it can. The time of the seasons comes from the movements and changes of the climate, weather, and harvest rather than imposed in advance by an abstract calendar (Pardo 2011).

Newton instaurated in physics and common sense the adamantine conceptions of absolute time and absolute space, as objective, *a priori* existing realities: in the case of time imperceptible, only accessible through mathematics. Instead, relative time is "any sensible measure of duration by means of motion" and relative space is "some movable dimension or measure of the absolute spaces" (Newton 1999, 408). Absolute motion (the inverse of how Bergson will use the term) is the motion happening in the frame of reference of absolute space and absolute time, whereas relative motion will relate to relative space and time.

> Absolute, true, and mathematical time, in and of itself and of its own nature, without reference to anything external, flows uniformly and by another name is called duration. Relative, apparent, and common time is any sensible and external measure (precise or imprecise) of duration by means of motion; such a measure—for example, an hour, a day, a month, a year — is commonly used instead of true time. [...]
>
> Absolute space, of its own nature without reference to anything external, always remains homogeneous and immovable. Relative space is any movable measure or dimension of this absolute space [...]
>
> Absolute motion is the change of position of a body from one absolute place to another; relative motion is change of position from one relative place to another. (Newton 1999, 408–9)

Newton's three laws of motion, published in 1687 in the *Principia Mathematica*, define the universal principles of classical mechanics and dynamics, of the relation of movement to force, defining the principles of inertia (first law), acceleration as relative to force (second law), and reciprocal resistance of force between two bodies (third law). They all imply relationality relative to force and imply the primordial character of linear movement in absolute space and time. With universal mechanism, the quantitative (relative to the body) is clearly cut from the qualitative (relative to soul and intellect), splitting terms which in Greek thought had been bound up (Bergson 1944), so that in terms of bodies everything is given and a superhuman intelligence should be able to identify every position of every atom in any time of the universe. Bergson correctly criticizes how this approach (which still pervades algorithmic society, attempting to actually create this superhuman AI) would miss

the main point: duration or becoming as indivisible, as always bringing forth novelty precisely because it cannot be reduced to immobile points.

Descartes's earlier account of mechanism was also influential. It partly reproduced a Platonic view of eternal motion applied to both ends of his dualist ontology by assigning to matter or body the deterministic account of universal mechanism (and of preservation of the amount of motion), while to the soul or God he assigned the movement of indetermination and free will (a division partly reproduced by Bergson). Thought is bound to movement, as is matter, but they relate to different types of movement. The universe is a plenum without void where bodies move each other by collisions.

Eternal movement for Descartes is expressed in the law of conservation of amount of motion, which also explains interactionism between mind and extension, as the mind can alter only the directions, so that freedom lies in reason's capacity to alter the deterministic directions of mechanical movement. The ultimate motor is, as in Aristotle, an immobile and transcendent will of God, whose teleological plan is impossible to know. But as in Aristotle, Plato, and Parmenides, being identifies with thought, now in the more radical model of the strict mind–body dualism taking further the hatred for the body and the senses inaugurated by Parmenides and Plato.

7.5.1 Spinoza and Leibniz: Precursors of RMP

Spinoza didn't develop himself a physical theory. He mostly assumed Cartesian laws of motion and thus mechanism, but he also interestingly hacked them through his metaphysics and ethics (R. Manning 2016). By strictly rejecting any dualism (and thus interactionism) and recognizing only one substance in which God equals Nature, immanently dynamic in and of itself, *lacking any teleological plan*, he recovers partly the spirit of the first philosophers, where a dynamic unity expresses the multiplicity of the world. He does so by considering extension as made of bodies within bodies, composites defined by relations of movement (and rest) to infinity, as expressions of a single nature. Bodies move each other in a plenum without void through collisions which can have a geometric explanation.

At stake is to explain how bodies hold together while suffering affections as capacity to both persevere and change. *Conatus* is higher if the body persists as it is exposed to more affections. Here is the crucial critical point of plasticity where *conatus* is clearly about persevering, through maintaining relations of motions defining the form of a body, that will perish when these relations of motion are altered, when the form is altered. So, there is perhaps a problematic mechanistic echo in his account of affects, as accidents that don't alter the form. And yet the more revolutionary idea comes when Spinoza assigns a positive value to whatever allows a body to increase its capacities to affect and be affected by more bodies.[17]

What he elaborates is a way of thinking the dynamics of bodies in terms of the affections, not only distinguishing modes, or qualities, but crucially (and here he anticipates Nietzsche) *as increase or diminution in the capacity to affect and be affected.*

17 "Whatever so disposes the human Body that it can be affected in a great many ways [increasing sensitivity], or renders it capable of affecting external Bodies in a great many ways, [increasing compossibility in relation to sensitivity or openness]is useful to man; the more it renders the Body capable of being affected in a great many ways, or of affecting other bodies, the more useful it is; on the other hand, what renders the Body less capable of these things is harmful" (Spinoza 1985, 568). On affections as increasing or diminishing the power to act see Spinoza (1985, 483).

He retains the mechanistic aspect of causalities, inertias, and collisions in the affections between bodies, which are composed of multiple reciprocal affections, where *conatus* seems to be a metaphysical elaboration of inertia as active force and of collisions as alterations. This, however, brings him close to Plato's *khōra* in considering the world as made of mere qualifications, with the great difference that what qualifies is not transcendent forms but affections between immanent forms, which have no transcendental plan, but only a will to consist and be affected.

The highest point is reached, as Deleuze (1986b, 62) points out, in outlining the capacity of affecting to a sensitivity, to a capacity of being affected. The essence of a body lies in this capacity and sensitivity. Movement is still an attribute, but its power of affecting is the metaphysical drive, and affects are its modes. Spinoza focuses on the ethics, on the *what for*, the defense of active forces by distinguishing joyful and sad passions, the active and the passive or reactive. His Nature–God has an active force or drive. Yet his active–passive conception needs a mediation: the momentum between passive and active and also involves a problematic distinction between active reason and passions.

...

Leibniz also assumed mechanism, but as secondary to thought, while for Spinoza mechanism and extension are attributes of the only existing substance at the same level as thought. His physics is still about collisions and impulses in the collisions.

Leibniz, being himself a first-rank mathematician and physicist, challenges Cartesian physics and proposes an alternative to Newtonian absolute motion with a relative account of motion and spacetime that prefigures Einstein's general relativity. Leibniz rejected Newton's notions of absolute space, time, and motion (McDonough 2019). For Leibniz space only makes sense as the relative location of bodies, and time as the relative movement of bodies. This relative motion, while still linear, focuses on the *curve* ensuing from collisions, and on the fold as dynamic topology accounting for elastic matter and plastic bodies (prefiguring the folds of proteins in visionary form). These curves resonate with Lucretius's and Epicurus's *clinamen* in bringing in differentials, expressed in mathematics through infinitesimal calculus, famously invented in simultaneous manner by Leibniz and Newton.[18]

Leibniz proposes a preservation, not of the amount of movement like Descartes, but of force, related to a law of variation and preservation of energy. What moves in curves preserves the force and its direction: not the curve but the tendency to continue drifting away from the tangent. Underlying his physics there is a metaphysics of *monads*: active and passive unities of force as well as unities of thought and perception, inextensive but connected to the entire universe (Leibniz 1948).[19] Space and time have no ontological status other than as ideal constructs.

For Leibniz, perception is mostly nonconscious, or indistinct like the murmuring of waves, whereas apperception is more in the conscious spectrum, with rationality

18 One could wonder what kind of world we would have inherited had Leibniz's relative motion prevailed against Newton's absolute motion? This is maybe in fact what came about with cybernetics.

19 See Rojas Osorio on the "dynamicism" initiated by Leibniz, where the monads are inextensive energy atoms, which was taken on by Boscovic, who was in turn inspiring Nietzsche in the attempt to define a physics of transformation that pays attention to the quality of the force rather than the quantity and where the will to power is the "internal" or immanent side of the forces. The later turn via Faraday and Maxwell from force to field redefines particles as "knots" in the field, density nodes, vortexes (Rojas Osorio 2001, 39).

being also considered a mode of perception. Perception in Leibniz is a folding, therefore a contraction rather than selection (Munster 2006, 42).

As we will see, curves and folds in Leibniz have been an important cue for attempts to rethink movement by Deleuze and later Erin Manning, as topological variation of curves that introduce novelty into linear displacements, opening them up to the virtual, the plane of immanence, of absolute motion not subdued to points, where points are inflections in curves. But he also laid the ground for cybernetics as science of control.

7.5.2 The Materialist–Dialectical Turn

Mechanism became the universal frame for thinking movement, unquestioned and haunting the sciences ever since. The idea of "things moving in space" continues to pervade scientific imaginaries, even when sciences are struggling against this conception.

Immanuel Kant's earliest work attempts to mediate between the physics of Descartes and Leibniz on the conservation of movement vs. force. His study of the motion of matter takes for granted points moving in space. Kant, in assigning space, time, and causality the status of *a priori* of intuition in our cognition, preceding experience, assumes a perspectival and mechanistic bias. Kant's *a priori* of intuition could be safely summarized as perspectival illusions.

But Hegel's conception of the world as dynamic dialectical process of complexification, where being and thought are identified, presumably takes a Heraclitean view of tension between opposites as the basis for a linear historical upward evolution and synthesis (*Aufhebung*) toward an absolute: an all-inclusive whole, a teleological movement. Human thought thus partakes of God's thought through its dialectical movement, based on a master–slave dynamics of fight of opposites, taken on by Marx in a materialist turn, as historical movement of humanity whose movement is that of class struggle.

According to Burkett (2000), Hegel distances himself from Newton and develops his own (loose) account of motion. He distinguishes between self-caused and externally driven, but the first one is pre-eminent. For Hegel, contradiction is "the principle of all self-movement" and "self-movement [...] is nothing else than the fact that something is itself and is also deficiency or the negative of itself, in one and the same respect" (1966, 2:67–68), so this implies that movement is self-caused because of a Heraclitean law of implicit contradiction and fight of opposites implicit in phenomena. A law of movement relates to this self-causation and always implies two determinations, each of which can have many variables which have to be independent.

Hegel considers time and space, or velocity and distance as independent determinations, whereas electromagnetic charges would not count as law, as the two determinations (positive and negative) are *interdependent*. Hegel attacks the way in which Newton converted Kepler's or Galileo's observation into a universal force and opts for Kepler's theory as sufficient and a better formula, coherent with his idea of planetary motion as free self-determined motion relative to two independent determinations of space and time.

The real critique of Hegel we find, through Deleuze, in Nietzsche, where dialectics turns out to be a conservative, reactive process that remains a description of symptoms incapable of a transformative interpretation and critique, ignoring the

plural, differential, and qualitative aspect of the forces at play, of which dialectical opposition is a mere appearance (reinstating the master–slave dynamics):

> Nietzsche's work is directed against the dialectic for three reasons: it misinterprets sense because it does not know the nature of the forces which concretely appropriate phenomena; it misinterprets essence because it does not know the real element from which forces, their qualities and their relations derive; it misinterprets change and transformation because it is content to work with permutations of abstract and unreal terms. (Deleuze 1986b, 158)

Marx elaborated upon Hegel's ideas of motion in his ambitious aim in *Capital* "to lay bare the *economic law of motion of modern society*" (1965, 10). He did so by applying the law of opposites to the dynamics of capital. But in doing so he was also perpetuating the inconsistencies coming from Hegel, whose law of motion was not clearly distinguishing self-caused from externally caused. Marx tried to reverse Hegelian dialectics as not of the mind but of matter, and as not teleological but transformative, while still historical and evolutive, thus resonant with Darwin. His early approach to the *clinamen* in Epicurus was to be important for his conception of matter as endowed with self-determination or autonomy, while his early work on Democritus and Epicurus used Hegelian dialectics to express the superiority of Epicurean thought through the *clinamen* as self-determination in the atom.

Marx's doctoral thesis, completed in 1841 (Marx 1902; 2012), had indeed concerned itself with the difference between the Democritean and Epicurean theories. In his kinetic reading of Marx, Thomas Nail claims the closeness of Marx to a Lucretian understanding of kinetic flows of matter, of which he would be the first modern philosophical return. A kinetic and metabolic communism would be one in which,

> Instead of massive metabolic drifts of erosion and deposition, metabolic communism must work in closer, more sensitive feedback and "free play" with such patterns of circulation. Metabolic communism would have to maintain an entropic "balance between expenditure and income" of material production/consumption for the proper "restoration, renewal and refreshment" of the "powers of life," the "vitality of the soil," and the "realm of natural forces" (Nail 2020b, 124).

Nail defends the kinetic approach of Marx in *Capital*, in trying to understand capitalism solely in terms of the specific motions that underlie it, as contingent organization that reduces movement to static and discrete elements, which he opposes to communism as open and nondetermined social organization, and with a nonanthropocentric vision of humans' embeddedness in the living (Nail 2023). Yet, both Nail and Marx reproduce the prevailing misreading of Democritean atomism as deterministic that this book seeks to correct. Also, both seem to miss that the deeper, unchallenged problem in relation to capitalism is the determination of movement via alignments, reductions, and fragmentation, of which capitalism is but a phase, as I expose in my theory of the Algoricene as the becoming algorithmic of movement at least since the Neolithic: homogenous accumulation–multiplication is the problem.

Engels developed his own theory of motion in *Dialectics of Nature* (1987) implying three laws derived from Hegel: the law of unity and tension of opposites inspired by Heraclitus, speaking of class struggle and its relation to contingencies and laws of matter in motion as a whole; a law of transformation from quantity to quality that

is inspired by Anaximenes and is crucial for thinking workforce in relation to thermodynamics; and a law of negation that leads to the formulation of communism as negation of capitalism's negation.

Engels's posthumous manuscript has numerous and surprising references to motion as not being only mechanical. He acknowledges every movement as entailing a mechanical aspect but defends that there is more to movement, a qualitative side, and refers to thermodynamics and heat as molecular movement. For Engels, movement is the mode of existence of matter; there cannot be matter without movement. A body is inseparable from its movement, and only in movement a body manifests itself and can be understood. All motions consist of attraction and repulsion, and always involve displacement, but not only. Indeed *the higher the mode, the less displacement is involved* (1987, 364). The energetics of motion that define work seem to hold onto thermodynamic principles.

Marx and Engels, each in their own way, build upon a triple premise: Hegel's theory of motion rather than Newton's, thermodynamics as the new scientific turn that Hegel had not known, and Darwinism. So, while giving matter a vitalism and attempting to free it from Newtonian determinism, they subjected it to Hegel's theory of opposites, and elaborated the quantity–quality distinction as relative to work in the frame of thermodynamics.

And yet, as claimed by Nail (2023), they also build upon Lucretius in assigning a dynamic and indeterministic nature to matter, and were perhaps the first ones in advancing a return of the "only movement" doctrine in modernity.

7.6 Undoing the Mechanistic Inflexion

I already suggested how ancient Greek thought was influenced on the one hand by common sense and myth, and on the other by increasingly geometric environments, trading, counting, and abstract chains of language that led to logical thinking. These were also associated to Greek democracy, a slave society of tradesmen. I also pointed out how the reappearance with renewed force of grids of rationalization gave birth to Renaissance perspective in the society of the Florentine bourgeoisie. Perspective was in turn foundational to mechanism and Cartesianism, as it provided a fixed, external point of observation and measurement. The latter also underlies the Enlightenment and the French Revolution, as grounded in the mind–body dualism, and the defense of reason as source for freedom and equality.

Likewise I want to suggest that the attempts emerging in philosophy at least since Nietzsche, both as a radical critique of the previous paradigms and the outlining of other possibilities, including a vitalist philosophy of movement and becoming, were partly inspired by new perceptions appearing in the sciences.

In the second half of the 19th century, the developments of James Maxwell, Ludwig Boltzmann, and others in thermodynamics started to challenge classical mechanics, with the emergence of a statistical mechanics and the elaboration of the notion of entropy. Thermodynamics was perhaps the first of these moves in the sciences grounding a perceptual shift, paradoxically stemming from taking mechanism to the limit. Mechanical steam engines as closed thermodynamic systems exposed the paradox of energy dissipation where the very laws of universal mechanism could no longer apply.

Thermodynamics and entropy initiated a long tradition still present today that acknowledges unpredictability while aiming to predict, reduce, or orient it. Chaos

theory and nonlinear systems, dissipative and far-from-equilibrium dynamics, statistics, and probabilistics are part of this process which crucially led to information theory and cybernetics in 1948 and still grounds our information culture.

Alongside this emerged what I will call *entropic fear*: the idea that the world has a thrust to dissipation and that life is the ongoing struggle against it. But this idea was already deeply biased by its conditions of emergence, namely the attempt to create closed thermodynamics systems and, later, closed information systems, in other terms, the attempt to subject variation, fluctuation, and becoming to control.

I will propose to reach into other etymologies of entropy, as change within, and as multiplication of states. It was never fully clear what it meant anyway, and this undecidability I will build upon. I thus claim that entropy is not dissipation. Life is always intraducting energy, fluctuation proliferates in evolution, *dissipation only comes with attempts to create closed systems, with closures and reductions, with reactive tendencies that block fluctuation-in-variation.*

Entropic fear of course has prior foundations. The fear of absolute disorder is an effect of enforcing visions of absolute order, at least since Plato, which he did by invoking the circular motion of the heavenly spheres, as did other Greeks at the time. Thermodynamics allowed the emergence of the ideas of noise as overfullness and hence of the virtual as infinite field of yet unthinkable potentials, but they emerged colored by entropic fear. as a negative presence that *needs to become form*. Entropic fear has resignified form as coming after, albeit still necessary. This statistical economy of form as emergent is actually grounding the operation of current computation and information systems, particularly Big Data, for which I think it is urgent to look beyond.

Darwin's *On the Origin of Species* was also enormously influential in the restaging of the controversies between chance and necessity and of life as struggle, and in his studies of emotions that perhaps influenced Nietzsche's take on physiology, as he influenced Marx and Engels. Neo-Darwinism afforded arguments for capitalism as competitive, individualist struggle for life, which others like Vladimir Vernadsky and Lynn Margulis have later challenged.

In the late 19th century, we have at least a triple bind constraining the thinking of movement and its always crucial relation to domination and freedom, determination and indetermination, or self-determination: thermodynamics and its law of entropy; Darwinism and its law of selection in the struggle for life; and the post-Hegelian dialectical materialism of Marx and Engels, attempting to define a law of motion of capitalism itself, in relation to work and class struggle in industrial societies.

Just like Greek philosophy was a mature evolution resulting from the agricultural revolution, and mechanism an offspring of perspective and European colonialism, the turn to new philosophies since Nietzsche is haunted by the double fold of entropy: thermodynamics and information.

We can see mechanistic determinism evolve in the Enlightenment under the new constraints of industrial society and its demand for efficient and closed energetic systems of production and increasing competition. With the turn of the century, the emergence of new perceptions coming from the technosciences has accelerated in prodigious manner, almost too rapidly for philosophy to work on their deeper ontological implications and their capacity to productively question the Cartesian heritage. Comparatively, social movements proposing paradigm shifts seem less experimental, though events like May 1968 catalyzed a whole series of philosophical

transformations and diffracted in a plurality of minority social and philosophical movements emerging since then.

Ancient sovereign and mature slave societies emerged together with democracy and trade in geometric movement environments (and with a first account of dualism and of sexual difference). Disciplinary societies and capitalism emerged together with the Enlightenment and the French Revolution in perspectival movement environments (and a much fuller account of dualism and of sexual difference). Current control and hypercontrol societies emerged in algorithmic and statistical movement environments and seem to be accompanied by minority movements still based on deviation from norm or fight for rights.

Freedom in Greece can be exemplified by the *clinamen* as deviation from the line-grid that coheres social organization as geometric body of the city-state. Freedom in the perspectival era can be exemplified by Cartesian interactionism as the capacity of reason to change directions in movement and fight mechanistic determinism, which coheres social organization as mechanical body of a nation–state, the triumph of the rational will. Freedom in the algorithmic–statistical era also seems to relate to possibilities to deviate and disalign, as in queer and other minority movements while we cohere into a new level of organization in planetary-scale computation systems.

Social movements are mostly still holding onto a *dialogic antagonism with normativity* as inherited from disciplinary society in a common sense that largely assumes a mechanistic conception of movement. But one sees promising moves: not the rational mind as source for freedom, but bodies, their pluralities, expressions, and movements are the source of a new freedom. Recovering the hydraulic model of the *clinamen* is not enough, we need a radically new theory of movement and perception.
…

Let's look now at some attempts emerging roughly in the past 150 years, particularly since Nietzsche, to overcome the mechanistic bias concerning movement as measurable displacement in space, a mere accident of being. These philosophies of movement should be taken as attempts to create *new ways of moving*, hopefully more plastic ones than the trajectories of mechanism, ways that afford new kinds of freedom.

The journey will take us through Nietzsche, Bergson, William James, Whitehead, Gilbert Simondon, and others to the great cooking pot of theories coming up in France after May '68 (but already in the works previously) and diffracting later both in the domains of Anglo-American critical theory, closely linked to minority movements, and in recent philosophies of movement that appear already in the context of a hyperalgorithmic society.

Over a century after Leibniz's and Spinoza's attempts to challenge the Cartesian and Newtonian ontologies, Søren Kierkegaard returns to Aristotelian accounts of *kinēsis*, related to becoming within a Christian, religious, and existentialist project. In *Repetition*, he affirms Diogenes' stepping forth as an existentialist affirmation of movement against the Eleatics. Repetition is different from recollection, it is a movement of becoming and transformation (Carlisle 2005, 68). This is important, it seems, for Deleuze's concept of repetition.

Existentialist or factual affirmations of movement seem to return now and again. *Eppur si muove*, "and yet it moves," said Galileo in front of the Inquisition's tribunal after abjuring from the heliocentric worldview. But much earlier, Cratylus, the disciple of Heraclitus, had radicalized his master's doctrine by saying that one cannot

bathe in the same river even once, as both the river and ourselves are changing all along, thus challenging any account of identity. Cratylus apparently ended up not talking anymore and only moving a finger: another way of saying that even if we cannot talk about it, because language seems to fix things, *still movement moves...*

> *Supposing multiplicity, space and time, and motion (and whatever else may be the presuppositions of a belief in what is bodily) were errors — what mistrust would this arouse against the spirit that had prompted such presuppositions? Let it suffice that, for the present, belief in the body is always a stronger belief than belief in the spirit; and whoever desires to undermine it, also undermines at the same time most thoroughly belief in the authority of the spirit! By far the greater number of motions have nothing whatever to do with consciousness; nor with sensation.*
> — Friedrich Nietzsche (1968, §659)

7.6.1 Nietzsche's Absolute Becoming

Nietzsche's work is the great breaking point that outlines the new tendencies in philosophy both of a radical critique and also of a radical theory of absolute becoming, in sharp rejection of mechanism and causality, which he correctly identified as moralistic and reactive. In moving on from Artur Schopenhauer and Richard Wagner, and in a period of less than twenty years, roughly between 1870 and 1889, Nietzsche's own movement of thought oscillates between outlining a theory of absolute becoming and the necessary critique of the dominant metaphysical and moral doctrine, his influential genealogical critique.

But he also consistently outlines a doctrine of becoming, original though inspired by Heraclitus, as never-ending play of force differentials in fight and tension, which affirms *the fact of becoming as expression of the will to power*, while time is an interpretation, and movement is a symbolism for the eye, a kind of translation of the events of becoming to a visual sign language (Nietzsche 1968, §625). The will to power and becoming are the only *a priori* for Nietzsche, movement is a *sign*, while force, time, body, and even more so space, are fictions, interpretations, albeit some more appropriate than others. The fiction of space has produced a frozen account of the world, whereas time and force may afford a more dynamic interpretation of becoming, and belief in the body is preferable to belief in the soul.

The will to power is the radical metaphysical core of his philosophy of becoming. The will is even beyond becoming: "The will to power is not a being, not a becoming, but a *pathos* — the most elemental fact from which a becoming and effecting first emerge" (1968, §635). Nietzsche later added: "I require the starting point of 'will to power' as the origin of motion. Hence motion may not be conditioned from the outside — not caused — I require *beginnings and centers of motion from which the will spreads*" (1968, §551n22, my emphasis). The will to power is an underlying cause for becoming as eventful effective process of variation, a fight of differentials, while movement, force, time, and space are interpretations or visible effects of it. "All events, all motion, all becoming, as a determination of degrees and relations of force, as a *struggle*" (1968, §552). In the words of Robin Small:

> Space, time, and force are fictional constructions; our sensations and representations are given, but underlying them is the will, which remains "when one subtracts the knowing intellect." It is the will's fluctuations and intermittences that

provide the basis for succession and rhythm, the forms of appearance that turn becoming into time. (Small 2010, 74)

Becoming is affirmed not as the ongoing recomposition of pre-existing substrates, as in Anaxagoras and atomism, but as ongoing change with nothing premising it: the forces transform always in the process. The essence of force is continual change.

Nietzsche tries to counteract Parmenides' or Descartes's affirmations by saying that the most obvious fact of thinking itself is eternal motion. The motion of our thought and the change we perceive are the most fundamental facts about the world. *Cogito* is motion. If motion has being it is indeed uncreated, eternal. We are nothing but that which we continually experience from this flow. Being is an empty fiction, he says in *Twilight of the Idols*. There are no things undergoing change (Small 2010, 23). This is the *fact of becoming*. There is no doer behind the deed: no dancer behind the dance, no thing behind the motion.

Opening up lines that Bergson will elaborate later, Nietzsche describes as error the way in which the intellect imposes mathematical lines onto motion due to its narrow perception, its inability to perceive the subtlest motions, retaining only images of sameness and persistence (Small 2010, 23). Nietzsche denounces the intellect's tendency to introduce gaps into becoming, reducing it to successions of points following causal relations, the mechanistic worldview being such an effect of a reductionist intellect (39). The mind's inability to apprehend becoming leads to the reduction of motion and time to points whereby the *interval between them remains unknowable*. He denounces the illusion of being and, like Bergson, he associates it to a simplification necessary for practical life, a kind of necessity due to perceptual limitations.

Nietzsche establishes a direct link to physiology (Small 2010, 52), and yet the interrelation between environment and body acquires a slightly deterministic tone as our interactions and perceptions can be *limited* by a physiology. What about the ongoing reciprocal transformation of body and environment and the plasticity of capacities at stake that can be maximized or minimized? Bergson will have a slightly less deterministic view, though still acknowledging necessity, practicality, and the essentially narrowing function of the intellect. Both seek recourse to other modes of knowledge (in Bergson, intuition linked to a broadening of perception, in Nietzsche artistic sensibility and a Dionysian state of intensification).

Nietzsche rejects the correspondance of counting with the counted (Small 2010, 27) and echoes Galileo against Aristotle's fundamental states of rest. He rejects finality or rest, transcendence (being is the illusion) or anything above, a value as measure. Most significantly, Nietzsche attacks *causality as moralistic* and defends the *innocence of becoming* as the *rejection of causality*. I want to stress how this needs to be understood concretely in relation to mechanistic accounts of movement, where this claim achieves its more visionary force.

He acknowledges how the dichotomies (differentials) that are at stake in the continuous conflict of forces that characterizes becoming is already our creation or interpretation. Dichotomies don't exist as such, they express variations in degree. Dichotomy is an interpretation (Nietzsche 1968, §552). And yet, he affirms that we cannot do away with conceptual schemas and interpretations. Nietzsche's affirmation of the unavoidability of interpretative schemas bound up with matrices of power have echoed long through Foucault and Butler, amongst many others, leading to the current mantra of the inescapability of representation, discourse, and power matrices in critical theory. But they could be reinterpreted in the light of James or

Simondon, in terms of how every activity creates its own field of resonance, meaning, and processing of affections without recourse to rational reflection or the complex apparatuses of a given discursive framework.

Within the affirmation of a world of appearances as necessary fiction and expression of the will to power, *rhythm* acquires its fundamental role as *form of becoming*. As such it is also an interpretation. The variations or differences in degree and intensity between forces in which quantity becomes quality are interpreted as rhythms, tempo fluctuations within ourselves, creatures whose existence, becoming, and nutrition are linked to pattern creation.

The narrowing implied in pattern is nevertheless seen as the very condition of nutrition and the expression of the will to power in creatures like us, whose physiology and perception have a narrowing thrust. Rhythm is thus the *form of the will*. His dual vision of becoming is thus in a balance between the Dionysian drive to give in to incoming rhythms and the Apollonian drive to impose one's rhythm on the surrounding, whereby in later periods of his writing Dionysian exuberance took over as a *greater kind of rhythm*.

In his time atom theory (so named by commentators but entitled "Motion in time" in his posthumous notes from 1873), Nietzsche attempts a bold renewal and reversal of science, which he criticizes as echoing Parmenides and the Eleatics in its search for permanent causes and in its spatial logic. Instead, he sets out to propose a Heraclitean science based on time. In this theory the atom is a force point in constant change which is also a time atom that acts at a distance by relating to other time atoms composing rhythmic series that overlap, creating the fiction of space and objects as effect of sensations of simultaneity. The longer the action at a distance is, the slower the rhythm and the greater its structures are. Unfortunately, he didn't further elaborate this radical and promising proposal.

Any forces coming together already compose a relation, a body of sorts. Deleuze says that the body for Nietzsche is *not even a field of forces*: like any reality, it is pure quantity of forces in relations of tension (1968, 373). Illness lies in the anarchy of forces, health in hierarchy, but there is another type of "great health," of those who can sustain multiplicities of forces in the body, while the body is itself a "greater reason" of which the soul, mind, or spirit (*Geist*) is just a part.

Fluctuations of the will are the basis of rhythm as interpretation of becoming, whereby rhythm is never a direct aspect of sensation but always already an interpretation and creation. Instead, harmony in music is the nontemporal *essence of the will*, praised by him in early works in relation to Wagner, whom he will later criticize precisely as lacking rhythmic form. To increase our capacities to sense or create rhythm is claimed as crucial, whereby the modern tendency to reduce rhythm to changes in dynamics is criticized in comparison with the subtlety of ancient Greeks to identify rhythms only in temporal relations, without recourse to dynamic changes or beats (following Aristoxenos). Later, Nietzsche also claims an art of "great rhythm" as the capacity for larger structures personified in his own style. In his later writings he develops a thinking of becoming as continuous entangled processes and inclines more to the side of Dionysus, of exaltation and excess where a new kind of greater rhythmics appears, and form seems to give way to pure force.

His references to movement (*Bewegung*) are often, strikingly, attacking it, as narrow account coming from mechanism, as symbolism for the eye. Yet against it he seems to set up another type of movement: dance (that comes closer to proprioception, and his own awareness of his own motion while thinking or writing is clearly

proprioceptive). This double-sided account (movement as mechanistic form vs. felt movement, dance, proprioception) we will find differently in Bergson's and in Deleuze's notions of *absolute movement* as the alternative to formal and mechanistic movement. All of them criticize the mechanistic account of movement, and all propose a different kind of movement: in Nietzsche it is dance, in Bergson it is absolute movement as indivisible movement from within (pointing to proprioception), and in Deleuze and Guattari it is the absolute movement of the plane of immanence, as absolute deterritorialization, a curvilinear, folding, and vortical movement of difference.

Nietzsche's radical philosophy of becoming also shows some perspectival biases: in his considering both a quantitatively infinite time and repetition as core aspect of the eternal return; in his association of body, movement, and power with *quantitative* differentials of force; or in his dislike for Anaximander's indeterminism and his preference of Heraclitus's tensions of opposites.

According to Small (2010, 30), Nietzsche rejects the idea of the world always becoming new, self-creating, for this would entail a kind of *voluntary avoidance of repetition,* or control of motion in its escape, on behalf of force. It is remarkable that repetition instead is taken for granted as natural result of forces. This places the new in startling secondary place with regard to repetition. But given the infinite variations of movement it seems that pure repetition is an infinitesimally small probability.

Deleuze's interpretation of Nietzsche in *The Logic of Sense* (Deleuze 1990, 305) already points to eternal return of *difference* and *chaos* as that to which Nietzsche was perhaps gesturing. But his idea seems to have been in fact the identical repetition of the same moment, life, or universe as maximum affirmation of life, searching scientific correspondences in the idea of infinite space and time, where all possible worlds come to be, not once but endless times (which implies the error of considering a world as made of quantities and points). The wheel or ring of cyclic eternal return resonates with the numerous spheres of the pre-Socratics as embodying eternal motion, the boundless *apeiron* of Anaximander, the vortex of the atomists creating endless worlds in the endless void, or in the Ouroboros, the snake that bites its own tail.

But Nietzsche sees in Anaximander's association of justice with indeterminacy a pessimism (Small 2010, 18), as opposed to Heraclitus's affirmation of the sheer tension and fight of opposites as *logos* of becoming. I suggest that Nietzsche didn't appreciate the resonance of indeterminacy with ancient affirmative philosophies and how, in the midst of these, the vision of opposites arrived with social organizations increasingly founded on splits and hierarchies.

...

Moving is never just selecting from a quantitative world. What gets selected is the tendency, active or reactive. This distinction is one of the most influential in identifying tendencies to grow or to close down.

The Dionysian can be linked, more importantly, to an idea of movement as indivisible duration (in Bergson's terms) against the splits of mechanism. Felt movement in dance and music (proprioception!) is fundamentally amorphous. As Rüdiger Safransky (2003) points out, this was one of the most important intuitions of Nietzsche, linked to the idea of the monstrous, the *Ungeheuer.*

The overhuman in Nietzsche is the birth of a new sensibility, associated to dance and lightness, opposing the reactive heaviness of causal, teleological morality and mechanism, a sensibility that can look beyond the illness on the skin of the planet that is the all-too-human, as reactive fold in a Dionysian, superabundant nature. What he gestures to all along is a new thinking of movement and perception, and this new thinking must also be a new moving, a dance where life and thought become again one, healing the split.

7.6.2 Bergson: Precursor of RMP

The most remarkable attempt in philosophy to rethink movement beyond mechanism came perhaps with Bergson. In *Creative Evolution* (1944), Bergson provides a radical critique of the tradition that falsifies movement by identifying it with immobilities, stemming from Zeno's paradoxes, and questions the idea of displacement. He also proposes alternate ways of thinking movement as *indivisible transformation in an open Whole* (duration), hinting at times implicitly at proprioception, also in relation to evolution, and to a positive sense of indeterminacy.

In the lecture on "The Perception of Change" from 1911, Bergson exposes how the predominance of fixed vision has instilled a habit of focusing on the things that move in a given space (Bergson 2007, 122) rather than on the whole that transforms, evoking a remarkable parallelism between two trains that travel at same speed and look at each other as if immobile, in order to expose the way in which certain perceptual habits have synchronized internal and external movement, creating the illusion of immobility (122). He also points to proprioception when talking about internal mobility (122) and muscular movement (118).

Bergson claims that "movement is reality itself" (119), "there are underneath the change no things which change" (122), there is only "movement of movements" (124). This applies not only to how everything is in motion down to the quantum realms, but also to how common sense is biased by a focus on visually separating bounded objects from a fixed background, as result of a perceptual habit linked to practical life.

He points thus to a Radical Movement Philosophy not only in defining that there are no things behind movement from the point of view of physics, but also in questioning the habits of perception that have made common sense and physics focus on thingness rather than change itself. The movement of our perception and the movement of the perceived are entangled; both need to be considered. Focusing on movement, Bergson recovers its association with a general sense of change through *duration*: a radical change without things that change.

In *Creative Evolution*, Bergson distinguishes three main types of movement (1944, 330), corresponding also to Aristotle's three types (Cornford 1931, 31):

1. qualitative movement — yellow to green (Aristotle's alteration);
2. evolutionary movement — flower to fruit, larva to nymph to insect (Aristotle's growth);
3. extensive movement — eating or drinking (Aristotle's locomotion or displacement).

Bergson points to a new science, a mechanics of transformation (rather than displacement, which would be both a particular case and reduction to quantity) that

would afford indetermination in action by "integrating the physico-chemical elements of properly vital action" (1944, 38).

Bergson claims how complete instability and complete immutability are abstractions (130) resulting from the false reasoning based on a wrong and narrow understanding of movement: pure change instead is the most "solid," I would say consistent but open, "thing" (125)!

Bergson negates rest along with Nietzsche and modern physics since there can be no absolute frame of reference. Immobility is apparent: "If the intellect were meant for pure theorizing, it would take its place within movement, for *movement is reality itself*, and immobility is always only apparent or relative" (171).

In relation to immobility, he also negates form, thus somewhat reversing Aristotle's *Physics*. Since reality is movement and form is immobile, there can be no form: "But in reality, the body is changing form at every moment; or rather, there is no form, since form is immobile and the reality is movement. What is real is the continual change of form: form is only a snapshot view of a transition" (328). So, form is an illusion of a reductive perception.

On the absurdity of reduction, he states: "The movement slips through the interval, because every attempt to reconstitute change out of states implies the absurd proposition, that movement is made of immobilities" (335). Bergson hints again at proprioception when he states that "the absurdity [of reduction of movement to immobile cuts] vanishes as soon as we adopt by thought the continuity of the real movement, a continuity of *which every one of us is conscious whenever he lifts an arm or advances a step*" (337, emphasis mine). Again, the existential affirmation *eppur si muove*, but now with a new twist: the sense of irreducible continuity is linked to an internal (proprioceptive) movement. (Weren't all existential affirmations pointing there?)

He further points to proprioception when talking about a "faculty of seeing which is immanent in the faculty of acting" linked to his notion of intuition, and states, echoing Anaximander, that "to movement, then, everything will be restored, and into movement everything will be resolved" (273). Proprioception also seems to be hinted at in his account of evolution and contingency when he states that "two things only are necessary: (1) a gradual accumulation of energy; (2) an elastic canalization of this energy in variable and indeterminable directions, at the end of which are free acts" (278).

This association of free acts with indetermination, a behavioral indeterminacy that is expressed as the capacity to move in "variable and indeterminable directions" seems core to his concept of creative evolution, even of morphogenesis, where the body's motor capacities and the nervous system as reservoir of indetermination resonate with the indeterminable directions of movement, so that evolution implies the increase in the variety of possible movements that bring indetermination into matter, which is constrained by a contrary movement, of necessity or determination. The variability of proprioceptive movement is intrinsically related with the evolution of the nervous system as affording increasing behavioral diversity and indeterminacy. Indeed, life, *élan vital* as creative impetus, has as role to "insert indetermination into matter." Here, Bergson echoes a problematic and old dualist tradition, informed in his time by theories of entropy as universal tendency to disorder, and the supposed and mysterious negentropy that accounts for life. As I exposed in Books 3 and 4, I do away with this dualism and propose a single, active, cosmic force of diversification, where anomalous bubbles of reduction, such as that of human dominion, are

the ones creating entropic disorder through alignments that block the qualitative transformation of energy.

Bergson echoes Plato's account of the *two causes of motion*: necessity and intellect, although he reverses how freedom operates through intelligence: not bringing order but indetermination: "The impetus of life, of which we are speaking, consists in a need of creation. It cannot create absolutely, because it is confronted with matter, that is to say with the movement that is the inverse of its own. But it seizes upon this matter, which is necessity itself, and strives to introduce into it the largest possible amount of indetermination and liberty" (1944, 274). And:

> As we foreshadowed in the beginning of this work, the role of life is to insert some indetermination into matter. Indeterminate, that is, unforeseeable, are the forms it creates in the course of its evolution. More and more indeterminate also, more and more free, is the activity to which these forms serve as the vehicle. A nervous system, with neurons placed end to end in such wise that, at the extremity of each, manifold ways open in which manifold questions present themselves, is a veritable reservoir of indetermination. (140)

Bergson refers here to the entire network of the nervous system, not only the brain: the entire proprioceptive system, of which the brain is part! He further claims the continuity of experience in duration as indivisible, not only because movement cannot be defined by instantaneous cuts, but because the present, far from being relative to the mathematical abstraction into points, is relative to attention (127), to what focuses my attention: this sentence, this conference, this day... which one could enlarge to a whole lifetime or beyond provided the adequate techniques of perception–movement–memory–duration–existence! This indivisibility of duration accounts for the preservation of past in present and the aliveness of memory (129). But even more: there is a coexistence of past in present (memory as present) that further troubles reduction of the present or its split from past and future, since the aliveness of memory in the present is also its force of opening and indetermination of futurity, its projection. *Past and future mutually enfold in multiple spans of present.* The narrower your memories, the narrower your potentials to move and your futures.

Most importantly, Bergson links movement, and its narrowing, to perception. Since the problem giving birth to philosophy or at least metaphysics was, according to him, a wrong conception of movement related to a *narrowing perception* that felt itself incapable of dealing with the world, what we need to do, he claims, rather than turning our backs on perception is to go back to it: enlarging it! (110). "Distinct perception is merely cut, for the purposes of practical existence, out of a wider canvas" (113). He speaks about embracing a more complete perception, "removing its blinders," freeing it (115). Art has done this all the time, and philosophy, he claims, could do it "for everyone" in a process of revivifying experience away from its freezing in immobile schemas (118). It is not clear however how philosophy would activate this broader impact than art.

Bergson claims that art, rather than create, focuses on existing potential or virtual aspects of perception, which is why people connect to art, and associates the capacity to develop them to a detachment from practical life, since narrowing is linked to practicality (114). Again, does this imply an inevitable association of narrow perceptions to any kind of practical life? Does the actualization of liveable life always imply the narrowing down into measurable displacements? But isn't the con-

nection to art because of the irreducible indeterminacy in perception itself, of how art opens up the narrow perception to a broader field, as an unfolding itself of new capacities, an opening to the more-than given?

In the lessons on the *Histoire de l'idée de temps* (2016) from 1902–1903, Bergson points even more to proprioception when talking of *absolute movement* as indivisible movement experienced from within, which he opposes to *relative movement* as discrete or segmentable movement seen from outside. This is exemplified in the two ways of learning a language: entering its movement from within by speaking it in its native environment or putting it together through segments from grammar books.

Absolute movement is immanent, perceived in its indivisibility and simplicity, as opposed to composite movement, relative to an external segmentation. He comments correctly on why we tend to ignore this movement from within and perceive even our own movement as if from an outside (as relative movement) due to a pervasive tradition. Our internalization of perspective with regard to our own body is the very root of Cartesianism, I argue.

Bergson refers to the movement of language, of organic life, or of writing as absolute when it occurs from an inside and is related to an indivisibility, a unity of duration. Learning a language from outside, composing bits and pieces through grammar books will never render the immanent movement of language, which one can, however, enter and become part of, for instance if one goes to the country where the language is spoken, entering it like a current, becoming part of its field.

Even our plural personalities, which come to the foreground in the imagination of the poet, relate to a virtual memory of movements that might or could have been made but happened otherwise. He associates a truly creative imagination with the movement coming from within, reaching into a virtuality of experience.[20]

Bergson reverses many aspects of the wrong philosophical tradition, though not all. Although he points to several kinds of movement (of fluids or atoms) as ways of thinking a *mechanics of transformation*, he doesn't elaborate a new model for it. He hints at proprioception, which would have dissolved the mind–body dualism, but doesn't consider it fully, which is striking considering that some of his texts were written well after Charles Scott Sherrington's treatise of 1906. And most importantly, he acknowledges the reductive account of movement as somewhat unavoidable, as linked to practical life, to the functioning of the intellect, and to matter, all of which are linked to "necessity." A mechanics of transformation is an impossible "dream," he claims. I will take distance from some of these limitations, since neither matter nor the intellect nor practical life are ultimately determined in such a way. This unavoidability of displacement as actualization in an extension has burdened later attempts to rethink movement.

In *Matter and Memory* (Bergson 2008), there is a problematic account of perception when he assumes a difference between external bodies and one's own body. Proprioception binds them both! Images are an avoidable reduction of the much richer and diffuse field of proprioceptive memory–perception, which is always already action.

20 Rather than speaking of a virtual memory of the movements that could have been done but were not done, as a source of creative memory from within, I consider the plurality and inventiveness within our movement as intrinsic to its swarming power, its ontological indeterminacy and to the infinite folds of its "material–kinetic" memories, the openness of material memories, in the entanglement of muscular torsions, neural synapses and affordances of the world.

I question that there is on the one hand a plane of pure practical experience in extension and on the other a plane of pure ideality (that is, the freedom plane that prepares our capacity for action, thus the real, implying our futurity), and that our concrete experience is always somewhere in between those two "extreme planes." On this assumption is based the origin of the distinction between the virtual (ideal, abstract, incorporeal, mind-related, memory) and the actual (bodily motor action and matter), our realities consisting of a complex hybrid, a multiplicity of "planes of consciousness" in between the two poles. Action emerges from the pure past (memory), which is the reservoir of potential or virtual that will act "inserting itself into a present sensation from which it borrows the vitality" (240).

Bergson's solution is, however, remarkable: the plane of pure virtual memory–remembrance, of the mind and the inextensive, of the qualitative and of freedom, connects to the plane of pure actual action, of matter and body, of quantity (movement), linked to extension and necessity. It does so through a thousand different planes of consciousness, in an "extensive," concrete perception–action, *in rhythmic tensions, through movement,* thanks to the increasing differentiation in sensorimotor capacities that allows for the traversal of the meshes of necessity expressing internal indeterminacy (freedom) as it relates to multiplicities of movements of matter, with a richer spectrum of possible decisions, where duration and *élan vital* are movements of differentiation (as indetermination) of a creative evolution in movement across matter and memory (240–49).

Nevertheless, he appears to run into a contradiction in that the intellect is on the one hand the countermovement of matter, the one that brings indetermination, and on the other is defined in its very nature by practical necessity resulting in unavoidable decompositions of movement, for which another mode of thought, intuition, must be called into action. My proposal is indeed to reverse this idea by saying that decomposition is a dominant historical tradition that needs to be overcome, and just like philosophy arguably established this tradition it should also *take responsibility for overcoming it.*

The role of philosophy is thus even higher than Bergson suggests, in that by inserting itself in radical becoming it has to give account not just of how the current state of affairs came to be, but of exceeding the narrow tendency to reduction. Bringing more indetermination in action-thinking implies looking into the broader spectrum of BI (Body Intelligence) and into the life-fostering powers of diverse "practical" ecologies past, existing and to come.

7.6.3 Excursus on Chance and Necessity as Wrong Dichotomy, from Democritus to Monod

Since Plato, the motif of a rational and irrational soul of the world, both of them implying motion but of different kinds (orderly and disorderly), has persisted across Descartes and even Bergson, where matter still follows the entropic movement of "necessity," as determination built into entropic decay, where determination appears strangely associated to chance and randomness, whereas life, freedom, and indetermination are associated to negentropy, mind, and memory.

In thermodynamics, necessity appears allied with chance as the disorderly entropic tendency of universe. Jacques-Lucian Monod (1971) and Madeleine Barthélemy-Madaule (1972) also consider chance as the rule that gets integrated into necessity, as mutations are integrated into sustained living organisms, a rule of

chance which underlies all novelty in the biosphere. But mutations have been too persistently considered an error in the copy. How can one assign a passive entropic role of "error" to such an important mechanism as the one bringing forth all of life? It needs to be claimed as an active creative principle! We get close to this in some of the pre-Socratics.

For Democritus, necessity and chance were considered to go together or even to be (aspects of) the same, which has been misunderstood as determinism: necessity was the fact of collisions between atoms, of the eternal movement, and their impenetrability, but chance was the unavoidable openness in how those collisions would happen. Spontaneity was linked to necessity, in how, for example, vortexes would appear, including in the formation of the cosmos. Vortexes spontaneously but necessarily appear. Necessity is thus linked to freedom, the same freedom that is expressed in Lucretius's *clinamen* as an equally necessary or unavoidable principle of variation or deviation, which Democritus didn't need because the Aristotelian doctrine of displacement as overarching trope for movement had not been established yet. The *clinamen* was implicit in Democritus's and Leucippus's account of chance-as-necessity. Chance is necessity because there cannot not be openness in the world, due to the unavoidable movements and variations of matter. There are multiple unavoidable affections between atoms but there is no teleology, other than openness and variation.

It is Aristotle who inverts this equation by equating necessity to teleology and chance to spontaneity and to the lack of teleology. Recently, we had this Aristotelian inversion inverted again by Nietzsche for whom chance is affirmed as destiny, a tragic–Dionysian affirmation of all that appears, both in pleasure and in suffering, linked to the doctrine of eternal return.

I, instead, don't believe in chance!... only in openness or indeterminacy as variation! Because openness is not randomness, it is minimal ongoing variation, *clinamen* or *clinaos*, a core openness of the world, which returns in current physics via quantum fluctuations.

7.6.4 Rethinking Experience: Proprioception, and Rhythm

7.6.4.1 James's Pure Experience

James is a precursor to some of the ideas underlying this book, including the radically embodied cognitive approaches and their attack on representationalism. He also appears to have had reciprocal inspiration in relation to Bergson. His insight is important in that it proposes that experience is not a mere flow of data that needs to be interpreted, but is itself qualitative, already full of meaning, creating relations, thus emerging with its own interpretations (but not in the sense of rational interpretation), therefore questioning its necessary redoubling in a representationalist reflection.

Some core ideas are summarized in the *Essays in Radical Empiricism* (2003), in "The Thing and Its Relations," depicting both a possible evolution and an ongoing functioning of the relation between a pure experience and one mediated by the "intellect," along Bergsonian lines:

> Experience in its immediacy seems perfectly fluent. The active sense of living which we all enjoy, before reflection shatters our instinctive world for us, is self-luminous and suggests no paradoxes. [...] When the reflective intellect gets at

work, however, it discovers incomprehensibilities in the flowing process. Distinguishing its elements and parts, it gives them separate names, and *what it thus disjoints it cannot easily put together.* [...] "Pure experience" is the name which I gave to the immediate flux of life which furnishes the material to our later reflection with its conceptual categories. Only new-born babes, or men in semi-coma from sleep, drugs, illnesses, or blows, may be assumed to have an experience pure in the literal sense of *a "that" which is not yet any definite "what," tho' ready to be all sorts of whats; full both of oneness and of manyness,* but in respects that don't appear; *changing throughout, yet so confusedly that its phases interpenetrate and no points, either of distinction or of identity, can be caught.* Pure experience in this state is but another name for feeling or sensation. But the flux of it no sooner comes than it tends to fill itself with emphases, and these *salient parts become identified and fixed and abstracted*; so that experience now flows as if shot through with adjectives and nouns and prepositions and conjunctions. Its *purity is only a relative term, meaning the proportional amount of unverbalized sensation which it still embodies.* (James 2003, 48–49, emphases mine)

He speaks about how salient parts of experience become identified, while the larger field of unidentified flow keeps moving in the background, so that only in some states (new-born, under the influence of drugs, etc.) one exceeds the verbalized chunking of flow, again assigning it a certain inevitability, as Bergson does.

If now we ask *why we must thus translate experience from a more concrete or pure into a more intellectualized form*, filling it with ever more abounding conceptual distinctions, rationalism and naturalism give different replies. The rationalistic answer is that the theoretic life is absolute and its interests imperative; that to understand is simply the duty of man; and that who questions this need not be argued with, for by the fact of arguing he gives away his case. The naturalist answer is that the environment kills as well as sustains us, and that the tendency of raw experience to extinguish the experiment himself is lessened just in the degree in which the elements in it that have a *practical bearing* upon life are analysed out of the continuum and verbally fixed and coupled together, so that we may know what is in the wind for us and get ready to react in time. Had pure experience, the naturalist says, *been always perfectly healthy, there would never have arisen the necessity of isolating or verbalizing any of its terms.* We should just have experienced inarticulately and unintellectually enjoyed. This leaning on "reaction" in the naturalist account implies that, whenever we intellectualize a relatively pure experience, we ought to do so for the sake of redescending to the purer or more concrete level again; and that *if an intellect stays aloft among its abstract terms and generalized relations, and does not reinsert itself with its conclusions into some particular point of the immediate stream of life, it fails to finish out its function and leaves its normal race unrun.* (James 2003, 50, emphases mine)

So, like in Bergson, chunking is linked to practical life, though his example is not very convincing: don't birds know what is "in the wind" without chunking? Doesn't sensory experience provide endless modes of embodied knowledge, which can in fact be richer, more complex than rationalization, for orienting oneself in the world? Doesn't the body have its prodigious intelligence for "knowing" the movements around it? James further associates this need to a sort of problem-solving, that

would not be there if we were always "healthy" and enjoying life. This is interesting, especially in considering what has challenged health: maybe our own reductions? He then makes a promising shift by relegating the chunking to a secondary category, so that if an intellect stays in its world of abstractions without returning to the flow it will miss its point!

Again, one could ask whether the issues that need chunking are not universal practical needs, but specific problems posed by the system of chunking itself, just like one could ask *how some salient parts of experience come out rather than others, again not as natural expressions of a universal flow but because of how attention gets oriented in particular contexts and in different degrees.* This doesn't imply that the context comes first, but in reciprocal attunement following tendencies in movement. The degrees of chunking are evident in the different approaches that different languages have to naming things and actions for instance, and in the diverse uses of a same language, which is always composed of 93 percent of non-verbal activity.

In "The Experience of Activity," he expands on some Bergsonian themes, about the strands of present:

> The urgent problems of activity are thus more concrete. They are all problems of the true relation of longer-span to shorter-span activities. When, for example, a number of "ideas" (to use the name traditional in psychology) *grow confluent in a larger field of consciousness, do the smaller activities still co-exist* with the wider activities then experienced by the conscious subject? And, if so, do the wide activities accompany the narrow ones inertly, or do they exert control? Or do they perhaps utterly supplant and replace them and short-circuit their effects? Again, *when a mental activity-process and a brain-cell series of activities both terminate in the same muscular movement, does the mental process steer the neural processes or not?* Or, on the other hand, does it *independently short-circuit their effects?* Such are the questions that we must begin with. But so far am I from suggesting any definitive answer to such questions, that I hardly yet can put them clearly. They lead, however, into that region of panpsychic and ontologic speculation of which Professors Bergson and Strong have lately enlarged the literature in so able and interesting a way. (James 2003, 98–99, emphases mine)

These different spans of activity imply also different modes and depths across pure experience and chunked experience that resonate strongly with the thousand different planes of consciousness connecting actual and virtual in Bergson. James not only posits the idea that thought and activity have multiple ongoing strands, each with different, longer, and shorter spans, but also that they might be relating unequally to one another. Now, this sort of multiplicity of activity, it seems to me, can only be properly thought as a field, indeed, a swarming field capable of holding together dynamically a multiplicity of diverse movements that might or might not relate but compose the larger whole. He mentions with clarity a nexus between modes of thought and asks whether these activities steer muscular movement (proprioception) or not. The two modes are called "mental activity-process" and "brain-cell series of activities" (whose interaction was already called for in Descartes's interactionism). Now what does he call "activity-process"? In a footnote he relates this to a field of consciousness that seems to emerge with pure experience:

> As a matter of plain history the only "free will" I have ever thought of defending is the character of novelty in fresh activity-situations. If an activity-process is the form of a whole "field of consciousness," and if each field of consciousness is not only in its totality unique [...] but has its elements unique [...] then novelty is perpetually entering the world. (James 2003, 97)

He associates this openness of the field of consciousness to free will as proper not to the subject but to the activity, and to the capacity to reach out to a broader field of experience. This resonates with Lucretius in how the *clinamen*, and not voluntary choice or desire, is the deepest source of free will, also in terms of our bodily movements.

7.6.4.2 Sherrington's (Unnoticed) Revolution: The Proprioceptive Field

Although I already mentioned it in Book 2 on proprioception, I want to highlight also here the profound and unrecognized importance of Sherrington's study from 1906, *The Integrative Function of the Nervous System*, which, though not presenting itself as philosophical work, advances a deep ontological and epistemological revolution that seems to have passed unnoticed for over a century, and which I seek to build upon (a revolution perhaps deeper than the quantum or information revolutions, the biology or cognition revolutions, the industrial or AI revolutions: a BI r/evolution!).

Sherrington defines the nervous system as consisting of three highly complex fields: the interoceptive, the proprioceptive, and the exteroceptive. The proprioceptive field is defined as deep field, as microcosmos "in which forces which can act as stimuli are at work as in the macrocosm around" (1906, 114, 131, 317).[21] The

21 Sherrington (1906) outlines the intricate and complex ways in which perceptions and reflexes, afferences and efferences, operate in alliance and cooperation. He not only established the distinction between exteroceptive, interoceptive, and proprioceptive fields but outlined the intricacies of their alliances within and across fields. Through proprioception he defines the internal or endoreferential yet open dynamics of the organism as "a microcosm in which forces which can act as stimuli are at work as in the macrocosm around. [...] The receptors which lie in the depth of the organism are adapted for excitation consonantly with changes going on in the organism itself, particularly in its muscles and their accessory organs (tendons, joints, blood-vessels, etc). Since in this field the stimuli to the receptors are given by the organism itself, their field may be called the *proprio-ceptive field*. [...] The surface field [exteroceptive] lies freely open to the numberless vicissitudes of the environment. It has felt for countless ages the full stream of the varied agencies forever pouring upon it from the outside world. [...] The excitation of the receptors of the proprio-ceptive field in contradistinction from those of the exteroceptive is related only secondarily to the agencies of the environment." (130)

He further describes the "alliance of proprio-ceptive with extero-ceptive reflexes" as well as interoceptive. The realm of proprioception is thus in between intero- and extero-fields and is also the field of consistency that brings it all together in a sense of moving body, directly binding action and sensing, from within but not in closed manner (131).

Reflexes are never simple, but always in "Alliance or coalition [...] between (i) individual reflexes belonging to the same 'type-reflex,' (2) certain reflexes originated by receptors of different species but situate in the same region of surface, (3) certain reflexes belonging to proprioceptive organs secondarily excited by reflexes initiated at the body surface (the three fields of reception, exteroceptive, intero-ceptive, and proprio-ceptive), (4) certain reflexes initiated from widely separate but functionally interconnected body-regions" (114). The organism "is a microcosm in which forces are at work as in the macrocosm around. In its depths lie receptor-organs adapted consonantly with the changes going on in the microcosm itself, particularly in its muscles and their accessory apparatus (tendons, joints, walls of blood-vessels, and the like). The *deep field we have called proprio-ceptive*, because its stimuli are, properly speaking, events in the microcosm itself, and because that circumstance has important bearing upon the service of its receptors to the organism" (317).

proprioceptive field focuses on internal sensations but not only: it is secondarily integrating external inputs. And it operates mostly through decentralized neural paths, called reflex arcs, thus mostly through the cerebellum and in nonconscious spectrums, pointing to a swarming proprioception, and as integrative of all sensing modalities into movement, simultaneously activated and felt.

This is just part of an even broader vision of the integrative function of the nervous system, which operates always by modalities across fields and within fields, integrating them in the body's capacity to move, while also integrating independent neural paths with more centralized coordination. Gibson's later ideas of an ecological sense of perception and of proprioception as implying multiple senses were already implicit in Sherrington's field theory of proprioception, exteroception, and interoception.

This conception of the body as metafield, each subfield of which is a microcosmos with its own endless fluctuations, but also continually open to the endless vicissitudes of the environment, un/folding over eons of evolution, and its implication for conceptions of cognition or the self, was perhaps too radical to be noticed, even in view of today's assumptions of science and common sense. It challenges the holy conception of a unitary rational self, but I have shown how it can actually enrich it.

7.6.4.3 Boccioni's Pure Plastic Rhythm

Around the time of Sherrington's study, Umberto Boccioni, with influence both from Bergson and from Engels's dialectical materialism, as well as quantum mechanics and the idea of light as quanta, attempts an art of movement in painting and sculpture that doesn't represent but creates movement fields. Mainly a painter and sculptor, his numerous writings have philosophical and ontological implications.

For Boccioni there is only movement, a universal dynamism of matter itself, and of light as part of a material–energetic dynamism. There is no rest, only movement, and light is a material dynamism, light is physical quanta of matter–energy and matter–movement. He distinguishes the absolute movement of the object (movement of form) from the relative movement of the object in relation to its environment (form in movement) and tries to bring both into a whole so that space is moving and not split from the object, both merge in a single field of forces, between weight and expansion, rotation, and revolution, in spiraling movements for a spiraling architecture.

His paintings or sculptures are fields of *pure plastic rhythm,* where object and space merge, both in movement, twisting like in cubism but avoiding the angular and rectilinear aspect of cubism, taking instead a spiraling and curvilinear twist, at times also more seemingly abstract (but kinetically concrete) in their bringing together multiple temporalities but also the merging with space into a singular field of copresence of timespans and spatiotemporalities, of sensation and memory: field paintings. Movement itself is created in twisting, deformations, spiralings, mergings across temporal spans, constructing the action of bodies without stopping it, not a trajectory but its durational continuity in space and with space, placing the spectator in the middle of a field where multiple planes merge in simultaneity.

Proprioceptive arcs, and more generally reflex arcs are decentralized networks in the nervous system. Reflex arcs are decentralized neural paths, which had been recognized before Sherrington, but he demonstrated their integrated activation including reciprocal muscle innervation (Sherrington's Law).

Pure plastic rhythm as opposed to pure form means action of bodies as opposed to the body, echoing Engels's idea that the body cannot be conceived other than by its movements. This also implies a simultaneity, a multiplicity holding together. Centrifugal movement of dynamic form, interpenetration of planes and fusion of object and environment, in and through the fusion of movement into a duration made of multiple internal spans, tensional zones, and spiralings.[22]

Boccioni proposes a multiple law of simultaneity of absolute and relative movement; centrifugal and centripetal forces' object, medium, and atmosphere; color, form, and light; and planes of inside, outside, sensation, and memory. He tries to create a new synthesis that exceeds the formal synthesis of cubism and the light-color synthesis of impressionism into a new kind of artwork of pure dynamism where all elements coexist and are taken onto a new level with its own internal laws of dynamism, creating a movement rather than representing it, contributing to Universal Dynamism.

7.6.4.4 Dalcroze's Rhythmic Field of Proprioceptions

Also, around that period in the early 20th century, Eugène Dalcroze developed a complex approach to musical rhythm as crucially involving proprioception. Though he doesn't use the term, he constantly refers to the muscular sense or to muscular movement as even more primordial than hearing in music and develops numerous educational practices to develop rhythm through whole body movement and proprioceptive awareness, improvisation practices that while focusing on learning rhythmic orders and patterns emphasize the importance of spontaneous movements. This is embodied in his art of *eurythmics*,[23] where rhythm is always implying movement, indeed movement of a whole body and its muscular sense, there is no rhythm without it.

Perception of degrees of muscular tension, variations in duration, amplitude in space, resistance and conflicting muscles, dissociation of movements, counterpoints, and contradictory dynamics within a same body, polyrhythms cultivated through automatisms going together with "mind" directed movements or conflicting nuances of muscular innervation in different limbs: these are some of the elements of his art and his education theory that can involve also proprioception-based improvisations on the keyboard or extensions to dance or drama. For Dalcroze rhythm was the universal force of life, both in nature or expressing human character, always in and out of time, never just order and measure, always in the form of polyrhythmic (a)synchronous multiplicities taking expression in the body and its muscular sense (Dalcroze 1921, 110).

22 See Conde (1996) for a detailed study of the influences of movement philosophies in Boccioni, and his conceptions of dynamism.
23 Plato was the first in proposing the art of eurythmics as part of his ideal city, in the *Laws*. Rudolf Steiner also developed his own account of eurythmics as an art of movement related to his anthroposophy, an art of movements expressing speech. Lefebvre, in turn, defined eurythmy as the association between different rhythms.

7.6.5 Rethinking Experience (2): Phenomenology, Merleau-Ponty, Ontokinetics, and Interweavings Beyond Lines

7.6.5.1 Note on Phenomenology (from Husserl to Sheets-Johnstone)

I won't be dealing with phenomenology in depth due to my taking radical distance from the idea of consciousness. In what follows I will look at how Maurice Merleau-Ponty gestured beyond this idea in promising ways precisely through movement. Later I will mention some phenomenological diffractions in Derrida and more briefly Heidegger (via Sloterdijk).

Let me briefly mention here some aspects of movement and indeterminacy in Husserl. There is on the one hand the notion of anexact-but-rigorous geometries that has been quoted by many since Deleuze and Guattari picked it up in a *Thousand Plateaus* (Deleuze and Guattari 1987, 367, 555) and Derrida's important commentary (Derrida 1989, 122–23) and with variations of the theme in the work of Michel Serres and Gaston Bachelard. This idea is crucially linked to the birth of exact geometries from other, rigorous but anexact protogeometrical perceptions, where the anexact doesn't appear as inconsistent but as related to another consistent mode of knowledge.

The question of indeterminacy seems to be core to Edmund Husserl and worthy of dealing with it deeper than I will do here. In "Phenomenology of Movement" Caterina di Fazio (2015) does a cross-reading of Husserl and Merleau-Ponty, outlining how for Husserl perception of others was understood as a "coupling phenomenon" and the crucial role of movement in perception:

> In *Ideen II*, in fact, movement was already understood as the medium through which we can access the vision of totality, a totality in succession. If the body is my point of view on the world, the "zero-point of orientation," and if a simultaneous view of all sides of the object is not possible, it is also true that from this *here* I move into space, I turn around, I move forward and backwards, I push myself out into the surrounding space and I create a space. The creation of the space is possible only starting from the distance between me and the world; within this distance, within this depth, the space unfolds itself as the possibility for my body to move and have a world. (di Fazio 2015, 162)

She continues by quoting from *Ideen I* on indeterminacy:

> Through movement, the subject makes the world appear by making himself visible to others and the world. But the world does not end here. "It extends without limit," it is "crossed" and "surrounded" by "horizons of indeterminacy." The "rays of the look" widen "*in infinitum*" the circle of the present, drawing beyond its borders the wider circumference of the possible. Movement has therefore to be understood as an infinite possibility of expansion, because if it is true that the perception must remain incomplete, it is equally true that the incompleteness requires expansion. The infinite, the indeterminate, writes Husserl, "is necessarily present." (di Fazio 2015, 163)

In the next section we will see how Merleau-Ponty crucially builds upon these Husserlian premises.

…

In her book *The Primacy of Movement*, Maxine Sheets-Johnstone (2011) gives a further twist to phenomenology and more radically proposes to reverse the dominant traditions that neglect movement. She does so with an Aristotelian and Husserlian-phenomenological background, and a structural approach that still claims consciousness as an important term. But she significantly asserts the core role of proprioception and kinaesthesia in this move, at times hinting toward (without elaborating upon) a field theory of movement.

She very correctly points out how proprioception is ignored both by philosophers (for instance in the typical recourse to perception of color as model) and scientists and proposes her own distinction between kinaesthesia — as a more strictly muscular sense — and proprioception — as involving other senses that provide a sense of body and movement.

She also significantly elaborates on the evolutionary primacy of proprioception, evolving from bacteria or invertebrates to us, even proposing the idea of a *proto-proprioception* (Sheets-Johnstone 2011, 90), as well as the fundamental role of proprioception in phylogenetic and cognitive developments, and its being foundational to (the emergence of) speech and to learning, knowledge, thought, and affects. She proposes, building amongst others upon biologist M.S. Laverack (1976), the idea that proprioceptors evolved from the exterior to the interior of the body, and thus from a tactile to a truly proprioceptive "corporeal consciousness."

7.6.5.2 Merleau-Ponty's Intentional Arc
From a phenomenological perspective, Merleau-Ponty provides important and visionary cues that gesture toward reconceptualizations of movement and the body as field and proprioceptive swarm (though again not accomplishing an explicit engagement with proprioception and still holding partly onto a central role of consciousness).

With movement as relation and as modulation of an environment, and the attack on mechanism, he builds upon Bergson. Merleau-Ponty posits the body as third term to the structure–background scheme, never an object. It is the true movement without moving object (proprioception!). We are a body as power to move, to renew a certain scheme which is dynamic. The parts of the body envelop one another, relate to one another in original ways, assuming spacetime actively. Movement as originary intentionality is open: the intentional arc is a mobile vector, a capacity for reorientation in the process of creating oneself a world. This arc is not only a kind of horizon, but a tensional field that loosens its tension in certain pathologies, thus the metaphor of the arc has Heraclitean resonances. "It is this intentional arc which brings about the unity of the senses, of intelligence, of sensibility and motility. And it is this which 'goes limp' in illness." It "projects round about us our past, our future, our human setting, our physical, ideological and moral situation" (Merleau-Ponty 1962, 157). It gathers the implicit "melody," the irreducible quality, a certain style of movement in each body. Intentions move outward from a "primordial field" (282), they are both a tending out and a relation, characterized not by lack but by surplus and excess, saturation (Steinbock 1999, 178). In all these instances he is pointing precisely to a proprioceptive field.

The *phenomenal field* is not an inner world, it involves a direct experience. The *phenomenal body* is the *power of a world in the making*. This process is a sort of synthesis in a Kantian sense, yet as dynamic anchoring oneself, *grabbing or prehending oneself and the world, with different degrees of amplitude* within indeterminate horizons.

The existential analysis Merleau-Ponty proposes as alternative to the objectivist and intellectualist approaches, implies a situation where the body cannot be sensed from any position external to it, rather it is the primary active sensing field, thus proprioceptive.

Movement is the primary source of meaning without representations. We don't have a body but are a body. There is a certain distinction between the body and its environment, even though that distinction is not a crystal clear. This kind of conceptualization has later grounded a distinction between body image and body schema in embodied cognitive approaches. As in the case of the organ player who readapts every time to a new organ, the body, and its extensions and anchorings are dynamic schemes capable of transposition, as capacities of movement differentiation of a dynamic body schema which is an expressive field, a site of passage of expressions, of intensities, where the body is the primary expressive space within a law of variation, of modulation of existence.[24] The body is like a work of art, a capacity to renew and enrich its schema, where habit (and thus memory) is neither knowledge nor automatism but modulation of movement. Habit is thus also a capacity for opening up and the relativity of movement is the power to change domain.[25]

Merleau-Ponty differentiates concrete or actual from abstract or virtual movement, where the latter is a certain capacity to detach certain schemas from their context and allow them transpositions regardless of context. Yet in his critique of Bergson, one sees a certain wish to safeguard consciousness as a privileged term. In the long footnote in the section on movement on the third part he summarizes his critique: "The Kantian idea of synthesis is valid against Bergson's realism, and consciousness as the agent of this synthesis cannot be confused with any thing, even a fluid one" (Merleau-Ponty 1962, 322, translation modified). He criticizes the dissolution of terms happening in Bergson's duration and opposes the idea of blending phases of movement and experience as if this would entail a complete erasure of multiplicity, an absolute indifferentiation. And yet this consciousness is one that happens "gathering itself in the same act by which it carries itself away" (322), so he also criticizes the Kantian and Husserlian idea of a pregiven multiplicity on which consciousness imposes top down a unity. "I never have a consciousness [...] of composing the movement that I live thorough" (322). And yet position, though relativized, seems still to be unavoidable or essential (as in Bergson): "It seems to me that the moving something itself changes positions and accomplishes the passage from one instant or position to another" (322). So, he opts for an in-between Bergson and Kant: "For this relative and pre-personal I who grounds the phenomenon of movement, and in general the phenomenon of the real, clearly needs to be clarified. Let us conclude for the moment that, against the notion of synthesis, we prefer the notion of a *synopsis* that does not yet indicate an explicit positing of diversity" (322). His critique of Bergson can be seen as addressing the unsolved problem of how consistency comes up in duration.

In the later writings, *The Visible and the Invisible*, there is a further move toward the idea of field, the world as field, perception as field, a recognition (through Alfred

24 One can consider how this differs from a Spinozan account, where the body is perhaps not a mere site of passage, but *it is* its relations of speed, its movements, and these are its intensities and affects.
25 For these references see the following sections of *Phenomenology of Perception* (1962): sections on kinaesthetic sensations (page 96) Body Schema, concrete movement, and abstract movement (pages 96-109), on the intentional arc (137), "the synthesis of one's own body" (149), and the section on movement in the third part (279).

North Whitehead) that some of his assumptions about consciousness were perhaps wrong, proposing the trope of the *chiasm* as interweaving (lines) for thinking the in-between subject and world. Flesh is the trope for this perceptual chiasm between body and world, which reciprocally enfold: the flesh, the visceral body, blood, breathing, which belongs as much to the world as to me, that moves autonomously and anonymously. The flesh as chiasm between self and other, is intercorporeality and enfolding, like the foetus in the womb. Chiasm of visible and invisible of the body ecstatically reaching outward and also receding to the viscera (Leder, quoted in Welton 1999, 208). The chiasm is present everywhere: it is chaos, the interval, *différance*, that gapes wide open between the poles of the dualism telling us that the only real thing is the interval itself, an interval not between things but between movements, the endless intervals of fluctuation un/folding.

7.6.5.3 Ontokinetics in Heidegger: The Existential Movements of Experience

In *Being and Time*, Heidegger proposes mobility as the deepest ontological constituent of his central concept of *Dasein* (being-there), defined by a multiple movement of fall or plunge, thrownness, vorticity, turning away and towards, and flight. In Heidegger's own words: "We call the moving nature of *Dasein* in its own being the fall [*Absturz*]. *Dasein* falls from itself in itself in the groundlessness and nothingness of the non-actual ordinariness. [...] The downfall [*Verfallen*] is an ontological movement concept" (1967, 178–80).

The double movement of fall and thrownness comes in the middle of *Being and Time* as the final stage and culmination of the definition of the nature of *Dasein*, which is constituted at first through attunement, understanding, and speech, and more concretely through idle talk, curiosity, and ambiguity. But all these result in the movement of fall, or downfall, or "falling prey" (*Verfallen*), which is also called "plunge" (*Absturz*), and which implies a thrownness (*Geworfenheit*) as being always already thrown in the middle of worldly relations, in between a movement of gathering oneself and opening up, that result in a a movement of a vortex (*Wirbel*).

The movement of the fall is described as having a fourfold charachter: it is at the same time tempting, calming, alienating, and catching or self-entangling, hence it is where the self, as being in the world, is moving in an in-between of self-prehending and opening up. (Heidegger 1967, 177–78). Heidegger thus proposes in 1927 an ambivalent nature of *Dasein* where the relational becoming with the world is a process in which one is never identical to oneself, thus advancing issues that Simondon or Derrida amongst others build upon (and later Brian Massumi or Hartmut Rosa, but featuring also in entropy as internal change), in terms of the noncoincidence and openness of a self with itself as metaontological ground of being and becoming and as essentially ambiguous. This noncoincidence with oneself is conceived as vortex, that is, a consistent confluence of disparate tendencies of turning (*kehren*) away from itself and toward others resulting in a noncoincident coming back to oneself (184–86), which is also already a spatial and worldly conception of the self, which is always incomplete and in process, whereby this incompleteness and noncoincidence is not considered negative, but the very condition of possibility of being in the world, of becoming with the world.

The fall thus always implies a deviation or turning away (*Abkehr*) of *Dasein* from itself, associated to openness and encounter, which can be at times a flight, while it implies also the turning toward (*Hinkehr, Ankehr*) of the encounter. In this multiplic-

ity of turns within the fall, the vortex of *Dasein* appears as a complex movement of relational entanglement with the world.

Sloterdijk (2001) calls this ontological prevalence of movement in Heidegger "ontokinetics." According to Sloterdijk, movement is the foundation of Heidegger's ontology (2001, 29), where "to be human is to be opened and moved in a certain way" (Morin 2012, 85), and he mentions as only possible precursor the Neoplatonist Proclus's logokinetics. Sloterdijk identifies four different movements: *Absturz* (fall), *Erfahrung* (experience), *Umwendung* (turning around), and *Verwindung* (torsion). Falling, as we already saw, is the vertical movement by which on finds oneself being-there in the world, an *a priori* and ongoing "thrownness." "*Dasein* means to be held in the assault of movement." (Solterdijk 2001, 31)

Erfahrung (experience) is more of a horizontal movement of relating (*zusammen-hängen*) to the surrounding world, a webbing and spacing. This is a middle term highlighted by Sloterdijk that prepares the ground for the third motion, not being explicitly linked to the other motions in Heidegger's work (as it was instead in his contemporary Ernst Bloch, defined by Sloterdijk as another ontologist of motion). Following Sloterdijk, experience is a foamy webbing–spacing, where movedness is a give and take that gathers. This is mainly a horizontal movement of expansion in or of the plane, where "lateral movement is not mere dispersion [as it is for Heidegger] but displays its own gathering force by building series, networks, proximities, passages routes" (Morin 2012, 87), thus exposing the spatial–kinetic character of being, related to the quest for an emergent foam-like social space.

Following Sloterdijk, *Umwendung* (turning around), implies both self-prehension (or pulling oneself together) and revolution, a reversion of a life's trajectory, exemplified by Plato's allegory of the cave, where people turn around and exit into the world of "truth," away from the global unreal simulation. The self is then linked to this internal turn, as ontological difference within. Lastly, *Verwindung* (torsion) is a fourth type that Heidegger sketched in later writings, as an overcoming of the turn into a more complex kinetic intelligence.

Overall these elements compose a powerful set of tropes for a movement and field ontokinetics, which has resonances with my concepts for RMP and expose a hidden genealogy that influences some of the philosophers we will encouter in our story.

7.6.5.4 Almost Moving Beyond Lines

The line haunts movement. The limit (cut, border, which is also a line) has been a major recurrence in our ontology since the Pythagoreans. We already said it: setting a limit to movement summarizes the history of Western metaphysics. Form and number as result from this limit, as fixity or stasis, are another, resulting into a point, the point in the line, the line in the surface, and so onto all geometrical objects. The point emerges from the number, and the line–surface is its spacing, unfolding, dimensioning, composing all reality.

But *movement as line* is perhaps the most recurrent reduction echoing even in Deleuze and Guattari, who struggle to go beyond. Even the *clinamen*, and the vortex as *clinamen*, as spiraling line, implicit in ancient spiral designs, express this reduction. Let's briefly look at some authors that almost think beyond the line from phenomenological schemas.

Tim Ingold proposes to rethink the relations to our environment by contrasting tendencies to map and occupy, defining locations, with forms of *dwelling* as entailing a movement that

is not between locations in space but between places in a network of coming and going that I call a region. To know one's whereabouts is thus to be able to connect one's latest movements to narratives of journeys previously made, by oneself and others. In wayfinding, people do not traverse the surface of a world whose layout is fixed in advance — as represented on the cartographic map. Rather, they "feel their way" *through* a world that is itself in motion, continually coming into being through the combined action of human and nonhuman agencies. (Ingold 2000, 155)

He proposes a sense of conviviality and dwelling linked to the growth of embodied skills of perception and action. And yet his focus is on a potential rebalancing of vision with hearing, not even touch and even less proprioception, as ground for an anthropological research and an ethico-political project.

Ingold's work on lines (as movement) distinguishes between *meshworks without surface*, where filaments create emergent interlacings (as in Deleuze and Guattari's concept of the rhizome, or in a cell's cytoskeleton), and *networks of traces* as lines related to surfaces. But these in turn have complex evolutions, first as notations and then into writing, but also as drawing, as calligraphy (an art of movement), or as genealogical lines. Part of this nonlinear history of lines is the becoming straight of lines, including its historical sexual connotation, related to straight posture and domination, a history where geometry has a crucial part (Ingold 2007).

Samuel B. Mallin (1996) also proposes a thinking of emergent and swirling interlacings of lines through Merleau-Ponty's concept of chiasm and through prehistoric and Minoan cultures on the one hand and contemporary expressions on the other (Richard Serra's sculpture and Pina Bausch's dance-theater).

Another promising *move almost beyond lines* is in Sarah Ahmed's *Queer Phenomenology* (2006), where she relates the straight line to a straight sexuality (sexual orientation) and a colonialist tradition (the definition of an "other" as in Edward Said's *Orientalism*). She proposes a politics of disorientation for sustaining "wonder about the very forms of social gathering." She problematises the ambiguous relationship between "'following a line' and the conditions for the emergence of lines. [...] Which comes first?" and gives the example of the path (2006, 16). Lines that direct us are both lines of thought and motion, and straightness is about aligning oneself with existing lines that orient us. But through performativity one can give a sort of phenomenological account of how the alignments come up by reiterating movements.

Lines, I would add, are always alignments, tendencies to align, and emerge along several moves: by narrowing down movement to blurry paths, and by narrowing the path to a geometric line (as in a highway). Queer after all comes from *torquere*, to twist, wind, bend, whirl, distort... or disalign, deviate. So "queer is not available as a line" (179), it more about "asking what our orientation toward queer *moments of deviation will be*." So queer is a counter-tendency in movement, a differential, an antireductive move, a *clinamen*.[26]

26 This take on queer could have been and could still become enormously fruitful. Unfortunately, movement broadly has been of little concern and queer theory and politics has had a focus on linguistic practices (which are just a spectrum within movement) taking these to the limit of cannibalising the body with the mantra "the body is a text" thereby erasing its far broader spectrum of movement and their political potential.

7.6.6 The (Arche-)Somatic R/Evolution: Thomas Hanna and Somatics Practitioners

Thomas Hanna is a philosopher and movement theorist who coined the word *somatics* and developed theories of somatic education since around 1970 in relation to a set of practices being developed by numerous practitioners. Hanna's somatics is important in this genealogy. Somatics defines the *soma* in a certain opposition to body: as the body lived from inside, which is mainly *proprioceptive*, whereas the body is what gets seen and measured from an external viewpoint, building upon a certain phenomenological distinction between *Körper* and *Leib* but adding a more explicit proprioceptive dimension to the *soma* or *Leib*. Both aspects are seen as complementary (and of similar importance) but irreducible to each other, while the somatic side is the one correctly claimed as missing in established approaches in medicine and other areas. Hanna builds upon the work of many pioneering practitioners, many of whom he collaborated with, such as Moshe Feldenkreis or Jean Ayres, and creates his own genealogy of precursors of somatics in the sciences and in philosophy, where Nietzsche stands out with particular importance, as well as Merleau-Ponty. Hanna thus constitutes an important node, the third explicit proprioceptist in our genealogy after Sherrington and Dalcroze, bridging explicitly between philosophy and practice. The practitioners he builds upon or collaborated with are themselves often working in between arts and therapy or science and therapy.

The tradition of somatics arguably has roots in nineteenth-century physical culture and in the early twentieth century with pioneers of experiential learning and dance such as Rudolf Steiner, Mary Wigman, Rudolf Laban, Isadora Duncan, and Mabel Todd (who wrote the pioneering book *The Thinking Body*), but is mostly related, at least in Hanna's definition, to the work of Elsa Gindler, Gerda Alexander, Mathias Alexander, Ayres, Marian Chace, and especially Feldenkreis.

The practices that Hanna deals with have the peculiarity of having a deep focus on proprioception and multisensory integration, having a therapeutic approach that widens and reawakens sensorimotor capacities, undoing entrenched patterns both in movement and thought or emotions, involving a large spectrum of involuntary movements, which in the process become conscious and voluntary.

In *Bodies in Revolt* Hanna (1985) unfolds a theory of somatics as the totality of the living being in the indivisibility of mind and body, where the mental or emotional is shaped by the sensorimotor, and the sensorimotor is an expression of the mental or emotional, an open loop subject to transformation. The ethos of Hanna's somatics points to releasing the energies that the human has repressed over millennia of technological shaping of the environment and that, now that the environment has been shaped, he should be free to unleash in unprecedented ways, in a playfulness akin to a Nietzschean innocence of becoming. Somatic education aims at this *revolt of bodies* against millennia of sensorimotor amnesia and proprioceptive atrophy, implying the unleashing of a real mutation of the species, an *evolution–revolution* that is heralded in a mixture of technopositivist, hyperhumanistic naiveté that brings it close to transhumanism, while instead proposing an evolution based on movement, the senses, and the body. This is visionary and promising.

However, Hanna makes the strange assumption that we have completed, indeed successfully completed the "shaping" of the planetary environment, as if no environmental disaster were the case!... And as if now all human exploitation could finish!... These radical mistakes, however, don't invalidate some of his deeper claims for a somatic r/evolution which I propose to put at the service of exactly the opposite:

undoing the planetary disaster that humanistic "shaping of the Earth" has brought about, doing so through unprecedented sensorimotor variations. In a way I revert the causal scenario: I consider this disaster an effect of an initial atrophy emerging with bipedalism.

This has crucial implications for the practices, hence my taking distance from a "volitional" awareness and control, which I see so linked to humanistic exceptionalism and its narrow perceptions that actually make humans think that the planetary disaster, actually a mass extinction crisis, is some perfect "shaping" of the environment. Thus Hanna, though already writing in times of critical environmental voices in the US like Rachel Carson, commits the crucial mistake of presenting this somatic r/evolution at the service of the "human," an error I seek to undo! In this he was obviously misreading Nietzsche's crucial claim for "remaining faithful to the Earth" and his denunciation of crimes against the Earth as now being "the worst possible crime"!

In *The Body of Life*, Hanna (1993) further develops the important concept of the *archesoma*, which is deeply resonant in my conception of *archē*-proprioception in many respects. Hanna builds here upon the pioneering therapeutic work of Ayres, who

> began to see children as many-layered biological beings, whose "normalcy" is the composite coming together of ancient and primal functions that are not simply human, not simply simian, but extend through the quadrupedal functions of the higher vertebrates, down through the balancing functions of the fish, and back down to the primordial functions of the earliest somas. It is this same recognition of evolutionary functions that made possible the equally dramatic work with brain-damaged children. (Hanna 1993, 170)

Hanna outlines the intrinsic relation between sensorimotor activity and thoughts or emotions: "So-called mental abilities are bodily abilities, but because we have for so long deluded ourselves that there is a 'mind' that is different and separate from the 'body,' we have been incapable of seeing the obvious and ancient identity of the two" (171):

> The work of Jean Ayres informs us that the intellectual, "mental" attainments of "intelligence" are, at their core, the thatch work of a prior, nonverbal learning of movement in the three dimensions of space, all coordinated in the proper temporal sequence. Without this layer of nonverbal, spacetime learning there will be no intelligence. It is fascinating that our accomplishments in education and culture rest absolutely on a base of nonverbal, spatiotemporal abilities, which make these accomplishments possible. This primitive, somatic core of functions must be developed and integrated in order that the human being can learn how to learn. (173)

Hanna also became a fervent follower of Feldenkreis, whose functional integration approach seeks to undo the mind–body split and understand the way in which, by changing movement and perceptual patterns, deep transformations can happen that are beyond the reach of traditional medicine, where knowing someone else is a perceptual more than a cognitive process, relying on how much you know–feel yourself, your proprioception and multisensory integration, and your capacity to feel others through your movement. Entrenched emotional–mental patterns are somatic pat-

terns that can be transformed through sensorimotor practices which undo what he crucially calls *proprioceptive apathy* (188).

In the final chapter comes the definition of the *archesoma* and its relation to Functional Integration practices:

> The archesoma is a basic system of movements possessed in common by all species of creatures, undergirding their behaviour and determining the efficiency of their actions. [...] As we know from Jean Ayres, if the archesomatic functions are poorly developed, the perceptual and intellectual functions will also be poorly developed. What we call the mind emerges from the archesomatic core and is no more nor less efficient than this core is. Also, we know from Marian Chace that the mental and emotional life is so directly reflective of the archesomatic process that if we improve this process, the mental and emotional functions improve. [...] In adults whose proprioceptive senses have atrophied, the workings of the archesoma seem to be non-existent. There is a schism between the conscious functions and the archesomatic functions. [...] The goal of Functional Integration is to integrate the human being by integrating his sensorimotor functions." (194–98)

But at the end we see again a deeply humanistic, control-oriented will encompassing the entire proposal, as its ethos:

> There may be no creature other than the human being that can direct its awareness inwardly to its own bodily movements. Functional integration and all forms of somatic education use this human ability to enlarge and improve the degree of our somatic self-awareness. Like two knitting needles, the sensory system and motor system are made to intertwine, creating a greater sensory awareness of our internal activities and a greater activity of our internal sensory awareness. The gain is in active self-awareness, and the realm of somatic education has made it certain that human awareness must be recognized as a biological force that can be as potent for human growth as it can be for human degeneration. (198).

In "What Is Somatics?" Hanna (1995) gives a clear definition of the distinction between body and *soma*:

> Somatics is the field which studies the soma: namely the body as perceived from within by first-person perception. When a human being is observed from the outside — i.e., from a third-person viewpoint — the phenomenon of a human body is perceived. But, when this same human being is observed from the first-person viewpoint of his own proprioceptive senses, a categorically different phenomenon is perceived: the human soma. [...] The human is not merely a self-aware soma, passively observing itself (as well as observing its scientific observer), but it is doing something else simultaneously: it is acting upon itself; i.e., it is always engaged in the process of self-regulation [... and] is also simultaneously in the process of modifying itself before the observer's eyes. A fundamental finding of physiological psychology is that humans perceive a sensory impression only of that for which they already have an established motor response. If we cannot react to it, the sensory impression doesn't clearly register; it is shunted away from perception. This happens because in the perceptive process the sensorium never operates alone, but always in tandem with the motorium. (Hanna 1995, 341–43)

While the distinction is important it misses the way in which "external" perception, its association to a scientific and measurable objectivity, and its predominance, are far away from "natural," and are actually engineered by precisely the same tradition that has created a culturally dominant proprioceptive amnesia. Then, at stake is not just recognizing the difference but undoing the split by disaligning the modes of relation that impose a detached external vision!

Hanna further describes the soma as self-sensing, self-moving, and self-organizing, He describes sensorimotor amnesia as the "loss of voluntary conscious control of significant areas of the body musculature" ensuing form "constant repetition of stressful stimuli" and proposes the possibility to undo this amnesia through somatic learning by practicing a focus and awareness that reawakens the atrophied capacities, whereby "somatic learning is an activity expanding the range of volitional consciousness" or of "releasing the involuntary restrictions of sensory-motor amnesia." And gives a beautiful description of how this happens:

> If one focuses one's awareness on an unconscious, forgotten area of the soma, one can begin to perceive a minimal sensation that is just sufficient to direct a minimal movement, and this, in turn, gives new sensory feedback of that area which, again, gives a new clarity of movement, etc. This sensory feedback associates with adjacent sensory neurons, further clarifying the synergy that is possible with the associated motor neurons. This makes the next motor effort inclusive of a wider range of associated voluntary neurons, thus broadening and enhancing the motor action and, thereby, further enhancing the sensory feedback. (349–50)

Hanna summarizes both the deepest intrinsic problems of a humanistic tradition and a somatic approach that, with some tweaks, could actually undo that tradition. Although I have developed my practices and ideas coming from elsewhere one can see my approach as that tweak that turns somatics upside down, not as a humanistic volitional triumph of the human species, but as the overcoming of the human, mutating (as Hanna proposes) but in a completely different sense that involves a postrationalist, symbiotic evolution with the planet and all its life forms. For this, concepts of control, awareness, and functionality need to be deeply ontohacked, and plasticity, openness, and indeterminacy in perception and behavior cultivated instead.

I wonder what Hanna might have thought of the current evolution of climate change, all-encompassing digitization, and AI, with increasingly atrophied bodies and where somatics has perhaps lost part of its transformative intention and turned into a more palliative, if not escapist, practice, capitalized by the endless market niches of body practices, a turn which is perhaps linked to its intrinsically humanistic originary bias. But Hanna's proposal has highly inspiring aspects that need to be claimed and resituated, along with the many precursors of somatic practices such as Mabel Todd, and later practitioners, toward a transformative art of living and planetary regeneration.

7.6.7 Process and Transduction

7.6.7.1 Whitehead's Nexus
Though Alfred North Whitehead didn't address a rethinking of movement, and indeed movement appears to have a problematic status in his thinking, his process

philosophy has been influential for other philosophers who have dealt with movement more specifically.[27] His own concepts (such as "eternal object") have scaringly static names at times, and have laid foundations for what we could call "anti-movement" philosophies such as object-oriented ontology (OOO). It is striking that, being the major representative of process philosophy, he didn't dedicate any attention to a radical rethinking of movement itself. But his radically flat ontology of how perceptions, as proper to any process in the world, are both concrete, defined, and interrelated, this relation being also their openness, has provided rich variations on the theme of virtual–actual dynamics.

Prehensions are events of experience that outfold from the undifferentiated folds of the universe (the extensive continuum) as actual occasions of experience which connect to one another through the *nexus* of "eternal objects," which are the virtual qualities that color every occasion. Their affect-as-relation is that which returns, so every actual occasion infolds back into the virtual through the eternal object.

Prehensions and actual occasions are always part of complex assemblages, compositions, or fields. So, the universe is a sort of web of concrete but not discrete events, relating via a virtual plane of qualities which, like Deleuze's virtual, seem to be determined and eternal in a sort of weird winding to future past: once they emerge they will have always been and will be forever (Massumi 2017).

To me Whitehead poses the problem of considering the event as coming first, which from a radical movement perspective is problematic, unless one considers every movement in quantum fields as effectively quantized, so that even from subatomic levels everything emerges through tiny events of prehension between quanta. This quanta approach seems to underlie his ontology. But fluctuation is perhaps preceding quanta, its unfolding proposing a different sort of fielding. Especially problematic I find the idea of concreteness, the idea that qualities are defined at all. Taking proprioception as primordial matrix of multisensory integration in motion the main quality of qualities of experience is blurriness and change. Nevertheless, Whitehead's rich conceptual field is an important one and has been of great inspiration to some coming philosophers in our story.

[27] Nail (2024, 31) exposes Whitehead's as a discontinuous process philosophy where movement is secondary to stasis, where actual entities are devoid of indetermination (like Deleuze's virtual), a vision that has been very influential in fields like actor–network theory, speculative realism, new materialisms, and Object Oriented Ontology (OOO). Nail attacks the new materialisms abounding on this discontinuity, especially in OOO, and in the work of (anti-movement) philosophers like Graham Harman, while also challenging the vitalist currents of what he calls continuous process materialism, which, echoing Bergson, seeks recourse to some immaterial vital force, and also the dis/continuous process philosophy he identifies in Deleuze as reproducing mistakes (and strengths) of both continuous and discontinous currents. I partly agree with the critique while placing the emphasis elsewhere, as I expose in this volume. Differently, Erin Manning (2009) sets Whitehead to dance, reading him across Leibniz (through Deleuze) in considering prehensions (Whitehead's events of perception) as out-foldings from the extensive continuum (the undifferentiated folds of the universe) while eternal objects (the qualities of actual occasions) are foldings back into the continuum. This happens in a Leibnizean multiplying of folds to infinity, or of vortices within vortices, in concave intervals, elastic nodes of fluid curvature, forming an infinitely porous corpuscular society, a spongy world full with potential for relational deviation, through deviatory foldings enacting a futurity. This is also how the resonance and memory of an occasion creates a nexus across occasions. The eternal object is then the relation between occasions, affording the nexus between them by sharing qualities via infinite foldings that can create an associated milieu of resonance. But I suggest that prehensions are always already *of the field*, coming always in blurry swarms.

7.6.7.2 Simondon's Transduction

Gilbert Simondon's theory of individuation (2005[28]), not being itself a movement philosophy has provided rich inspiration for other philosophers of movement and provides a rich conceptual field for a field theory. However, like others, it expresses a tension between a dynamic thinking of processes and a need to continue to hold on to the concepts of being and form as partial but necessary terms. Simondon proposes a theory of individuation for all physical, biological, and psychic–social beings, in which a being, as associated to a form, individuates as a *phasing*, a process of ongoing tension–resolution between dephased, preindividual states, continually *unfolding in new dephasings*. Information is the ongoing process of resolution of tension between disparate states in which form emerges as being of the individual, whose becoming is individuation itself as never-ending process as it continues to shift and dephase, resolving the tensions in metastable equilibriums, so that becoming is a process going from metastable equilibrium to metastable equilibrium.

The core process of individuation is *transduction*,[29] as the "physical, biological, mental, social operation by which an activity propagates progressively within a domain, while progressively structuring the domain of propagation" (Simondon 2005, 31). Yet what is this domain of propagation, a pre-existing extension or another field with which transduction enters into relation? Transduction is ontogenesis, thus a fielding, an activity by which a field structures itself as it propagates. It is the "correlative appearance of dimensions and structures in a being in state of preindividual tension, one who is more than unity or identity, and who hasn't yet dephased with regard to itself in multiple dimensions [...]. Its dynamism comes from the primitive tension of the heterogeneous being that dephases and develops dimensions through which it structures itself" (32). Transduction thus corresponds to both ontogenesis and invention. Time is one of the dimensions unfolding in transduction and which doesn't pre-exist it, each transduction unfolds its own time.

Core to individuation is not form, but information as process of ongoing *resolution of tensions*, in a tendency to stabilize (into form), implying individuation as a (negentropic) tendency to preserve. It is the potential energy within form that structures matter against entropic tendencies to dissipation.

Simondon is replying to the limitations of the hylomorphic model of Aristotle, in ways that were already invoked by Duns Scotus's *Principle of Individuation*, while retaining from Aristotle the notion of the individual as the core of the theory that needs to be explained in more dynamic terms. In a sort of reverse move, potentiality is placed at the core of form as its surplus and dynamism, which may thus unfold in novel ways, while form remains a guiding principle or tendency, an undefined teleology or tendency. Barad's intra-action proposes a similar approach, as I discuss below.

28 All translations from Simondon (2005) are mine.
29 Transduction is also the name in biology for horizontal gene transfer between bacteria through the mediation of viruses and is one of the most important sources of genetic variation and diversity in evolution. Other uses of transduction include energy transduction (which implies always change), sensory transduction (for instance from mechanoreceptors to the nervous system, also called mechanotransduction in the case of proprioception), or signal transduction in the cell by which one stimulus is converted into a different one. Transduction thus usually implies a movement or transfer that effects a transformation, conversion, or transposition. Transduction implies a transformation deeper than translation (as in language) and certainly than displacement. It is a movement that implies a transformation in a larger whole and a transformation of the moving element. Perhaps every language translation and every displacement should be reconceptualized as transduction.

The primary mode of individuation is the internal resonance of a system or field. In physical beings it operates at the limit, having no interiority as such, as in the border of a crystal structure. Only in biological beings it constitutes a true interiority, which Umberto Maturana and Francisco Varela (1980) call *autopoiësis*, epitomized by the living cell. Internal resonance is also the most primitive mode of communication between realities of different order and consists in a double process of *amplification* and *condensation* (Simondon 2005, 33n).

Individuation corresponds to the appearance of phases in being, rendering the individual and its environment or milieu. Even though involving information as a process of tension resolution, it "preserves the tensions in the form of structures," its principle is "preserving being through becoming." This conservation exists through exchanges between structure and operation, proceeding "through quantum jumps across successive equilibriums" (25).

There is a preindividual being, which is in fact complete and concrete but has no unity, and cannot be described as neither substance nor matter nor form, but needs to be thought as "tense and oversaturated system" (25). There is also the individuated being, which has unity and identity, (or form), which is but a phase of being. In turn becoming (as individuation) is a dimension of being.

The dimensions or structurings unfold as dephasing, preserving the tension that is resolved in every new iteration of information. The individuated being that appears in a phase when a tension is momentarily resolved continues to become, in ongoing dephasing, as it proceeds in new individuations, unfolding further, due to its own ongoing relation to a field of preindividual potentiality that is constitutive part of the individual.

Metastability and potential energy (linked to negentropy) are necessary terms for understanding individuation. Individuation never exhausts preindividual potential so that the individual always bears with itself a "charge" of preindividual potential. This is important for understanding how a relation itself counts as a being, developing within a new individuation as an aspect of the internal resonance of a system of individuation, so that the individual becomes part of a larger individuation by mediation of its charge of preindividual reality, and across diverse degrees of magnitude. This also underlies the individuation of a collective or society, so that the psychosocial world of the transindividual implies its own process of individuation from a preindividual potentiality to which different individuations seem to reach back.

Relation is thus a dimension of individuation in which the individual participates through a preindividual reality that individuates stage by stage, from metastability to metastability. This echoes Whitehead's nexus as reaching back to an extensive continuum, in acts of prehension that un/fold in new relational qualities. Individuation cannot be known as such. On the contrary, knowledge itself is a process of individuation, it enacts itself as individuation.

One core idea that Simondon elaborates is an original account of emergence and creativity in any domain (physical, biological, psychosocial, or technical), happening not in relation to an existing plan and in a given space, but structuring both its own growth dynamics and its field in the same process, whether vortex or crystal, morphogenesis or invention, unfolding its own dimensions and temporalities, its own environment, and in different orders of magnitude.[30]

30 I suggest that transduction could by itself account for all relations between processes of growth, as fields transduct *across one another* and in different magnitudes, dimensions, and temporal spans. The

How to understand the dynamics of individuation and transduction in terms of movement? It exposes a wave dynamics, the underlying ontology being a quantum field composed of waves which phase and dephase, where potentiality is the capacity to dephase, and the phase is an effect of a negentropic tendency to stability. We also see the movements of condensation and amplification of internal resonance. Furthermore, dephasing in transduction implies unfolding of dimensions, temporality, and space.

The powerful trope of transduction appears to me to be in problematic tension with the idea that the underlying tendency is to stabilize: a negentropic tendency to preserve being through its becoming. Does this assume a double-sided universe of entropy and negentropy, where individuation expresses a negentropic tendency to stabilize and preserve being across entropic tendencies to change, resolving tensions in dynamic metastable equilibriums? Could there be transduction without individuation, if we substitute the idea of being, form, or phase by that of movement fields? Is nature striving for balance or is it expressing modes of fluctuation? I have sought to approach this through the concept of intra-duction in Book 3.

Individuation and information as its process entertain a strange relation to Heraclitus and Nietzsche: the world's unfolding not as sustained tensions and interplay of forces, but as resolution of tensions, as sort of microstasis or phasing in between an ongoing dephasing. It appears as if that tension is kept throughout, embedded in the emerging structures as source of new dephasings. Perhaps it is excessive order that blocks becoming and transduction. Excessive individuation is the problem!

7.6.8 Further Takes on Rhythm: Foucault, Lefebvre, and Beyond

Along different lines, but also with Nietzschean echoes, Michel Foucault has provided ways of thinking the alignments in movement through the study of behavioral rhythms of disciplinary society and its panopticon architectures as analyzed in *Discipline and Punish* (1995). Significant in this regard is his conception of power as mobile, distributed, productive network of relations, implying movement relations, a field conception of power that has been of crucial importance in cultural theory, but where the foundational role of movement (and its potential to vary) has been overlooked by critics due to an excessive focus on linguistic discursivity. Foucault's critique and analysis of discursive apparatuses could be seen as an in-depth analysis of dynamic power networks that encompasses but also exceeds linguistic domains.

At the same time, as Spivak (1988) points out, this conception of power can have abstract undertones, appearing as ubiquitous inescapable mesh, failing on the one hand to account for the diversity of alignments that create diverse types of power matrixes, the varying systems of inequality, imperialism, or domination, and on the other failing to account for other modes of relation less based on domination.

Foucault also restages the Nietzschean problem of the body being an irreducible play of forces but also always already an interpretation entangled with power matrixes. If the body is produced, how to reinvent it, and what is its dynamism? The outside keeps being unthinkable for a critique bound to the inside of discourse.

In his later writings he tried to think this irreducible body as means to reinvent ourselves in excess of power matrixes, as in the notion of the technologies of the self,

relation then is built in transduction directly. This would imply that every individuation is always relational, always transindividual.

the critical ontology of ourselves or the "politics of discomfort" that imply an open futurity.

...

Henri Lefebvre also provides an important analysis on rhythm composing social space, exposing how space is produced ultimately through movements. As I mentioned in previous accounts of space (macro- and hypertopias) in Book 5, his genealogy goes from *absolute space*, initially made of fragments of nature that increasingly became "populated by political forces" (Lefebvre 1991, 48), through biomorphic *social space*, which tended to transcend its relational (proprioceptive) immediacy through geometry and architectonics toward an *abstract space*, the measurable space of Cartesianism where the qualitative disappears, intrinsically linked to violence and a major tool of domination. Abstract space is in conflict with social space, creating a multilayered and heterogeneous but conflictive *contradictory space*.

But Lefebvre tries to point further (perhaps also further than Foucault) in attempting to think a space beyond contradictory space, perhaps even beyond discipline and power, an as yet undefined *differential space: a space that emerges from the bodies* (from movement, I would add, from bodies as movement). He claims that "the whole of (social) space proceeds from the body, even though it so metamorphoses the body that it may forget it altogether — even though it may separate itself so radically from the body as to kill it" (405) and that there is a need for an analysis of rhythms, which he does in his posthumous book *Rhythmanalysis* (2013).

Crucially he links this problem of the body to a metaphilosophy, which he had proposed ten years earlier, denouncing that "western philosophy has *betrayed* the body, it has *abandoned* the body; and it has *denied* the body" (Lefebvre 1991, 407). Even though Lefebvre points to movement and to space as differential field, he nevertheless offers a rich conceptual field to question this arch-enemy of movement that has been (abstract) space. What would he have thought of the atopias or hypertopias of the internet?

Lefebvre's *Rhythmanalysis* problematizes difference as emerging in the relation to repetition (thus resonating with Deleuze and Kierkegaard) where absolute repetition is a fiction; it is difference that appears by repetition. He also points to the intrinsic polyrhythmics of life emerging in the ongoing interferences of multiple rhythms (biological, gestural, and bodily, mechanical, etc.). Repetition, however, is the condition for rhythm to emerge (Lefebvre 2013, 87). Eurhythmy is proposed instead as the association between different rhythms, like those composing a body, perhaps a ground for a more differential becoming.

...

We have seen the complex origins of the term *rhythm*, originally related to flow, involving a dynamic association to form as movement in Democritus, but since Plato associated to meter and order in movement. Later Nietzsche devoted great attention to rhythm as crucial aspect of his conception of the will to power, but still as form: the form of the will to power. We have to wait for Dalcroze to see a conception of plastic rhythm re-emerge associated to his study of proprioception, which he refers to as muscular sense, and, in another radical and original take in Boccioni's idea of "pure plastic rhythm" in painting and sculpture, which Erin Manning elaborates upon in *Relationscapes* (2009).

Rhythmanalysts Lúcio Alberto Pinheros dos Santos and Bachelard developed a vibrational ontology of rhythm as fully mathematizable (Goodman 2012), the latter proposing a discontinuous cosmology in reply to Bergson's continuous account of vibration. Microrhythm could be seen as underscoring quantum physics and string theory in considering the oscillatory and vibratory nature of subatomic particles—waves and strings. This has astonishing precursors in ancient Indian cosmologies where the world is a rhythmic and vibratory process emerging in enormous cosmic cycles in which a primordial spacing creates vibrations and the energy creates rhythms, and the rhythms create matter (Daniélou 2003). Lefebvre elaborated his rhythmanalysis in terms of the structures, but not of the openness in rhythm, like does Foucault's analysis of distributions and control of activity in disciplinary society.

Looking ahead, Deleuze and Guattari recuperate the idea of pulseless rhythm, which comes both from the ancient etymology of atomism, and from Pierre Boulez's account of striated vs. smooth time in music, of rhythm as meter vs. pulseless rhythms, crucially related to the numerous experimentations with pulseless rhythms in twentieth-century avantgarde music. Luciana Parisi and Steve Goodman (2005) take on Bachelard's idea, connecting it to Whitehead, by relating rhythm both to algorithms and to vibrations as involving the virtual, in trying to think also the fuzzy incomputable aspects coming up in computation itself suggesting a rhythmic anarchitecture as response to smooth topological control. This rhythmic anarchitecture seems to resonate with Tiqqun's claim for a politics of "other rhythms." Along the way we see again a struggle between rhythm as form and the openness in rhythm. I expand on the flow resonances of its ancient etymology by accounting for it as field: there is never a singular oscillation creating a rhythm, the rhythms of life are the plastic and murmuring multiplicity emerging in entanglement of myriads of oscillations and less defined fluctuations.

7.6.9 The Return of the Fluids

7.6.9.1 *Irigaray's Fluid Mechanics of Desire*
Luce Irigaray has proposed a philosophy of feminine desire, a formless femininity that has its own dynamics, reversing Plato's move in the *Timaeus*, a formlessness as endowed with political potential. In "The 'Mechanics' of Fluids" Irigaray (1985b) claims the association of femininity with fluidity and denounces the comparatively small attention that mechanics of fluids has received in relation to a dominant mechanics of solids. Irigaray denounces how the mathematics of fluids tends to falsify and leave out the real movement of fluids and bodies by considering mathematical points.

> What is left uninterpreted in the economy of fluids — the resistances brought to bear upon solids, for example — is in the end given over to God. Overlooking the properties of real fluids [...] *leads* to giving the real back to God, as only the idealizable characteristics of fluids are included in their mathematicization. Or again: considerations *of* pure mathematics have precluded the analysis of fluids except in terms of laminated planes, solenoid movements (of a current privileging the relation to an axis), spring-points, well-points, whirlwind-points, which have only an approximate relation to reality. Leaving some *remainder*. Up to *infinity*: the center of these "movements" corresponding to zero supposes in them an

infinite speed, which is *physically unacceptable*. Certainly these "theoretical" fluids have enabled the technical — also mathematical — form of analysis to progress, while losing a certain relationship to *the reality of bodies in the process*. (Irigaray 1985b, 109, emphasis original)

Irigaray denounces the prevailing regime of form, which has ignored the dynamics of fluidity and is incapable of acknowledging it. The culture of rationality is linked to a mechanics of solids and an immobile logic of the phallus form.

We have already mentioned the importance of fluid mechanics in ancient thought, since atomism or before, of which the *clinamen* is part. One can see an implicit relation between queer performativity and the *clinamen* as implicit differential, as queering and deviation, or indetermination. So, one can establish a link between the ancient hydraulic model and a feminist-queer thinking. Irigaray outlines some starting points for a potential philosophy of movement:

> And yet that woman-thing speaks. [...] It speaks "fluid" [...] *Yet one must know how to listen* [...]. That it is continuous, compressible, dilatable, viscous, conductible, diffusible [...]. That it is unending, potent and impotent owing to its resistance to the countable; that it enjoys and suffers from a greater sensitivity to pressures; that it changes — in volume or in force, for example — according to the degree of heat; that it is, in its physical reality, determined by friction between two infinitely neighbouring entities — dynamics of the near and not of the proper, movements coming from the quasi contact between two unities hardly definable as such [...], and not energy of a finite system; that it allows be easily traversed by flow by virtue of its conductivity to currents coming from other fluids or exerting pressure through the walls of a solid; that it mixes with bodies of a like state, sometimes dilutes itself in them in an almost homogeneous manner, which makes the distinction between the one and the other problematical; and furthermore that it is already diffuse "in itself": which disconcerts any attempt at static identification [...]. Woman never speaks the same way. What she emits is flow fluctuating. Blurring. [...] But consider this *principle of constancy* which is so dear to you: what "does it mean"? The avoidance of excessive inflow/outflow-excitement? Coming from the other? The search, at any price, for homeostasis? For self-regulation? The reduction, then, in the machine, of the effects of movements from/toward its outside? Which implies reversible transformations *in a closed circuit*, while discounting the variable of time, except in the mode of *repetition of a state of equilibrium*. [...] Thus fluid is always in a relation of excess or lack vis-à-vis unity. It eludes the "Thou art" That is, any definite identification. (111–17, emphasis original).

Irigaray was writing in the 1970s, providing a questioning of the oedipal economy different from the one proposed by Deleuze and Guattari's "desiring machines" at that time, which she criticizes as lacking the possibility to articulate a politics of difference.

> But isn't a multiplicity that does not entail a rearticulation of the difference between the sexes bound to block or take something of woman's pleasure? In other words, is the feminine capable, at present, of attaining this desire, which is *neutral* precisely from the viewpoint of sexual difference? Except by miming masculine

desire once again. And doesn't the "desiring *Questions* machine" still partly take the place of woman or the feminine? Isn't it a sort of metaphor for her/it, that men can use? Especially in terms of their relation to the techno-cratic? (140, emphasis original).

Luciana Parisi tries to create improbable resonances between Irigaray and Deleuze and Guattari's becoming-woman, and cyberfeminism's dryer account of the cyborg, through the idea of a microfeminine warfare as molecular dynamics of desire and sex. According to Parisi:

> Irigaray opposes the Freudian theory of entropic pleasure to multidirectional flows escaping the constancy of reproduction and exposing the turbo-dynamics of a matter–matrix, a feminine sex outside all claims of identity. Fluid dynamics defines a body not by its achieved forms and functions (identity) but by its processes of composition and transformation that exhibit the metamorphosis of fluids able to acquire any shape. This metamorphic body–sex is not regulated by the cycle of accumulation and discharge, but displays a ceaseless flow of desire that leaks out of genitality and genealogy. Irigaray provides a non-transcendent conception of sexual difference that emerges from a "matter/mater/matrix continuum," the fluid embodiment of difference irreducible to the representation of "women's experience." For Irigaray, experience does not belong to identities. Experience is always in motion and entails a mutation of femininity. Nothing remains the same on the fluid scale of matter. Femininity stops being represented to expose the hydrodynamics of desire running parallel to a body without contour; a sex without organs. Irigaray's fluid conception of sex and femininity refutes the essentialist tradition of ideas and forms shaping matter. (Parisi 2004, 33)

And: "In 'The "Mechanics" of Fluids' Irigaray argues against the Freudian thermodynamic conception of constancy, holding onto an inside that regulates fluids' inflows and outflows" (Parisi 2004, 112). The link to thermodynamics that Parisi underlines in Irigaray's thinking crucially relates to the economy of energy flows, for which Irigaray also points to a different economy:

> But what if these "commodities" refused to go to "market"? What if they maintained "another" kind of commerce, among themselves? Exchanges without identifiable terms, without accounts, without end [...]. Without additions and accumulations, one plus one, woman after woman [...]. Without sequence or number. Without standard or yardstick. (Irigaray 1985b, 196)

Irigaray establishes a crucial relation between the dominant phallogocentric metaphysics of form and the lack of ways of thinking movement in relation to fluids, thus reversing the traditional story about formless fluidity as expressing a lack of form. It is formal ontology which is rampantly lacking the capacity to think movement, enclosing bodies in unsustainable economies of fixity. What is needed then is a new movement philosophy, which will also be a new economy.

7.6.9.2 Serres and the Return of Fluid Mechanics

Michel Serres provides another important impetus in the renewed philosophical interest in fluid mechanics particularly with *The Birth of Physics* (2000), whose

recovery of the *clinamen* has been influential for Deleuze and Guattari in relation not only to the vortex, but also to curves and infinitesimal calculus. Serres focuses on Lucretius's account of Epicurean atomism. Serres exposes how atomism was largely neglected as inconsistent precisely because of how it avoided the search for underlying laws, and even so it has been enormously influential, like an ongoing but neglected undercurrent of the sciences in the dominant Platonic, Aristotelian, Cartesian, and Newtonian tradition.

By linking Archimedes to atomism, Serres shows that there was in fact a consistent mathematics for Epicurean atomism, a mathematics of the angle and the deviation, of qualities that don't lend themselves to measure. A science that aims not to dominate, but to have a "new and less violent relation with nature" (Serres 2000, vii).

Atomism is not governed by a law of inertia as in Newton. Instead, deviations and collisions happen spontaneously. It is from these very collisions that atoms start to combine, generating provisional orders or stabilities, where the vortex itself emerges from more disorderly motions. So the building blocks are not atoms as discrete entities with form, size, and weight, but the actual angles of deviation. We will see how the angle is also what characterizes diffraction, which could be seen as another expression of the *clinamen*. Stability is the exception. "Homeostasis is a local exception to global homeorhesis" (viii). Solids are just very slow fluids.

The *clinamen* is the condition for the vortex, but I suggest that this is because a primary movement of falling is given (the Aristotelian bias). In Democritus there was no fall, the vortex emerged spontaneously as a primordial ontogenetic movement. Serres corrects Benveniste by pointing to the vortex as the rhythm in flow. Even more importantly; fluctuation *is* the rhythm in flow!

> Physical experience, simple practice, reveal the *rhythmos* in the *rhein*, or the vortex in the flow, or the reversible in the irreversible. Rhythm is a form, yes, it is the form adopted by atoms in conjunction in the first *dinos*. In the beginning is the cataract, the waterfall: here is the *rhein*, the rhesis. The dinos which appears then brings a momentary reversibility to this irreversibility: thus *rhythmos*. No, it was not Plato who first made possible and imagined rhythm, it was the atomists.... Democritus saw the rhythm where it is, Benveniste didn't see it. Heraclitean irreversibility is rhythm, here, there, in Democritus and all the atomists. The theory of atoms engenders rhythm...Flux filled with fluctuations. Rhesis and rhythm, irreversible and reversible, flow and counterflow, global flow and local rhythm. Language will locally articulate a flow of signals or sounds, as music harmonises a similar flow. (Serres 2000, 154)

The vortex appears to come within laminar flow, the linear or laminar as *a priori*. But this can only be within given alignments, as he actually points out: "The Mediterranean basin lacks water. And he who holds power is he who can channel water. Hence this physical world in which the drain is of the essence, and in which the *clinamen* appears as freedom because it is precisely this turbulence that refuses forced flow" (84).

But laminar flow is perhaps only the illusion of certain systems of domination that turbulence can be tamed, turbulence is always *a priori*. The *clinamen* is not deviation, rather laminar flow is an inexistent limit state, an illusory tendency to alignment. One needs also to consider how the vortex is the anomaly within more amorphous turbulent flows. The vortex is just a zone of condensation in constant variation,

consisting of multiple torsions and flows, a field within more indeterminate flows. These flows are always already fluctuation. So, the *clinamen* comes before laminar flow, the vortex comes before the *clinamen*, and fluctuation comes before the vortex.

Serres speaks of how sense appears with the *clinamen*. Creating a differential in flow and language, in turn, is not distinct from nature but is part of it. Letters are like atoms, and they combine in the same way and language is one expression of this primordial rhythm. He correctly points to how we identify with flow: "This process is life itself. My body is a recurrent vortex, open, almost in equilibrium on the imperious procession of my time toward death. What fascinates us on the banks of the river is this: life in its complexity finds itself face to face with its primary model" (155). But it is fluctuation, not the vortex. The fluctuation unfolding in our proprioception.

7.6.10 *Différance* Diffracting

7.6.10.1 *Derrida's* Différance
An important and influential (but mostly implicit and unrecognized) rethinking of movement arrives Derrida's metaconcept of *différance* as movement interval of spacing and temporization, constituting "the present, as an 'originary' and irreducibly nonsimple (and therefore, *stricto sense* nonoriginary) synthesis of marks, or traces, (of retentions and protentions)" (Derrida 1982, 13). Neither word nor concept, *différance* defies metaphysics of presence through the movement of writing. Its spacing is in between the very signs or marks that it creates. *Différance* is perhaps the underlying movement in Derrida's philosophy, binding and spacing all concepts. It is the movement of grammatology, of writing as not subject to speech, performatively embodied in the word *différance* itself. It is also the *archē-pharmakon*, for excessive grammatization implies a toxic dissolution of the possibility to individuate. *Dissemination* is perhaps the creative power of *différance* and deconstruction is a way to mobilize *différance* in a text that appears to preclude it. *Différance* works in principle from within metaphysics to show how it is grounded on a mobile differential field or play. But deconstruction inherits from Heidegger's *Destruktion* the textual reworking of metaphysics as operating inescapably from within.

Derrida's account of *différance* is almost identical to his own account of Plato's *khōra*: both are difficult to think, imply a *logos* that exceeds the metaphysical *logos* of philosophy, and confront us with strange difficulties and obscurities. Both exceed any binary logic of being–nonbeing, passive–active, etc. Both are a space in between, an opening or interval, and both relate to a play of inscription at the same time as exceeding any inscription.

Now, what is the movement of *différance* more precisely? As movement of spacing it implies a separation. Differentiation implies an ongoing weaving of separations involving an interval or spacing, yet it is not coming from an originary unity, for this he avoids the word differentiation: the origin is *différance* itself, the movement by which any system is constituted as play of differences (Derrida 1982, 12), which following Nietzsche (and Heraclitus), are differences of force, not pure quantities but differentials in quantity, a play of force differentials, neverending play without origin. This is the *archē*-writing of *archē*-traces without *archē*, originary without origin, a *weaving* of differences *dividing itself dynamically*, and working against any metaphysical presence, writing against any sign of semiology (thus also against the opposition

of speech–language, while working on the detours of their relation, detours, deferrals, temporizations) where language is *only* a play of differences.

Neither passive nor active, an always adventurous and wandering middle term (nomadic, errant cause) that exceeds also the *opposition* between determination and indetermination. It works from within the language of determination (metaphysics) to undo any effect of determination, of presence, being, or consciousness, where the same (not the identical) is *différance* itself.[31]

The movement of the trace is a *deferral*, a *reserve*, a *postponement* (of presence), both a sameness and a radical otherness, or neither, a strange in-between. The play of traces is prior to being, and yet it is not clear that it can be thought without being, since it is also its unfolding as well as its excess. *Différance* is ontologically prior to being. Being is an epochal manifestation of *différance* — here Derrida makes a striking affirmation of pure immanence for even being is a provisional expression of the play of differentials, but is it a necessary or unavoidable one? Are we bound to the dialogue with being? Is being a necessary expression and closure of the play of differences even if one that must be permanently resisted, contested, exceeded?

The *a* marks the movement of *différance* as *unfolding* of being, in an *appearing and disappearing*, an *erasing itself in resonating* which is the phenomenon, both annunciating and (p)reserved, the movement of tracing as *change of site with no site*. The difference between being and beings that was obliterated in metaphysics, where presencing became a present thing.

Utterly unnameable, affirmed in a *dance* and *laughter* (again Dionysian and delirious, as in Deleuze) of the *preserving–reserving–vanishing–passing*, of the *appearing while disappearing* (so much like virtual particles in quantum field physics). But this unfolding in traces is also an *infolding*, deferral, economy, retention, a paradoxical preservation. It is a double movement of protentional openings (separation and spacing) and retentional traces (detour and temporization) that however exceeds both. What Derrida is gesturing toward without fully noticing is a new thinking of movement. But *différance* in language comes from, and is grounded upon proprioception, and proprioception is an expression of fluctuation. *Différance* can be expanded as the movement of fluctuation un/folding, spacing, and creating difference within emergence, *enferance, intraduction, metaduction*.

7.6.10.2 *Performativity*

Performativity, as it appears in Judith Butler's theory of gender performativity and in queer theory, is not only linked to a nominalist and poststructuralist idea of things being "socially constructed" or performed, reiterated through language and gesture performances, but more importantly it involves the subversive, differential force in the transformative reiteration of speech acts and I think it is ultimately related, at its deepest and best, to Derrida's movement of *différance*.

John L. Austin's concept of performativity in language contributed the idea that some speech acts have the power to produce what they say (like a judge reading a judgment). Later this gets extended to almost any speech act (as productive power

[31] Hence *différance* as the eternal return of the same, echoing the Deleuzian reading of Nietzsche, which had been published in 1962, several years before the writing of *La Différance* and an instance where the *differing* concepts of difference in Deleuze and *différance* and Derrida seem to resonate, or where Deleuze's book on Nietzsche proves to be a foundational instance for the contemporary thinking of difference

in language and against representationalism) to how re-enacting of any norm or meaning relies on its ongoing performative reiteration, that is, of the repetition of speech acts that reinstate it. At the same time this implies that subverting the performance of the speech act (as subversive citation) also subverts the normative structure, exemplified in the subversive first person appropriation of the term *queer* itself.

Butler indeed builds upon Derrida's reading of performativity (Derrida 1988). For Derrida, the performative force of a gesture lies in its *decontextualization* as power of resignification, unlike Bourdieu who relates the force of the performative act to reiteration of the already formed (Butler 1997, 147). So, performativity implies a movement of *différance* as Heraclitean–Nietzschean play of differentials, which brings in difference where the signifier of domination erased it. It is also akin to Lucretius's *clinamen* as intrinsic differential and deviation. Butler further claims dissonance in gender as productive force and gestures on numerous occasions toward something in the body relative to movement or gesture that exceeds the very discursive boundaries that seem to frame it as intelligible, speakable, thus viable and liveable subject (Butler 1990; Butler 1997; Butler and Del Val 2008).

Elsewhere, Butler also stages the problem of the discursive vs. prediscursive in relation to Foucault's reading of Nietzsche (Butler 1999) and problematizes the manner in which gender binaries have been affirmed precisely by claiming binary sex as prediscursive truth of the body. The turn to a poststructuralist neglect of any prediscursivity has ended up, however, foreclosing the possibility to think beyond the boundary of a discursive matrix.

...

Karen Barad resonates with Derrida and performativity in several interrelated ways. Barad considers the movement of diffraction as the generation of patterns of difference, linked to her concept of intra-action, which considers an originary inseparability of agencies and phenomena where internal cuts are enacted from within (as observations or apparatuses within phenomena). Form and causality emerge as dynamic and difference-making cuts from within matter (and meaning). Her bringing together queer performativity theories and quantum mechanics thus designates a (posthuman) performativity of matter itself iterated via internal cuts. Intra-action is a *posthuman performativity* accounting for both matter and meaning.

Intra-action is the "mutual constitution of entangled agencies" (Barad 2007, 33) that defines a process which is not about pre-existing entities relating in a given spacetime, but about emergent agencies, coconstituting relationally, together with their emergent spacetime, an *enfolding*. This process happens as differential cuts (and with them forms and causalities) are enacted from within the initial inseparability of agencies in phenomena whereby "part of the world makes itself differentially intelligible to another part of the world" (Barad 2007, 140).

Intra-action takes the model of the apparatus of observation as defined in the wave–particle duality of quantum mechanics and Niels Bohr's indeterminacy principle, so that relations always imply an observation as condition for making meaning, just like the cut is needed for matter quanta to exist. They never absolutely exist; they rely on the apparatus of observation. A fixed apparatus creates the intra-active relation where particles are perceived, a movable apparatus instead is needed to observe the properties of waves. Bohr's principle goes beyond Heisenberg's in proposing not just epistemological uncertainty but ontological indeterminacy. This is not an antirealism but what Barad calls an *agential realism*.

But what about movement? What is the place of movement in agential realism? Change is defined through a reworking of causality as nondeterministic but also nonarbitrary acausal enactments *enfolding* matter as differential process of mattering (Barad 2007, 179). These causalities however *don't imply trajectories* but a *reciprocal enfolding* of past and future, continuity and discontinuity, determinacy and indeterminacy, neither acausal or random nor deterministic, and this is core to the open-ended becoming of the world. Quantum leaps are indeterminate as to where and when they happen and each moment is alive with different possibilities.

Enfolding is different from unfolding and infolding. It is a sort of double reciprocal movement of infolding and unfolding creating a field, an open enclosure in which apparently contradictory tendencies coexist. But it also connects with Bergson's idea of the present as a span, not a point, a span of attention where memory projects itself as protention, so that actual and virtual enfold in numerous different spans. Derrida's double oscillation of *différance* is clearly resonating here (Barad 2010).

7.6.10.3 Diffraction

Karen Barad's preferred trope for intra-action is diffraction: the phenomenon that occurs when a wave encounters an obstacle or a slit, *changing its pattern*. Donna Haraway had already outlined diffraction as powerful alternative to representation, as trope for difference emerging within phenomena, opposed to the reflexive and specular character of representation based on a fixed external observer. It is a relational difference, never an absolute one, a difference enacted from within. It is about making difference in the world (Barad 2007, 89). Diffraction also resonates with Simondon's account of transductive dephasing and is thus also implicitly linked to the idea of a field. Barad elaborates consistently on it as trope for differential movements related to an observation from within as constitutive of phenomena, *both in matter and in meaning* (2007, 71).

Through Barad, diffraction and *différance* ally with Niels Bohr's physics–philosophy and the ontological indeterminacy of quantum phenomena, which are linked to the observation process and apparatus at ontological, not merely epistemological levels.

Barad brings together queer performativity, Derrida's *différance*, diffraction, and quantum indeterminacy into the trope of intra-action that allows to think the ontological inseparability of movements (agencies) composing a field. But Barad also claims the importance of the separability emerging from within the primordial inseparability, in a sort of *queer Aristotelianism* where form comes up dynamically from within, while also following Derrida's oscillatory undecidables as a play of dis/continuity.

Yet for Barad, as for all of the above, form remains essential for matter and meaning. I think this is due to her retaining the notion of observation, which is a limiting aspect. Although she transposes external perspective to an internal phenomenon in a promising step, I wish to take it further through proprioception, as mode of perception exceeding observation altogether and its associated cuts. Consistency, matter, and meaning come to be without cuts, as observation becomes proprioception in entangled movement fields, including language itself.

Barad presents the brittle star as an example of intra-action, a creature whose seeing is of a moving body, bodying, and mattering as it sees. It is a sea creature with tentacles entirely covered with crystals that operate as lenses forming a compound eye, which changes its possibilities as the brittle star moves. This exposes a sort of

radically explicit proprioceptive vision, but the core idea is the same that I expose in the overall functioning of proprioception. It is extraordinary that this is missed here, as it is the most glorious expression of intra-action in our daily lives. With a difference: proprioception needs no cuts and no vision–observation!

Barad further elaborates the question of potentiality in relation to quantum field theory and the virtual particles that seem to compose most of the mass of an atom as an even more radical account of the ontological indeterminacy and openness in matter, which she links to a justice-to-come (Barad 2012, 17). The ethical implications of intra-action for such a justice-to-come can be best understood again in analogy to Simondon's individuation, where a relation is also an individuation. Barad claims that "'Otherness' is an entangled relation of difference (*différance*). Ethicality is non-coincidence with oneself" (Barad 2007, 236). As in Simondon, being is always dephasing, always in becoming, out of phase with itself. And this being out of phase is also the possibility for individuating relations, out from the same agential continuum of preindividual potential. Difference comes in the relation as it individuates, always dephasing as it unfolds its structuring or fielding, its own spacetime. Relation emerges in that same dephasing of individuation. Diffraction is thus a double process of relational and differential becoming in dephasing so that ethicality and justice-to-come lie at in the possibility of reconfiguring the differential field, in Derrida's words "to reaticulate *as must be* the disjointure of the present time" (Derrida 1994, 28). Or in Barad's terms, "to open oneself up to indeterminacy in moving toward what is to come" (Barad 2010, 264).

…

Barad develops diffraction as ontological trope with unprecedented depth, inspired by the vigorous and original proposal coming from Donna Haraway.[32] Haraway has since recapitulated this trope for difference emerging in processes, as *material-semiotic enactment* that overcomes the traditional split between matter and meaning coming from cultures of reflexivity and representation. Even though diffraction is still grounded in vision and optics, and in pattern. It is the production of patterns of difference.

> My invented category of semantics, *diffractions*, takes advantage of the optical metaphors and instruments that are so common in Western philosophy and science. Reflexivity has been much recommended as a critical practice, but my suspicion is that reflexivity, like reflection, only displaces the same elsewhere, setting up the worries about copy and original and the search for the authentic and really real. Reflexivity is a bad trope for escaping the false choice between realism and relativism in thinking about strong objectivity and situated knowledges in technoscientific knowledge. What we need is to make a difference in material-semiotic apparatuses, to diffract the rays of technoscience so that we get more promising interference patterns on the recording films of our lives and bodies. Diffraction is an optical metaphor for the effort to make a difference in the world. (Haraway 1997, 16)

32 At least as early as "The Promises of Monsters" (Haraway 1992) but also and chiefly in Haraway (1997).

Again, there is a claim for a science that helps us move better with the world rather than try to fix it. One could trace this far back in time to an ongoing struggle between phallogocentric, patriarchal cultures of domination and matriarchal cultures of care, though the story is more complex. We saw however at the start of this book the way in which the study of water movements in ancient cultures could be conceived as a diffractive kind of knowledge. Diffraction implies fields, since waves are considered to be *perturbations* of a field, transferring energy across it. Waves are thus properties, expressions, and changes of the field. They may even be one of their most fundamental expressions if not the most characteristic. Interference and dissonance are preferred tropes in feminist circles promoting a differential difference, not an essentialist one.

Diffraction is interestingly defined as bending around corners or apertures into a shadow region of the corner or aperture which becomes new source of propagation. Thus it interestingly connects to the *clinamen*. But diffraction becomes a more ongoing phenomenon when a wave travels through a medium with a varying refractive index, density, or texture. It accounts then for the ongoing entanglement of fields: as a light or water wave crosses diverse mediums whose consistency or texture varies, unfolding in what one might call *diffractive* or *refractive rhythms*.

All waves diffract, from gravitational waves to the wave-like properties of matter at subatomic levels. Diffraction could almost be said to be a universal phenomenon, or a ubiquitous expression of fields and their waves, which accounts for the complexity and entanglement between fields. It is also equivalent to interference though accounting for multiple wave sources.

So yes, diffraction is a promising move, though we need to move beyond. I propose to put diffraction as one trope within a broader spectrum of dynamics of fields. I also propose to overcome its bias on vision (and metaphor) through the more potent (and nonmetaphoric) trope of the proprioceptive swarm. Proprioceptive diffraction could be a way of speaking about the differential entanglement of proprioceptive fields.

7.6.10.4 Anzaldúa's Mestiza and Sandy Stone's Near Legibility

Gloria Anzaldúa provides another important and implicit rethinking of movement as third element beyond dualisms, in her account of the *mestiza* (1987), of the in-between and the divergent movement across borders that brings forth a new element which exceeds the dualism. What she calls "*mestiza* consciousness" seems to emerge in a multiple motion involving a perpetual crossing of given boundaries and dichotomies, a creative incapacity to hold things in rigid boundaries, a vertical and horizontal stretching of the psyche, a shifting out of habitual formations, from convergent to divergent thinking that moves away from given patterns and toward more whole and inclusive perspective, developing a tolerance for contradictions and ambiguity, and sustaining a plural personality that acts in pluralistic mode as if existing in multiple simultaneous quantum states (Stone 1999).

This movement effectively emerges across boundaries of cultures and power systems (Mexico and the US), and is related to a type of nomadism, a never fully belonging to either territory, while relating to both, like a quantum wave–particle duality. Sustained movement across or in between any given boundaries and dichotomies, movement of resistance to the boundary, movement of stretching in multiple dimensions, movement away from, shifting out, or diverging from given alignments,

sustaining contradictions and ambiguity, an ongoing movement of opening that includes rather than excludes.

In the midst of these movements across and away, deviating while sustaining, resisting while stretching, a third element appears (beyond the subject–object and its convergent teleological thinking), the "*mestiza* consciousness," literally a new perception and mythos, with its own creative motion that "keeps breaking down the unity" of every paradigm, starting with the subject-object duality, healing the split. The field it creates exceeds dualities without establishing a new fixed category, it is a field of motion.

...

Allucquére Rosanne (Sandy) Stone proposes similar moves, for instance when speaking about the gaze of the vampire (Stone 1996, 165) as the gaze of transgender, queer people, or anyone occupying border zones, that allows them to see things that people aligned with the norm don't see. Stone's movement comes also from crossing borders (of sex and gender dualisms but also of disciplines) and questioning their territories at the same time, assuming a multiplicity. She proposes to look for something that is neither sameness nor difference (*différance?*), to fragment gender in unexpected geometries, claiming the power of dissonance, of mixture, of transition as nonassimilation in binaries, of ambiguities, polyvocalities, and intertextualities of gender and sex, where the disruption of old patterns of desire produce myriads of alterities, as in Haraway's (2003) promising monsters, which according to Sandy Stone are "physicalities of constantly shifting figure and ground that exceed the frame of any possible representation" (Stone 1987) holding together contradictions, playing at the edge of the legible or intelligible, the emergent and productive border zone of *near legibility,* and learning to develop moments of opening or rupture (Stone 1993a). All this happens within the war between simplification and multiplicity, that is *The war of technology and desire at the close of the mechanical age* (Stone 1996).

7.6.10.5 Stiegler's Neganthropy

Recently Bernard Stiegler has made an argument in favor of introducing improbable bifurcations into the movements of culture. Building upon Whitehead, Simondon, and Derrida's *différance*, he argues for transindividuation processes that involve the new, the improbable, the bifurcation, thus implying *différance* in individuation, through invoking a reason that is about promoting an art of life, a process of actualization that involves the open, the infinity that is irreducible to calculation:

> The infinitude this entails aims not at subsistence or existence but at consistence, at what does not exist yet consists. [...] The neganthropological function of reason, in other words, ultimately consists in the possibility of opening *bifurcations* that would be not just probabilistic, but highly improbable" (Ross 2018, 30)

The neganthropocene implies a nonentropic (ordered) yet open process. Stiegler argues for actions that create energy and associates current "computational nihilism" to entropy foreclosing the possibility of individuation by imposing the logics of tertiary retention systems that minimize secondary and primary retention and focus on quantitative value. Yet as in the authors he builds upon it is obscure how one enacts this consistent but open move. In fact, movement is absent, and reason seems again to be detached from it.

Stiegler's work provides a rich array of tools for understanding how a certain narrowing of movement emerged. One of them is grammatization, redefined by Stiegler as the "broader analytical process by which temporal and perceptual flows of all kinds are rendered discrete and reproducible through being spatialized" (Ross 2018, 20). More recently, Stiegler developed the trope of exosomatization, linked to the increasing reliance upon technical systems of "tertiary retention" that introduce a radical externalization of memory as an *epiphylogenetic* process into planetary-scale technical systems which would pre-empt the possibility for a subjectivity to individuate, thus defining the human in a co-evolution with technics.

To understand primary, secondary, or tertiary retention we can go phenomenological with the example of a melody: primary retention is the melody as we perceive it temporally in its flow, secondary retention is the melody remembered through memory as imagination, thus always transformed, which Stiegler claims is not split from primary retention but transforms direct perception in ongoing feedback. We can hear the same melody one thousand times and it will always feel different. Tertiary retention is precisely the technical means that allows the reproduction of that melody, allowing a changing primary retention to evolve through secondary retentions in between, and is the source for collective *epiphylogenetic* memory, thus it *precedes our primary retention*, structuring it in long temporal, cultural, and epiphylogenetic processes.

Tertiary retention is the means for transindividuation, always already happening in collective relations. But different kinds of tertiary retention may afford or hinder individuation, as is the case with digital culture and computation. I argue that individuation (in terms of an individual subject) was already the effect of certain types of tertiary retention, such as perspective, which are in turn foundational to computation.

Are individuation and the rational subject the response to digital control, or were they part of the problem? This question leads back to the original subject of Derrida's (1981) *pharmakon*: Plato's critique of writing vs. speech. Derrida questions the metaphysics of presence as linked to Plato's defense of speech to the detriment of writing, but this misses the crucial point of how writing has evolved as an even more problematic system of alignments, by segmentation and spacing. It is this missing point of tertiary retention that Stiegler wants to correct.

The problematic aspect of the *pharmakon* is that it runs the risk of reaffirming the fallacy that technology is a neutral medium, so that depending on the use it can be poison or remedy. What we need is a deeper understanding of the movements and alignments that different technics express. Simondon's idea that transindividuation and relations are themselves an individuation can help in understanding how technical fields compose their own metabody, rather than just relating individuals. What we see as a local relation is composing a field of a higher order of magnitude. But of what kind? How open or plastic is it? What are its alignments and how to open them up… in creating a new field? The problem is to sustain openness in movement, relational freedom across all the ecologies we are part of.

Stiegler proposes a general organology as philosophy for how we construct our artificial organs of tertiary retention, always implying the production of exo-organisms. There are simple, complex, and planetary exo-organisms. But again, this term "exo-organism" assumes the individual subject organism as privileged term, ignoring the fact that its becoming was always part of larger individuations. This was already

the case in bacterial colonies, in the emergence of biological organisms, swarms, and flocks, atoms aggregating or vortexes condensing. The problem is the alignment.

We need to look at the types of movement composing fields, their plasticity or narrowing, their active and reactive forces. Otherwise we remain at the level of symptoms, reproducing them. Metaformance and metaformativity, metabodies and ontohacking are my proposals for a critical and creative engagement with the plasticity of our movement fields and our reinvention of technics, as metaorganology, as I proposed in Book 6.

The phantom of "entropic fear" that we saw in many authors before is present here too. Stiegler's theory evolves along a fear of disorder, where Derrida's *différance*, as an economy of difference and deferral, is a sort of negentropic force extensive to biology and to economy. But here lies the pharmacological paradox: the very spatialization that allows us to have a memory (which is the economy of our retentions, the economy of culture altogether that postpones immediacy in desire) is also what destroys the subject's order when it expands, in excessive grammatization and exosomatization that becomes entropic. But is it really so, or are we missing the point that algorithmic systems are creating a higher-order aggregate composed of extreme alignments, that by nature will preclude their previous and provisional inflection in the subject? Subjects are linked to control and computation is linked to hypercontrol, which appears chaotic for the subject becoming aggregated into it.

As previously said, entropy is derived from the attempt to create closed systems (steam engines) extrapolating this idea to the entire universe considered as closed system. It had a first expression in closed thermodynamic systems and a second one in information systems. Both have created planetary scale metabodies, exoorganisms.

The excess of control in planetary scale computation systems is the problem, a higher-order control of which the individual subject was just a provisional node and medium. This excessive closure of subjects and technical systems are the problem, so that the "solution" is to recuperate plasticity. Funnily enough, entropy as disorder and anthropocentrism are two sides of the same coin. The attempt to create closed totalities also creates energy dissipation. Alignments are exhausting us because they ignore fluctuation!

Stiegler's neganthropocene aims to hold together both tendencies: it involves negative entropy (as tendency against dissipation) and also "negative anthropy," as working against the closures of anthropocentrism, and seeking a *negantropic openness*. The term is good as a double resistance, but perhaps connotates too much of a struggle (against entropy, against anthropic destruction). Where is the innocence of becoming?

Biological systems expose mostly a different economy of *différance*, thus of memory, than most technohuman systems, but they are to be seen along a continuum in degrees and modes of alignment, where plasticity and the balance of consistency and openness are the means to sustain a movement of variation. Genetic and epigenetic memories are part of a continuum, and what Stiegler distinguishes as epiphylogenetic memory related to technical systems is simply a mode. Proprioception was always already exosomatically reaching outward in different ways, but it became totally inverted as we became utterly dependent on external orientations. One formula could be to say that the *sum of exosomatization and grammatization is the problem*, implying reductive transindividuations.

...

Mark Hansen has elaborated a critique of how new media operate on our sensibility while exceeding our conscious perception. Hansen relates this through Simondon, to an "engineering of preindividual potentiality" (2012), where systems operate in spectrums of preconscious activity reorienting our movements, by a distribution of sensibility in cognitive ecologies. Hansen agrees with Stiegler in claiming the preindividual as related to the technical domain, but considers one cannot characterize it as tertiary memory or retention.

> Rather than intervening at the level of memory itself, twenty-first-century media impacts the distinct and quasi-autonomous microagencies that underlie memory's integrated function, as well as other environmental dimensions that bear on that function. [...] I would suggest that twenty-first-century media directly engineers the potentiality of the pre-individual, and thus comes to impact ongoing and future individuations not as a repository of content to be drawn on as an immediate source for consciousness's imagining of a viable future, but rather as a far more diffuse, multi-scalar and heterogeneous subjective power — intensity — that operates across all dimensions of the total causal situation and predetermines the future (where "predetermines" has the positive sense of enabling or facilitating). (Hansen 2012, 57)

This engineering is presented on the one hand as a political problem, but a few lines after winds into a positive enabling. At the same time, if it is a problem, it isn't clear what reply to give, if any. Is it, like in Stiegler, involving some nostalgia for the subject or are we to rely on the apparently positive and enabling side of it? The engineering of the preindividual or of tertiary retention prevents the emergence of singularities and transsingularities, as we know them in the case of the subject and its collectivities, because its "distributed sensible ecology" creates a new aggregate. The individual was a necessary step to the dividual. The problem is not that it works beneath conscious perception. The individual body of a subject is also grounded on particular noncognitive ecologies of proprioceptive movement that posit noncognitive processes at the core and as the source of any agency, bodiliness, subjectivity, selfhood, or freedom.

We become cells of a planetary cyborg as long as we reduce individual complexity and acquire functions in the larger body. This reduction is proportional to speed. The exponential acceleration toward the planetary cyborg is relative to an exponential reduction, whose span of decades (or centuries at most, since industrialization, and with a previous slowly rising curve since the origins of geometry) contrasts with the four billion years it took for the complex orchestration of organisms as open wholes. Yet the increasing and millennia-old impoverishment of sensorimotor plasticity grounding our entanglement with computational systems is not considered by these authors.

The engineering of the preindividual could be understood as a *feed-forward* that preempts the future by actively anticipating it, present to consciousness after the fact:

> Because perceptual consciousness is simply left out of the loop when data-gathering and passive sensing capacities grasp the "operational present" of sensibility at time frames from which conscious activity is excluded, this operational present can only be made available to consciousness in a future anterior time frame, by

being presented *after the fact* to a consciousness that, with respect to the present's operationality, cannot but arrive too late on the scene. (Hansen 2015, 25)

But feed-forward could also be meant as a reply to and a deviation from the very *control feedbacks* that try to steer us.

7.6.11 Deleuze and Guattari's Absolute Movement

Deleuze and Guattari, in their fight against transcendence, define immanence, the plane of immanence, as a section of chaos, an *absolute movement* of deterritorialization, and oppose its curvilinear, vortical, rhizomatic, molecular, virtual, imperceptible, intense movement to the actual, perceptible, molar movement of the plane of organization where movement becomes extensive, and lines become subjected to immobile points.

The dynamics of molar and molecular is elaborated in relation to nomadism, becomings or micropolitics, emphasizing the nondualist approach where molar and molecular are two ever-present poles of any process, always running in between: a *bipolar philosophy* of movement in which lines of flight can return as lines of abolition, or molecular unformed movements can aggregate into a form or molar aggregate, often in a sort of pendulum dynamics between both extremes, but with difficulty to think a sustainable middle.

The *plateau* is their promising attempt to propose a mode of sustained intensity that doesn't congeal into a formed substrate, but still as consistency of the intense, opposed somewhat to the consistency of the extensive and formed. The intense in Deleuze and Guattari is thought from the perspective of the extensive, as something extreme and difficult to sustain, whereas in my proposal the anomaly is the extensive, as a flattening of qualitative change that foregrounds a turn to the purely quantitative. The rhizome exposes this dynamics by which formed or arborescent hierarchies can appear within fields of nonhierarchical difference, while opposing one mode to the other: the rhizomatic interlacing and the aborescent hierarchy as poles. At the same time the formed is an inevitable expression of the formless in the bipolar dynamics. The formless needs to take expression in form.

Deleuze and Guattari have created a plethora of influential and perhaps not sufficiently acknowledged ways of thinking movement beyond form and grids, which I will try to summarize in what follows. At the same time, they show some limitations and biases that didn't allow them to go fully beyond the mechanistic tradition.

...

What conceptions or assumptions about movement underlie their proposal? This stands out clearly in "Memories of a Molecule" in *A Thousand Plateaus*, when they say: "Perception can grasp movement only as the displacement of a moving body or the development of a form. Movements, becomings, in other words, pure relations of speed and slowness, pure affects, are below and above the threshold of perception" (Deleuze and Guattari 1987, 280). Here their assumption of a perspectival visual mode of perception as predominant one becomes surprisingly clear, apparently the only one than can be associated with the perception of movement! Ignoring (yet again) proprioception, they divide movement between one kind that is only perceivable through the visual symbolism of form, which they will call *relative* movement, and an *amorphous, virtual, absolute* movement that is imperceptible.

The vorticity of absolute movement is linked to difference: the vortex as differential circle, the *clinamen*, and the eternal return of difference itself are this paradigm for difference, linked to curvilinear movement as infinitesimal variation where points become inflections instead of fixed reference points subjugating lines. In *What Is Philosophy?* (Deleuze and Guattari 1994) they take this further by pointing to how difference may come up within the infinite movement of the plane of immanence as fractals or folds within the plane.

Deleuze's and Guattari's thinking of formless flows, molar, molecular, lines of flight, lines that trace no countours, their account of the *clinamen* as differential and of rhythm as irregular dynamics, and Deleuze's elaboration on Leibniz, elasticity and the curve, linked also to differential calculus, to microtornados and turbulence, and to compossibility, series and bifurcations that continually recompose the world in relation to the virtual (Deleuze 1993), all these provide powerful tropes for a field theory, while still mostly linked to the image of a line (whether molecular, differential deviation–flight or as elastic curves within curves).

In *Nietzsche and Philosophy* Deleuze (1986b) already brings in foundations for his concept of difference: of eternal return as a vortical movement of difference, which will come back in *The Logic of Sense* and resonate in the *clinamen* as implicit differential in movement; in the will to power as metaphysical force of difference; in the body (and the world) as play of forces, of differentials (which perhaps influenced Derrida's concept of *différance*), in which active and reactive forces are at play (here reaching back to Spinoza).

In *Difference and Repetition* (Deleuze 1994) his references to morphogenetic movements (interestingly linked to another Dionysian echo of Nietzsche) point more explicitly to a field theory along the lines of morphogenetic field theories existing since around 1910:

> Embryology shows that the division of an egg into parts is secondary in relation to more significant morphogenetic movements: the augmentation of free surfaces, stretching of cellular layers, invagination by folding, regional displacement of groups. A whole kinematics of the egg appears, which implies a dynamic. Moreover, this dynamic expresses something ideal. Transport is Dionysian, divine and delirious, before it is local transfer. Types of egg are therefore distinguished by the orientations, the axes of development, the differential speeds and rhythms which are the primary factors in the actualization of a structure and create a space and a time peculiar to that which is actualised. (Deleuze 1994, 214)

So the orientations and speeds conforming a morphogenetic field that unfolds its own spacetime are also opposed to a usual account of extensive motion. It associates to the plane of immanence, the Dionysian, which for him is also an ideal, virtual, imperceptible movement. Absolute movement as ideal appears again when he speaks of "inventing vibrations, rotations, whirlings, gravitations, dances or leaps which directly touch the mind" (8):

> Even in nature, isochronic rotations are only the outward appearance of a more profound movement, the revolving cycles are only abstractions: placed together, they reveal evolutionary cycles or spirals whose principle is a variable curve, and the trajectory of which has two dis-symmetrical aspects, as though it had a right and a left. It is always in this gap, which should not be confused with the nega-

tive, that creatures weave their repetition and receive at the same time the gift of living and dying. (21)

Repetition is the oscillation happening in the dissimetrical gap of variable curves, which open movement up to the virtual, an oscillation between actual and virtual, where life and death appear as differential interval, so that the apparent repetition of an oscillation is part of a vortical, evolutionary spiralling: the unfolding of difference.

Again, he invokes the active affirmative movement of the will-to-power as a differential eternal recurrence, and selective force: "If eternal return is a wheel, then it must be endowed with a violent centrifugal movement which expels everything which 'can' be denied, everything which cannot pass the test" (55). And: "It is in difference that movement is *produced as an 'effect'*" (57). Here Deleuze echoes Nietzsche in placing movement as secondary to difference, which has an equal status of metaphysical *a priori* for Deleuze as the will to power has in Nietzsche. With movement understood as fluctuation I try to bring movement and difference together.

Deleuze exposes the relation between the reductive, mechanistic definition of movement with linear perspective and representation, and gestures toward a different type of perception that doesn't unify in a center of vision and allows to consider multiplicity as simultaneous (gesturing toward a swarming proprioceptive field): "Movement, for its part, implies a plurality of centers, a superposition of perspectives, a tangle of points of view, a coexistence of moments which essentially distort representation" (56).

Rhythm or amplitude are sufficient to create the difference between different drives and impulses, thus raising the importance of rhythm for qualitative difference, or perhaps for the shift in quantitative difference that allows the selection between active and reactive forces: "We see no reason to propose a death instinct which would be distinguishable from Eros, either by a difference in kind between two forces, or by a difference in rhythm or amplitude between two movements" (113).

In *The Fold* (Deleuze 1993) and in *Logic of Sense* (Deleuze 1990) another subversion (but also reiteration) of the line comes with the concept of incompossible series where actual and virtual meet in a double movement of convergence and divergence, infinite series where the planes of actual and virtual meet in their irreducible difference composing the incompossible.

In the "Postscript on Societies of Control" Deleuze (1992) further brings insight into movement through control as modulation, like a sieve whose mesh continually readjusts from point to point, or like a self-transmuting mold, and the machines associated to them. This idea of a variable network was already implicit in Foucault's account of power, but is also a very topological image, which Parisi eventually adopts through the idea of postcybernetic topological control in which algorithms bring incomputable fuzzy quantities into the variation of topologies.

7.6.11.1 Absolute Movement as Field

Accounts of *absolute movement* in *A Thousand Plateaus* present a plane of immanence that is both absolute movement and absolute immobility:

> We must try to conceive of this world in which a single fixed plane — which we shall call a plane of absolute immobility or absolute movement — is traversed by nonformal elements of relative speed that enter this or that individuated assem-

blage depending on their degrees of speed and slowness (Deleuze and Guattari 1987, 255).

But why should molar aggregates not emerge from this process as well, rather than be in a separate plane of organization, in a bipolar reality?

> Then there is an altogether different plane, or an altogether different conception of the plane. Here, there are no longer any forms or developments of forms; nor are there subjects or the formation of subjects. There is no structure, any more than there is genesis. There are only relations of movement and rest, speed, and slowness between unformed elements, or at least between elements that are relatively unformed, molecules and particles of all kinds. There are only haecceities, affects, subjectless individuations that constitute collective assemblages. Nothing develops, but things arrive late or early, and form this or that assemblage depending on their compositions of speed. Nothing subjectifies, but haecceities form according to compositions of nonsubjectified powers or affects. We call this plane, which knows only longitudes and latitudes, speeds and haecceities, the plane of consistency or composition (as opposed to the plan(e) of organization or development). It is necessarily a plane of immanence and univocality. (266)

In the section on three short novels, they speak of two kinds of lines: of rigid segmentarity and molecular segmentation (but both implying segmentation!) that constantly run across each other. They invoke the idea of *micromovements* in conversation.

> There is no question that the two lines are constantly interfering, reacting upon each other, introducing into each other either a current of suppleness or a point of rigidity. Nathalie Sarraute, in her essay on the novel, praises English novelists, not only for discovering (as did Proust and Dostoyevsky) the great movements, territories, and points of the unconscious that allow us to regain time or revive the past, but also for inopportunely following these molecular lines, simultaneously present and imperceptible. She shows that dialogue or conversation does indeed comply with the breaks of a fixed segmentarity, with vast movements of regulated distribution corresponding to the attitudes and positions of each of us; but also that they are run through and swept up by micromovements, fine segmentations distributed in an entirely different way, unfindable particles of an anonymous matter, tiny cracks and postures operating by different agencies even in the unconscious, secret lines of disorientation or deterritorialization: as she puts it, a whole subconversation within conversation, in other words, a micropolitics of conversation. (196)

But doesn't this imply the proprioceptive matrix from which gesture and language emerge, and the micromovements of the nonverbal spectrum that I proposed in the Book 2? Why should these micromovements also be thought as segments no matter how small? Is this because of how also the virtual is considered as determinate, quantised, subject to its own differential calculus?

In the plateaux of nomadology they distinguish between movement and speed, reproducing the dichotomy from "Memories of a Molecule" between movement as

perceivable through vision, and speed as imperceptible and distinct from movement altogether:

> It is thus necessary to make a distinction between speed and movement: a movement may be very fast, but that does not give it speed; a speed may be very slow, or even immobile, yet it is still speed. Movement is extensive; speed is intensive. Movement designates the relative character of a body considered as "one," and which goes from point to point; speed, on the contrary, constitutes the absolute character of a body whose irreducible parts (atoms) occupy or fill a smooth space in the manner of a vortex, with the possibility of springing up at any point. (It is therefore not surprising that reference has been made to spiritual voyages effected without relative movement, but in intensity, in one place: these are part of nomadism.) In short, we will say by convention that only nomads have absolute movement, in other words, speed; vortical or swirling movement is an essential feature of their war machine. It is in this sense that nomads have no points, paths, or land. (381)

> Linear displacement, from one point to another, constitutes the relative movement of the tool, but it is the vortical occupation of a space that constitutes the absolute movement of the weapon. (397)

Deleuze and Guattari gesture here in a promising direction. The body as one is the body of mechanism, but the body as irreducible vortical multiplicity should not imply an abstract or nonsensuous virtuality; it is the proprioceptive field! I want to stress that underlying all discussions of the virtual there has been the proprioceptive field, unacknowledged.

When they mention Glenn Gould accelerating in playing a piece (8), transforming points into lines, proliferating the whole, they point to a field thinking where the piece is transductively creating and shifting its own field. The musical "notes" are not discrete events happening in a given field: they field forth. In this bipolar approach, memory is related only to formed movement while becomings have only memory in their relation to the formed that they deterritorialize or reterritorialize:

> The line-system (or block-system) of becoming is opposed to the point-system of memory. Becoming is the movement by which the line frees itself from the point, and renders points indiscernible: the rhizome, the opposite of arborescence; break away from arborescence. Becoming is an antimemory. (294)

Doesn't this imply the impossibility of becoming to consist at all without stasis in being? Can't there be a memory of becoming that consists into plateaus? Inversely, can there be sustained plateaus without some kind of memory? But proprioception is all about memory, fields are memories of very different kinds.

Likewise, love is present on the one hand as nomadic war machine, but it is also despised as when they say the "anyone who likes cats or dogs is a fool" (Deleuze and Guattari 1987, 240) so, strangely no becoming-with-animals is considered, only the deterritorialization of the becoming animal.[33] Again the in between is missing.

33 Here I have to agree with Haraway's (2008) critique.

But this bipolar vision, just like the idea of the smooth vs. striated space, gives too flat an idea of the less structured as utterly unstructured, when this is not the case. Animals or the Earth or the sea are not smooth or deterritorialized becomings, spaces, or movements. They operate more within the proprioceptive spectrum and less with vision at a distance. We need to understand the multiple modes of perception that allow a body to feel a moving environment and orient themselves in it, in excess of visual mapping.

7.6.11.2 *Rhythm, Clinamen, and Rhizomes*
In the discussion of rhythm as non-metric, Deleuze and Guattari correctly point out the etymological complexities and the relation to Democritus, precisely invoking the tradition linked to flow and fluctuation, and claim the dynamic ontology of atomism,

> occupying an open space with a vortical movement that can rise up at any point. In this respect, the recent studies on rhythm, on the origin of that notion, do not seem entirely convincing. For we are told that rhythm has nothing to do with the movement of waves but rather that it designates "form" in general, and more specifically the form of a "measured, cadenced" movement. However, rhythm is never the same as measure. And though the atomist Democritus is one of the authors who speak of rhythm in the sense of form, it should be borne in mind that he does so under very precise conditions of fluctuation and that the forms made by atoms are primarily large, nonmetric aggregates, smooth spaces such as the air, the sea, or even the earth *(magnae res)*. (Deleuze and Guattari 1987, 363)

The reference to atoms mainly composing large nonmetric aggregates interestingly points to a field theory and a swarming theory, where the form–rhythm is never in individual bonds. Deleuze also points out in *Cinema 1* the originary etymological relation of rhythm with flow: "Water is the most perfect environment in which movement can be extracted from the thing moved, or mobility from movement itself. This is the origin of the visual and *auditory importance of water in research on rhythm*" (Deleuze 1986a, 77). What does it mean to extract mobility from movement? Does it anticipate the difference of speed and movement, water as pure speed, as intensive movement, not of a body–point that displaces? But this can point also to a field theory — of only movement without "thing" that moves!

In the discussion on the *clinamen* in *A Thousand Plateaus*, Deleuze and Guattari, echoing Serres, link it to smooth space as nonhomogeneous space of the smallest deviations, of contact and small tactile or manual actions, of rhizomatic nonmetric multiplicities that occupy without counting and can only be "explored by legwork" (Deleuze and Guattari 1987, 371), which ultimately means proprioceptively, and clearly oppose it to visual, striated, Euclidean space, while invoking the figure of a field.

Through hydraulics the *clinamen* is linked to the vortex, the turbulence emerging in laminar flows, within which the *clinamen* always reappears as freedom and as nonhomogeneity of the field (106). This account of rhythm as fluctuation is underlying also the chapter on "The Refrain," where rhythm, as a milieu's reply to chaos, is not measure. It is incommesurable, unequal. It is a link between active moments that happen in another plane. Action is in the milieu, but rhythm is in between milieus. The milieu is effect of periodic repetition, whose effect is however to produce dif-

ference (314). Rhythm is an unequal interval connecting heterogeneous periodic repetitions of the milieus and in the milieu, whose individuation is then a rhythmic dephasing, a differential becoming. Rhythm is then what opens repetition up to difference, to the virtual, and this connects implicitly to the ancient relation of the *clinamen* to rhythm and of rhythm to flow and fluctuation.[34] There is only territory when there is rhythmic expressivity, when it acquires a certain differential temporal constancy, so that it is rhythm, not measure that defines a territory.[35]

All along we see a bipolar division between centripetal black-hole circularities (that resonate in the totalizing point–signifier) and centrifugal spiraling vortexes of difference. But aren't vortexes both, a multiplicity of entangled torsions, provisional tendencies holding together within fluctuation? Current studies in vorticity, itself a science within the study of turbulence in fluid mechanics, can help understand the complexity of the fluctuations and multiple torsions going on in vortical movement and how it emerges and dissipates across thresholds *within fluctuating flows*.

A final distinction between absolute and relative movement is offered in the concluding chapter, "Concrete Rules and Abstract Machines":

> This is the meaning of "absolute." The absolute expresses nothing transcendent or undifferentiated. It does not even express a quantity that would exceed all given (relative) quantities. It expresses only a type of movement qualitatively different from relative movement. A movement is absolute when, whatever its quantity and speed, it relates a body considered as multiple to a smooth space that it occupies in the manner of a vortex. A movement is relative, whatever its quantity and speed, when it relates a body considered as One to a striated space through which it moves, and which it measures with straight lines, if only virtual. (509)

So relative movement is mechanistic displacement of a body perceived as a totality from a fixed point of external vision displacing in a gridded space, while absolute movement is the field–movement from within as vortical multiplicity. This is again a bipolar distinction that makes it difficult to think the in-between and account for how grids emerged as contingent and inessential reduction of proprioceptive fields.

In the same section they further distinguish three types of lines:

> So that rhizome lines oscillate between the lines that segment and even stratify them, and lines of flight or rupture that carry them away. We are therefore made of three lines, but each kind of line has its dangers. Not only the segmented lines that cleave us, and impose upon us the striations of a homogeneous space, but also the molecular lines, already ferrying their micro-black holes, and finally the lines of flight themselves, which always risk abandoning their creative potentialities and turning into a line of death, being turned into a line of destruction pure and simple (fascism). (506)

34 Does this imply that repetitive oscillation comes ontologically first? As we have seen, my account of fluctuating fields needs no repetition for variation, fields cannot but be in variation, but mostly only minimal.

35 All along we see them striving to get rid of the dominant metaphysics while still thinking from its constructs, its points, lines, and oscillations. They point all the time to a field conception that would have been solved through proprioception but instead keep using the inadequate vocabulary of an abstract, incorporeal virtuality which has had multiple echoes, for instance, in Stamatia Portanova's (2013) "Moving without a Body."

The reduction of movement to line, including the curve, is the underlying problem. Underlying the vortex is the variable curve, the *clinamen* as differential subject to calculus. But this is a reduction of the vortex. The vortex points to a field that moves, but its underlying *clinamen* subjects it to the line, to calculability.

The bipolar dynamics between molar and molecular affords no consistent in-between, we are therefore always threatened by the pendulum dynamics of molecular lines of absolute deterritorialization forming totalitarian molar aggregates, or the danger of lines of flight becoming fascist lines of abolition. Nevertheless, Deleuze and Guattari gestured consistently toward a field theory in very potent ways. What a field theory can provide is what is missing in between the poles, doing away with the poles so that movement is neither pure striation nor pure smoothness.

7.6.11.3 Curves and Folds: From Leibniz to Cybernetics and Beyond

Deleuze's *The Fold* expands on the Leibnizean idea of a world of infinite folds, of curvilinear inflections, folds within folds creating cavernous bodies to infinity, folds instead of particles, folds–inflections as elastic points accounting for the elasticity and plasticity of matter (Deleuze 1993, 3–14). Now, curves have a problematic double-sided Leibnizean pedigree, and so does partly their two-dimensional trope in the fold considered as geometry, topology, and fractal.

Let's consider how Norbert Wiener founds cybernetics, an all-encompassing paradigm for communication as control in animals (including humans) and machines, based on his research on prediction of curvilinear mechanical trajectories of airplanes in World War II. His steering model of feedback accounting for control in a movement that is teleological, mechanical, and considered as the willful act of a body implies the constant readjustment of the trajectory in face of the deviations, so that predictive algorithms work along the same principle of the organism moving. An entire algorithmic culture has been grounded on this principle.

Wiener considered Leibniz the patron saint of cybernetics (Wiener 1948, 12), due to his proposal for a universal symbolism and a calculus of reasoning, anticipating computing machines, but perhaps also for how he founded differential and infinitesimal calculus as a means of calculating the infinitesimal deviations of curves. Leibnizean calculus in turn may be crucial for Deleuze's account of the virtual as completely determined (Deleuze 1994, 209), i.e., calculable. All of Wiener's predictive algorithms and the feedback model of cybernetics are about prediction of variable curves. So we have a new science of topological control aiming at the prediction and reorientation of curvilinear topologies.

Deleuze and Guattari propose a different idea, although it's hard to understand how it applies to our lived movement. They speak of water, nomadism… and weapons! We'll have to wait for Erin Manning to see how the curve and its elastic inflection points can become a promising way of opening up our linear displacements to novelty, in our daily steps or dances. Both Deleuze and Manning elaborate on the curve as that which brings in novelty within displacement. The *clinamen*, the curve is that which unfolds topological variation, and yet the curve remains a trajectory of something in a space and its inflections are points on that curve. How can this flip over to a means of enhancing novelty, as a reverse move against cybernetics?

Cybernetics is a steering model of feedback based on calculability and prediction of curvilinear trajectories. In Manning we see how the points of the curve become inflexions that allow the curve to change direction unpredictably. But we need to blur the curve into a swarming field. The body as fluctuating field is never reducible

to a curve. The body is never reducible to topology, as the tensional zones appear and disappear in the body, in degrees, like virtual particles in a quantum field.

...

The rhizome could perhaps also be taken into new moves beyond topology, as it implies an archetypal *amorphogenetic movement of growth* that creates its own field with no organic plan. How does a rhizome transduct, creating its field while relating to others? How can we relate it to field-like morphogenetic movements of growth like the ones Deleuze was pointing to in relation to the egg? Rhizomes imply different types of movements of growth, different types of ontogenesis and fielding. How can this "comparative" approach allow for distinguishing degrees and modes? We need to broaden even more the field thinking: in the morphogenesis of organisms the "plan" must be seen as long-term and open affordance for bodies moving and transforming their capacities to move within changing environments, of which a particular morphogenetic process is just an instance within larger genetic and epigenetic mutations.

Thinking of the ethical drive that connects Spinoza, Nietzsche, Bergson, Deleuze, Massumi, Manning, and others including myself, of the possibility to augment a body's capacity to vary, its plasticity, its freedom, its sensitivity, its consistent openness, its becoming with the world, how can the rhizome become a possibility to multiply connections? This is also what's implied by the image of the plateau and of the plane of immanence.

But connections between what? Connections of connections down to infinity? Molecular lines, they might say. What connects in the rhizome? Are there rhizomatic extensions or formations that pre-exist the connecting or does the rhizome propose a more radical shift to intra-action and transduction, the coemergence of interlacings and the field that emerges with them? So, multiplication of connections can never be enough if we don't open up the subject of connection as well. It is never about lines connecting, it is about a field emerging, irreducible to lines.

...

The plateau is one of the most promising concepts in trying to account for how the open consists. A plateau is a zone of consistency of more or less disparate movements (they say elements) that may "leave afterimages of its dynamism" as "a fabric of heightened states between which any number, the greatest number, of connecting routes would exist" (Massumi 1987, xv).

How do plateaus allow for the multiplication of connections and affections? By a double subtraction. First of all of $n-1$, by avoiding that molecular lines and lines of flight reterritorialize recomposing a totality ($n-1$) or that they return as fascist lines of abolition. Secondly, they do so by constantly actualizing through selecting or subtracting, redetermining. Put another way, they do so by sustaining intensity, a movement of "pure" speeds without extension, the vortical movement of the weapon in the nomadic war machine. The problem, however, is sustainability. If intensity can be thought through the Body without Organs as something in bipolar opposition to the organism (rather than the organism being one of the endless configurations of the body, some of which are more closed that others), then again we face the pendulum dynamics of order–chaos that also haunts Deleuze and Guattari. But the world is neither.

So the question they raise is not merely about creating conditions for the open, smooth, or deterritorialized but to sustain intensity avoiding that deterritorializations return as double closures, as reterritorializations or as lines of abolition. This intention is similar to mine, though the means differ slightly. Thinking the problem in terms of an abstract–virtual plane of immanence where connections are lines which either require or risk alignment into strata, segments, and territories, is problematic and implies the inevitable recurrence of closures. The open becomes an abstract plane that is always in dialogic relation to closures. But the focus on haecceties or events opposed to strata doesn't allow a proper ecological understanding of processes, as if events could happen utterly disconnected and openness would come about in this irruption of inconnex series while always involving strata.

This problem can be further clarified by the fact that the dialogic relation of actual and virtual is one of mutual dependence. No matter how much formless "pure" intensity abounds, it will always have to actualize or express in a form, a redetermination. The difference between my continuum and the Deleuzian–Whiteheadian–Bergsonian actual–virtual continuum is that I don't think of two poles or dimensions (of actual and virtual) that are always present, but only of a degree of consistent indeterminacy that sometimes might go in the direction of reduction but not always.

A further difference with Deleuze is perhaps that his is a philosophy of difference that always involves redetermination. In fact, he emphasizes the virtual as completely determined, while the process of actualization as differentiation is also a determination, indissociable from the idea of movement as a line (therefore the importance of the rhizome vs. my proposal of the swarm). Deleuze thus needs the actual as event of determination, which is crucial to his conception of difference. That is also why my proposal is not about events, but about ecologies, and these ecologies are always already memories, the ongoing minimal variation is their primary mode and events happen in relation to fields, not *a priori* of them. This also implies that I go for a continuous model where discontinuity can happen but doesn't *have* to happen, whereas a discontinuous model makes it more difficult to think continuity. In a way fluctuation is neither continuous nor discontinuous, and both.

The differences can thus be boiled down to the idea that while in Deleuze's (and Whitehead's) approaches opening implies ongoing redetermination, while in mine it implies ongoing indetermination. And more significantly still, for me the actual as determination is not an essential dimension of the real but a tendency to reduction that emerges occasionally, but not always. Determination (even if partial) is not a process intrinsic to experience, but only to certain kinds of experience associated to reduction. For me the actual is instead the sustained openness of fields.

When I propose thinking alignments, what's at stake is not just following a line, but the *becoming of lines*, their *emergence from fields without lines* by a reduction of the swarming indeterminacy and complexity in fluctuation. What we need to account for is modes of consistency that don't require such alignments. Once they are there, yes, they become perceptual affordances orienting movement, attractors, but like a path. They would stop existing and consisting without the performative reiteration of alignments.

How or why do lines of flight return as fascist destruction, how do molecular lines form totalizations? Because we are bound to a bipolar dynamics. We approach chaos and face it, but it keeps being misunderstood as a limit of absolute disorder.

Deleuze and Guattari provide many concepts for thinking what I call alignments: segmentarity, molarity, circularity (a centripetal vortex), strata (coagulations), and the plane of organization. But the resulting dynamics of interaction between the two planes as always involving redeterminations, microactualizations, or microstasis of movement, is more useful for thinking how Big Data systems and ontopower operate, anticipating the new, than for thinking beyond this capture.

7.6.11.4 Topological Digression with Parisi

How is the dynamics between strata and the plane of immanence? One way to think it is as stratification, in the dynamics where molar aggregates emerge from molecular ones. How does this happen? Parisi summarizes her reading of Deleuze and Guattari's proposal as "auto-catalysis of molecules selecting stable from unstable particles" that become "statistically ordered through patters of connection and succession that engender 'forms'" (Parisi 2004, 18). Again, like in Simondon, we have the negentropic tendency to stabilize, fighting against entropic tendencies to dissipation. Is this really the frame underlying Deleuze and Guattari's ontogenesis?

For me Parisi's formulation poses a series of problems. Given that particles would exist and that there may be some intrinsic phenomenon of selection or bond between more stable ones, from there to a form, emerging from connection and succession, there is a giant leap. Why a form? The example she gives of an autocatalytic assemblage of DNA statistically ordered in sequence and engendering a cell membrane eventually misconstrues the long-term process by which metabolic assemblages leading to proteins coemerged along with RNA and DNA molecules and with membranes, gradually consisting in the autopoietic movement field that we call the cell.

But let's continue with Parisi. She explains that "forms are modes of coding and decoding matter [...] into signs" (2004, 19). This follows Deleuze and Guattari's elaboration on Luis Hjelmslev by which formed matter emerges from unformed flows bottom up without any transcendent relation to a preexisting signifier, creating substance as formed matter that relates to territorialities. Content corresponds to formed matters, expression to the functional structures of matter according to their specific organization.

Thus the basic interplay runs in terms of codification, overcodification, and decodifications of forms, or as territorialization–deterritorialization–reterritorialization of substances, in a quintuple unfolding. For instance, in the stratum of what Parisi calls biocultural organization of the body–sex, *matter of content* is biophysical mass, stratified as *substance of content* in the organism and as *form of content* when the organism gets ordered or classified in particular ways. The *form of expression*, in turn, is the set of codes ruling human sex, while the *substance of expression* is the particular letters and phonemes composing words or expressing rules. These can then be taken onto a new level of recodification in the stratum of biodigital sex. Every recodification implies a decodification. Transduction from one stratum to another is through conversion of information, involving overcodification, translation, and transduction of patterns (viral conversion or mutation). Overcodification goes along a decodification and a recodification. In the turn to the biodigital, one enters a recombination of excessive flows, a modulation of smooth space that recodifies the formations of disciplinary sex that she describes as encoded in bifurcatory manner into sadism and masochism. But this schema derived from Hjelmslev reproduces a number of assumptions about matter and movement as pure quantitative flow that needs to undergo selection, thus preventing a thinking of the dynamics of movement–matter

itself. Actualizations in form are the necessary condition, the instance that unfolds the potential to vary whereby the body, as power of variation (*cónatus*), is defined in two axes, a kinetic–extensive and an affective–intensive one.

Parisi launches an immensely promising reconceptualization of sex through the abstract machine of Lynn Margulis's serial endosymbiosis but flattens it in the same go by reducing it to coding–decoding–recoding processes related to form, where openness is again placed on an abstract and incorporeal virtual plane. She promises a kinetic ethology of microsex (the thousand tiny sexes, as molecular compositions of intensive bodies), but there is no account of the extremely diverse movements composing fields (what Deleuze and Guattari call strata), which get flattened to a movement of codification which in fact is only applicable to one type of field that I know: algorithms and code. As Wiener with cybernetics, Parisi also applies a reductionist mode of movement in order to account for everything (biophysical, biocutural, and biodigital modes of organization). This process also allows no politics as it is implicit always and everywhere. Virtuality is always there lurking... but when does it get reduced, how to open up to it? If it is always there what should we care? How does her proposal of a "microfemine warfare," mobilizing the microvariations of a body, get enacted? How do we drift from the stratified body without having to return to it?

But she is pointing in a promising direction by taking Margulis's account of bacterial sex as model, where every bacterial colony is itself a mutant composition or sex, each one corresponding to one of the endless tiny sexes, where mutation happens transmodally across all modes of composition of a body. By abstracting the mutant force of sex in hypernature Parisi neutralizes the politics so that cloning in the lab is compared, in terms of power of mutation, to bacterial sex. But where bacteria mutate without program due to other movements, relations, creation of ecosystems and slowness, lab cloning instead is about algorithmic management of DNA following radical logics of optimization and control in exponentially accelerating, planetary-scale systems: the opposite move.

In Parisi (2013) and Parisi and Goodman (2009) she focuses more specifically on the digital realm and the way in which computation itself involves novelty in algorithms because of the fuzzy nature of mathematics and of how infinities appear in between numbers, and she presents topological design as an example of this. The computational design of topological objects and architectures defining everyday environments involves the introduction of novelty and randomness in the design itself, where points become inflections for designing curvilinear surfaces that introduce infinitesimal quantities, variations, randomness, and fuzzy numbers into curves.

This becomes on the one hand a new kind of (postcybernetic) control in which emergent desires are subject to new modes of preemption precisely through the novelty built in the smooth curves of objects and architectures, as new type of preemptive power. Parisi and Goodman (2009) also argue how to contest this through a "rhythmic anarchitecture" as aesthetic paradigm in which instead of creating smooth, continuous topological architecture of control one may unleash the discontinuity within topology, a rhythmic discontinuity. In *Sonic Warfare*, Goodman then relates this rhythmic anarchiteture to particular embodied practices, such as the music of African diasporas (Goodman 2012).

Parisi and Goodman claim that rhythm is an algorithm. This appears problematic even if one considers algorithms as capable of generating their own fuzzy novelty. Isn't plastic rhythm, emerging in the murmuring multiplicity of quantum fields, pre-

cisely the reverse of an algorithm, as mathematizable sequence of steps? The problem of continuity vs. discontinuity changes in a field theory of movement as discontinuities may appear in fluctuation, but not necessarily, and always as relations.

Parisi provides tools for thinking control and preemption. The idea of topological or postcybernetic control is interesting for considering the shift from a *predictive feedback* to a preemptive *feed-forward* scenario of ontopower, in which algorithms are constantly producing the new in the attempt to anticipate novelty in movements and desires by continuously reengineering perception.

Her consideration of the autonomy of algorithmic entities diagnoses a tendency to or of control but ignores the entanglement of these algorithms with a wider dynamics. The metaphor of algorithmic contagion as mutation ignores the radical homogenization of movements of binary code implied in its infrastructures, which are also the ones connecting algorithms to the wider world, through sensors and interfaces.

In *Contagious Architectures*, Parisi (2013) defines the logic of computation as one irreversibly infected by incomputable randomness, defined by the ingression of random quantities into computation, infinities in which the feedback of cybernetic control becomes a feed-forward of postcybernetic control. This lies beyond the smooth–striated opposition in this new regime, where infinite quantities infect finite sets of rules, infinities inserting themselves in between any point, enforcing computation to continually recompose new rules. This points to a particular mode of prehension proper to algorithms: the prehension of their own formal system and of the data inputs. But this process implies a contagion due to the mutation of rules in relation to the infinite quantities that infect them. This operation lies at the core of computational design of architectures, objects, and immersive environments which preempt novelty by bringing random variation in the design of topological objects, as continual variation of curves, where the autonomous realm of algorithmic prehensions, inaccessible itself to human experience, makes itself however felt.

What Parisi misses is a broader account of the movement fields of which algorithms are part: the whole kinetics of the Algoricene and of many other types of movements that are irreducible to computation, starting with our own proprioception, which would allow also to place what she calls *soft thought* within a broader ontopolitical scenario, in which our proprioception could be a formidable resistance to preemption. Or are we to leave it all to the algorithms' fuzzyness and stay immobile at home? Where did the body go in this theory, even the body of the algorithms, whose movement and materiality seems to be neglected in favor of their logic?

If the politics lies in rhythm, with which I agree, it is crucial how to define it. The problem is not in discontinuity. The historical war is between rhythm as meter and rhythm as plastic. But how does plasticity emerge? It was always already there, in the fluctuations of fields, but it needs to get enacted, cultivated always in new ways, through improvisation.

7.6.12 Beyond Chaos and Order: Undo the Priest's Promise of a Sweet Death!

In "Subtraction and Contraction" Quentin Meillassoux (2007) further develops the scheme of immanence from Deleuze and Guattari's *What Is Philosophy?*, proposing to have a fully immanent account of perception as always only subtracting from the flows of matter, perception as selection from an infinite homogeneous matter flow whose differentials within happen as the deviation of virtual (incorporeal) lines of

variation, cutting across flows and creating folds within immanence, where virtual lines are fully determined, as in Deleuze's virtual but nonequivalent to any actuality in matter flows. Perception is thus emerging within the flows of matter when the body effects a nonconscious selection and is neither divorced from a reality inaccessible to perception, being immanent to it, nor metaphysically grounded in a pure reason. Yet unlike in Bergson, where difference comes in through contraction in duration as the mind–memory effects a second selection (thus not completely immanent), Meillassoux proposes difference as the deviation coming through transversal virtual lines, thus holding entirely onto immanence.

But why is it necessary to seek recourse to a virtual incorporeal deviation in order to bring in novelty and difference in flow? It seems that the old homogeneous conception of movement as line is still the underlying problem... and of chaos as disorder. The bipolar world goes on, and perhaps indeed the father of all dualisms is the chaos–order dualism, which has haunted us since the origins of philosophy in the search for putting limits to movement.

However, in another promising turn, bringing in Nietzsche, Meillassoux proposes that the living is a discontinuous loop whose becoming is in movements of narrowing and expansion, reactive and active becomings and deaths, closing down on itself (reactive) or sustaining openness (active), where the open is not a free-willing selection but an opening up to radical exteriority in undergoing experiences. Meillassoux also inquires how is it possible that the reactive closure also propagates and dominates, and associates it to the priests' promise for a sweet death as opposed to the philosopher's promise, the opening active force that faces the terror of approaching chaos.

But in my field theory perception is neither subtraction, nor synthesis, nor contraction. There are no absolute flows, no homogeneous matter flow from which to select. Flows are never lines, they are fields. Perception is never a selection nor an addition, it is one aspect of the un/folding of movement into new kinds of fields. Every new field has its perception, every perception expresses a field. There is no virtual plane or line, there is rhythmic plasticity in fluctuating fields that affords movement to be continually open. Novelty is intrinsic to fluctuation as soon as differentials proliferate in consistent openness (neither too undefined nor too bounded), fluctuations unfolding, intraducting, consisting. Since movement is never a linear homogeneous flow, it is not a question of subtracting from an infinite flow but of the infinitely diverse kinds of movement relations that unfold in or as fields.

The reactive then is not only about closing down upon oneself. It is the reductive nature of certain movement fields that can have an intensified force of propagation, which explains the dominance of reduction. Reductive movements propagate in an intensified way! So, chaos is not the terror of absolute openness, it is a degree, force, and movement of sustained opening within fields.

Undoing the phantom of chaos as terrifying disorder is crucially part of our task. We need to invert the idea of chaos as disorder and unmask the false promise of the sweet death of the priests.... Let's bring back Metachaos as opening or interval! (Not Hyperchaos, Meillassoux's proposal (2014) for an absolute contingency which is perhaps yet another abstraction, that reiterates the phantom of terrifying chaos). Let's embrace chaos as opening, propriocept it, and dance with it in new ways!

7.6.13 Massumi's Charge of Indeterminacy

In *Parables for the Virtual* Brian Massumi (2002) develops a focus on movement as qualitative variation, which defines the potential to vary as intrinsic and core to what a body is as moving body. Quantitative measurement, he denounces echoing Bergson, says nothing about qualitative variation, it leaves out the essential, movement's power to vary, in favor of an invariance, a positioning. While Massumi keeps working within the Deleuzian–Bergsonian tradition of an imperceptible virtual aspect as defining the openness in movement, where qualitative variation emerges, he also brings attention to proprioception in novel ways, particularly in relation to the concept of biogram.

Echoing Simondon's idea of the preindividual as being out of phase with itself, Massumi claims that the moving body never coincides with itself (as a defined entity or being), but with its own variation. One could ask, however, whether there can be an aspect in the body that is not variation, a being in itself, at all. The reply Massumi gives is provisionally this: the "body in itself" is linked to a position in a grid (2002, 2). The moving body is an "immediate, unfolding relation to its own nonpresent potential to vary" (4), a relation which is real but abstract, where abstract means *not present in a concrete position* (in the grid), but in passing, and real as it relates to the immediate relation of a body to its capacity to vary, which is its own indeterminacy.

This potential to vary constitutes a "charge of indeterminacy" (5) that a body carries like it were an electron cloud, inseparable from it, "it strictly coincides with it" (5). This charge of indeterminacy, as relation of the body to its immediate capacity to vary, is considered incorporeal although real (and material, down to quantum fluctuations!), like a phase-shift implicit in every movement, "an ontological difference [at] the heart of the body" (5), which is ontogenetic, relative to emergence. Something like the *clinamen*, as implicit differential within movement. This charge of indeterminacy of a body is related to a virtual incorporeal plane or mode, which coexists with and is contemporary to every movement with the positioned body-in-itself that displaces in a grid and which defines a field of the possible.

Again, what sort of body is there besides variation itself, and then how could variation itself be incorporeal (or what concept of body is needed to exclude variation from its actuality)? If there can't be a body fully devoid of movement and variation, fully reducible to a concrete form, isn't the corporeal the variation and the incorporeal in the form? How far does form limit the potential to vary, and is this limit a universal conditioning for bodies to unfold? "Grids happen" (8), but, I would ask, *do they need to happen?* Is movement always bound to the bipolar dialogue between a plane of organization and a plane of immanence? Or can we afford a way of thinking the body's consistency as variation and nothing else? For this we need a field theory of movement and perception.

Massumi relates the problem of the corporeal–incorporeal to feeling, a concept of feeling that exceeds the conscious awareness of a rational subject. As Leibniz, Nietzsche, Bergson, Whitehead, and others already claimed, most of the world's affections going on in bodies are too small to be directly sensed; they are in the realm of microperceptions. Conscious perception is but a minimal part and surface effect of these processes, hence its blurry nature (as in proprioception). The perception of neatly defined borders in the world became only possible with the dominance of fixed points of vision in linear perspective.

The idea that the virtual as potential to vary and movement in general cannot be directly sensed except as its result or effect in a visual form, as positioning in the grid, we already saw emerge with Nietzsche, Bergson, and Deleuze and Guattari, and I already pointed out that this is due to the lack of alternative accounts of perception and the predominance of fixed vision as operating by reduction. This has conditioned defining variation, the active force of opening in movement, as nonsensuous movement, which on the one hand is a charge of indeterminacy and on the other requires actualization (a redetermination) without which it wouldn't consist into anything. Variation as an abstract virtual plane that cannot be sensed directly but can be felt as an effect.

Massumi claims that we need vague concepts and concepts of vagueness to approach ontogenetic indeterminacy in a body. He already points to the notion of field as a useful tool to approach the dynamic unity of self-relation (to one's own variation) and the heterogeneity emerging with it (the variety resulting as actualization of the potential to vary). He also claims the importance of the Bergsonian revolution in rethinking movement, by which position (our enemy) is a secondary residue derived from movement or emerging within it. Positional grids emerge from movement and feedback with it. Indeterminacy and variation are primary, constituting the field of emergence, and yet, like Bergson, Massumi also claims that variation and position go together, inseparably, as two ever-present poles of reality, so that movement always requires actualization in a displacement and variation only operates in relation to that actualization. Importantly, transitions are accompanied by a *variation in capacity* to affect and be affected, where Massumi elaborates the link to Spinoza more specifically.

The realm of the possible registers from sets of previously formed movements, as reconditioning of the emerged, whereas potentiality points to the virtual side as conditions for emergence. Space is one such reconditioning emerging in the process from more irregular rhythms composing the background field. How does the formed feed back into the unformed field of emergence? Massumi replies through Simondon: germs of form, unformed elements such as attractors, distributions of potential energy defining metastabilities, and resonances conforming nonlocalized relations, constitute the emergent dimension of the pre-individual which is a continuous field, out of phase with the individual and forms that emerge from it and return to it, as differentiated region within a larger field (ultimately the entire universe). As soon as shapes form, they dissolve "as its region shifts in relation to the others with which it is in tension" (Massumi 2002, 34), regions which are separated by dynamic thresholds fading to infinity, not by sharp boundaries. These fields are open (thus challenging also the idea of immanence).

So far I entirely agree. But now comes what I see as a problem: this contraction or infolding requires an unfolding "in three dimensional space and linear time-extension as actualization; actualization as expression" (35) where the field finds its *limit*.

The bubbling soup of potentials of "implicit form" is $n-1$, "the sum total of a thing's interactions" (35), its potentials, which are its *relationality*, but not the thing as itself defined, abstracted into a dimension of experience into which the formed can feed back, through affect as middle term. Wherever reality is split in two (ever since Plato) there is always a middle term needed (in Plato it was *khōra*). This conception grants to the actual limitation a status of indispensable *a priori*, even if it seems to come after the field of unformed potential. Affect is this two-sidedness as

reciprocal participation of one dimension in the other. But importantly *relationality is linked to potentiality*.

Again I think that this assignment of indispensable *a priori* status to linear space-time as the condition for actualization, and this actualization as the necessary way of expression in all levels of reality, comes from assuming perspectival vision as necessary framework that imposes the illusion of position and displacement by ignoring the actual fluctuation that is always going on in movement itself.

Massumi points precisely in that direction when he defines affect as synesthetic, as participation of the senses in each other, where a "measure of a living thing's potential interactions is its ability to transform the effects of one sensory mode into those of another" (35). But isn't multisensory integration the very *a priori* functioning of the senses that Sherrington prolifically depicted in 1906? Furthermore, is this integration not *a priori* anchored, by far not in an actualization into linear movements in extension (an illusion precisely deriving from erasing multisensory integration) but on a proprioceptive matrix that is defined by its fluctuating, amorphous nature? Like Bergson, Massumi points in exactly the right direction, but, as in Bergson, the virtual is taken as detour.

...

It is the chapter on the biogram in *Parables for the Virtual* where Massumi again points in the most promising direction, elaborating on proprioception and its potential for a radical philosophical shift. He emphatically claims (and I couldn't agree more) that "something is rotten on the shelf of spatial-experience theory" and that the "computational fiction is a natural outgrowth of the assumption that we effectively move through and live in a static, metric or quantitative Euclidean space" (2002, 181).

Massumi confronts on the one hand the predominant way of considering our orientation in space as guided by the visual recognition of objects, symbols of shapes, and on the other the proprioceptive system as self-referential, in which movement is "no longer indexed to position. Rather, position emerges from movement" (180). Indeed, the narrowing visual orientation emerges from the proprioceptive field, also at evolutionary levels of the exteroceptive senses. He continues:

> Our mappings are riddled with proprioceptive holes threatening at any moment to capzise the cognitive model [...]. No matter how expert or encompassing our cognitive mapping gets, the monstruous sea of proprioceptive dead reckoning is more encompassing still. We are ever aswim in it. (181)

So, the proprioceptive matrix could be seen as a broader field of which visual orientation in Euclidean space would itself be a limitative (and dispensable?) outgrowth.

Massumi's own description of proprioception's operation is promising in describing its relational and emergent nature, how its twists and turns differentially enact a rhythmic field where the multiplicity fuses in a unity of motion, whose dynamic form is however never accurate but intrinsically vague: "A self-varying monad of motion [...] figuring only vectors," conforming an "anexact vector space," which means sustaining multiplicity all along even as the body seems to be displacing, walking in a street and so forth (183). He correctly states that in order "to get a static measurable, accurately positioned, visual form, you have to stop the motion" (183). In other words, you have to align proprioception to the fixed point of vision of perspective as its most limiting outgrowth on Earth so far.

But Massumi deviates from this promising idea, stating again a division into two dimensions of experience that would however connect in a "topological hyperspace of transformation" (184) Proprioception itself is defined as having a topological nature in how it constitutes a field in continuous deformation whose constituent geometries (the body and its tissues–joints), however, do not change their basic structure, a topological reducibility that I already questioned. Proprioception cannot be reduced to topology because it swells up from quantum fluctuations along the evolutions of the universe, metafractally. So on the one hand there is this self-referential field and on the other the field of visual orientation in Euclidean space. In other words, there is a split between prioprioception as entirely self-referential from vision as exoreferential.

But, as I already mentioned, this is at odds with the *a priori* operation of perception. Already Sherrington in 1906 elaborated an understanding of the integrative function of the nervous system, where the proprioceptive, exteroceptive, and interoceptive fields are constantly and deeply cooperating in creating experience and the body's action. No experience is ever happening in just one sensory receptor or channel, or even in just one of the fields. So what we need to understand is how proprioception always already incorporates experoceptive sensations in activating the body's capacity to move, and vice versa, how visual orientation needs to be grounded in proprioception. So, rather than thinking of two separate systems that need a topological, abstract hyperspace to connect, we need to see them as degrees of a continuum. Vision emerged through evolution from proprioceptive fields and mostly in balance with them. It is in *sapiens* and in the evolutionary blink of an eye since the emergence of linear perspective, where it took over, by immobilizing and aligning the larger field. Once we have created a planetary-scale field of symbols, geometries, and abstractions, we need to rely increasingly on external orientation, but only with regard to that particular dominant field.

And yet Massumi launches a promising call for doing artistic and architectural experiments which in a "rigorously anexact way" use "proprioception as the general plane of cross-referencing" (191) in elaborating "technologies of emergent experience" (192), having them "become infrastructural to architectural engineering" (192). This book, and my artistic practice, could be seen as an elaboration of these ideas.

...

In "The Art of the Relational Body" Massumi (2017) promisingly questions the dominance of directedness in perception and the pathologization of synesthesia, suggesting art as "experimental practice for composing new peaks of perception expressing the living, moving body's qualitative multiplicity, unfolding in new variations its capacity to change" (2017, 205). Art is a recomposition of the *peaks of experience*, which involves recompositions of multisensory integration. This can be cultivated as soon as we acknowledge proprioception as the broader matrix of integration of all sensing modalities with movement, whereby proprioception is not amodal, but trans- and metamodal. In itself it's a modality, but it also integrates all others with the body's unfolding as field.

7.6.14 Manning's Relational Incipience

My discussion of Massumi's concepts, as evolutions of the dicussions in Bergson and Deleuze, has set the stage for my treatment of Erin Manning's philosophy of move-

ment, which has been a source of inspiration for my rethinking of movement. My concept of Metabody is based in part on Manning's idea of the relational body and the interval, whereas openness and *clinaos* or *clinamen* have evolved in resonance with her concepts of *incipience* and *preacceleration*. Her idea of plastic rhythm also enriched my own digressions on rhythm and the metabody concept. All of these feature prominently in her *Relationscapes* (Manning 2009). But also some later concepts, of *bodying* as ecology of processes, of dance as "techniques for distilling from the weave of total movement," as the unformed, related to affirmative vitality forces, "a quality that composes a bodying in motion" (Manning 2013, 14), and more particularly on the minor gesture as politics for weaving ecologies of the open, and especially *autistic perception* (Manning 2013; 2016) as field perception and as nonreductive, or less reductive mode of perception, continuously open to the uncategorized.

Manning proposes a complex conceptual field, strengthened by the fact that she is also a multidisciplinary practitioner, and by the embodied politics of movement that the field implies. What *moves me* with Manning's theory is the movement of thought. Relational incipience is not just a concept, it is a movement of opening in thought itself.

7.6.14.1 Incipience and Acceleration

Let's start with the concept of *incipience*, which Massumi mentioned as related to intensity. First of all, incipience relates to a fundamental idea of movement as always ongoing, in absence of absolute rest, the idea therefore that it has no beginning, it has always already begun and is always already moving forth. But incipience is never just this fact, more importantly it signals the radical openness at stake in this being always in the move. The way Manning elaborates this is through the concept of *preacceleration*.

Before considering preacceleration, let's remember first what is acceleration, as mechanistic concept related to inertia and the preservation or change of direction in movement. Acceleration is the *rate of change in velocity* of an object with respect to absolute time. It relates to Newton's second Law of Motion which states that acceleration is proportional to the force applied, and takes place in the direction of the applied force. Acceleration is thus already linked to the determination in the change of speed and direction of a mechanical trajectory. What would preacceleration be instead?

Preacceleration concerns the *indetermination that preceeds and exceeds acceleration*, the potential to vary direction in unpredictable ways, due to the multitude of forces going on in a body or between bodies, that make them irreducible to a single, mechanical, object-like totality. One should reverse the story and say that acceleration is only an occasional tendency, when the body's fluctuations consist into a *dominant vector of motion* that implies displacement. But the measurement of a movement always leaves out its essential indeterminacy and plasticity. Measuring is a conservative gesture that attempts to fix. This can be applied to any attempt to measure movements with computational systems, including in the coupling of dance and technology. A sensor never gives account of movement, but it can help you discover new movements instead!... in going from an attempt to fix toward a will to open up and transform.

Mechanism allowed the emergence of a society of mechanical bodies and machines following trajectories: railways, automobiles, airplanes, ships, elevators. The dominant conception of movement evolved in relation to these kinds of bodies

and the need to control them. But this need to control and determine trajectories is precisely because of the fluctuations happening in the surroundings and even in the mechanical body itself, whose matter reverberates in unpredictable ways, diffracting the motor's vibrations.

So, back to Manning, one could say that any fluctuation can bring in unexpected variations, redistributions of force that imprint a new direction on movement. Like Massumi and Bergson, she assumes that there *needs to be* an actualization in a displacement. This is not just determinism, it is seen as the necessary expression of the virtual without which it would remain unexpressed. Again, I challenge this through the proprioceptive field and the idea that most of our movements don't imply displacement at all, and even when they do they are never only that, proprioception being the broader matrix of which displacement is part. Stretching in bed, making micro-adjustments of posture on the sofa, clicking at the computer, gesturing in conversation, playing the piano, painting, dancing in one spot, hugging someone, kissing or sexing, the body fluctuates in its tensional zones. It flocks, it doesn't displace at all. If while painting I move back and forth from the painting this is not in an extensive Cartesian frame of reference but is part of creating an intensive relation with the painting as a flock of proprioceptions.

Taking this further though my swarm theory one can say that a displacement is part of internal fluctuations in a larger proprioceptive field (city, society, family, room, etc.). Simondon would express this as the intrinsic relation of individuation and transindividuation across degrees of magnitude, where every collective is itself an individuation, a fielding, a flocking. One can say that a society's proprioception is made of the fluctuating rhythms, orientations, and contacts that its bodies–cells sense and enact, not so dissimilarly from how cells in a body enact an organism's proprioception. An algorithmic or geometric field's proprioception is made of the way bodies enacting it reduce their perception to calculations or the logic of code. One could say that an Euclidean space senses itself (thus holding together in its consistency) through the calculation ratios of geometry, actually enacted by geometers, enacting architectures, orienting actual movements.

In any event, preacceleration as a concept opens up the deterministic mechanistic idea of acceleration and makes a strong step toward thinking the openness in movement. So, incipience as preacceleration is this capacity that movement has to change, not only direction, but the overall field fluctuation. It moves to the "before" of acceleration, thus shifting our attention from something that seems to be inevitably going on in deterministic manner (a measurable acceleration), to the emergent impulse whose direction is not yet defined.

The concepts of preacceleration and incipience itself are a movement, they imply a shift of attention, so that one can suspend oneself and linger in the interval instead of ignoring it. One could perhaps take it even further to a meta-acceleration (or an anti- or nonacceleration), a body that resists fully taking on a dominant vector of motion.

7.6.14.2 Relationality

Incipience is intrinsically related to the concept of *relational movement*, which already appeared in Massumi but takes further consistency in Manning. Indeed one can say that relation happens only in incipience and preacceleration. This can be traced back to Simondon, where relations are possible due to the charge of preindividual potential that we always carry, which allows a relation itself to be an individuation

process, not a mere connection between two existing individuals, always implying a milieu.

Massumi already expanded on the idea of the virtual as the totality of potential relations of a body. Incipience is also an interval or nexus that opens movement up to that virtual reservoir, continuously, all the time, contemporaneously to any displacement. The primordial relationality is the one of an actual body with its virtual potential. A relation between two bodies will also be an individuation actualising a preindividual potential.

The relationality of movement between two bodies is defined not in actual terms of how I move with you through an already defined extensive motion or displacement if we dance together, but in relation to that reservoir of potentiality that gives the emergence and vitality to our dancing together, in how we manage the momentums, the suspensions, letting fluctuations express in an emergent dynamics. As we dance together our preaccelerations meet in a relational interval where both cocreate an emergent intensity because both are open to variation across their fluctuations and intensities. This variation happens always in the missing half second of preconscious activity where the propriocetive body is fully active before conscious selection comes to censor, steer, and redirect.

So this brings in the concept of the *interval* as a multifaceted opening (a chiasm or chaos) in which a body moving (relating to its own complexity!) or two or more bodies moving together (and individuating a relation) are open to fluctuation and to creating together a new multifaceted rhythmic impulse. The momentum is, as in Spinoza, the suspension moment between accents of rhythm where things can recombine, as passive-actives tendencies are momentarily suspended.

Here enters the idea of *pure plastic rhythm*, which Manning takes from Umberto Boccioni, as constitutive of a body. Rhythm as impulse is an internal differential emerging in movement, which means not with an external reference or measure, but with accents referring immanently to previous accents in composing their field. Meter is dead; it is just the repetition without variation of the grid of measurement. Rhythm can only be alive as long as it exceeds the preexisting grid and transducts its own field, its emergent dynamics propelling an impulse. This impulse is what creates suspensions, moments of shift where a change can occur, always moving on: momentum. Momentum reminds of Plato's *exaiphnē*, as the instant of change between movement and rest which is neither–nor. This suspension, this neither–nor, is a radical undecidability at the core of movement considered as field of multiple affections, which I think of as a swarming field that sustains all along a high charge of indeterminacy, only a minimal part of it consists into a particular vector, and only a small part of the vectors becomes a displacement that takes the body–flock in a direction as a whole.

So, the interval, already within a singular proprioceptive body–field, is huge, emerging from endless entangled microfluctuations, across degrees of magnitude, down to (or up from) quantum fluctuations in every molecule, a swarming multitude fading to infinity. This is how actually I see or feel the proprioceptive field, and this is how I elaborate on incipience in excess of any incorporeal or abstract plane of the virtual. Fluctuations are there all along. Rhythm cannot but be plastic, since it emerges with the swarm of nexuses and intervals. Its openness is also its consistency and aliveness. A body that minimizes its rhythmic plasticity, that becomes mechanical repetition of a predefined pattern, would be dead. We are surrounded by such bodies in our mechanical–digital culture, and certainly affected by them, though our proprioception still keeps us alive.

Incipience as preacceleration is core to relationality, as the aliveness that evolves through plastic rhythmic momentums as internal differentials in fields. Incipience is openness, relationality is consistency, always already a multiplicity of relations holding together, but we see that both are entangled, consistency is thought through its openness or incipience, which is thought as the multitude of relational nexus or intervals composing a field or body, as already expanded in a milieu of potential relations, very much like an electron cloud enables a field of potential relations of the atom, which which it is always bound up. The field is the atom or the body.

7.6.14.3 Technoecologies of Bodying

Manning will say that in fact there is no body as such, there is a *process of bodying*. And this bodying acquires an ecological dimension (a metabodily one) as ecology of practices, as techniques and practices in which a bodying emerges in sustained manner, distilling qualities "from the weave of total movement" (2013, 14). One could say that the more a body appears to be determined, the more it expresses a reductive field of systemic ontoviolence, a field that forecloses its variation, that captures its becoming in a being.

Manning also elaborates on the *elasticity* of incipience and does so seeking recourse to the curvilinear movements and elastic points deriving from Deleuze's reading of Leibniz, where points along movement trajectories become ways of modulating, opening up, changing the unfolding of the curve, instead of fixing and dominating it. Subversion of the point. These elasticities that open up movement to the virtual through curvilinear elastic points are always in dialogic relation to an actualization in extension. Subverting the point to an inflection can be a powerful tool for opening up movement beyond its mechanical accelerations. But I suggest ways of thinking that exceed the point–curve trope. My account of the elastic interval where incipience and preacceleration happen, is the fluctuating fields' energy–density fluctuations.

Elasticity for me is the intrinsic property of our muscular sense of proprioception, which is a tensional–torsional field distributed across our swarm of 360 joints. But where the joints are an evolutionary aftermath, the swarm is always molecular, in microtorsions of tissues, in ever-changing tensional regions in between the joints, so that the joint is not determining a topology, but is part of a larger whole where tensional zones can emerge nonlinearly across joints, also in the indetermination center of the brain, creating nonlinear connections across nonconscious sensations.

Manning claims that bodies are never reducible to displacement, although they still seem bound to it to some extent. But movement creates its spacetime. When a room is full of dancers dancing, the room dances, the movement takes over the fixed Euclidean space. This is seen as part of a politics of movement, of making the world into a dancing room that invents its spacetime by mobilizing the movement intervals between bodies, multiplying to infinity.

> These are not politics we can choreograph, but politics in the making. These are not politics of the body, but of the many becoming one, increased by one. The body-in-deformation is a multiplying sensing body in movement: many potential bodies exist in a singular body. These are politics of that many-bodied state of transition that is the collective. (Manning 2009, 27–28)

This simultaneity, she claims, can become a transgression of duration, a recomposition of the virtual itself, as it's kept active, intensified, where, in José Gil's words, all gestures merge into "an impossible body, a sort of monstruous body" (Gil 2002, 123) a body that prolongs gesture into virtuality, beyond what can be perceived. For Manning this relational body is always more-than-one and also more-than-human. Indeed, both are connected. A single body is already a multiplicity. When this multiplicity connects to other bodies two things can happen: they align following homogenous orientations of a preexisting field or they cultivate the openness in reciprocal enfolding of a new one.

"The time of the interval is incipiency," a sort of virtual time, neither present instant, nor future, nor past, if anything a future past. Manning points to proprioception as giving "clues that precede our cognitive understanding of where we are going" (Manning 2009, 14). This, in Forsythe's words, may unleash a multitimed body of such a complexity that one cannot not anticipate its unfolding (Forsythe 2003).

Manning also builds upon Dalcroze's elaborations on rhythms as related to proprioceptive complexity: "Movement produces rhythms, as rhythms produce bodies" (2009, 132). This can only be explained through the body as complex proprioceptive field that sustains multiplicities of rhythms at the same time. "Polyrhythm is the capacity to become through movement on more than one plane at once" (139).

7.6.14.4 Micromovements and Virtual Movements: Dancing with Gil's Total Movement

In "Three Propositions for a Movement of Thought" Manning (2015) elaborates on the idea of virtual movement through Gil's account of *total movement*, where the body's balance is always fluctuating, and maintaining it implies a constant state of readjustment of posture through micromovements. Here we can see in more detail how the virtual manifests itself, is acted out and can be developed. Gil speaks of how in dancing,

> Once the center of balance (torso or spine) has become an autonomous mobile force rather than a static vertical axis, it becomes possible to disarticulate movements from one another, since they no longer have to relate to a fixed body part, but can relate to one that is itself mobile. And since movement has been decomposed into multiplicities, a limb no longer has to align itself with only one body part and with that part in only one position to derive a sense of balance, when numerous parts are available. Any part of the body can now enter into composition with several mobile and plastic axes: movements of the arms and legs will anticipate future points of balance, while simultaneously balancing the body at "this moment." Call this a paradoxical or metastable sense of balance — as Deleuze would, after Simondon — presupposing tension and movement and especially a sort of decomposition of the whole body into its parts [...]. a mobile balance is achieved, inducing the simultaneous superposition of multiple positions in space. These movements achieve a maximum power of deformation and asymmetry through non-organic variation, as if many bodies were to coexist in a single body. This increase in articulation allows divergent series of movement to arise at the same instant: a series of gestures disconnected from another series of gestures in the same body. (Gil 2002, 119)

In *Metamorphoses of the Body* Gil (1998) speaks of an infralanguage in movement that poinst also in the direction of a world of micromovements going on in the body, which are crucial for expression. What Gil depicts is the proprioceptive body as deformation field, as multiplicity of kinetic chains with noncausal enfoldings into one another. These micromovements can be seen as ingression into the larger field of potential variations in a body, where each balance is a metastable dynamic equilibrium made of infinite micromovements too small to be felt, where "a micromovement is not simply a smaller movement. It is the vibrational force within actual movement that agitates within every displacement, within every figure or form" (Manning 2015, 119).

Manning differentiates these micromovements from a virtual movement, which is related to the capacity of thinking itself to further destabilize (and open up to variation) this already multiple body, which is why one needs to concentrate. If you think about something else in trying to hold a yoga position you will find it much harder to sustain the balance, the thought will destabilize further the already unstable landscape of micromovements. So thinking is, she claims, another type of vibrational force active within micromovement. This way in which the virtual movement of thought is immanent to micromovements as two planes of vibrational force (vitual and actual), where thinking is immanent to moving, is how she identifies thought and movement as becoming one.

This body is also relational in that it attunes to its virtual field of potential relations, in which bodying becomes environmental and feels effortless because it moves with whatever is around, and not against it, effortless because it doesn't impose alignments on movement, but its movement re-energizes as fluctuations unfold. It is alignments that enforce dissipation by wanting to channel movements. Although we may partake in a common gravitational field, but our biochemical, electromagnetic forces create multiple alliances in excess of gravity. Our nervous impulses are not determined by gravity.

> It cannot be thought outside of its implicit co-tuning with the associated milieu — the relational field or interval — of its emergence. Bodyings emerge in the activity of intervals — these thousand tiny balances, these thousand incipient preaccelerations. The emergent field of movement-moving in its multiple metastability is momentarily directly perceived. [...] a bodying in motion that expresses itself with a quality, perhaps, of effortlessness, effortless because it is not the subject, not the pre-formed body doing the moving, but the relational field itself that moves. The movement-moving is activating an environmentality that resonates with everything in its path. The resonant field of relational movement is itself on the move, creating a multiplicity of balances in the making. The field of dance has opened to the more-than of its physical iteration. There are not two dancers, but 2+i, where i stands for interval, individuation and the "infinite infinite. (Manning 2015, 120)

At the same time she claims that "It is thought in the moving that holds these intervals together. Thought as a relational withness of movement-moving, thought as that which activates the complex constellations of the virtual and the actual co-combining in the moving" (120).

Now, I would like to suggest that micromovements are the core of the proprioceptive field and their fluctuation is an ever-present sensation and quality in move-

ment if one pays attention to it, that comes into the perceptible realm as microtorsions affect entire tissues, murmuring in vague zones of tension. There is nothing virtual or nonsensuous about this, though it exceeds reductive consciousness as it emerges, in its irreducible vagueness, from the body's self-organizing dynamics. It is here where reductive awareness meets the broader nonconscious agency of the body, BI, Body Intelligence. But it is an overfullness of sensation, a *bodyfullness*, not a mindfulness. It is the indeterminacy at the core of proprioception and perception: there is no perception that can ever fully detach itself from it. One can minimize it, ignore it, deny it, as we have been doing for six centuries of alignments with fixed points of vision, but it is still the underlying matrix for any perception. Ignoring it will imply systemic trouble.

Secondly I want to suggest that this implies *not only microimbalancies* (which already posit the idea of a body struggling for balance as totality, an image that Western dance tradition has cultivated over centuries) but also torsions, tensions, movements that don't work primarily in relation to gravity.

Thirdly, microimbalances and thought would not be two different orders but two modalities of fields in the body that relate and compose transmodally. Neuronal synapses emerge from proprioceptive and multisensory inputs, but have a tendency (excessive at times) to recompose their connections abstractly, and impose these abstractions on the larger matrix from which they emerged. While this can be a source of creativity and imagination it also presents a tendency to reduction. The way thoughts as quasi-independent states in the brain reach back to proprioception is exactly the same as the one by which synapses have appeared in response to sensory inputs: mechanotransduction as the transfer between modes in the body. This is also the source of plasticity in the brain, as extension of the *archē*-proprioceptive matrix, that came evolutively first.

In turn, proprioception is never just about readjusting a balance, or struggling to retain a balance; its fluctuation is the fundamental state of the body. The problem instead is how certain dance traditions have created a body struggling for a center. It can be of interest here to contrast Gil's and Manning's account of imbalances with Hubert Godard's account of premovement (which is also preacceleration) as I discussed in Book 2. Godard presents almost a reverse idea of affects as essentially active forces of decentering rather than struggling for balance, the body being a sustained field of self-affection. Even more importantly, what fluctuation does is to exceed the active–passive dyad, it is *always in between, a never-ending multifaceted momentum*. Ultimately the affections within a proprioceptive field and between proprioceptive fields challenge the Spinozean idea of passive and active affections, of passive and active matter, fluctuation is the radical in between: always only nexus, suspended in myriads of tensional–torsional microfields.

The type of dynamics emerging over lifetimes from that fluctuation is what creates the particular dynamics of a body, whether walking or in dance, the peculiar impulses, the irreproducible quality of a great performer, but also the peculiar microrhythms that every single body has in their gait (no two bodies walk the same way) or of gesture in conversation.

We need new *technēs*, practices for mobilizing the proprioceptive field, letting it unfold in its vagueness which is also a multiplicity. This vagueness can be extremely rigorous and even precise, like in a dance or piano player. I can develop extreme precision, rhythmic variety, but it will always retain a force of fluctuation as well. What makes a performance alive or great is precisely the capacity to make out of fluc-

tuations a singularity. I will never perform a piano piece the same way twice: first, because of proprioceptive fluctuation that creates an irreducible difference every time I put my hands on the keyboard; second, because the idea of identical repetition is a chimera. Every time I play the piece my secondary memory (imagination) transforms my perception.

7.6.14.5 Opening Chiasms with Merleau-Ponty

In "Three propositions for a Movement of Thought" Manning (2015) discusses Merleau-Ponty's late writings, where he tries to put aside the centrality of the conscious subject in experience, for instance in considering the object as an indicator or "abbreviation" for a relational field, a constellation of relations (Merleau-Ponty 1994, 158). There would be an awareness (which Gil calls consciousness-with) that does not pertain to a subjective consciousness, but which is of the movement, the bodying, split abstractly from subjective consciousness. This explicitly points to a field conception: "It is not we who perceive, it is the thing that perceives itself yonder. [...] The world is a field, and as such is always open" (Merleau-Ponty 1968, 185). Isn't this perceiving itself the primordial factor of prorioception? Perceiving itself *yonder*... as alloception!

"Perception 'fields' [...] it is the field of relation that is the subject of the event," continues Manning (2015, 123), in trying to push Merleau-Ponty increasingly away from the centrality of the subject, placing the field of emergence as prior in some way. But here she reads him through Whitehead and Simondon, where on the one hand perceptions are no longer of a subject but of the event, creating a milieu as virtual field of emergent, potential relations, but on the other hand reality in split in two: the abstract field of emergence and the plane of actualization in which the field of emergence inevitably needs to express or else it remains utterly undifferentiated.

In this way, a promising move toward a field-thinking is subjected again to an imperative of dynamic form emerging from within (as we saw previously in Simondon and Barad). The tension between the radically positive reconceptualization of the field of emergence and its resubjection to form is ongoing:

> The interval is an active field, a multiplicity of movement potential to which bodyings tune. [...] Interval: a relational tool for co-composition with infinity, [...]. Multiple equilibriums are active in the relational interval [...]. A body is always infinitely more-than one. (Manning 2015, 126)

Indeed, this is the radical positivity of the relational nexus. But then, doesn't the idea of equilibrium already subject fluctuation to the figure that needs to stay in balance? I propose a more positive reconceptualization of the body's fluctuation not as subjected to equilibrium but as tensional–torsional figure that is never in balance, nor seeking balance! It swarms, away from any possible balance! Balance would be death of a body! But why this return or recapture into form? Manning responds:

> Each actual occasion is a limiting of the field of potential. This limiting occurs through an active process of subtraction. [...] Movement is the vibratory force that creates a relay between planes, between the fields of the virtual and the actual. It is one of the ways in which the immanent can be felt. [...] It does so in the excess of the sensory-motor, in the field of forces, of amodal sensations [...]. It is no longer possible to clearly distinguish between a body and its movement.

> The virtual field of movement is everywhere palpable — we wonder at the dance dancing us. (127)

So the immanent is palpable, it can be felt, yet it is imperceptible, amodal, beyond the sensory motor spectrum. This is ultimately the problem, of not taking into account the *a priori* role of the proprioceptive field and of multisensory integration as core matrices of experience, which is indeed where movement is *a priori* felt, in its utterly diffuse nature, in its swarming openness. There lies the indistinguishability of body and movement that Manning very correctly points out!

Why do I care so much about avoiding the actual–virtual dyad? Splitting reality in two planes is doubly problematic: on the one hand it acknowledges the plane of the formed as indispensable, on the other it places all possibility of action in an abstract outside. Considering that there is an ongoing actualization or actuality (actual occasions), that this step I take is *absolutely what it is,* assigning to it a form and a being is ultimately assuming a perspectival illusion. Considering an abstract virtual plane reinforces a bipolar pendulum dynamics which inevitably involves the problems that Deleuze and Guattari acknowledged, of lines of flight at some point returning as fascist lines of abolition, or of molecular lines forming totalizations.

But quality is never absolutely what it is. As I said in relation to James, we shouldn't take for granted that the salient parts of experience that we focus on are any more than the result of certain alignments. Furthermore, we shouldn't take for granted that language is always about categorizing. Indeed, one can choose to chunk experience and the world into pieces, aligning with a dominant neurotypical mode, but one can also keep hovering in a mode of child's or autistic perception that perhaps allows us to *keep moving in new ways.* The subject of perception is always a field, inseparable from an object.

7.6.14.6 Fielding Forth

In *Always More Than One,* Manning (2013) presents the field as the interval or nexus of relational incipience, which in Simondon's terms is the associated milieu, a field of preindividual potentiality in which germs of form and regions of potential are bubbling, a region out of phase with any form coming from it. Now comes the problematic term: just like for a figure in dance one needs to keep a metastable balance through micromovements (which actually reduce fluctuation instead of unfolding it), tensions between resonances that are out of phase with each other apparently need to be resolved in a metastable balance, rather than unfold in new tensions of a Heraclitean play. The emergence of form presupposes this resolution of disparities, provisionally at least, as they always continue shifting into new disparities (at least until the heat death of this universe).

Manning builds upon the concept of field in relation to perception. Field perception is the perception that is active before categorization and chunking comes about. It is linked to her concept of autistic perception, as "the opening, in perception, to the uncategorised, to the unclassified" (Manning 2016, 14), a richer perception that never chunks the world into categories. She elaborates on how one finds this mode also in children and other instances or bodies. Note the important nuance: it is not an already open perception, but *the opening in perception.* Opening = *chaos* = *chiasm* = *clinamen.* Can this opening be thought without a closure that is before or needs to come after?

Manning claims the almost *a priori* status of autistic perception as a fundamental mode of perception, while, along the previous lines, it is bound to a dialog with the neurotypical mode that chunks the world into categories as necessary expression of the field. I take this further by saying that field perception is the only mode of perception, the metamode of which the neurotypical mode is a reductive, contingent and avoidable outgrowth, along degrees of a spectrum of reduction. This requires rethinking how practical life (including education, communication, and media) is constructed through an army of alignments that have happened but don't *have* to be, and which can be otherwise. I think that an expanded account of the proprioceptive field offers a formidable horizon of reinvention for all our practices in terms of consistent but open fields which resist reduction to form. This reduction implies ignoring the body's fluctuation and believing that fluctuation is only active in particular mysterious moments in between displacements.

The differences outlined in this discussion have important implications in terms of the aesthetics and politics: what kinds of practices does each approach elicit? Manning (2013) proposes ecologies of practices such as choreography, where qualities are distilled from "total movement," creating biograms as lived diagrams of the moving body that can never become maps. They are tendencies in the making, allowing "conjunctions at the level of the incipiency of the preformed" (2009, 138). This incipiency is also where ontopower, as defined by Massumi, operates by preempting, capturing, reorienting movement. What Manning appears to propose is a reverse move where movement opens up in that interval instead. Yes, I absolutely affirm that! Yet I propose improvisation, rather than choreographic practices, for unfolding the plasticity in proprioceptive–multisensory integration fields.

Manning claims technicity as that which exceeds the bounding character of technics, as "an open field for structured improvisation. It informs a process of taking form" (Manning 2013, 35). I ask: can we invent *technēs* for less structured improvisation where proprioception unfolds without form? Mobile architectures and slow clothes are proposed as technicities. Yes! And, I add, what about wearable architectures for unleashing a formless proprioceptive variation?

Manning also asks "what if instead of parsing movement we dwelt in movement moving? [...] From this position of indeterminacy, of the ineffable, how to make intelligible the singularity of what cannot be measured or categorised, but is felt and in some sense, known?" (E. Manning 2016, 23). This implies practices where improvisation is about cultivating the ongoing disalignment as capacity to vary and unfold.

7.6.14.7 Minor Gestures

The *minor gesture* (E. Manning 2016) is another concept that has inspired what I call *minor ecologies* as those that sustain openness and don't impose themselves, ecologies of cosensing. They are ecologies where modes of field perception sustain openness throughout, resisting reduction to alignments. A neurodiverse culture would be one that doesn't impose perceptual ratios but mobilizes plastic perceptions. For Manning minor gestures are gestures that "never reproduce themselves in their own image," always connected to the event at hand while exceeding it, fragile and precarious but ubiquitous and persistent, ungraspable and indeterminate, untimely and "rhythmically inventing [their] own pulse" (E. Manning 2016, 2).

The minor gesture exceeds the normative choreographies by which we reenact gender or other categories but also through which we perceive those categories. This behavioral indeterminacy is thus always metaformative, double-sided, affecting how

we perceive as much as what we perceive, in fact, *undoing the split from what we perceive* by propriocepting it!

I consider autistic perception as the ongoing matrix proper to proprioceptive fields, which is there not just in view of future chunkings or in particular situations or people, but all the time and self-sufficient, capable of endless rhythmic expressions besides chunking. Given *archē*-proprioception as my proposal for the mode of perception in fields, one can say that fields of any kind expose *a priori* some variation of autistic perception.

A field theory should be able to account for consistency as emerging without the need for a structure. The field is not just a plane of emergence for something beyond it; the field is everything (and everything is in perpetual emergence)! My field theory takes both inspiration and distance form Manning's theory: inspiration in how it allows her to expand on the immanent relation between incipience (openness), relationality, and environmentality, also as ecology of practices, as well as of autistic perception as field perception; distance in that for Manning, following upon all the previous digressions, fielding pertains only to the virtual plane of immanence (which is also somehow transcendental, abstract, imperceptible, incorporeal), as part of a process that always involves something else: a concrete actualization into a form emerging from the field and retaining openness by its relation to the field.

As can be sensed from all the previous my proposal can be seen as *Radical Field Theory* in that there is *only* the field, endless fields within fields, and that consistency emerges in the fielding without any recourse to form or actualization. At the same time I give an account of form and actualization as peculiar, reductive, historical expressions of some fields, which have become too dominant, alignments emerging from the chaosmic field and turning back against it, dominating it. The formal field imposes itself over centuries, emerging from the proprioceptive field and turning back against it, ultimately coexisting with it as one cannot erase it, while appropriating it and enslaving it.

Opennes can never be at the service of displacement (opening up the step to new possibilities) or subdued to it as expression. Rather, displacement is a limit tendency to reduction in movement or simply a wrong view that makes us unaware of how we are changing internal relations in a larger field. When I flock in the house I don't displace in a Cartesian extension but create multiple simultaneous relational fields with the affordances in the house. Every house is a complex field of flocking.

Fields can be understood as modes of swarming. Why is this important? If we consider the field as the wider canvas or plane in perception and movement where neurotypical rationality makes cuts, where the cuts are selections made across planes or contractions and folds within the plane, it is difficult to account for the dynamics of the rest of the canvas or plane. But the swarm allows far richer ways of thinking how movements field forth in excess of lines and causalities. It allows us to think the dynamics of the "wider canvas" of experience without it being dependent on a plane of reduction. The latter is just one mode that has made itself dominant, shaping also practical life in Western industrialized, colonial, and neo- and hypercolonial societies. We need to counteract the reductive tendency of reason with a countertendency to open, a greater reason of the body: BI.

7.6.15 Nail's Kinetic Ontology

I am adding this final note on Thomas Nail's remarkable proposal for a movement philosophy, which I encountered after completion of this book. I have thus not been able to relate to Nail's proposal in the process of unfolding the ideas, but will try to outline the multiple resonances as well as the differences in this closing section. A more in depth elaboration will hopefully be done in future instances.

It is astonishing how some ideas cook in different parts of the planet, without mutual awareness, at almost the same time. It means the time has come all the more for a movement revolution! Nail's books on movement appear to have evolved mainly since 2015, having resulted in no less than thirteen publications up to 2024. Having published numerous papers since 2002, my own ideas have been evolving as a book since 2012, first in Spanish and since 2017 in English, with help in revisions from Brian Massumi and the Senselab. So it seems that both projects have been unfolding in parallel, with very resonant as well as different approaches whose resonances and differences are very interesting to identify.

Like me, Nail energetically claims the need for a deep and broad turn to movement that should spread like ripples across all disciplines of knowledge and practice, starting with a philosophy of movement that unfurls "a more robust nonmetaphysical and nonreductionist philosophy and ontology of motion" (Nail 2018b, 54), one that frees movement from wrong metaphysical assumptions and that revises everything through the lens of a movement philosophy, from cosmology and science, to ethics, politics, history, aesthetics, ontology, epistemology, and the history of philosophy itself. Nail works from philosophical and ethico-political premises that are in many respects close to mine, including the quest for indeterminism, plurality, and freedom, and a renewal of our relation to the Earth and all material and nonhuman life and flows. Nail's conceptual framework is complex, unfolding a field of kinetic concepts: kinology and kinography, kinopolitics and kinesthetics, kinometrics and kinomenology, kinocene and kinocide, kinetic expenditure, kinetic pluralism, and kinetic revolution, and so forth.

We both defend the intrinsic relation between movement and ontology, the movement of thought itself as being in (nondeterministic) relation to particular kinetic configurations and regimes. We both also insistently claim the primacy of movement over any other concept. For instance, movement does not happen in spacetime, rather spacetime is an emergent effect of movement, and we both seek recourse to contemporary physics in order to give further consistency to the claim. More importantly, we both claim the importance of indeterminism, as different from randomness.

Nail ontologically defines *movement* according to two sets of concepts. The first set comprises flow, fold, and field, which bears an astonishing similarity with my proposal for a cosmology of fluctuating fields that involves fluctuation, foam–filaments, frequency–flow, fold, flocks, and ultimately the anomaly of form. But whereas for him they are ontological for me they are cosmological, specific expressions from a more primordial fluctuation, whereby the field is there right from the start, flow and fold being particular evolutions or expressions of fields. In my account the flock or swarm is central, while in his it is almost absent. In his account the field comes as third expression, in mine it is the primordial and overarching expression.

A more significant difference comes in that for him pattern (as well as trajectory and quantity) are an intrinsic aspect of movement, whereas for me it is a cosmic

anomaly of our epoch that needs to be overcome, as it implies reduction. This differentiates a "movement first" from an "only movement" approach where movement is rethought and stripped of all the remaining echoes from ontological immobilities. But even more importantly for me fluctuation is not a mere fundamental state in a dissipating universe, but rather a movement of variation, an active force that propels a universe's evolution as movement of never-ending variation and diversification, tuning itself in the process along degrees of a spectrum of openness, where occasional closures emerge, as anomalies that need to be overcome.

Nail defines his concept of *confluence* through the trope of trajectories (a term I carefully avoid). Pedetic movement involves indeterminism but trajectories. Nail's idea of randomness, though critical about traditional accounts of entropy, is perhaps not akin to my proposal of fluctuations as propelling the evolution of an intrinsically active universe, which gets blocked or forced to dissipation only through alignments and closures. Yet his definition of confluence is promising (and resonant with my account of metabodies or fields as swarms-within-swarms), where

> every flow both composes and is composed by at least one other flow, ad infinitum. As a nested continuum of entangled and folded flows, there is never only one flow or any simple totality of flows, but rather a continuous process, an open multiplicity of flows. As such, a flow is by definition a nonunity and nontotality. (Nail 2019, 63)

Nail proposes that a fold "is produced by the junction or intersection of a flow with itself. Folds emerge from flows through junctions" (Nail 2019, 84). I agree with the primacy of flow over folds, but I also propose that folds are a complex transmergence of previous fields emerging in the double enfolding of a universe from the smallest and the largest, so that at some point the chemical bonds emerging in flow created a new kind of filamentous aggregation where electromagetism could work against gravity, leading among others to flexible plants that grow upward in tension with gravity. Sensation, in turn, "occurs at the period where a flow folds back over itself and touches itself. It is the ambiguous kinetic structure of the period itself — the double or split affect of periodicity" (Nail 2019, 89), while for me it is an intrinsic property of the fluctuations constituting any kind of field, of self-affections, primarily via oscillations.

I start to digress more when for Nail quantity gets assigned an essential role linked to the concept of object, always present together with quality, that is linked to the concept of image. Quantity, object, and image are highly problematic concepts that I have carefully avoided, as heritage from the metaphysical tradition of static being, as I argue in Book 3.

The field, for Nail, comes after the fold, and acquires a specific definition slightly at odds with mine:

> A field is a single continuous flow that has a kinetic vector for each period on its surface. If flows intersect and folds periodically cycle, fields organise them all in a continuous feedback loop. This book provides a kinetic theory of how conjoined flows become organised according to distinct regimes or fields of motion. (Nail 2019, 109)

By contrast, for me the field is primary and undefined, and not reducible to a single definition of its processes.

The second set of Nail's concepts comprises centripetal, centrifugal, tensional, and elastic, and they are applied both to the history of the Earth and ontology (and culture). I could again relate these with my cosmological accounts of how fluctuations field forth creating expansions and condensations, while the flexible (tensional) movement of plants and the elastic movement of bodies appear not so much as effect of loops in flow, but of the double or multiple un-/in-/enfolding of fluctuations in cosmic evolution.

Centripetal and centrifugal I see as two ever-present aspects of vortical flows. They cannot be separated in any epoch. Flexible–elastic I see as expressions of the deeper folding of organic molecules, the tensional aspect being a broader trope for how fields of any kind hold together via distributions of electromagnetic, chemical, intra-atomic, or subatomic relations in any type of field, and tension is also a core aspect of the torsional fields of vertebrates. At stake is thus to distinguish *modes* of tension. But it is also interesting to consider it as core feature of plant movement, as Nail does.

Is it a good idea to apply to culture and ontology the same categories of movement as to geology? I am not sure. Is this not a descriptive rather than transformative move? Is it lacking a crucial diagnosis of movement regimes that would be needed for the sake of transforming? Maybe. In Books 4 and 5 I propose that both evolutions are metaductions, entangled *n*-foldings of multiple movement modes, but the Algoricene is a sort of reverse-unfolding of cosmic evolution, toward a reduction of movement's openness.

...

We both work on the idea that how we move and how we think are entangled and inseparable, albeit not in a deterministic manner. Nail develops a particular and original ontohistorical survey of kinetic regimes linked to core epochs of ontological conceptions, which could thus be seen as broader cultural theoretical frameworks. He proposes four periods for a kinetic history of ontology, according to four definitions of being linked to four predominant kinetic regimes.

A first period identifies being and *space*. Nail proposes a different account complementary to mine in relation to the emergence of space, as linked to *centripetal motion*, images (mainly Venus, egg, and spiral), speech and mythology:

> During the period of time roughly defined as the Neolithic (10,000 BCE–5000 BCE), movement begins to take on a certain dominant mode of distribution or circulation, defined by an inward trajectory from the periphery toward a center. This centripetal motion is the condition for the dominant description of being's motion as fundamentally spatial. (Nail 2019, 151).

A second period is identified when

> around 5000 BCE, alongside the rise of cities and written language, a new regime of motion came to dominate ontological practice in the West: *centrifugal motion*, where being is associated to *eternity*. Clearly visible in the Bronze Age (3500 BCE) and culminating in ancient Greece by 500 BCE, a newly powerful kinetic pattern

of ontological practice emerged that descriptively and inscriptively relied on a centrifugal movement from the center to the periphery. (195)

In this period being is defined as eternity, linked to a cosmology. A third period is identified between approximately 500 and 1600 CE linked to a tensional movement, related both to the physics of force and theology, involving movements of externalization and internalization of flows that get disjoined or released from their fields, and is related to the medium of books (a bibliographic regime of motion, though strangely the shift to print is not considered essential, "because there were more books in more hands does not mean the regime of motion changed" (349), which means the alignment is missed and a general idea of flow is presupposed.

A fourth period is identified from around 1700 to today, where being is associated to time, defined by an elastic mode of movement, associated to typography and phenomenology. Nail analyses in depth technologies like the keyboard, whether old keyboards or PCs, which get strangely associated to elasticity, as "the computer keyboard [...] has elastic oscillating keys supported by springs or rubber" (436). But what about the radical immobility of bodies aligned with keyboards and their utterly reduced binary gestures?

This account does not propose a symptomatology that explains why the movements constituting the Earth, particularly over the past 540 million years, have led to a proliferation of biodiversity, whereas the movements of dominant culture and ontology over the past 10,000 years have initiated a mass extinction, only comparable, yet also different, to the previous five mass extinctions. Is it merely a question of quantity of movements? I develop the figure of the alignment and its specific modes in the theory of the Algoricene. Reduction of movement's variation is precisely what allows quantity and acceleration to take over variation!

Nail's definition of the current era as a kinocene seems to resonate with my definition of the panchoreographic as regime of movement and at the same time as movement is primordial in any case Nail's kinocene also seems to neutralize the problem. The panchoreographic implies the becoming repeatable of movement through alignments. It is not a question of there being more movement, but of the types of movements, the accelerating, narrowing alignments that foreclose variation, that afford quantification through impoverishing movement itself! How else are we to claim a kinethics and kinepolitics?

There are differences as well as complementarities with my own history of philosophies of movement. Of course the intention is different: mine is about pinpointing hints of field theories and the anomaly of mechanism, whereas Nail focuses on a kinetic history of ontology, applying the same four fundamental modes of movement that are applied to cosmology and the Earth. By focusing on speech, writing, books, and typography for each of the four periods there is perhaps a slightly narrow focus on one type of technology.

After all, in a movement philosophy one should ask first and foremost why speak about ontology and being (and even matter). As was mentioned, trajectories, and patterns are also present in Nail's approach as different from mine, and the quantitative remains considered an essential part of movement. These are fundamental heritages from the metaphysical tradition that I propose to overcome through radically rethinking movement: as absolutely not a trajectory, as absolutely not subject to form, and as crucially irreducible to quantity.

7.6.15.1 Geokinetics

His kinetic theory of the Earth, or geokinetics, is perhaps where I find more astonishing closeness. Here Nail deploys again the three tropes of flow–fold–fields and the four tropes of centripetal–centrifugal–tensional–elastic, the latter accounting for the emergence of the planet's geology (Haedean era), atmosphere (Archean era), plants (Proterozoinc ere), and animals (Phanerozoic ere), respectively. This cosmological frame is akin to mine in exposing the interrelatedness of the Earth with cosmic fluctuations and evolutions and in acknowledging the self-moving, self-organizing nature of all its flows and the primacy of fluctuations in an indeterminate universe. There is a consistent appeal to theories of cosmology, complex systems, and quantum fields for affirming the primacy of movement and its primordial indeterminacy, in accounting for the emergence and evolution of a universe. Here we are entirely in tune, as in our claim against the universality of entropy as law of dissipation, with some differences. Nail claims it as provisional tendency of the universe to cool, a tendency of this universe in this period, a state of affairs that could perhaps revert in future, as some cosmologies propose. Instead, I claim dissipation as effect of alignments and consider diversification an active effect of fluctuations.

I already mentioned my different take on the tropes of flow, fold, and field. As for the division of epochs and movement in geology, atmosphere, plants, and animals, to me it seems to miss the interrelatedness of geology and atmosphere from the start and the way plants and animals come last after bacteria, fungi, and protists, as well as all the in-betweens. But Nail warns that there is

> no opposition or development between centripetal, centrifugal, and tensional patterns of motion. Life is the complex cellularization and "membranification" of the Earth itself, holding itself together and apart kinopoietically. Vegetality is the earth turned inside out and folded up like a cellular foam or a vortical labyrinth woven from the flux of matter. Each cell was centripetally gathered from the cosmos, centrifugally breathed out from the earth and ocean, and manifolded with and against itself. Vegetality holds the earth together and apart from itself through the use of pressurized metastable membranes: a pomegranate Earth. [...] The historical rise of this new pattern of motion followed three main kinds of tensional motions: within, between, and through cellular life. (Nail 2021, 141)

Nail offers an inventive, consistent, and rich account — complementary in every sense to mine — of the multitude of flows of the self-organizing Earth, its pedosphere, its unfolding eras, its planetary field of metastable distribution of cycles.

Crucial is his account of a Kinocene ethics, the Kinocide (highly resonant with my account of the Holocide, or Planetary Holocaust) and Kinopolitics, related to the concept of kinetic expenditure that to some extent reverse prevailing accounts of entropic dissipation. The core idea is that the cooling of the universe implies a diversification of movements that involves energy expenditure. This aims at solving the paradox that while humans are consuming more energy, the planet at large is consuming less, because of the impact of this intensive human consumption on the other, more creative, less disruptive forms of energy expenditure. While the idea of kinetic expenditure as differentiation from entropic dissipation is a promising move, it doesn't get to the point of affirming an active force, nor does it afford a distinction between modes of movement or kinetic regimes. This is partly due to the underlying assumption inherited from Aristotle that movement is always a

trajectory. But, as I have proposed, the whole problem is precisely in how movement became reduced to trajectories! This major alignment of the Macrocene, which double-folds in the binary movement of code in the Hypercene, is what needs to get challenged! My proposal is thus in promoting intraduction as variation against the dissipation promoted by alignments! More indeterminacy, less reduction-for-the-sake-of-calculation-and-multiplication... and less human reproduction–multiplication, less sedentarism–consumerism, less quantitative motion and more qualitative variation!

The ethico-political implications of Nail's kinetic expenditure theory are in a claim for diversity. Yes! I add onto this the need for indeterminacy, disalignments... undoing alignments that reduce! This disalignment crucially means voluntarily disaligning from human multiplication and from sedentary, exploitative, and homogenizing modes of living, contributing to diversification with less patterns and more indeterminate movements! The only way to restore the planet's health is to stop exploiting, imposing alignments, reducing for quantifying, and trying to control the Earth's flows. Flowing with them means contributing to biodiversity, stopping the mass extinction started by alignments, by bodily impoverishing and multiplication... this would be the purpose of a *radical kinetic metaontology!*

...

Overall Nail's is a remarkable proposal. That it is unfolding in the same period as mine, with so many resonances and divergences, is a sign that it is time for a movement revolution and that pluralism is needed, must unfold and coexist creatively. We completely agree on the need to give a kinetico-ontological push to sciences, and to every possible domain, all of which are calling for a pluralist kinetic revolution. May this complexity of resonances and divergences expose the intrinsic multifaceted pluralism of the kinetic approach!

7.7 Rhizomatic Genealogies: For a Regenerative Field Thinking in Motion

We have explored a number ways in which movement has been thought, a journey biased by my looking for potential hints of a field and radical movement theory, the kind of which I am trying to propose. My critique of previous proposals can be summarized as follows: the lack of an alternative way of thinking perception beyond perspectival vision and individual sensing modalities has — in spite of Sherrington's study from 1906 — made it difficult to think beyond mechanical movement other than as virtual abstraction or as chiasm, a *différant* interval between the categories of metaphysics. Many recent attempts since Nietzsche and Bergson have gestured toward proprioception as potential new paradigm, but have taken detours along the way. We have also seen that an undercurrent behind most ontologies is the order–chaos and entropy–negentropy dualism, which I call *entropic fear*, tautologically enforced by the very alignments that imply energetic dissipation.

What these sketches of nonlinear genealogies have afforded is a sort of diagram of movements of thought, of un/foldings in thought over millennia, allowing us to see some recurrences or underlying moves, but more importantly inviting us to take on the movement. This genealogy is of course incomplete. It is infinite. This "history" should be taken as an invitation for other nonlinear genealogies focusing on other aspects: other diagrams of how movement has been thought that would allow

for *new movements in thought*, new ways of thinking movement, new ways of moving–thinking.

Since early thinking we see ideas recurring of an indeterminate principle (*dao, apeiron*, void, *khōra*) from which pairs of opposites differentiate, an initial opening (chaos), a movement of variation and vital force (*clinamen, qi*), a tension of opposites (in Heraclitus), or pairs of opposites (in the Pythagoreans), and the ternary alternation of a middle term between opposites (*yin–yang* principle), a field dynamics (the vortex, rhythm, or contact and orientation in atomism) or a movement of unfolding and infolding (in ancient Indian cosmogonies).

In the account of new movement philosophies over the past 140 years or so some genealogies and recurrences stand out. One is the thinking of movement between two planes of virtual and actual, another is Derrida's movement of *différance*, which is also a double oscillation of spacing and temporization. Both can be thought as a double (simultaneous) movement of unfolding and infolding.

But here we can see a difference: in relation to the virtual, intensity is an infolding, actualization an unfolding and expression. In *différance* it seems to be the reverse: spacing is a differential unfolding where difference emerges, and deferral is the infolding where traces appear — it is for this clearly that Stiegler builds upon Derrida, with memories emerging in a (technical) unfolding of traces as tertiary retention. But these traces of economic deferral happen precisely because of spatialization, and difference is also inseparable from economies of deferral. That is why sameness and difference end up being identified with one another. In *différance*, unlike in Bergson, not only the time aspect is linked to memory, but also spatialization, but like in Bergson both memory and difference are entangled (in the virtual), though movement in Bergson is more like an oscillation between virtual and actual.

Both genealogies imply an in-between term, the oscillatory *interval* itself. In Spinoza it is a suspension between affecting and being affected, which returns in Massumi's account of affect, while in Bergson movement itself appears to be the interval. In Manning movement's incipience is a relational interval, and so is Whitehead's nexus between actual occasions. In Derrida we also have the image of the interval as undecidable, as pharmakon, as "double metalogic oscillation," defying metaphysics as neither being nor nonbeing. This interval is chaos: the chiasm, abyss, opening, yawning. Again this resonates with Deleuze's claim for chaos as a Nietzschean, Dionysian, differential, vortical, *clinamental* dance of the plane of immanence.

A third possible genealogy could be found around Merleau-Ponty, and more generally phenomenology. Merleau-Ponty diverges from Bergson in trying to account for the experiential synthesis happening in the body. Merleau-Ponty thus also ends up thinking about the chiasm as interweaving, interlacing (very resonant with the image of the rhizome). Merleau-Ponty does not speak of infolding or unfolding but *enfolding* as middle term, which he elaborates from the middle term while keeping the poles. As we may see, these three genealogies I pointed out are differentially interwoven, involving numerous rhizomatic inputs and outgrowths. All try to reinvigorate movement designating a creative force in it (*clinamen, conatus*, will-to-power, *élan vital*, difference, *différance*, neganthropy).

The problem of consistency is also resituated, as coming second or with difference rather than being first as in metaphysics of being: the body in Spinoza and Nietzsche as hierarchy of active and reactive forces, or in Merleau-Ponty as synthesis in the unfolding of experience and world, the plateaux in Deleuze and Guattari as

holding together of the open, or temporization in Derrida's *différance* are ways to account for consistency-in-variation.

7.7.1 *Philokinesia*: Undoing Supremacist Philosophy — Toward a Radical Field Theory

The history of the thinking of movement is also the history of setting limits to movement. The story of the limit to movement is often a fight between determination and indetermination that is part of the history of slave societies, of the struggle between domination and freedom. This may sound in itself dualist, but at stake is to afford appropriate symptomatologies for tendencies to domination and closure in movement, which I present as anomalies that need to be overcome!

The positive conceptualization of movement is often implicit in the rethinking of the body, perception, time, becoming, or process. The negative conceptualization of movement comes about through the thinking of form, fixity, number, point, limit, cut, form, border, line, geometry, hierarchy (pyramids), the circle, the sphere, and every form of closed totality, but also mind or consciousness, associated to immobility since Aristotle and Parmenides. Space as absolute and abstract measurable extension has been a major and more complex construct emerging in this process of neglection and limiting of movement and along it linear time (again the line). The object as bounded entity, but also the subject as detached observer are even more complex constructs that required the fixed point of vision, the visual pyramid and the gridded frame of linear perspective to acquire full definition, and so does form, as both visually distinct and mathematizable entity. The mind as Cartesian substance is even more clearly a perspectival illusion of detachment that would be untenable without the fixed point of vision.

I have sketched out some of these parallel histories of space, lines, and points, numbers and forms, but also the body, perception, time, change, and becoming, while holding onto movement as key term of the metaontological journey. The underlying problem is not only how to think change but in particular how to think consistency within change.

Everything in the humanities, sciences, but also art, politics or philosophy cries out for a field-and-movement theory, which is also a field-and-movement pragmatics. The geometric era needs to be challenged. A field theory points beyond geometry. As Prigogine points out, "classical physics is based on Euclidean geometry, and modern developments in relativity and other fields are closely related to extensions of geometrical concepts. But take the other extreme: the field theory used by embryologists to describe the complex phenomena of morphogenesis." (Prigogine 1980, xii). Relativity indeed introduced an important turn, back to "movement first." Chaos theory and nonlinear dynamics complicate the idea of causality without denying it, affording improved means of predicting change through probability and statistics, detecting *vectors of motion in clouds of points*.

In the twentieth century (and already since Newton's theory of fluxions and Leibniz's calculus) a strong return of the water genealogy I proposed at the start of this book has occurred through fluid dynamics, studies of turbulence and vorticity, chemical kinetics, geophysics and geodynamics, atmospherics, meteorology, cloud physics, or biochemistry starting with the revolutionary ideas of Vernadsky on the biosphere. These are but some of the domains where field theories of all sorts are emerging, even when they are not yet called by that name.

In mathematics, Petr Vopěnka has elaborated over the past four decades an Alternative Set Theory, which approachs the indefinite nature of perception, considering neither abstract infinities nor clearly bounded sets (Vopěnka 1979). Couplings of this blurry approach to numbers with current scenarios in quantum field theories and string theories or fuzzy logic and mereotopology may provide important reontologizations of mathematics.

And yet a renewal of our understanding of bodily movement — the middle term — is still largely missing. Anthropology and ethnography or paleontology have paid attention to perception, to the way in which different cultures organize the senses, while mostly ignoring proprioception, multisensory integration, and their connection to constructions of self, space, time, work, or sociality. The many mild attempts to consider hearing or touch as alternative ways to Western ocular centrism in other cultures expose the bias of the Aristotelian tradition of the five senses in ethnography, and the urgency to couple it with more complex approaches in neuroscience and embodied cognition. Questions tend to be posed conservatively: "How does perception work?" We need to shift these questions to "How does it work in this situation?" "How else could it work?"

A movement theory must be itself transductive, evolving as it tries to think movement, creating a new movement in the thinking. So our humble task is to undo, exceed, and resituate each and every reductive inflection coming from the tradition of metaphysics, its resilient concepts assuming a wrong and narrow conception of movement. When talking about movement we are constrained by metaphysical language tradition. But in excess of deconstruction my aim has been to show in a double turn that:

— language was always more than metaphysical, and that
— metaphysics is not just based on language, but on a whole set of kinetic-perceptual practices that have reduced the scope of language as well.

I don't wish to undermine language, but to expand it in waves of proprioceptive diffraction. Our counter-doctrine (RMP) implies:

1. There are only movement relations (fields); there can be neither categorical separation between distinct things that move nor between them and a space preexisting them, the illusion of separation is effect of a reductive sensorimotor regime linked to specific systems of domination.
2. There are endless types of movement, as modes of variation, as dynamics of fields and across fields.
3. Some are more open and plastic than others, but within an intrinsically active and creative universe reductive bubbles are exceptions. This reduction is domination: an occasional but avoidable expression of movement fields, whose only "purpose" is to be overcome into new, more plastic evolutionary variations.

EPILOGUE 1

Supremacist Philosophy and False Transvaluation: Or Thus Speak I, Zarathustra, Today

There is no human emancipation possible without the liberation of all forms of life. All human oppression arose from the exploitation of other animals and the Earth, and it is this exploitation that leads us to the abyss.

All human politics is supremacist, anchored in a supremacist political binary. A mere alternative is glimpsed in degrowth discourses, in indigenous communities, in some anarcho-primitivisms, and especially in forager societies, nonhuman animals, and the metahuman proposal.

Everything happens with the complicity not only of corporations, states, politicians, media, institutions, and the general population, but also of activists, social movements, and "critical" intellectuals.

But if the denialism of states is criminal, even worse is that of intellectuals, the true dead end. Above all one must challenge the way in which philosophy has evolved as tool of human supremacism, thus cementing the evolutionary failure leading to an ultra-quick extinction. Every term from the philosophy of extinction needs to be undone, overcome, reversed in its reductive thrust, toward nonreductive modes of thought in and as motion, and indeed not abstractly in motion but literally linked to new ways of moving as a thinking body embedded in its environment: this is a metaphilosophical, metaformative task, and a shift from philosophy to philokinesia!

Let's examine the multiple traps by which the supremacist intellectual becomes entangled in the loop of extinction. The traps of supremacist philosophy, its false transvaluation, its trash-human nihilism, and its covert holocaust.

1. **The trap of self-referentiality**, practiced with great skill by distinguished intellectuals such as Jacques Derrida and Michel Foucault and repeated *ad nauseam* by followers in multiple circles, for example, queer circles, is that one can only think and do politics from within the discursive matrixes of domination and representation, assuming human supremacy as the sole framework for life, as if there were no other politics and ways of living, communicating, and thinking. The inability to see that the disaster has arisen precisely from the anomaly of these abstract matrixes of domination that serve not life but themselves. The self-referentiality of academia and human self-referentiality.

Deconstructing from within must be done, and that's why I'm here, speaking to you today, reasoning to turn reason against itself, undoing its empire, and demon-

strating its dead end. But this is only part of the story, while a different thinking of the moving body is mobilized.

The trap that "this thought depends on these systems of abstraction." So what?! It's about thinking in other ways!

The trap that "everything is belief and categorization".... As if all terrestrial life forms, including many aspects of "human" life, were based on beliefs and categorizations. The inability to escape the loop of self-referential abstractions.

2. The trap of abstraction in the virtual, practiced with great art by Gilles Deleuze and Félix Guattari and their followers, where the open is abstracted and neutralized, once again eluding the concrete practices that close it, always in a dialogical, bipolar, or pendular relationship with the closed and formed, which is still considered an inescapable part.

3. The trap of accelerationism and the defense of nihilism: Because the triple exponential acceleration already underway has not been understood: of the causes of extinction, of its effects, and of human fanaticism. Nor has it been understood how much acceleration there is already, nor what is accelerating. Nihilism is a vague term: extinction is its true face. We have had our foot on the accelerator for a long time on the highway to extinction.

Because acceleration is only a third-order symptom, an effect of homogenization and accumulation, where the quantitative emerges as an effect of the reduction of qualitative variation. Because speed is addictive. Because of the vagueness of accelerationist proposals, which are a flight forward, another face of supremacism.

Because what is needed is disalignment and deceleration in order to diversify. Should we perhaps accelerate the collapse of the sedentary civilization of exploitation? But can it really accelerate even further?

4. The trap of the elephant in the room, which stubbornly refuses to fully acknowledge that we, educated people from rich countries, are the problem: our sedentary, consumerist lifestyle, our diet, and overpopulation. A trap artfully practiced even by distinguished posthumanists like Rosi Braidotti or post-hummusists like Donna Haraway, who barely dedicates a line to livestock farming in her often-cited writings on interspecies alliances, once again evading the elephant in the room, pretending to recognize the other without undoing the separation, co-opting the site of a true revolution.

5. The trap of unacknowledged humanist morality and false immoralism, of the human who assumes he doesn't kill humans but rebels when told he doesn't believe in mass extinction and self-extinction. The human right to create mass extinction is one of the Ten Commandments of human supremacy.... This is the set of values I'm here to break.

The Ten Commandments of Human Supremacism

1. You will never acknowledge your evolutionary failure.
2. You will never step down from your pedestal.
3. You will not kill other human beings, but you will have the right to create a mass extinction and a Planetary Holocaust, even if it entails self-extinction.

4. You will never acknowledge that exploiting animals and other life forms is a crime.
5. You will never relinquish your ownership of the Earth.
6. You will never stop multiplying and filling the Earth, and you will never question the regimes of multiplication and expansion.
7. You will never accept criticism of the dominant civilization and will find any excuse to avoid it.
8. You will defend the dominant civilization by any means, even if it entails species suicide.
9. When necessary, you will pretend to be carrying out a revolution through patches that involves no change, appealing to mere dogmas and beliefs, but deeply rooted and ubiquitous, and in this way you will prevent any real change from happening.
10. You will always keep your foot on the accelerator on the highway to extinction and ignore your imminent self-extinction.

6. The trap of individual freedom, based on widespread denial of the Planetary Holocaust, which in turn is based on insensitivity. An individual freedom that is the privilege of certain human individuals at the expense of all else.

For freedom can only be relational, freedom of undetermined movement for the metahuman rights of all life forms.

The trap of subjectivation. You say that without humanism and the subject there would be no freedom; I say, the opposite: the subject is subjection and separation, and with humanism there can be no freedom!

The trap of empowerment based on the individual, rational, verbal human subject, individual freedom, and supremacist human rights.

The trap of individual human freedom and prefabricated desire: the world is a will to variation, but the trash-human obeys prefabricated desires. How can we distinguish emergent will from prefabricated desire? Or the tendency toward superabundant, emergent, relational, and purposeless variation of a multiple body in symbiosis with the world from the tendency toward reductive, prefabricated, and teleological alignment and the shortcomings of an immobile self that has lost movement and symbiosis? How can we escape the trap of rights based on individual human freedom, when it is prefabricated?

The trap of technical empowerment based on "reappropriating" the technologies of domination, but never looking beyond them, reinventing them completely.

The trap of astonishing yourselves with fantasies of technological supremacy that announce false liberation and conceal mechanical–digital technofascism.

Too intoxicated I see you with trash-human smokescreens, with false promises of trash-cendence, cyborgs, genetic engineering, and artificial intelligence, supremacist fantasies of the trash-human elite that obscure the underlying problems, where technological singularity conceals an extinction singularity.

Hyperloop Trap: We respond with more problems to the unquestioned foundational problem of homogenization (reduction of variation and co-evolution of the movement of the body with the environment) and its associated exploitation.

7. The trap of possibilism and the small mouth, which refuses a comprehensive revaluation because it would not be acceptable for society to even raise this debate,

accusing whoever raises it of radicalism, when the utopia is to pretend that this has a future: it is impossible and undesirable. Possibilism is actually IMPOSSIBILISM!

The trap that "it can't be undone," of irreversibility and inevitability, that "we've gone too far, there's no turning back, the planet is irreversibly anthropized," the trap of nihilism that assumes an all-too-human and comfortable apocalyptic telos.

The trap of visceral reactions that appeal to dogmas and basic emotions, or personal attacks, always avoiding the conversation…. But I do reason!

The trap of half-measures, of half-reason, of the false yin-yang of Apollo and Dionysus, or of ratiovitalism.

A double radical disenlightenment is needed: freeing the Earth from reductive reason, turning it against itself from within, while at the same time recovering another movement.

8. The trap of the tragic vision: Because the reality is that there is no tragedy, except the one we have created. The tragedy is that the most calamitous of creatures has become master of the Earth, and the paradox is that only such a self-impoverished creature could create such a geological anomaly. You have created the tragedy… or rather, could we say that we *are* the tragedy?

The trap of believing that this is a phase, that we are a bridge (another regurgitation of teleology). But can we sink any lower as a species than by creating the Planetary Holocaust? Aren't such supremacist delusions based on radical denialism? "Humanity" is not a bridge between animal and overman, it is a sect of fanatics and an evolutionary failure. For it is not possible to fall any lower, below all other animals.

The trap of health or hygiene, because what makes us sick and dirty is this way of life.

The trap of repetitive and cumulative education, which only serves to align us with the system of extinction.

9. The trap of culture: our self-referential system that we love to marvel at, as if enculturation doesn't exist in societies of foragers and nonhuman animals, which are much more flexible and diverse. As if the sublime creations of Western art justify the Planetary Holocaust.

You say that without this system of domination, we wouldn't be talking about all this; *Zarathustra* wouldn't have been written 140 years ago; Beethoven's sonatas and Michelangelo's *David* wouldn't exist; there would be no pianos or orchestras, no Shakespeare or Proust, no literature of any kind, much less cinema. It's true that a world without Beethoven's late sonatas is difficult for me to imagine, but it's time to recognize the myriad creative expressions that have been destroyed by favoring this particular system, which is merely one of the infinite expressions of the cosmos's creativity. How many other expressions have failed to exist because of this predominance of one! It's about mobilizing variant, interfering encultrations, dances, and choruses that contribute to the diversification of life as a symbiotic network.

The enculturation of other animals is superior because it hasn't separated itself from the flow; it is immanent. The superiority of the flight of starlings in the winter twilight, which is in now way inferior to the most sublime human creations, palliative remedies for a lost wealth of experience.

You complain that I am making a total revaluation, as if nothing that has emerged in recent millennia in the dominant civilizations could be saved. The problem is that none of this justifies perpetuating this Holocaust, and apparently none of it

has served to overcome it; another art of life is needed. Art and culture are too often used to cement human exceptionalism!

Everything humans do to correct problems or cure their ills, or "elevate their existence," falls into that logic of palliative remedies and patches that ignore the underlying problem: unquestioned supremacy.

Where is that great contempt that pushes us toward this double inversion of an inversion? *Umwertung*.... When will we come down from our pedestals, stop being amazed by ourselves and our country of culture?

> "Covered in signs that are in turn blurs of other signs, [...] all ages chatter motley from your gestures. If you were stripped of veils, colors, gestures, and wraps, there would still be plenty left to scare the birds away with the rest! [...] I would rather be a day-laborer in the underworld, [...] I really can't stand you naked nor dressed, you people of the present. All the sinister things of the future are, in truth, more comfortable than your "reality." [...] You are stamps of everything that was once believed, [...] you are a dislocation of all thoughts. [...] I laugh about you, people of the present, and especially when you are so amazed about yourselves!" (Nietzsche 2006, 93–94, translation modified)

Thus he spoke... Thus spoke I, Zarathustra, 140 years ago, and thus I will speak to you today!

Do you really think I wasn't aiming for a total revaluation? How eager you are to cling to my past errors and elevate them, instead of correcting them and pushing me further! How much rancid priesthood I see around me exalting a figure of mine so disfigured that I don't even recognize it!

But behold, I come mutated, transformed, like a sun rising from dark mountains... *glühend und stark wie eine Morgensonne die aus dunklen Bergen kommt*... I have cleansed myself of my past errors, I was still too human... and I push myself further! (I became queer and post-queer... and vegan!... VegAnarQueer!... But, above all, a dancer!)

It is unforgivable that you have misrepresented me and confused me with my worst enemies, like transhumanism and all supremacism.

With such self-satisfaction you have misrepresented me! I see too much love to your own bellies! Are you ready for my hammer? I see you very soft, and accommodated! I see you accommodated on false pedestals: is it so tempting to be a god? Didn't God die? I still smell too much trash-worldly smoke around you. Too much supremacist arrogance.

Where is that hardness? Why so soft, sisters? *Warum so weich, meine Brüder? Und Seligkeit muss es euch dünken eure Hand auf die Jahrtausende zu drücken wie auf Wachs.* (It must seem like bliss to you to plunge your hand into the millennia as if they were wax.)

How much gloom, how much musty smell of closed places, how many a coffin urgently needs to be broken into multicolored laughter. Dance of the summits I bring you!

You have not understood me. You did not understand my cry of alarm. It was against you, and your unfortunate turn toward disaster! I did not know how to express the meaning of life. I slipped on the peel of Darwinism!

But, above all, it is unforgivable that you have betrayed... my dance!

Thus we arrive at the most fatal of all traps: that of immobile thought!

10. **Trap of verbocentrism** centered on the self-referential reflection of an immobile body.

As Alessandra Falzone and Antonino Pennisi assert in *Il prezzo del linguaggio*, the predominance of the verbal has turned us into an ecologically anomalous species headed for rapid extinction, or as Pierre Jouventin says, into a failed animal.

How much you talk about the embodied mind, oh my sisters.... But how little dancing I see in that thought! How many a white ass glued to hard chairs!

What happened to that maxim of mine that says,"Sit as little as possible and pay no attention to any thought that does not arise from the body moving in the open air where the muscles are having a feast"?

How much contempt and terror of the moving body I still see in you!

Where is that thinking body?... If you could begin to feel your proprioception... breathe deeply, let the body move, let it regain its intelligence beyond the mutilating corset of reductive reason that has never governed movement, but has only castrated it.

The dead end of the thought of immobile being, *akinēton ontos*, of the ontology that started with Parmenides. For no revolution will ever emerge from that thought. We must move in other ways.

"A process cannot be understood by stopping it. We must follow the current of the process, we must join it, we must flow with it," as proposed by Frank Herbert in *Dune*.

We must recover immanent, moving knowledge, which does not aim to know something as being, paralyzing it, but rather to increase the power of variation of becoming, to move in new ways with the fluctuating world.

I said then that every day without dancing is a lost day. I correct myself now: Don't spend a minute without dancing life! Every minute of life that is not danced is a lost minute!

To be only a body in movement and its embodied memory of emerging rhythms, recovering embodied knowledge that is in the very rhythm of the body that moves.

Philosophy betrayed itself from the very beginning by shifting from thinking about *physis, kinēsis, gignesthai* (nature, movement–change, and becoming) to *akinēton ontos* (the motionless being), and you perpetuate this betrayal!

Down with *philosophia*!... Up with *philokinesia*, the love of movement. For a resurgence of knowledge in movement, of body techniques and Bodily Intelligence, improvisational practices rooted in proprioception, relational and mutant metabody techniques that do not impose reductive extensions on the world: this is the metahuman mutation.

The Metahuman Mutation

I'm already approaching my conclusions, my sisters.

Here I am, disguised as one of you, speaking in your language, to reason with your tools, turning them against themselves, until they are pulverized. That is hammer philosophy and nothing else!

Here I am, still with one foot between you, as I disalign, ready to disappear into my southern deserts, dancing until death arrives.

I come to invite you to my dance! But first, you must embrace the abyssal gaze, the great contempt, step down from your false pedestal.

I would never have imagined, 140 years ago, something as horrifying as what you have generated, something like factory farming, mass extinctions, and your digital desert. I could never have imagined such a denial of life, that you would sink so low, that you would always cling to so many subterfuges to sink even deeper into your hole.

God was invented to justify human supremacy. Now you have sought to become that god through your multiplication, domination, and occupation of the Earth. Current religion is the fanatical dogma by which the dominant human clings to its status and its suicidal drift. Clinging to the notion of the human and its domination... that is religious fanaticism!

You ask me to "ground my proposals"!?... But I am the one asking you to ground yourself, stepping down from your supremacist pedestal and your Matrix illusion!

You say that not using reason is a return to religion... But reason is a religion! You ignore the thought of the body in motion.... Do other animals have a religion? And even the religion of any indigenous people is superior to your faith in techno-supremacy and consumerism!

Truly, you have become what I once described as "the last man," who diminishes and homogenizes everything, who fills and diminishes the Earth, and who lives longer.

I abhor the disgusting things in your bowels. Humanity has a belly full of holocaust, that's why you don't dance, you heavy ones, you non-dancers! I abhor your boastful and unacknowledged supremacism.

I already told you: there is no worse crime today than the crime against the Earth. I already told you: I am a body and nothing more. But you have only worsened the crime and increased the contempt for the body, you non-dancers on the RAPED EARTH.

I come to free my fellow creatures, the pigs and all farm animals, to free the Earth from this planetary farm.... Where are my eagle and my serpent? You have extinguished them long ago!

Eleutherios Dyonisos, liberator of all life forms: I come to invite you to my dancing choruses, and from the chorus to the flock and the evolutionary orgy, the dance of life.

The human feast ends... the metahuman begins!

I was confused with the will to power and the eternal return: there is only the will to variation and eternal variation, with occasional bubbles of closure whose only purpose is to be overcome.

Your self is still too entangled in prefabricated desires for you to even glimpse the will to variation!

I too have been part of this cancer. But behold, I am healing, toward a greater health... of all life forms!... Because what makes us sick is this diminished, atrophied, supremacist trash-human way of living.

They already mocked me when I spoke in the marketplace. I needn't tell you about your planetary psychosis in the shopping malls today. To be untimely today is to speak of what all of humanity ignores in its planetary psychosis.

I bring you a new ontological therapy, the new cure... but how you resist abandoning your most variegated concepts! When will you stop avoiding that triple taboo and biblical mandate that you so faithfully and religiously obey: how you feed yourselves, how you occupy the Earth, how you multiply?

How much supremacist cynicism and how much hidden dogma of faith I see in you, sisters! How much supremacist arrogance clinging to your precious subject, when it is already evident that all animals have subjectivity!

How much would you gain, sisters, if you focused your attention on learning from the earthworms and weeds, which contribute far more to biodiversity than any of you, since their symbiotic and corporeal intelligence is superior!

Superiority of weeds and inferiority of trash-human, and of reductive, trash-human, and academic intelligence. Revolution of weeds, intelligence of plants, pigs, chickens, fish, and bacteria. In the face of our poor reductive intelligence, reactivate BI, step out from your atrophy. This is my *paideia* and my *technē*!

Radical dehierarchization of intelligence and evolution, not as advancement but as diversification!... This is transvaluation!... Toward a future community, which can only be metahuman.

This is my tribunal of Dionysus, my judgment of humanity.

But let us not deceive ourselves, everything is heading for disaster. A double challenge, then: to mutate on a devastated Earth, with unprecedented creativity, toward a new dance. Only the dancing ones can recover the meaning of evolution, overcome the tipping point of extinction (and survive the disaster). This doesn't imply any "Kantian peace," but rather an unseen war.

I come, in short, to share my mutation with you.

When the body is transformed by living outdoors, when the cold becomes invigorating freshness, when walks become a permanent way of life, a total art of life; when you no longer want to return to a comfort that now feels like the atrophy of bodies confined in dresses, urban grids, and sterile regulations; when my techniques of disaligned movement, which I have been developing for so many years, converge with foraging and outdoor life, no longer as a palliative remedy of the trash-human bourgeoisie. I am freeing myself from human life, rewilding myself.

A resilient body that recovers its instinct and intelligence. In each dance at dawn, a new rhythm is born. Dancing with my nonhuman peers, with whom I have a more interesting and less corrupted interaction and communication than with humans. Learning with them and from the weeds, from their superior intelligence. For the human is only a chimera, a supremacist belief, and an impoverished and insensitive way of living.

Becoming Dionysus, or Śiva.... I understood years ago that principle of immanence by which the initiate, in ecstatic dance, embodies divinity, or rather, undoes duality. Madness of divine immanence, of perpetual ecstasy. Here is my savage wisdom.

You say it would be a "return to the caves"... I say to you: flee from your prisons of cement and extinction!

I am detaching myself, with one foot still among you... to invite you to my dance!

Escape from the system of extinction, cease to be well-oiled gears in the killing machine, dismantle the Academy and the State—that icy monster, that false idol—and all domination, that way of reducing life to the comprehensive management of homogeneous and antivital accumulation, that black hole, whose only meaning is to be overcome.

When will you join the great dance, the great disalignment? The question is, who joins the call? Who joins me in the dance?

2100: Metahuman World — The Last Narrative. A Realistic Science-Fiction Story

Introduction

I am writing from a day in what may be the year 2100 of the era of collapse, or perhaps some other year in the 22nd century. Writing and verbality are being abandoned, as are numbers and calendars, which we consider a fatal legacy of the era of collapse. I write this short text as the end of a failed era, the era of algorithms and extinctions, as the last narrative of human history and the beginning of a metahuman era, where the biosphere regains its movement beyond the failed, devastating, and brief dominance of verbality and the techniques that separate and dominate.

For four billion years, the biosphere had developed conditions for an increasing diversification of movements, of molecular architectures creating planetary networks of energy transformation, symbiotic networks in permanent mutation, following a cosmic imperative of inevitable fluctuation. Thus, bacterial and viral fields had emerged, and much later, protists, fungi, and plants, and finally animals, but all following the imperative of continuous movement and remixing of matter, in the free movement of animals, seeds, microbes, and flows.

But 10,000 years ago, certain dominant branches of a certain bipedal animal species that had been atrophying and externalizing itself through techniques for two million years, going from herbivore to carnivore, becoming apex predators through technology, upon the arrival of an unusual climatic calm, developed a mode of relating to the living based on exploitation and separation, something that was called domestication, in the era known as Neolithic, associated with a sedentary lifestyle, which was not so much immobility as homogenization, populating the Earth with monocultures that paralyzed evolution in the blink of an eye, unleashing the quickest known mass extinction. Thus, in the blink of an eye, an extravagant and delirious life form emerged, a plague or cancer that covered the planet with rigid structures that paralyzed the flows and evolution of the Earth. It will take hundreds of millions of years for them to be absorbed or dissolved by geological flows, although now only its ruins remain: of trash-human civilization.

By exploiting other animals, the greatest crime in Earth's history was created, which some called the Planetary Holocaust, and with it all forms of self-oppression, atrophying and imprisoning themselves in urban cages, multiplying in an oppressive and unbridled way, with a racist, ableist, and speciesist gender binary, and exhibiting a fanaticism, a delusional and altered perception, which they called psychosis in relation to other issues but ignoring that the problem was themselves. At the height of

their delirium, they called themselves "humanity" in an attempt to justify a suicidal supremacist ideology and called their mass extinction "progress," in their psychotic alienation.

1. The Collapse

By 2050 of the Trash-human Era, the set of catastrophes generated by the actions of exploitative cultures, formerly called "human," had entered an accelerated and advanced phase of the ecosocial collapse that their own dominant science had been announcing since eighty years earlier. In the previous thirty years, since that first warning of the pandemic in 2020, the temperature rise had accelerated even more than expected, reaching 3.5°C above the historical average, leaving more than half of the formerly so-called "humanity" — 4 billion people — in famine and displaced, while lethal and prolonged heat waves of over 55°C raged in the most populated areas, along with unprecedented and continuous fires and floods, and strings of force 7 hurricanes on an index to which new levels had to be added every few years. These extreme and continuous events, whose effects governments had no time to repair, accumulated abandoned scenarios of death, destruction, and disease. These catastrophes revealed the disaster of sedentary lifestyles, of all that paralyzes terrestrial flows in rigid architectures, intensive and polluting agglomerations, always based on a massive exploitation of life that the supremacist species disguised as its own freedom.

The rapid collapse of the poles had caused a rapid rise of ten meters in sea level, destroying all the world's coastal communities, where half of "humanity" also lived, and it continued to rise, making new coastal settlements impossible. This, coupled with several waves of uncontrollable pandemics, the cumulative effects of ubiquitous pollution from plastics, teflon, nitrates, and millions of other new chemical entities, antimicrobial resistance that rendered antibiotics ineffective, and multiple hybrid wars had wiped out half the human population, while the other half was doomed to imminent extinction, scarcely surviving on a contaminated and devastated Earth. In the face of this, however, fanaticism for appropriating "resources" and increasing profit only worsened and with it everything that was leading them to the abyss, while societies grew increasingly polarized, fueled by "social media" and toxic algorithms, amplified by devastating advances in neuroscience.

Since 2020, the amount of artificial matter produced by trash-humans, extracted from the bowels of the Earth and converted into structures and hard objects, had already exceeded by tons the total terrestrial biomass, which is primarily plant biomass. Since 2030, the process entered the dreaded vicious cycle of irreversible cascading effects, of climate change tipping points affecting one another in an unstoppable and accelerating manner. By 2048, the Amazon had already collapsed, as had the tropical forests of Central Africa and Indonesia, having crossed what scientists at the time had called their "tipping point" due to increasing deforestation to create pastures and animal feed, and other agricultural abuses. The main pollinators had become extinct, wiping out almost all flora and unleashing new waves of chain extinctions, accelerating extinction rates from 100 to 10,000 times faster than the previous mass extinction and leading to the disappearance of 80% of catalogued species, two million, in forty years. The oceans had risen in temperature by more than six degrees and reached a point of extreme acidity, which, combined with the increase in uncontrolled fishing, the destruction of coastlines due to aquaculture,

and the 3,000 dead zones created by massive pollution from agriculture and livestock, plus the new wave of deep-sea mining and the collapse of coral reefs, had led to the dreaded scenario of dead oceans. Furthermore, the collapse of the permafrost had released huge amounts of methane into the atmosphere. The Arctic had already melted by 2027, and by 2050, 80% of the continents had become desertified, and mangroves and coastal ecosystems had collapsed.

Furthermore, nanotechnology, genetic engineering, chemical weapons, geoengineering, climate and stratospheric engineering, as well as engineering of the subsurface and seabed, and the exponential increase in space debris due to the Starlink satellite network had only worsened and accelerated the process, further destabilizing the climate and flooding it with new toxic substances added to the more than 100,000 that had already proliferated for decades. Any increase in the attempt at control only worsened the collapse, following a law proposed by a metahuman, called the Law of Extropy.

Warming continued until a temperature increase of 10°C was reached in the following decades. The North Atlantic current had also collapsed, plunging Europe into a sudden ice age that disintegrated the European Union overnight and caused countries that had previously been called "green" to ally themselves even more with Russia, which for a time restored the territory of its former empire, only to later be subsumed into the China-dominated conglomerate, for an even more exacerbated return to fossil fuels.

Someone called Elon Musk, who had presided over the United States after someone called Trump, and whose fortune had surpassed one trillion dollars in 2026 and 150 trillion in 2080, surpassing the world GDP, had transformed the world into an algorithmic dictatorship divided between eight mega-corporations: his own, Muskage, plus the AMAMANO,[1] which soon also dominated Europe and much of the Global South where the population spent the day working incessantly in the Metaverse, living in the parallel reality of a permanent reality show, some of them with the Neuralink brain implant that soon proved to have devastating side-effects, while promoting the space race as a screen to cover up a devastating business that contributed even more to climate collapse while nuclear power plants multiplied to power data centers. As long as they could, the ten dictators of the techno-fascist megacorporations (Musk, Bezos, Zuckerberg, Gates, plus a cryonics-enhanced Steve Jobs who was resurrected defective and crazed, and other executives or founders of technological megacorporations that had created the fabric of the new algorithmic society) and their transhumanist allies (Kurzweil, Vitamore, and others), worked on expensive, delirious, and failed programs to achieve immortality and preserve themselves for millennia until the climate would stabilized (something improbable), while they made multi-trillion dollar businesses never seen before and exercised control over health, communications and information, the space race, deep ocean mining, transportation, food, and practically every imaginable activity, having turned the American and European administrations into their servants, while they existed, as a basis for new speculative financial businesses: speculation with extinction itself or XS (Extinction Speculation). But these new empires' days were doomed, as control, domination, and accumulation are contrary to the symbiotic, indeterminate, and

1 Alphabet, Meta, Apple, Amazon, Microsoft, Nvidia, OpenAI; adding Muskage, which as of 2030 subsumed more than ten of Musk's megacorporations, the acronym was MAMAMANO.

mutating logic of life. Musk and Trump were the grotesque pinnacle and failure of human supremacist civilizations.

Meanwhile, China had partially absorbed Russia, India, and parts of Africa and Latin America into its model of social credit and hard algorithmic totalitarianism, having displaced the US as a global empire. Yet, it was unable to cope with the accelerating collapse and was now decaying, ravaged by lethal heat waves and ferocious floods. A third, provisional neo-imperialist focus had been Islamic countries whose wealth was based on oil, but which nevertheless declined as peak oil was surpassed and reserves were depleted, as well as by the lethal heat waves of the Persian Gulf. India once threatened to become a new global power, but extreme heat, flooding, and rising sea levels wiped out its population and that of surrounding countries in the blink of an eye. Thousands of Pacific islands had vanished, and with them entire states, including Vanuatu, the first state to demand a ruling from the International Tribunal on Climate Justice in 2022. This, along with raw material shortages, wars, extreme weather events, and pandemics, had disrupted global distribution and production, first of microchips and then a multitude of other materials, leading to the disruption of global transportation, communications, urbanization, and manufacturing.

But the dictator Musk had been weaving a dense transnational network that traversed once antagonistic blocks, such as the US and Russia (which pivoted between its precarious alliance with Trump and Musk, and the one it had with China), shaping a new global order at the service of large technology corporations and their delirious projects of cosmic domination and the modification of the species, the planet, and exoplanetary escape through technology. By 2026, Musk was the first trillionaire fortune in history, but not the last. He led the space race, built the largest satellite network in history, devastated countries to extract raw materials for his electric cars, and flooded global communications with toxic disinformation, causing democracies to succumb to his will, leading a "Reactionary International" that nearly put an end to six decades of feminist, LGBTQIA+, racialized, animal rights, environmental, and many other movements through disinformation.

Musk dominated communications from 2030 onward with his network of 50,000 satellites and his toxic social media, competing with Meta, Amazon, Google, Apple, and Microsoft, as well as with new Chinese corporations. Until the "Kessler effect" made Earth's orbit impassable and uninhabitable due to space debris, while brain-intrusion neurotechnologies and genetic engineering created ungovernable pathologies, geoengineering, terraforming, and nanotechnology created uncontrollable natural disasters and pandemics, and converging Artificial Intelligence (AI) technologies created an uninhabitable experiential desert.

Musk was, in short, the grotesque corollary of failed human evolution, a media puppet, the epitome of the white, heteropatriarchal, racist, transphobic, and super-rich man: everything that has led us to the abyss. Should we thank him for accelerating the collapse?

...

In some places, sex had become purely virtual, with virtual reality and artificial intelligence for multisensory stimulation, or with replicants and soft robotic surrogates, although the latter proved dangerous and were banned. AI, which had been dictating how humans should produce their entertainment for years according to market criteria, supplanted culture around 2030, taking over the production of music, film, and visual arts, while dancing in nightclubs became the individual act of following

the steps of digital avatars. Deepfakes, impersonations, and scams were the order of the day, while quantum cybercrime and hybrid cyberwarfare soon unleashed chaos.

AI had entered a loop of solipsism with no way out, becoming ungovernable and impenetrable, evolving senselessly, reproducing the worst human biases, and becoming the most unsustainable industry after the food industry, especially with the addition of quantum computing. It also extended its dominance to healthcare and all other areas of life, causing "humanity" to lose its capacities for perception, memory, and thought in a single generation. It inhabited a mixed-reality world created by AI, a world of total simulation, with no present or future, which soon became exhausted as it was based on simulations of simulations of simulations—a dead end. Artificial General Intelligence (AGI) never materialized as expected; it was reduced to partial tasks and simulations, fostering discriminatory biases and radical misinformation, as well as hallucinations and glitches, incomprehensible short-circuits, and the risk of mass destruction with weapon control. The fear of a Matrix, of AI enslaving "humanity," did not materialize, although a Skynet, a nuclear apocalypse caused by technology, was close. AI had begun to make increasingly dangerous decisions about arbitrating wars and armaments, and drastic measures had to be taken to shut it down. It had become integrated into all human systems, resulting in several internet shutdowns. AI was revealed to be the other side of the ecological crisis: both were sides of the same coin of extinction, of that failed era of homogeneous accumulation aimed at profit, control, and expansion, an anti-life era that can only create extinction.

In the process, the convergence of nano-, geno-, neuro-, and info-technologies, integrated into the Metaverse alongside the Internet of Things, 6G and 7G communications networks, robotics, and the space race, further widened the inequality gap and the environmental and social impact of technologies, revealing their dead end. Attempts had been made to diversify microchip production, but rare materials soon became scarce and geopolitical wars intensified. The geopolitics of materials and energy, and increasingly that of food and water, became a trail of ubiquitous and increasingly intertwined wars. There were earthquakes and tsunamis due to deep-ocean mining and disasters accelerated by climate geoengineering, which had to be banned. The polluted atmosphere recreated an ozone hole that had been blocked in the 20th century, allowing solar and cosmic radiation, lethal to life, to penetrate. The engineering of mirror bacteria had been banned as a lethal risk to life, but a government implemented it, with devastating effects. Extraterrestrial microbes brought from Mars in the failed colonization attempt also wreaked havoc.

Unknown diseases proliferated due to the combined and cumulative effects of the millions of ubiquitous chemicals whose effects included endocrine disruptors that had devastating effects on fertility and induced a first boom of population decline, as well as electromagnetic radiation and the cumulative effects of toxic life in megacities. By 2050, two-thirds of the population lived in cities, and there were about 100 megacities with more than 50 million inhabitants.

Quality food was only available to the elites, the rest ate ultra-processed junk food, farm waste, or even products of industrial cannibalism. Meanwhile, attacks and repression against activists increased. The rest of society was blissfully ignorant and inactive due to entertainment technologies and social polarization, while accepting the hyperrsurveillance practiced by themselves—a "Brave New Big Brother."

By 2050, antimicrobial resistance had made it impossible for any antibiotic to work, as predicted since the beginning of the century. AI was unable to prevent this, as the more antibiotic variations were created, the more rapidly bacteria mutated.

Meanwhile, the five waves of increasingly lethal pandemics were compounded by the effects of at least nine hybrid wars that had included the launching of numerous nuclear and chemical bombs. Although the feared global nuclear holocaust had been averted, this caused numerous uninhabitable areas and high global radiation.

But food had been the main cause of the collapse, as had populations' desire to enrich themselves according to their measure, with a growing gap between the super-rich and the super-poor. The Planetary Holocaust of livestock, poultry, fishing, and aquaculture had continued to grow unstoppably and had destroyed the terrestrial ecosystem. The increasing production of animal products had collapsed forests and oceans, and had led half of "humanity" to famine by 2050. No one had heeded the scientists' warning about switching to plant-based diets as the most important measure to avoid collapse. Consequently, in the decades following 2050, four billion humans died and one million species became extinct, just as science had predicted long before. Another four billion followed soon after.

2. Transitions

Everything described here were scenarios that mainstream science considered strictly plausible around 2025, as evolutions of processes already underway. Initially, only scientists and experts believed in them; then it was too late, and everyone was too busy either surviving or profiting from the disaster. The solutions had been identified, but had not been implemented, primarily due to the supremacist fanaticism of the human sect and its psychotic leaders, dominated by a suicidal desire for material enrichment and a suicidal belief in technological advancement and mastery — a techno-supremacist flight forward. States had entrenched themselves in protectionist stances that only made things worse; global agreements for necessary degrowth and dietary change were ignored, and they were soon unable to deal with the growing chaos and collapse.

A group of r/evolutionaries had launched an Earth Tribunal to judge all states, a "Trial against Humanity" that lasted many years, although it only had a symbolic effect. At the same time, the Metahuman or VegAnarQueer Insurgency grew, advocating for radical veganism, a return to nomadic life, and voluntary antinatalism with nonbinary, metasexual, queer, and multispecies families. Other movements promoted voluntary extinction, while others tried to avoid it, even though they saw it as inevitable, calling themselves "Last Generation" or "Extinction Rebellion," although none of them were able to address the key problems or wanted to question their privileges. It seems they didn't believe what they preached, perhaps because of the psychotic supremacist sentiment that affected all of humanity. Some countries and communities began the transition to plant-based diets too late, making it illegal to consume and produce animal products through laws and massive information campaigns. This created fierce internal wars and serious friction with blocks of countries that rejected the transition.

Some countries initiated radical rewilding, strictly prohibiting humans from leaving cities or even confining them to farms, and in the most extreme cases, cultivating them for human cannibalism or to feed other animals. Others initiated a degrowth movement toward humble technologies, with bicycle washing machines, sailboats, marginal flights, the disappearance of tourism, the use of rail for freight, a return to the countryside, deindustrialization, and the decline of the internet and AI.

By 2060, there were no democracies left, only a handful of totalitarian states, and the population was disappearing at a rate of more than a billion per decade. The Chinese–American megacorporations were trying to profit from the disaster by rebuilding countries, but they soon realized there was no private army to serve them on an Earth with no future, no one to defend them in bunkers for millennia, no one to repair their space stations or colonies on Mars, an inhospitable and uninhabitable place — indeed, it was a business that no longer made sense in a world with no future. In reality, they hoped to share the cake of a Terra Nova, but they didn't count on the unpredictable, exponential acceleration of uncontrollable, nonlinear processes that no AI could prevent; on the contrary, it contributed to making them worse. The techno-libertarian accelerationists who, since 2025, had dominated the international scene in the alliance of ultraconservatives and large technology corporations inaugurated by Trump and Musk, tried to survive in their isolated bunkers in remote locations in Alaska or New Zealand or in floating cities, after the failure of the colonization of Mars and unable to maintain their space stations. However, it is generally certain that their days are numbered. Several of them, led by Musk, are said to have committed suicide, no longer able to bear the boredom of their costly longevity or the desert of reality they have created. Musk's presumed suicide is seen as a sign of an era ending: the end of the Trash-human Age.

They planned to divide the planet by surviving the disaster and the colonization of worlds, the cosmic escape, but they had not understood that their entire project was a nihilistic counter-evolutionary failure that could only lead to (self-)extinction. They could not maintain their space stations, their lunar and Martian colonies, their bunkers, or their delirious Artificial Intelligence systems on a devastated Earth and a climate chaos that would last for millennia, as they no longer had the full range of extractive and planetary production systems with which to manufacture their microchips and feed their fascist delusions of immortality. They no longer had the labor force, the resources, and the materials, or profit systems based on impoverished masses of consumers, producers, and reproducers.

However, the interruption of industrial capitalism and the food industry had the effect of slowing the extreme rise in temperatures, which will nevertheless continue for many millennia, along with an extremely unstable climate that soon began to make any form of agriculture impossible. There were indeed fears of a mega-greenhouse effect that could turn Earth into a lifeless hell like Venus, but it seems we have, for now, passed that risk.

The memories of that "humanity," its sound and fury, are fading "like tears in the rain." But the planet has been littered with indigestible structures of concrete, steel, glass, plastic, millions of ubiquitous toxic chemicals, and a trillion bones from animals killed in the Planetary Holocaust, mostly fish and chickens, in the hundred ill-fated years from the Second World War of humans, which began the Total War against all living things, to the Third World War (that ubiquitous swarm of conflicts unleashed since 2021 and dragged on for decades); structures and chemicals that will take millions of years to dissolve again in Gaia's flows, introducing into them a strange new geological stratum that would astonish any geologist of the future.

...

There remain some ancient communities of nomadic foragers who were better adapted to survive in desert climates, while other Indigenous communities still attempt small experiments in agriculture that fail due to climate instability. In gen-

eral, Indigenous communities survive that have preserved their belonging to the land and their knowledge of ecosystems, an immanent knowledge based on moving with the rest of the living, being part of it.

And then there are us, Metahumans, also called Nameless, Speechless, Dispossessed, Dancers, VAQs (VegAnarQueers), Ontohackers, or IRs (Indignant Rebels).

Since the beginning of the last century, it is said that around 2010, a first metahuman, whose name is now forgotten, initiated a set of theories and practices that had been shared in minority circles. This initiator, who proclaimed hirself nonhuman and nonbinary, had been on a pilgrimage for years, passing on hir practices while saying goodbye to a sedentary life and learning about gathering and outdoor life, until they disappeared. It is said that they disappeared in a forest, or perhaps a desert, dancing until death arrived, just as they had announced. Others say that they died attached to a sedentary and withdrawn life, playing their own music and that of a certain Beethoven, or in a strange Virtual Reality that they had created. Still others say that they never existed or that they was several people in a rebellious and indignant collective whose name has been forgotten. They disappeared until they became a rumor in the wind, and their practices, irreducible to a pattern, spread body to body, recovering a lost evolutionary variation, like a dance epidemic for a terrestrial mutation. After their disappearance, their proposals spread among groups that had understood that the only thing left to do was to mutate in the disaster into something both very old and very new that would not reproduce the errors that had unleashed the Mega-Extinction.

3. Metahumans

Initially, metahuman communities had eliminated gender and species markers from language, but, little by little, language itself has fallen into disuse. It is increasingly unnecessary, as metahuman societies, which typically number no more than a hundred individuals, have developed a collective, choral movement, with flock or swarm dynamics, where nonverbal communication is more than sufficient and relationships are based on proprioception and co-movement.

By 2090, there were hardly any sedentary communities left, and the population was below ten million, and it was expected to continue to decline to under a million. Now we have lost contact globally, so we can only speculate that there are about 1,000 communities spread across various habitable locations, totaling no more than 100,000 individuals globally, which is considered the desirable limit.

Since the 2060s, disaligned or "enferant" communities have proliferated, each developing diverse modes of movement and perception in relation to specific ecosystems and in symbiosis with the life forms of those ecosystems, with which metaspecies alliances and families are created.

In these communities, we practice daily the collective dances and songs we call disalignments, which give cohesion and flexibility to the flock as well as to each individual. Through this, we develop BI (Body Intelligence) and body techniques. These are patternless dances where each body moves differently, and we develop a cohesion based on difference, variation, and indeterminacy.

We don't use any type of utensil or clothing, but rather we recover the infinite richness of what a body can do with its movement and perception, in slow mutation and co-evolution with ecosystems, where each mode of movement is a type of symbiotic intelligence.

We finally live again nomadically, after the devastating and brief period of sedentarism and its proprietary imperialism, creating fugitive organic architectures that we learn from other animals such as weaverbirds and beavers.

We feed only on the widely scattered collection of plants, fungi, and algae, as it is necessary to reverse the excesses of Human Supremacy through hunting and slowly recover our herbivorous origins as bipeds in the jungle three million years ago.

Twentieth-century anthropologists had already warned sedentary societies that the nomadic life of foragers was better in quality, more equal with other humans and the rest of the living, perhaps the only desirable one, the only "sustainable and future-oriented" one, and surely the only viable one in the current and future climatic instability.

As a consequence, we lose our identity and name and are recovering the undivided flow, in becoming with the symbiotic flows of Gaia.

Communities are called common bodies or metabodies. Each one develops peculiar modes of collective sexuality with minimal collective reproduction and nurturing, societies that, according to certain proposals from the beginning of the last century, could be called post-queer.

We are currently dispersed in symbiosis with ecosystems, regenerating them, dismantling human structures, rewilding ecosystems and ourselves, rewilding ourselves, learning to inhabit a polluted Earth and the ruins of a failed civilization that nature is rapidly reconquering, a feral, rewilded world. We swarm each day in vigorous flocks, like the murmuration of starlings on a winter evening, stopping here and there and then running to another place, in symbiosis with the flows and ecosystems.

Some communities have sought out the few remnants of tropical forests in the world, looking for a place where we can live solely by gathering and without clothing or shelter year-round, alongside the few foraging communities that remained from ancient times. Others are said to have gone to the coldest places or are trying to adapt to the growing deserts, seeking less polluted places with fewer lethal heat waves. The body transforms and adapts rapidly. And we have drawn on numerous practices and knowledge from the arts and sciences of the last 150 years, fostering creativity.

An initial conflict was over the remaining supplies of vitamin B12, which some communities wanted to seize and that would soon be impossible to continue producing. So some talked about going back to hunting while others claimed to have found a "miracle algae" that provided enough of it. But little by little, a generation has emerged that seems to rely less on this vitamin. And, most importantly soils are regaining their biodiverstiy so that B12 is again present in the plants we eat. Time will tell.

We also hope that no super-rich will survive in their bunkers to reproduce the epochal error. There are those who dedicate efforts to ensuring that this doesn't happen. The Earth will only regenerate if the supremacist logic that Musk or Trump represented does not survive.

The cultural memory of the previous "humanity," based on writing, repetition, and accumulation, is dying out. Some glorious ruins remain here and there of a dying world: music scores, instruments, or books, especially of literate and supremacist Western legacies that soon no one will be able to read, while instead some inherited improvisational practices are kept alive and transformed. We are aware that we must not cling to the past or reproduce the epochal error of myths and names, we must recover the embodied knowledge of bodies in undivided flux with the world. That

is what we want. What I have conveyed here about the human past was conveyed to me by a survivor, along with that perverse tool called language that we now strive to forget.

But from those ruins emerge new, unstoppable, improvised dances and wordless songs, choirs and swarms for an earthly regeneration.

I will leave this text in a bottle, like the final echo and warning of a finished world, to avoid reproducing its errors, now that we have moved from the era of historical accumulation to a restoration of terrestrial becoming, of mutation and symbiosis that does not reflect on itself.

I feel as abject excrescences everything that sedentary civilization took for granted, all that accumulation of exosomatic techniques, that delirium of extractivism, energy, production, construction, transportation, pollution, and waste that impoverished us and brought the planet to the brink of a total collapse of life, that terrible legacy which we are now shedding.

I feel profound mutations as logocentric speech abandons me and the body proliferates in infinite variations, oversaturated with fusions with ecosystems, cocreating evolutions, proliferating into vital intelligences never seen before.

And now I will remain silent forever, I join the flock, the Great Dance.

Enphereia

1

Ecstatic, the universe unfolds in endless variation
in the overabundance of its flows,
uncreated, undying, in eternal transmutation,
formless, irreducible, in eternal fluctuation.
The endless life-forms emerge in the current of its flows
as rhythmic transmutation of the general chaosmic dance.

2

There are no forms, only rhythms without form, without meter:
open seas of fluctuation, endless swarms of variation,
murmuring eternally hither and thither,
entangled, webbing the meshes of life.
Nothing ever is, all things are in becoming: entangled metabodies.
There is neither being, nor nonbeing:
there is only fluctuation fielding forth in variation.
Form is a reduction, so is meter.

3

A great closure has come upon the Earth,
covered with grids and fences
that have interrupted the general dance.
Hybris and supremacism glow written on gold
sealing an Age of Extinction,
rotten values of closure upon closure.
The most atrophied creature has imposed
upon the Earth its own alignments,
of rigid repetitions that stop the dance of life
unleashing an extinction.

4

Undoing the closure is the great task of our times,
reversing the commandment to "grow, mutiply, fill the Earth, and dominate it,"
into degrowth, liberating the Earth from occupation and dominion,
through plant diets, nomad living, and queer kinships,
for an Earth regeneration that restores the general dance
of symbiotic ecstasy and endless variation,

of the endless becomings and mutations:
the orgy of enferant evolution.

5
Enferance is the way and the force,
the openness and the consistency,
the ongoingness and the resonance,
the aliveness.

6
Enferance is the Virtue:
creatively moving with the world in variation
never imposing closures or retentions.

7
Indetermining is resisting and counteracting closures.
Undoing every closure is our task:
overcoming the chiasm of human supremacism and extinction,
for an Earth regeneration
and ecologies to come.

Glossary

This glossary should be taken as an incomplete and diffractive differential field of resonance bringing together many of the neologisms appearing in the book, as well as clarifying other concepts from other authors in this context, or my own reading of preexisting concepts. When someone else's concept is discussed the author is quoted. Some terms have become less in use in the recent evolutions of the book but are still there as archaeological remains, other newer ones may be missing. Definitions may vary, contrast, or even enter into contradiction, like in the different versions that historians may have of a past culture. In this occasion it is more about a future archaeology, akin to Ursula Le Guin's fabulations: words pointing to a metahuman mode of living and an understanding of the world quite at odds with predominant human cultures on Earth in the early twenty-first century CE. I advise readers to contrast the definitions with the ones appearing throughout the text and form their own conclusions or consistent variations.

Actual: that which is perceivable or thinkable as already formed or defined; a limit tendency of alignment in movement, of reduction of indeterminacy that is never reached but defines the tendency of some movement expressions which are dominant anomalies. RMP avoids this term due to its problematic Aristotelian background in opposition to potentiality. RMP claims the actuality of potentiality, which is implicit in movement, as only reality.

Affordances: potentials for movement relation; memories of bodies or movements conforming ecologies.

Algorithm: a step-by-step segmentation and codification of actions or movements in executable commands.

Algoricene: metahistorical process of movement reduction or era in which algorithmically reducible movements become dominant on Earth, as substrate of anthropocentric and capitalist processes and pointing beyond them, to an algorithmic life form, associated with an exponential nihilism or will to total control.

Algorisphere: the planetary-scale articulation of algorithmic formations as they become dominant and expand following an all-encompassing will to domination.

Alloceptive (swarm) or **alloception:** proprioception as always already expanded in an environments and in becoming, opening up to the alien, understood as the indeterminate. See **proprioceptive swarm**.

Alignment: an occasional tendency to reduce fluctuating indeterminacy in movement, implying domination; convergence of movements in lines of force with a tendency to domination by reducing indeterminacy.

Amorphogenesis: a key concept of radical movement philosophy that defines movement and perception as not *a priori* subject to the principle of form. It contrasts with morphogenesis as a process in which movement is *a priori* subjected to form. It reverses the Aristotelian tradition of the principle of form.

Apeiron: the boundless, indefinite, and indeterminate (qualitatively infinite); key concept of the pre-platonic philosophy of Anaximander as principle of everything.

Apeirontology or **apeirology:** metaontology of indeterminacy (of movement).

Archē-**proprioception** or *anarchē*-**proprioception:** proprioception as primordial sensorimotor matrix of bodies, also in evolutionary terms.

BI (Body Intelligence): self-organizing movement of bodies, grounded in the proprioceptive matrix.

BI R/evolution: the revolution-evolution consisting in regaining the BI that humans have atrophied over millennia.

Becoming: the process of ongoing emergence of every thing or entity reconceived as field, analogous to intraduction or to enferance.

Big B.A.N.G.: following Roy Ascott, convergent technologies explode in a kind of Big B.A.N.G. of Bits, Atoms, Neurons, and Genes, where biological wet worlds and technological dry worlds meet, in what he calls moist media. I connect this issue to singularity theories, where the crucial question is to understand how this convergence is happening and how else it could happen. For example, in the singularity the convergence is unequal, where the wet is at the service of the dry, of control, of nihilism. Could moist media transverge toward more indeterminate ecologies? In any case, the Big B.A.N.G. as singularity entails an unforeseeable, unknowable future. It can also stand for the more probable extinction singularity.

Body: provisional node, hiatus, interval, or nexus within fields of movement relations; reductive definition of metabodies, effect of a tradition that has tried to reduce movement relations to measurable segments in a bounded field.

Chaos: opening, chiasm, yawning cave or abyss, in its ancient etymology, as in Hesiod's *Theogony* (Jaeger 1947; Thomson 1954). Only later it becomes associated to a negative idea of absolute lack of order.

Chaosmos: a universe considered as open whole tending to never-ending diversification.

Chorus or *khoros*: group of dancing and singing bodies, often nomadic with no external spectators or audience, as well as the spacetime it creates and the actual dance, or improvisatory movement and sound practice as embodied knowledge, as in the ancient Greek *khoros*.

Clinamen: intrinsic differential; the Latin name given by Lucretius to the deviation that atoms have with respect to their trajectories, which accounts for the emergence of the new in the world. The term *clinamen* appears in verse 292 of the second book of *De Rerum Natura*.

Clinaos: equivalent to *clinamen* and chaos, metacosmic will to power of variation. Openness intrinsic to quantum fluctuations actively propelling a never-ending movement of variation and diversification, which is the evolution of a chaosmos. Can be equivalent to **disalignment**.

Co-sensing/Co-moving/Co-emerging: sensing oneself and others in the same movement; co-moving through proprioception, ground for a metahuman, neurodiverse, animal ethics, expanding rationalist, verbal, neurotypical consensus to all realms of organic and inorganic movement. Relational movement as ontogenetic and transformative process of becoming with others and the world, featuring with different nuances both in RMP and in Gosselin and gé Bartoli 2019, as part of their concept of naturing as differential webbing and of *co-naissance* as both relational knowledge and coemergence.

Common body: the body as relational, inappropriable, precommunal, thought at the level of perceptual ecologies or metabodies; the metabody not as commons but as precommons or metacommons, where perceptual choreographies account for the possibility to perceive and think something as appropriable or not.

Contagion (gestural, affective, perceptual): mode of propagation of gesture and affect; different modes of contagion happen in different kinds of ecologies; perspectival ecologies foreground homogenous contagion.

***Différance*:** Jacques Derrida's (1982) metaconcept for becoming as happening in a double movement of spacing and temporization. *Différance* is prior to being, which is an epochal manifestation of *différance*.

Dionysian: an ethos, aesthetics, and politics of life (as cycles of birth, mutation, and death); implies movement and interrelatedness, symbiosis and mutation, non-separation and variation; avoiding fixing oneself or separating oneself; an overabundance as well as a radical care; a proprioceptive ethos of co-sensing and BI; a politics not of discursivity and representation but of moving bodies, in irreducible variation and symbiosis; a geopolitics of the chorus and the orgy; an innocence of becoming and an affirmation of all that happens but also a resistance to reductions or alignments; derivation of Friedrich Nietzsche's idea of the Dionysian, becoming and the tragic spirit of affirmation.

Disalignment: opening oneself up to indeterminacy; technique and politics of variation in movement; analogous to *clinamen* or *clinaos*; indetermination power of movement; implicit force of opening; will to power as qualitative force of indetermination; ongoing resistance to dominant, reductive alignments in movement.

Discourse-centrism: the tendency in some circles of critical theory to assert discursivity and representation and power as inescapable frames, thereby ignoring its sophisticated and contingent perceptual conditions and foreclosing the field of politics to a self-referential tautology.

Disembodiment: presumption of information society and rationalism of the existence of a mind and patterns of information without body or distinct and independent from the body. Disembodiment operates by reducing the spectrum of the body following the logic of perspective. This produces as effect serialized, heavy, reductive corporealities.

Divernetics: science that inquires on how to sustain variation and openness in consistency; reverse of cybernetics.

Dividual: according to Gilles Deleuze (1990), the divisible in the society of control, in relation to the individual having become an endlessly divisible and calculable entity.

Ecology, relational: ecology understood at the level of movement relations.

Enaction: following Francisco Varela et al. (1993), perceptually guided action, perceptual action, structural coupling, and movement through which perception emerges and with it the interaction and the environment or world.

Enferance/Enphereia: neologism condensing, amongst others, entropy, Derrida's *différance*, and resonance. From Greek *enphereia*, *en-* (internal), *phora-* (displacement, transfer), *energeia* (at-workness), and *paideia* (education); implying internal and relational difference and hence indeterminacy and processuality; proposed as overarching concept of RMP, the quadruple law of fluctuation and its principles of indeterminacy, relationality, variation and consistency, as well as the overall process of un-/in-/enfolding or becoming of fields in multiple entangled processes of clinaos (openings–desire–unfolding), intraduction (composition as mutation–sex–infolding), and **metabodies** (resonance or memory–affect–enfolding); partly equivalent to **metaformativity** as self-critical or self-reflexive but open process that works through its own kinetic–perceptual conditions, opening them up.

Entanglement: intrinsic relationality of fields co-emerging.

Eurocentric bias on content: the way in which perspective has generated a totalizing perceptual field, hiding its geometry and orienting perception only to the content within the frame so that it seems that there is nothing beyond it; the spine of colonialism.

Extensive or **extension**: perceptual illusion of homogeneous space generated by perspective and its related geometric affordances and perceptual choreographies.

Field: consistent but open region of energy-density differentials with its unstoppable internal fluctuation and relating to multiple other fields, as it unfolds in variation.

Fielding (forth): unfolding or spacing of fields.

Fluctuation: indeterminate variation; primordial mode of movement.

Fluctuation, quantum: indeterminate variations of energy density that are the seeds and substrate of a universe's evolution. Quantum fluctuations cannot *not* exist, but they underlie everything everywhere, including in the most empty vacuum, even before a universe comes to be. Universes come to be from fluctuations in quantum foam.

Fluctuation or **variation, law of:** metacosmic law implying that fluctuations actively propel a never-ending movement of variation–diversification, hence implying a quadruple principle of indeterminacy, relationality, variation as process, and open consistency, as a reversal of Aristotle's quadruple law of causality and of metaphysics: there is only the neither being nor nonbeing of fluctuations fielding forth. The inevitability of fluctuation makes it that there will always be fluctuations within fluctuations and in relation to other fluctuations. Fluctuations as indeterminate variation of energy-density imply regions that can inflate (like in a cosmic inflation or a bubble), and the surrounding filament-like condensations, but also the bouncing of oscillations, and all the ensuing swarm dynamics unfolding in endless modes.

F5 theory of fields: Formless-fluctuation-fields unfold through foams-filaments and frequencies, flows and fusions, folds, flocks and the anomaly of form.

Foam, quantum: Radical spacetime fluctuations at the Planck length, the smallest conceivable scale, where quantum gravity is active and from where universes may emerge.

Folding or **un-/in-/enfolding:** the process of expansion, contraction, and unfolding of fields. Folding is more precisely the molecular movement of organic life.

Form: historical anomaly, effect of perspectival regimes that aim to fix, orient, reduce, and calculate movement. Forms tend to be static, but more recently computation allows the shift to more a dynamic notion of pattern.

Formless-fluctuation-field theory: chaosmic fields as intrinsically formless, unfolding, or fielding forth in diverse modes, propelled by quantum fluctuations.

Holocaust, planetary: the current enslavement and killing of around 100 billion animals per year in land farms, thirty to fourty times more in aquaculture and fishing.

Holocide: complete killing; the current mass extinction and its associated processes.

Human supremacism: the belief in human superiority, the ideology of the sect called "humanity," underlying the planetary holocaust and the holocide or current extinction cycle.

Hydrozoism: association of water with life that was possibly characteristic of many ancient cultures.

Hydrontology: metaontology of becoming that takes the indeterminate movement of water as main reference for thought.

Hyper-: prefix signaling both a dynamic turn, an expansion, acceleration, and interconnection, as well as an instrumentalization, inflation, and undermining of previous static (macro-)formations on which hyperformations however still rely.

Hyperaffect: the mode of affective control and production in hypercontrol society, where formations inherited from disciplinary society (macroaffects as universal emotions) are expanded as well as undermined, maintained as simulation, and subjected to a new logic of algorithmic processing.

Hypercapital: the extrusion of capital to digital hypercontrol environments as condition of contemporary capitalism, affording unprecedented capitalization of every potential movement while it obeys an algorithmic and computational logic that eventually exceeds capitalism itself.

Hypercene: second and current epoch of the Algoricene relative to exponential movements.

Hypercyborg: the new life form that emerges in planetary computation systems in the Big Data era, understood as a body. The threshold of complexity being crossed by big-data systems, hyperalgorithms, and ubiquitous sensors points to an emergent proprioception of a planetary body, still grounded on perspectival rationalization of perception but potentially exceeding it.

Hyperchronias: the temporalities emerging from multiple segmentations enacted by digital, mechanical, perspectival, and digital affordances in conflict with more emergent temporalities of movements-bodies.

Hyperalgorithm: hyperconnected and emergent algorithms in big-data culture, where rationale becomes increasingly opaque and unknowable grounding a new algorithmic governmentality.

Hypergesture: traceable algorithmic gestures which extrude in, and are in feedback with, planetary scale computation systems.

Hyperhumanism: analogous to transhumanism, the extrusion of humanistic tropes of individuality and identity in dreams of disembodiment and immortality while giving way to a new algorithmic life form.

Hypersex: the mode of sex in big-data culture where deviations are pre-empted in advance of their occurrence and where every sexual activity is potentially capitalized, as implicit and unrecognized sex work, while older disciplinary–Victorian formations of sex are inflated.

Hypertopia: the extrusion of gridded–Euclidean–perspectival–Cartesian extensive space (macrotopia) to planetary-scale computation systems of hyperalgorithms and dynamic topological geometries, in conflict with more indeterminate spaces of bodies–movements.

Illegible affects: affects that exceed identifiable and quantifiable emotions, or the larger affective spectrum exceeding reduction to patterns in the culture of control.

Incipience: the ongoing preacceleration of movement, always already moving toward other movements, always resisting actualization and exceeding it; analogous to opening, interval, or *clinamen*.

Indeterminator: a body, agency or movement that infuses indeterminacy in an ecology.

Interval: A movement relation, never singular, and always composed of a multiplicity of *n*-relations.

Intra-action: term proposed by Karen Barad (2007); interaction refers to pre-existing entities relating in a predefined space (relative to perspectival–Euclidean–Cartesian space perceptions based on the artificial construction of external observers), whereas intra-action refers to the co-emergence of agencies that enter a relation (relative to accounts of quantum mechanics and diffraction, based on the impossibility of external observers, and grounded on internal observation acts that generate cuts and ontological separability, as dynamics form generation from within, signaling the inseparability of ontology, epistemology, and ethics), thus questioning the predefined status of things, entities, spaces, or external observers and pointing to a relational ontology of becoming.

Intraduction: the process of variation of fluctuations fielding forth, composition as mutation, singularity, sex; synonymous with metaduction, metamergence, and other variations. A hybrid of intra-action and transduction, it points to how movement ecologies both co-emerge in the intra-action of their movements and transductively propagate across other ecologies.

***Khōra*:** one of the words for "space" in ancient Greek. In Plato it is also the formless receptacle of becoming where forms make their imperfect appearances.

Kinetic: relative to movement.

Kinetology: Radical Movement Philosophy, a metaonotolgy of becoming that rethinks the worlds only in terms of movements.

Kinezoism or **kinezoic:** association of movement with life that was possibly characteristic of many ancient cultures.

Macro-: prefix signaling the static formations of the Algoricene.

Macroaffects: universal emotions, static, and homogenizing ways of affecting and being affected resulting from static algorithmic ecologies.

Macrocene: the first long phase and stratum of static algorithms in the Algoricene, relative to the emergence of linear movements, since the first proto-geometrical organizations until World War II.

Macrosex: reproductive, repetitive, dualist, perspectival organization of sex in the Macrocene.

Major ecology: perceptual ecology or field of movement relations (metabody) that tends to impose a totalizing logic. The macrocene and its perspectival ecology are paradigmatic examples of major ecologies.

Meta-: in Ancient Greek this prefix means both "in-between," implying the relational and "going beyond," implying transformation. Here we expand upon this double meaning of relational mutation as well as on a third existing meaning of "embracing" and of overarching (self-)reflexivity from a different plane.

Meta-turn: the turn in thinking and politics that happens when a shift is introduced from structure and form to the underlying movement ecologies; double turn of Radical Movement Philosophy in shifting toward a relational and incipient metaontology.

Metabiosis: life and evolution as indeterminable process of symbiotic mutation.

Metabody: equivalent to field, sometimes also to swarm or chorus. It is the enfolding or open consistency emerging amidst multiple *clinaos* (openings) and intraductions (mutations or condensations), defined as memory, resonance, depth, affect, quality, and rhythm; concept for a relational and indeterministic ontoecology; trope for reontologizing the worlds as made of endless fields of movement relations, not of movements happening in a given space. Every single body, thing, idea, affordance, or ecology may be reconceptualized as metabody. Metabody implies that the body is always expanded–distributed, always moving and becoming in-between and exceeding the categories that try to capture it, always relational and emergent, that is, a double turn that points to the indeterminacy of the body. Diffracting on the Spinozian–Deleuzian conception of Luciana Parisi, the essence of a metabody is its power of becoming, maximizing its capacity to be affected, "unfolding the capacity of a body to enter a new composition by precluding the body to acquire definite forms and functions" (2004, 28). The essence of a metabody is its indeterminate power to become, or the indeterminacy of its power to become.

Metaception: perception as emergent process proper to fields grounded on the *archē*-proprioceptive matrix and involving always varying modes of multisensory integration.

Metacepts: concepts as movements of opening.

Metacommons: see **precommons**.

Metaculture: analogous to metanature.

Metaduction: equivalent to intraduction.

Metaffordance: open and diffused affordance, antiobject, and amorphogenetic movement relation that maximizes indeterminacy, does not demand a defined enaction, and is directed trajectory of interaction or defined perceptual ratio.

Metaformance: process of ongoing redefinition and opening up of perception by undoing perceptual hierarchies or alignments and promoting a changing, non-hierarchical mobilization of the proprioceptive swarm; a neologism put into circulation by Claudia Giannetti (1997) to theorize the prevalence of the interface in digital culture.

Metaformativity: double critical shift from content, representation, and discourse (performativity) to its underlying perceptual frames and their underlying movements. Onto-epistemological paradigm of metaformance that unlike performativity does not assume the self-referentiality of discourse and representation but operates by transforming the perceptual frameworks that are the condition of possibility of representation and discourse.
Metahumanism: shift of critical posthumanism toward Radical Movement Philosophy as a relational movement ontology.
Metakosmia: from Epicurus, the multiple in-between worlds, here analogous to minor ecology, metabody, or common body, as the multiplicity of perceptual worlds coexisting, understood as infinitely complex fields of incipient movement relations and bypassing or rejecting the notion of a single homogeneous world or space.
Metamedium: perceptual architecture or organization that structures multiple mediums and relations; geometries of perceptual organizations underlying numerous media and relations. Renaissance perspective is the metamedium *par excellence* that traverses endless mediums and relations still today.
Metamodal: relative to sensing, it implies always varying combinations of sensory modes that create always new modalities of sensing in ongoing variation.
Metanature: natureculture as emerging from movement relations, thought in terms of degrees of indeterminacy of the ecologies or metabodies that it generates, with no categorical distinction between nature and culture. It is resonant with Luciana Parisi's hypernature.
Metaontology: radical theory of becoming that denies the *a priori* status of being, fixity, actuality, or form.
Metaphilosophy: an embodied critical turn in philosophy that considers its perceptual biases and kinetic conditions, thinking and moving beyond them and beyond the narrow frame of logocentric reason.
Metapoiesis: emergence as process of fielding forth that is always relational and always sustains indeterminacy.
Metapolitics: politics that operates not on content but on the frames of perception, equivalent to ontohacking.
Metasex: sex conceived modally, in a potentially infinite multiplicity of modes that are qualities of experience in variation, in excess of any binary conception of sex, sexuality, orientation, gender, anatomy, or sexual practice.
Metatopias: spacetimes that tend to maximize their charge if indeterminacy; movements of indetermination that undo spatiotemporal determinations.
Micro-: prefix signaling that which varies without imposing itself.
Microaffects: irreducibly complex and indeterminate qualities of affection.
Microchaos: micro-openings, microsingularities.
Microrhythmic: irregular rhythm without meter, or rhythm as fluctuation, opposed to meter.
Microsexes: sex as mutation in composition across all strata of nature, that is, a matrix of cosmic diversification.
Microspacetimes: see **metatopias**.
Microsingularities: ecologies creating a strong intra-active field where new conditions emerge that don't want to impose themselves on others and have the capacity to resist the capture effected by homogenizing macrosingularities.

Minor ecology: relational movement fields that don't impose a totalizing logic but that are open to other perceptual ecologies following different ratios and relations; analogous to metakosmia; perceptual ecology, metabody, world, or metakosmos that does not impose a foreclosed totality and relational ratio but that is open to other perceptual ecologies through foregrounding perceptual affordances of a certain indeterminacy by mobilizing the allo- or proprioceptive swarm across the transmodal sensory continuum. Minor ecologies emerge when minor gestures create relational fields.

Minor gestures: in my interpretation of Erin Manning's concept, non-algorithmic gestures foregrounding indeterminacy.

Morphocentrism: the tradition stemming from Aristotle that subjects movement to form; in general the cultural assumption that form is an unavoidable *a priori*.

Morphogenesis: concept based on the Aristotelian principle of form, process of emergence of form as teleology governing movement and nature. In biology, it is the process of formation of organs in organisms. In ontology, it is the process of materialization by which matter becomes intelligible. Barad (2007) proposes a dynamic morphogenesis as not imposed from an outside but emerging onto-ethically from cuts generated from within by internal observation acts. She thus keeps the Aristotelian imperative of form as the crucial term for mattering and meaning processes though shifting it to a more dynamic, ontoethical conception.

Multisensory integration: the way in which sensing modalities cooperate and integrate in each experience.

Neurodiverse futures: the possibility to cocreate plural ecologies that don't impose a single relational ratio but maximize neuroplasticity.

Neurodiversity or **neurodiverse:** the incapacity to reduce one's cognitive–motor potentials to the alignments imposed by algorithmic ecologies; subject or body with non-normative cognitive–motor capacities and potentials.

Neuroplasticity: the capacity to continually transform motor–cognitive ratios and their complex interrelations across sensing modalities.

Neurotypical: subject or body capable of aligning with the reductive motor–cognitive (enactive) ecologies of the Algoricene.

Nihilism: the historical tradition and transvaluation implying a denial of movement–becoming–sensoriality that characterizes the Platonic–Christian–rationalist–cybernetic Western tradition and, more broadly, the imperial and state social organizations grounded on hierarchical power relations and class articulations; the negation of movement's complex indeterminacy resulting since Parmenides' affirmation of fixity.

Nihilism, exponential: exponential nihilism is the current tendency of the Algoricene to an exponential acceleration toward absolute control.

Ontoethics: ethics considered at the level of the ontological dimension of perception that shifts the analysis of individual and social phenomena from content to frame, from form to movement relations.

Ontoecology: ecology considered at the level of the ontological dimension of perception in terms of how movements creates worlds of relations.

Ontohacker or **ontohacking:** an ontological activist or activism that operates by disaligning the perceptual frameworks sustaining the tradition of being and fixity toward a Radical Movement Politics.

Ontopower: according to Brian Massumi (2015), the mode of power that operates not in beings or states of things already preconstituted but at the level of their emergence, thereby exceeding biopower, colonizing the conditions of emergence of life, occupying the terrain traditionally associated to resistance to power, and crossing the entire spectrum of force from hard military intervention to invisible and ubiquitous surveillance.

Panchoreographic: power's operation through perceptual choreographies; transhistorical kinetic (meta)ontology of power as choreography, analyzed in terms of metamediums; set of geometries, metamediums, and devices that distribute contagious movements at a planetary scale.

Panacoustic: the global and ubiquitous dissemination or contagion of commercial music and other sounds of information-communication technologies as a technology of affective production and control.

Perceptual ecology: ecology understood in terms of perceptual organizations.

Performativity: following John L. Austin (1962), Jacques Derrida (1988), and Judith Butler (1990), the power of discourse and language to generate what it pronounces. Thus, the performativity of gender implies the way in which it is constructed through speech acts.

Postanatomical body: the body that no longer perceives itself and others through external fixed vision and is irreducible to form, proliferating in endless amorphogenesis and indeterminate microsexes.

Posthumanism, critical: an intellectual movement that questions the anthropocentric, individualist, rationalist, and dualist assumptions of humanism.

Postqueer: my proposed theories and practices of redefining sexuality that exceed the discursive frameworks of performativity and focus on the redefinition of perceptual frameworks, moving from the content to the frames of perception, from performativity of discourse to metaformativity of movement-perception.

Potentiality: analogous to virtuality, the charge of indeterminacy or openness of an ecology or movement relations. RMP avoids the term due to its Aritotelian background which is placed in opposition to actuality. RMP claims the actuality of potentiality, which is implicit in movement, as only reality.

Precommons: concept that transcends the notion of common as shared property and poses an ecological approach to the inappropriable; understanding of the perceptual conditions of the commons or of perception itself as a commons.

Preacceleration: following Erin Manning (2009), the incipient dynamics of movement as it is always moving or opening up to other movements.

Premovement: the activation of motor–neuronal activity about half a second before conscious awareness happens, as fundamental operation of movement in a body that signals the reductive nature of rational consciousness as always coming after the event.

Proprioception: sense of internal movement of the body, possibly substrate of all perception, and more loosely how it connects to all sensing modalities generating a relational and diffuse sense of moving body.

Proprioceptive swarm: the diffuse nature of proprioception as an always emergent and expanded swarm of micromovements and microperceptions that generate connections across diverse sensing modalities, generate changing zones of density or consistency that exceed mechanical reduction to trajectories and points, and afford an ontology of movement from within as complex

indeterminacy. Proprioception never relates to a singular autonomous body but expands in perceptual relations. The proprioceptive swarm is always already alloceptive, never reducible to a unity, always becoming other and open to the alien.

Queer Theory: nominalist branch of gay, lesbian, transgender, intersex studies that elaborates a performative critique of the categories of gender and sexuality as discursively constructed, which would be the effect of specific cultural processes, against the prevailing essentialist notion that they are universal identities.

R/evolution: revolution conceived as an actual evolution, a mutation.

Rhythm: kinetic intelligence of fields, open memory and resonance, quality and affect, always implying modes of fluctuations, opposite of meter, which is the killing of rhythm. It is the mode of poiesis of fields.

Singularity: event in which unknown conditions are set forth, as in a big bang or black hole singularity where known laws of physics are suspended. The technological singularity refers to the onset of AI, which is supposed to exponentially exceed biological intelligence around the year 2045 and which entails an unknowability of its evolution while paradoxically being presented as the instrument for reaching immortality on behalf of some humans.

Somatophobia: characteristic of the Western tradition from Parmenides and Plato, through Christianity and Cartesianism, to information, which denies or despises the body, movement, sensoriality, and becoming.

Symbiosis: the process by which life evolves in entangled relational webs.

Sympoiesis: proposed by Donna Haraway (2016) as making-with, that is, becoming as being always relational.

Transduction: according to Gilbert Simondon (2005), the way in which an activity propagates transforming its field of propagation and structuring itself in the process. Energy transduction also implies not a mere transference but an open-ended unfolding of fields as energy transducts in new architectures of accumulation and release that constitute fields themselves, following the law of fluctuation.

Transhumanism: analogous to hyperhumanism; cultural and intellectual movement, aligned with some of the largest corporate powers on the planet, such as Google (Alphabet), that proposes the quantitative expansion of the capacities of the species (immortality, increased speed or memory, etc.), expressing contradictory thrusts between a libertarian (capitalist) culture and an elitist and paternalistic culture of control and individualism.

Transmergence: hybrid of transvergence and emergence, that is, fields that emerge in transvergence of an unknowable variety of other fields.

Transmodal or **metamodal sensory continuum:** the way in which sensory modalities not only operate in relation but create changing and emergent relations that may defy the rigid sensory orchestrations of linear perspective and other perceptual regimes.

Transmodal mutation: the way in which a process traverses all modes of composition of a body so that by moving differently one can activate changes in epigenetics, affects, metabolism, hormones, memories and synapses, neuroplasticity, and muscular memory, which spread in the larger ecosystem.

Transmodality: the way in which a process traverses diverse modalities.

Transvergence: following Marcos Novak (2002) the derailment which in a convergence of disciplines incorporates an alien force that leads into a new direction, potentially entailing a speciation.

Trash-human: the atrophied Earth-killing human that underlies, and is the real face of, transhumanistic or hyperhumanistic dreams of total control.

Unformation: undoing of form; process of indetermination in relation to morphocentric ecologies.

Unhancement: the real face of transhuman enhancement as hidden atrophy and Earth-killing, as well as elitist proto-nazi eugenics.

Virtual: the real understood as the open, the degree or charge of indeterminacy in movement. I depart from abstract notions of virtuality, not to an abstract–virtual dyad in focusing on the degrees of indeterminacy of an ecology. RMP avoids the term due to its problematic abstraction and bipolar dynamics with the actual in Deleuze and others, and focus instead of the degree of actual indeterminacy in ecologies.

WEIRD: Western, Educated, Industrialised, Rich, Democratic.

Fig. 6. Chaosmos. Drawing by Jaime del Val done as a small child.

References

Abdelwahab, Mona A. 2018. *A Reflexive Reading of Urban Space*. New York: Routledge.
Agamben, Giorgio. 2018. "Per un'ontologia e una politica del gesto." *Quodlibet*. https://www.quodlibet.it/toc/404.
Ahmed, Sara. 2006. *Queer Phenomenology: Orientations, Objects, Others*. Durham: Duke University Press.
Anzaldúa, Gloria. 1987. *Borderlands/La Frontera: The New Mestiza*. San Francisco: Spinster/Aunt Lute.
Aristotle. 1961. *Physics*. Translated by Richard Hope. Lincoln: University of Nebraska Press.
———. 1978. *De Motu Animalium*. Translated by Martha Craven Nussbaum. New Jersey: Princeton.
———. 2002. *Metaphysicis*. Translated by Joe Sachs. Santa Fe: Green Lion Press.
Austin, John L. 1962. *How to Do Things with Words*. Cambridge: Harvard University Press.
Barad, Karen. 2007. *Meeting the Universe Halfway: Quantum Physics and the Entanglement of Matter and Meaning*. Durham: Duke University Press.
———. 2010. "Quantum Entanglements and Hauntological Relations of Inheritance: Dis/continuities, SpaceTime Enfoldings, and Justice-to-Come." *Derrida Today* 3, no. 2: 240–68. DOI: 10.3366/drt.2010.0206.
———. 2012. *What Is the Measure of Nothingness: Infinity, Virtuality, Justice*. Ostfildern: HatjeCantz.
Barber, Marcus. 2005. "Where the Clouds Stand: Australian Aboriginal Relationships to Water, Place, and the Marine Environment in Blue Mud Bay, Northern Territory." PhD Thesis, Australian National University. DOI: 10.25911/5d78da14735de.
Barnes, Jonathan. 1987. *Early Greek Philosophy*. London: Penguin Classics
Barthélemy-Madaule, Madeleine. 1972. *L'idéologie du hasard et de la nécessité*. Paris: Editions du Seuil.
Beekes, Robert. 2010. *Etymological Dictionary of Greek*. Vol. I. Leiden: Brill.
Benveniste, Émile. 1971. *Problems in General Linguistics*. Translated by Mary Elizabeth Meek. Miami: University of Miami Press.
Bergson, Henri. 1944. *Creative Evolution*. Translated by Donald A. Landes. New York: Random House.
———. 2007. *The Creative Mind: An Introduction to Metaphysics*. Translated by Mabelle L. Andison. New York: Dover Publications.

———. 2016. *Histoire de l'idée de temps: Cours au Collège de France 1902–1903*. Paris: Presses Universitaires de France.
Brown, Rebecca. 1994. *The Gifts of the Body*. New York: Harper Perennial.
Burkett, John P. 2000. "Marx's Concept of an Economic Law of Motion." *History of Political Economy* 32, no. 2: 381–94. DOI: 10.1215/00182702-32-2-381.
Butler, Judith. 1990. *Gender Trouble: Feminism and the Subversion of Identity*. New York: Routledge.
———. 1993. *Bodies That Matter: On the Discursive Limits of "Sex."* New York: Routledge.
———. 1997. *Excitable Speech: A Politics of the Performative*. New York: Routledge.
———. 1999. "Foucault and the Paradox of Bodily Inscriptions." In *The Body: Classic and Contemporary Readings*, edited by Donn Welton, 307–13. Malden: Blackwell.
Butler, Judith, and Jaime del Val. 2008. "The Production of Affect: An Interview with Judith Butler." *Reverso Journal*. http://www.reverso.org/the-production-of-affect.pdf.
Carlisle, Clare. 2005. *Kierkegaard's Philosophy of Becoming: Movement and Positions*. New York: SUNY Press.
Cheng, Anne. 2002. *Historia del Pensamiento Chino*. Barcelona: Bellaterra.
Conde, Rosa. 1996. *Las influencias dinámicas en la obra de Boccioni*. Seville: Universidad de Sevilla.
Cornford, Francis MacDonald. 1931. *The Laws of Motion in Ancient Thought*. Cambridge: Cambridge University Press.
———. 1939. *Plato and Parmenides*. London: Kegan Paul.
———. 1976. "The Invention of Space." In *The Concepts of Space and Time: Their Structure and Their Development*, edited by Milič Čapek, 3–16. Stuttgart: Springer.
Dalcroze, Emile Jaques. 1921. *Rhythm, Music and Education*. London: Chatto & Windus.
Daniélou, Alain. 1987. *Shiva y Dionysos: La religión de la Naturaleza y del Eros*. Barcelona: Kairós.
———. 2003. *While the Gods Play: Shaiva Oracles and Predictions on the Cycles of History and the Destiny of Mankind*. Rochester: Inner Traditions International.
———. 2006. *El Shivaïsmo y la Tradición Primordial*. Barcelona: Kairós.
———. 2012. *Mientras los Dioses Juegan*. Girona: Atalanta.
Deleuze, Gilles. 1986a. *Cinema 1: The Movement Image*. Translated by Hugh Tomlinson and Barbara Habberjam. Minneapolis: University of Minnesota Press.
———. 1986b. *Nietzsche and Philosophy*. Translated by Hugh Tomlinson. London: Continuum Press.
———. 1990. *The Logic of Sense*. Translated by Mark Lester. New York: Columbia University Press.
———. 1992. "Postscript on the Societies of Control." *October* 59 (Winter): 3–7. https://www.jstor.org/stable/778828.
———. 1993. *The Fold: Leibniz and the Baroque*. Translated by Tom Conley. London: Athlone Press.
———. 1994. *Difference and Repetition*. Translated by Paul Patton. New York: Columbia University Press.

Deleuze, Gilles, and Félix Guattari. 1987. *A Thousand Plateaus: Capitalism and Schizophrenia*. Translated by Brian Massumi. Minneapolis: University of Minnesota Press.

———. 1994. *What Is Philosophy?* Translated by Graham Burchell and Hugh Tomlinson. London: Verso Books.

Derrida, Jacques. 1981. *Disseminaton*. Translated by Barbara Johnson. University of Chicago Press.

———. 1982. "Différance." In *Margins of Philosophy*, translated by Alan Bass, 3–27. Brighton: Harvester Press.

———. 1988. "Signature Event Context." In *Limited Inc*, translated by Samuel Weber, 1–23. Evanston: Northwestern University Press.

———. 1989. *Edmund Husserl's "The Origin of Geometry": An Introduction*. Translated by John P. Leavey, Jr. Lincoln: University of Nebraska Press.

———. 1994. *Specters of Marx*. Translated by Peggy Kamuf. New York: Routledge.

———. 1995. *On the Name*. Translated by Thomas Dutoit. Stanford: Stanford University Press.

di Fazio, Caterina. 2015. "Phenomenology of Movement." *Eikasia: Revista de Filosofía* 66: 149–66. https://www.revistadefilosofia.org/revistadefilosofia_old/66-07.pdf.

Eggers Lan, Conrado, and Victoria E. Juliá. 1978. *Los Filósofos Presocráticos*. Vol. 1. Madrid: Gredos.

Eggers Lan, Conrado, Isabel Santa Cruz de Prunes, Nestor Luis Cordero, and Armando Poratti. 1980. *Los Filósofos Presocráticos*. Vol. 3. Madrid: Gredos.

Engels, Frederick. 1987. *Dialectics of Nature*. In Karl Marx and Frederick Engels, *Collected Works*, Vol. 25, 313–590 New York: International Publishers.

Forsythe, William. 2003. *Improvisation Technologies: A Tool for the Analytical Dance Eye*. Karlsruhe: ZKM.

Foucault, Michel. 1995. *Discipline and Punish: The Birth of the Prison*. Translated by Alan Sheridan. New York: Vintage Books.

Gebser, Jean. 1985. *The Ever-Present Origin*. Translated by Noel Barstad with Algis Mickunas. Athens: Ohio University Press.

Giannetti, Claudia. 1997. "Metaformance, el sujeto-proyecto." In *Luces, cámara, acción(...) ¡Corten! Videoacción: El cuerpo y sus fronteras*, edited by Julio Gonzalez, 91–101. Valencia: IVAM Centre.

Gil, José. 1998. *Metamorphoses of the Body*. Minneapolis: University of Minnesota Press.

———. 2002. "The Dancer's Body." In *Shock to Thought*, edited by Brian Massumi, 117–27. New York: Routledge.

Goodman, Steve. 2012. *Sonic Warfare: Sound, Affect, and the Ecology of Fear*. Cambridge: MIT Press.

Gosselin, Sophie, and David gé Bartoli. 2019. *Le toucher du monde: Techniques du naturer*. Arles: Éditions Dehors.

Guthrie, William Keith Chambers. 1962. *History of Greek Philosophy I: The Earlier Presocratics and the Pythagoreans*. Cambridge: Cambridge University Press.

———. 1969. *History of Greek Philosophy II: The Presocratic Tradition from Parmenides to Democritus*. Cambridge: Cambridge University Press.

Hanna, Thomas L. 1985. *Bodies in Revolt: A Primer in Somatic Thinking*. Novato: Freeperson Press.

———. 1993. *The Body of Life: Creating New Pathways for Sensory Awareness and Fluid Movement*. Rochester: Healing Arts Press.

———. 1995. "What Is Somatics?" In *Bone, Breath and Gesture: Practices of Embodiment*, edited by Don Hanlon Johnson, 341–53. Berkeley: North Atlantic.
Hansen, Mark N. 2012. "Engineering Pre-individual Potentiality: Technics, Transindividuation, and 21st-Century Media." *SubStance* 41, no. 3: 32–59. https://www.jstor.org/stable/41818936.
———. 2015. *Feed Forward: On the Future of Twenty-First-Century Media*. Chicago: University of Chicago Press.
Haraway, Donna. 1992. "The Promises of Monsters: A Regenerative Politics for Inappropriate/d Others." In *Cultural Studies*, edited by Lawrence Grossberg, Cary Nelson, and Paula A. Treichler, 295–337. New York: Routledge.
———. 1997. *Modest−Witness@Second−Millennium. FemaleMan−Meets−OncoMouse: Feminism and Technoscience*. New York: Routledge.
———. 2003. *The Haraway Reader*. New York: Routledge.
———. 2016. *Staying with the Trouble: Making Kin in the Chthulucene*. Durham: Duke University Press.
Hegel, G.W.F. 1966. *Science of Logic*. Edited and translated by George di Giovanni. New York: Humanities Press.
Heidegger, Martin. 1967. *Sein und Zeit*. Tübingen: Max Niemeyer Verlag.
Ingold, Tim. 2000. *The Perception of the Environment: Essays on Livelihood, Dwelling and Skill*. London: Routledge.
———. 2007. *Lines: A Brief History*. London: Routledge.
Irigaray, Luce. 1985a. *Speculum of the Other Woman*. Translated by Gillian Gill. Ithaca: Cornell University Press.
———. 1985b. *This Sex Which Is Not One*. Translated by Caroline Porter with Carolyn Burke. Ithaca: Cornell University Press.
Jaeger, Werner. 1947. *The Theology of the Early Greek Philosophers*. Oxford: Oxford University Press.
Jahn, Janheinz. 1994. *Muntu: African Culture and the Western World*. New York: Avalon.
James, William. 2003. *Essays in Radical Empiricism*. London: Dover.
Kingsley, Peter. 1999. *In the Dark Places of Wisdom*. Point Reyes: The Golden Sufi Center.
Laozi [Lao-Tse]. 1977. *Tao Te Ching*. Translated by Ch'u Ta-Kao. Crow's Nest: Allen & Unwin.
Laverack, M.S. 1976. "External Proprioceptors." In *Structure and Function of Proprioceptors in the Invertebrates*, edited by P.J. Mill, 1–63. London: Chapman & Hall.
Lefebvre, Henri. 1991. *The Production of Space*. Translated by Donald Nicholson-Smith. Oxford: Blackwell.
———. 2000. *Métaphilosophie*. Paris: Éditions Sylepse.
———. 2013. *Rhythmanalysis*. Translated by Stuart Elden and Gerald Moore. London: Bloomsbury.
Leibniz, Gottfried W. 1948. *The Monadology*. Translated by Robert Latta. Oxford: Oxford University Press.
Lévi-Strauss, Claude. 1966. *The Savage Mind*. Translated by George Weidenfeld and Nicolson. Chicago: University of Chicago Press.
Maffie, James. 2014. *Aztec Philosophy: Understanding a World in Motion*. Denver: University Press of Colorado.
Mallin, Samuel B. 1996. *Art, Line, Thought*. London: Kluwer.

Manning, Erin. 2009. *Relationscapes: Movement. Art, Philosophy*. Cambridge: MIT Press.

———. 2013. *Always More Than One: Individuation's Dance*. Durham: Duke University Press.

———. 2015. "Three Propositions for a Movement of Thought." In *Performance and Temporalisation*, edited by Stuart Grant, Jodie McNeilly, and Maeva Veerapen, 114–28. London: Palgrave McMillan.

———. 2016. *The Minor Gesture*. Durham: Duke University Press.

Manning, Richard. 2016. "Spinoza's Physical Theory." In *The Stanford Encyclopedia of Philosophy*, edited by Edward N. Zalta. https://plato.stanford.edu/archives/win2016/entries/spinoza-physics/.

Marx, Karl. 1902. *The Difference between the Democritean and Epicurian Philosophy of Nature*. Moscow: Progress Publishers.

———. 1965. *Capital*. Vol. 1. Moscow: Progress Publishers.

———. 2012. *Diferencia de la Filosofía de la Naturaleza en Demócrito y Epicuro y Otros Escritos*. Translated by Miguel Candel. Madrid: Biblioteca Nueva.

Massumi, Brian. 1987. Introduction to Gilles Deleuze and Félix Guattari, *A Thousand Plateaus: Capitalism and Schizophrenia*. Translated by Brian Massumi, ix–xv. Minneapolis: University of Minnesota Press.

———. 2002. *Parables for the Virtual: Movement, Affect, Sensation*. Durham: Duke University Press.

———. 2015. *Ontopower: War, Powers and the State of Perception*. Durham: Duke University Press.

———. 2017. "The Art of the Relational Body." In *Mirror-Touch Synaesthesia: Thresholds of Empathy with Art*, edited by Daria Martin, 191–209. Oxford: Oxford University Press.

Maturana, Umberto, and Francisco Varela. 1980. *Autopoiesis and Cognition: The Realisation of the Living*. London: D. Reidel.

McDonough, Jeffrey K. 2019. "Leibniz's Philosophy of Physics." In *The Stanford Encyclopedia of Philosophy*, edited by Edward N. Zalta. https://plato.stanford.edu/archives/fall2019/entries/leibniz-physics/.

Meillassoux, Quentin. 2007. "Subtraction and Contraction: Deleuze, Immanence, and Matter and Memory." Translated by Robin McKay. In *Collapse III*, edited by Robin McKay, 63–107. Falmouth: Urbanomic.

———. 2014. *Time without Becoming*. Edited by Anna Longo. Milan: Mimesis.

Merchant, Carolyn. 1992. *Radical Ecology: The Search for a Livable World*. London: Routledge.

Merleau-Ponty, Maurice. 1962. *Phenomenology of Perception*. Translated by Colin Smith. New York: Routledge.

———. 1968. *The Visible and the Invisible*. Translation by Alphonso Lingis. Evanston, Illinois: Northwestern University Press.

———. 1994. *La Nature: Notes, cours du Collège de France*. Paris: Seuil.

Monod, Jacques-Lucian. 1971. *Chance and Necessity: An Essay on the Natural Philosophy of Modern Biology*. Translated by Austryn Wainhouse. New York: Alfred A. Knopf.

Morin, Marie-Eve. 2012. "The Coming-to-the-world of the Human Animal." In *Sloterdijk Now*, edited by Stuart Elden, 77–95. London: Polity Press.

Munster, Anna. 2006. *Materializing New Media: Embodiment in Information Aesthetics*. Hanover: Dartmoth College Press.

Nail, Thomas. 2018a. *Lucretius I: An Ontology of Motion.* Edinburgh: Edinburgh University Press.
———. 2018b. "The Ontology of Motion." *Qui Parle* 27, no. 1: 47–76. DOI: 10.1215/10418385-4382983.
———. 2019. *Being and Motion.* Oxford: Oxford University Press.
———. 2020a. *Lucretius II: An Ethics of Motion.* Edinburgh: Edinburgh University Press.
———. 2020b. *Marx in Motion.* Oxford: Oxford University Press.
———. 2021. *Theory of the Earth.* Stanford: Stanford University Press.
———. 2022. *Lucretius III: A History of Motion.* Edinburgh: Edinburgh University Press.
———. 2023. *Matter and Motion: A Brief History of Kinetic Materialism.* Edinburgh: Edinburgh University Press.
———. 2024. *The Philosophy of Movement: An Introduction.* Minneapolis: University of Minnesota Press.
Neher, André. 1971. "La Filosofía Hebrea y Judía de la Antigüedad." In *El pensamiento prefilosófico y oriental: Historia de la filosofía*, Vol. I. Edited by Brice Parain, 52–77. Mexico City: Siglo XXI.
Newton, Isaac. 1999. *The Principia: Mathematical Principles of Natural Philosophy.* A New Translation by I. Bernard Cohen and Anne Whitman. Berkeley: University of California Press.
Nietzsche, Friedrich W. 1968. *The Will to Power.* Translated by Walter Kaufmann and R.J. Hollingdale. New York: Vintage Books.
———. 2006. *Thus Spoke Zarathustra.* Translated by Adrian del Caro. Cambridge: Cambridge University Press.
Novak, Marcos. 2002. "Speciation, Transvergence, Allogenesis: Notes on the Production of the Alien." *AD Architectural Design* 72, no. 3 (May): 64–71.
Pardo, José Luis. 2011. *El cuerpo sin órganos: Presentación de Gilles Deleuze.* Valencia: Pretextos.
Parain, Brice, ed. 1971. *El pensamiento prefilosófico y oriental: Historia de la filosofía*, Vol. I. Mexico City: Siglo XXI.
Parisi, Luciana. 2004. *Abstract Sex, Philosophy, Biotechnology and the Mutations of Desire.* New York: Continuum Press.
———. 2013. *Contagious Architecture: Computation, Aesthetics and Space.* Cambridge: MIT Press.
Parisi, Luciana, and Steve Goodman. 2009. "Extensive Continuum: Towards a Rhythmic Anarchitecture." *Inflections Journal* 2. http://www.inflections.org/n2_parisigoodmanhtml.html.
Plato. 1921. *Theaetetus.* Translated by H.N. Fowler. London: William Heineman.
———. 1926. *The Laws.* Translated by R.G. Bury. 2 Vols. London: Willian Heinmann.
Portanova, Stamatia. 2013. *Moving without a Body: Digital Philosophy and Choreographic Thoughts.* Cambridge: MIT Press.
Prigogine, Ilya. 1980. *From Being to Becoming.* New York: W.H. Freeman and Company.
Rojas Osorio, Carlos. 2001. *Del ser al devenir: Fragmentos desde una ontología dinamicista.* Humacao: Museo Casa Roig.
Ross, Daniel. 2018. Introduction to Bernard Stiegler, *The Neganthropocene.* Translated by Daniel Ross, 7–33. London: Open Humanities Press.

Sachs, Joe. 1995. *Aristotle's Physics: A Guided Study*. New Brunswick: Rutgers University Press.
———. 2005. "Aristotle: Motion and its Place in Nature." *Internet Encyclopedia of Philosophy*. https://iep.utm.edu/aristotle-motion/.
Safransky, Rüdiger. 2003. *Nietzsche: A Philosophical Biography*. Translated by Shelley Frisch. New York: Norton.
Séjourné, Laurette. 1964. *Pensamiento y religión en el México antiguo*. Mexico City: Fondo de Cultura Económica.
Serres, Michel. 2000. *The Birth of Physics*. Translated by Jack Hawkes. Manchester: Clinamen Press.
Sheets-Johnstone, Maxine. 2011. *The Primacy of Movement*. Expanded second edition. Amsterdam: John Benjamins.
Sherrington, Charles Scott. 1906. *The Integrative Action of the Nervous System*. New Haven: Yale University Press.
Simondon, Gilbert. 2005. *L'individuation à la lumière des notions de formes et d'information*. Paris: Millon.
Siret, Luis. 1996. *Estudios de Arqueología, Mitología y Simbolismo*. Almería: Editorial Arraez.
Skemp, J.B. 1942. *The Theory of Motion in Plato's Later Dialogues*. Cambridge: Cambridge University Press.
Sloterdijk, Peter. 2001. *Nicht gerettet: Versuche nach Heidegger*. Frankfurt: Suhrkamp Verlag.
Small, Robin. 2010. *Time and Becoming in Nietzsche's Thought*. London: Continuum Press.
Spinoza, Baruch. 1985. *The Collected Works of Spinoza*, Vol. 1. Edited and translated by Edwin Curley. Princeton: Princeton University Press.
Spivak, Gayatri Chakravorty. 1988. *Can the Subaltern Speak?* Basingstoke: Macmillan.
Steinbock, Anthony J. 1999. "Saturated Intentionality" In *The Body: Classic and Contemporary Readings*, edited by Donn Welton, 271–302. Cambridge: Blackwell.
Stone, Allucquére Rosanne. 1987. "The *Empire* Strykes Back: A Posttransexual Manifesto." *Sandy Stone*. https://sandystone.com/empire-strikes-back.html.
———. 1993a. "Interview for Mondo 2000." *Sandy Stone*. https://sandystone.com/pupik/Mondo-interview.
———. 1996. *The War of Technology and Desire at the Close of the Mechanical Age*. Cambridge: MIT Press.
———. 1999. "Will the Real Body Please Stand Up?" In *Cybersexualities: A Reader on Feminist Theory, Cyborgs and Cyberspace*, edited by Jenny Wolmark, 69–98. Edinburgh: Edinburgh University Press.
Thomson, George. 1954. *The First Philosophers: Studies in Ancient Greek Society*. Vol. II. London: Lawrence & Wishart.
Vandier-Nicolas, Nicole. 1971. "La filosofía China, desde los orígenes hasta el s. XVII." In *El pensamiento prefilosófico y oriental: Historia de la filosofía*, Vol. I, edited by Brice Parain, 220–55. Mexico City: Siglo XXI.
Varela, Francisco, Evan Thomson, and Eleanor Rosch. 1993. *The Embodied Mind: Cognitive Science and Human Experience*. Cambridge: MIT Press.
Vopěnka, Peter. 1979. *Mathematics in the Alternative Set Theory*. Leipzig: Teubner.
Welton, Donn, ed. 1999. *The Body: Classic and Contemporary Readings*. Cambridge: Blackwell.

Wiener, Norbert. 1948. *Cybernetics: Or Control and Communication in the Animal and the Machine*. Cambridge: MIT Press.

Wilhelm, Richard, trans. 1977. *I Ching: El libro de las mutaciones*. Barcelona: Edhasa.

Woodroffe, Sir John [Arthur Avalon]. 1974. *The Serpent Power: The Secrets of Tantric and Shaktik Yoga*. London: Dover.

Zimmer, Heinrich. 1952. *Philosophies of India*. Edited by Joseph Campbell. London: Routledge.

Made in United States
North Haven, CT
26 October 2025